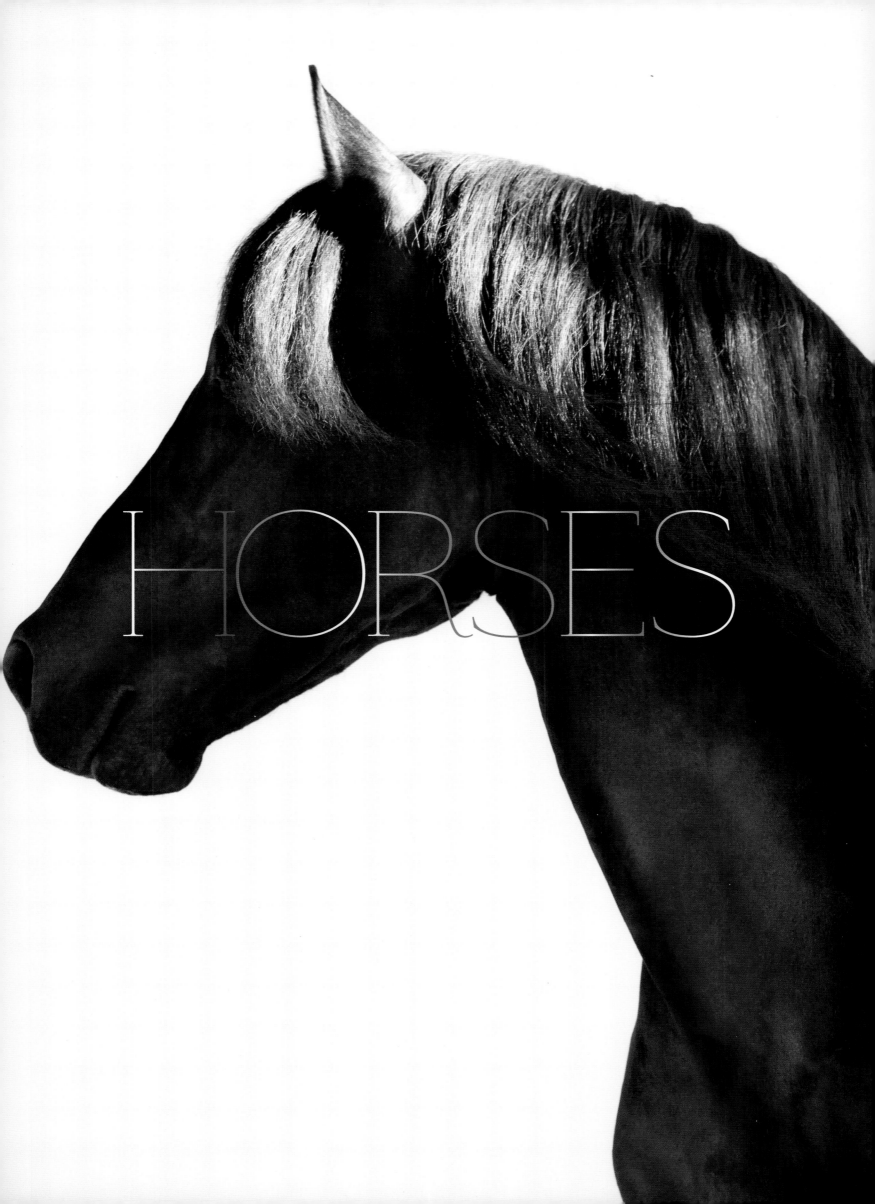

HORSES

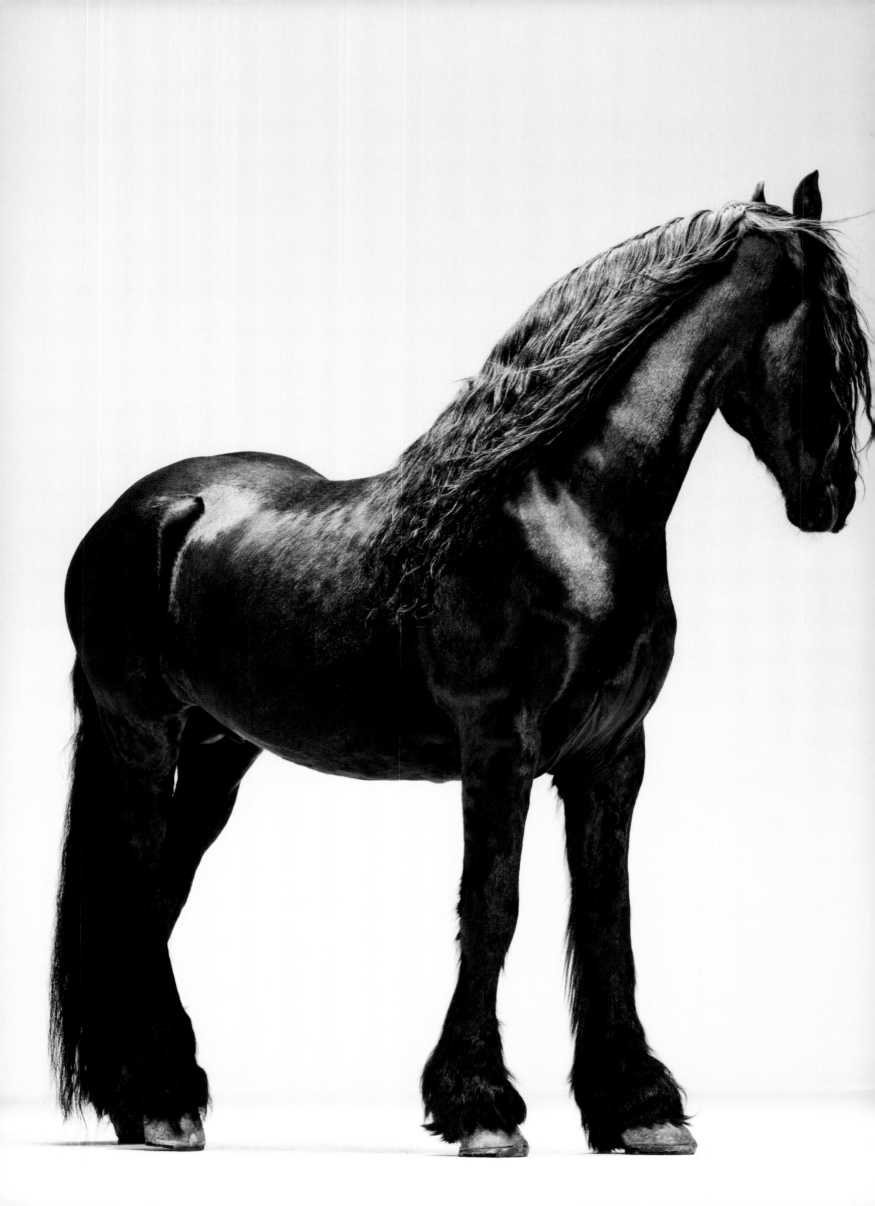

JILL GREENBERG
HORSES

WITH A TEXT BY A. M. HOMES

RIZZOLI
NEW YORK

New York · Paris · London · Milan

CONTENTS

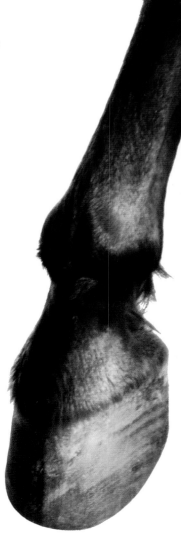

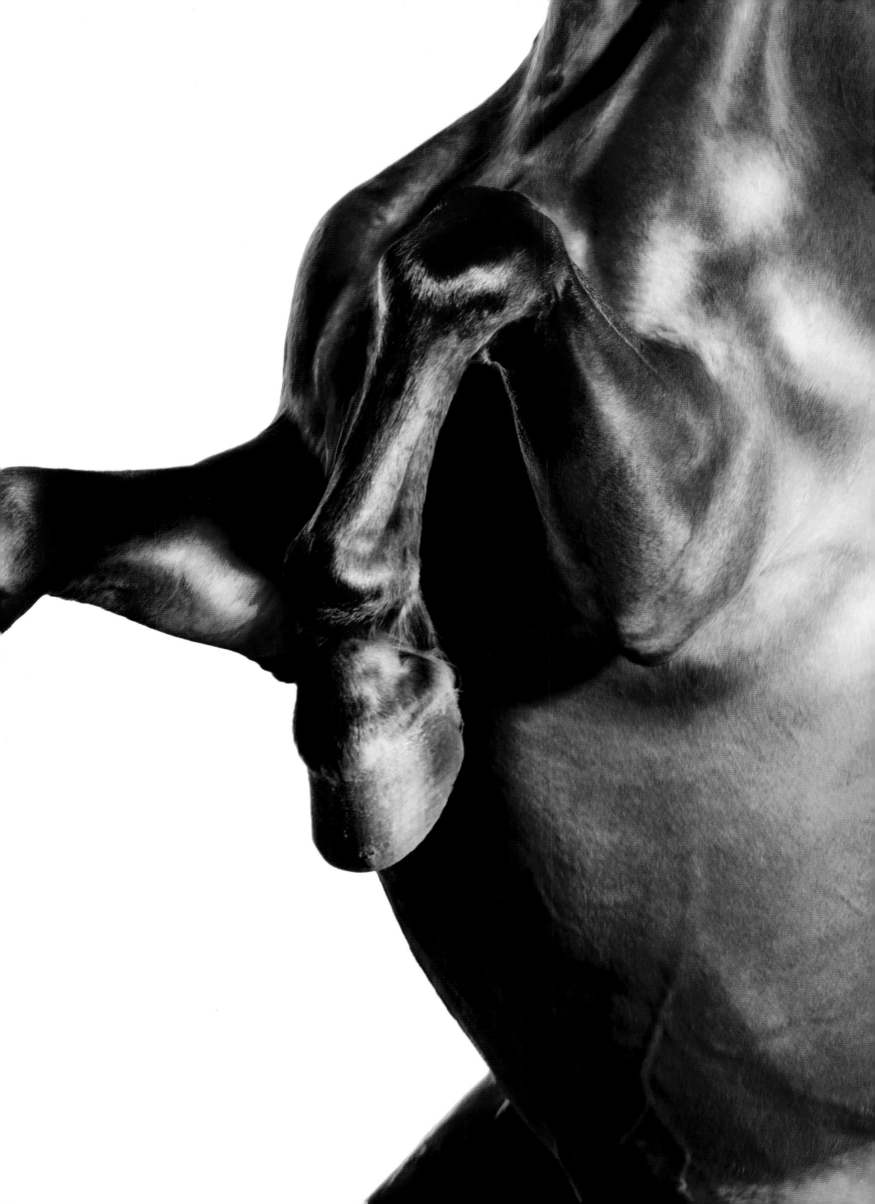

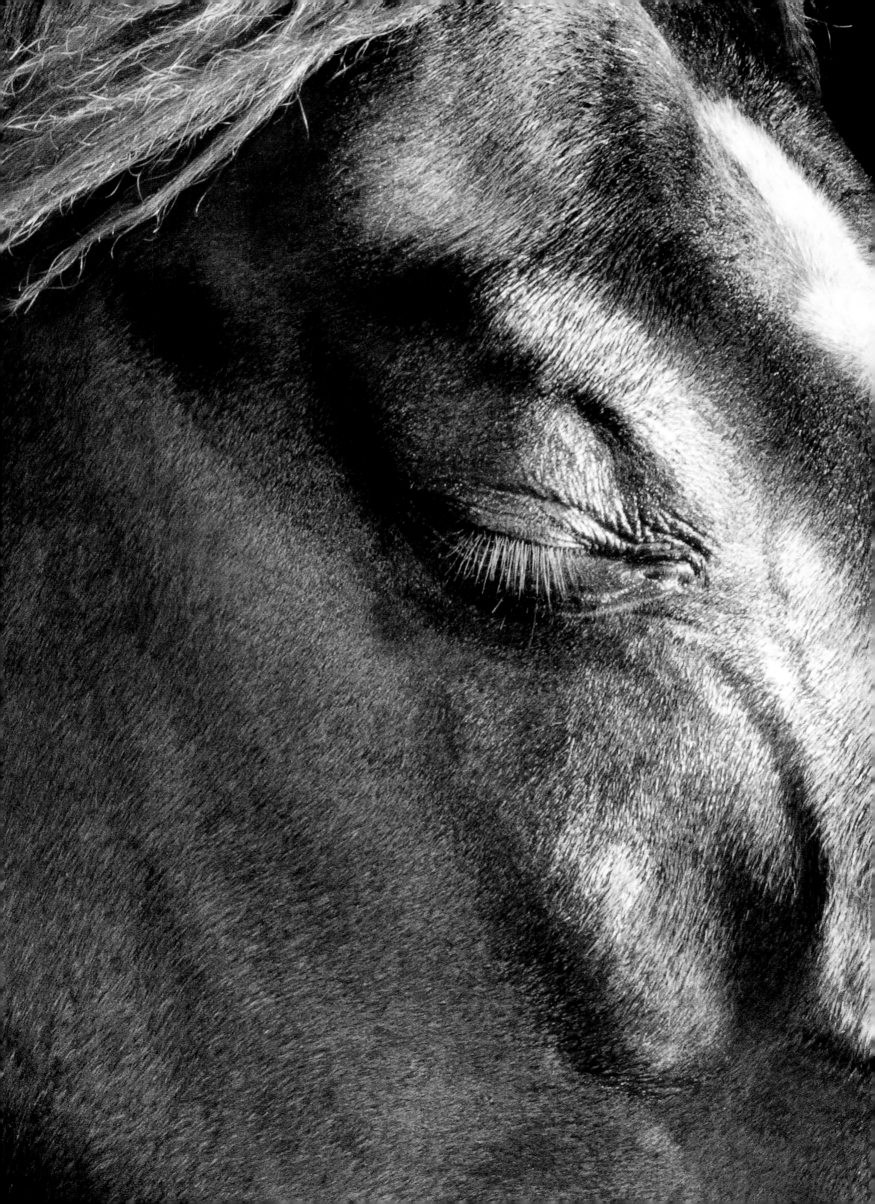

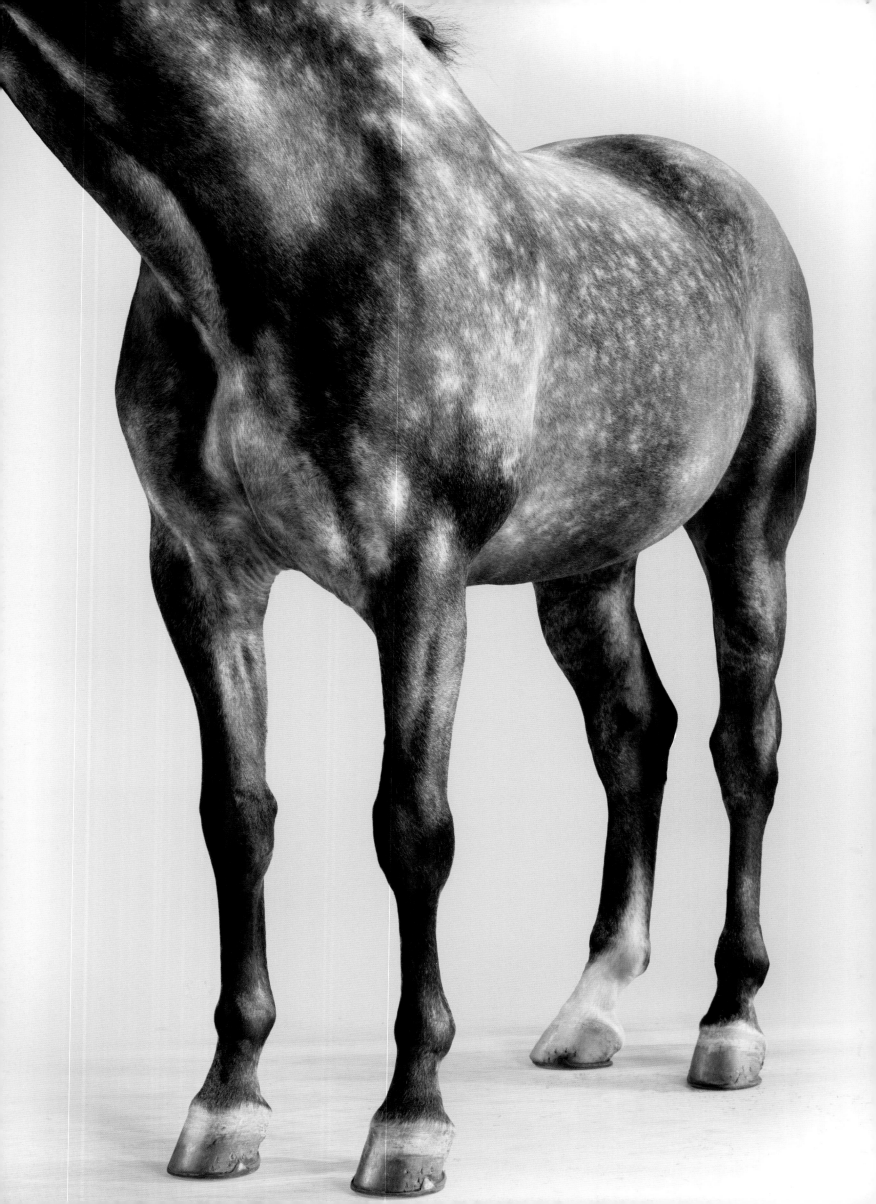

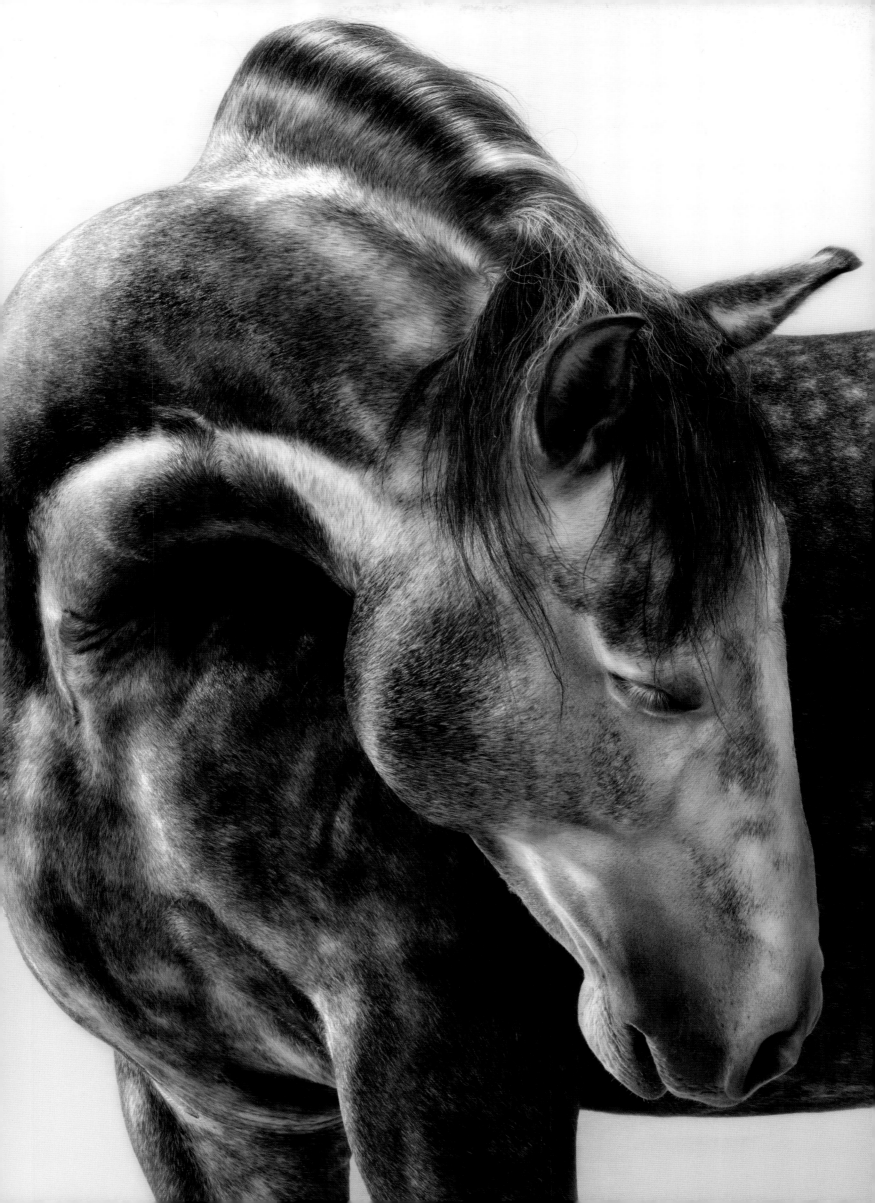

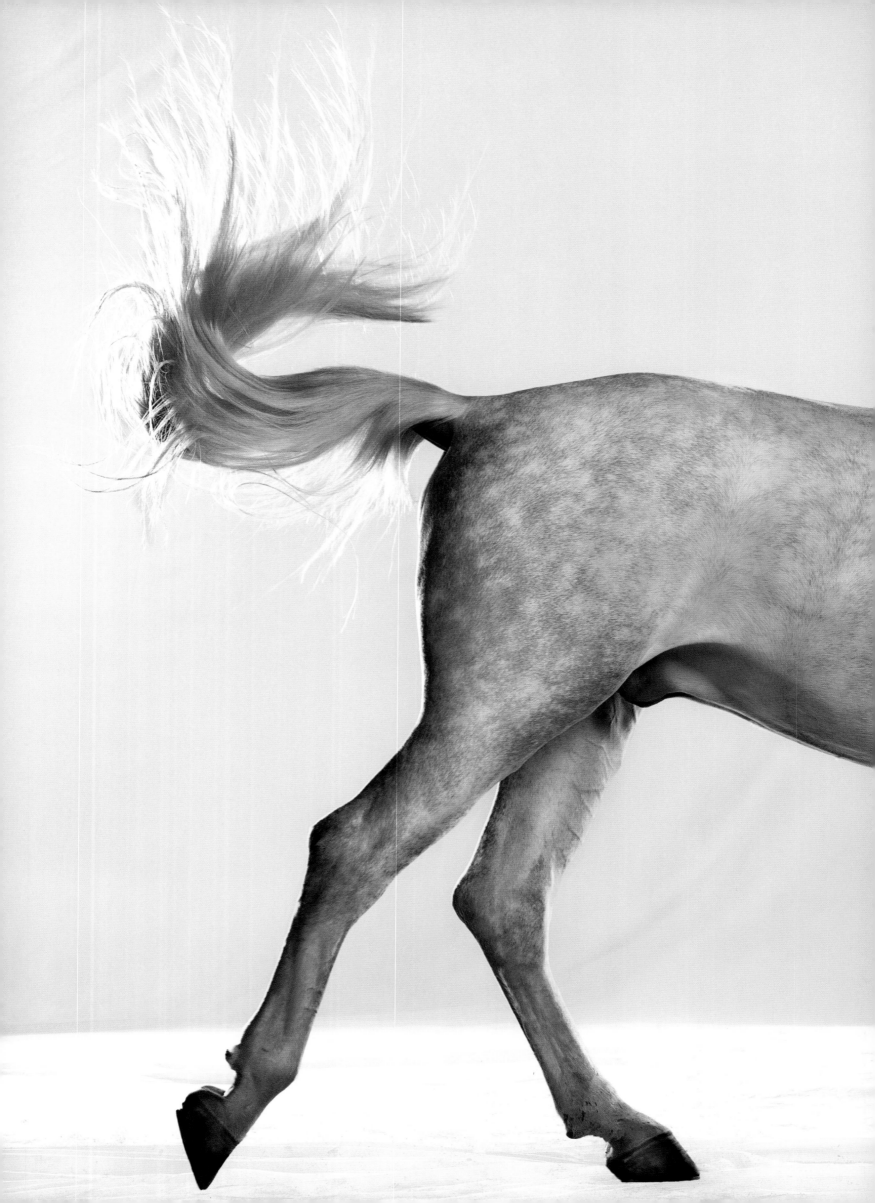

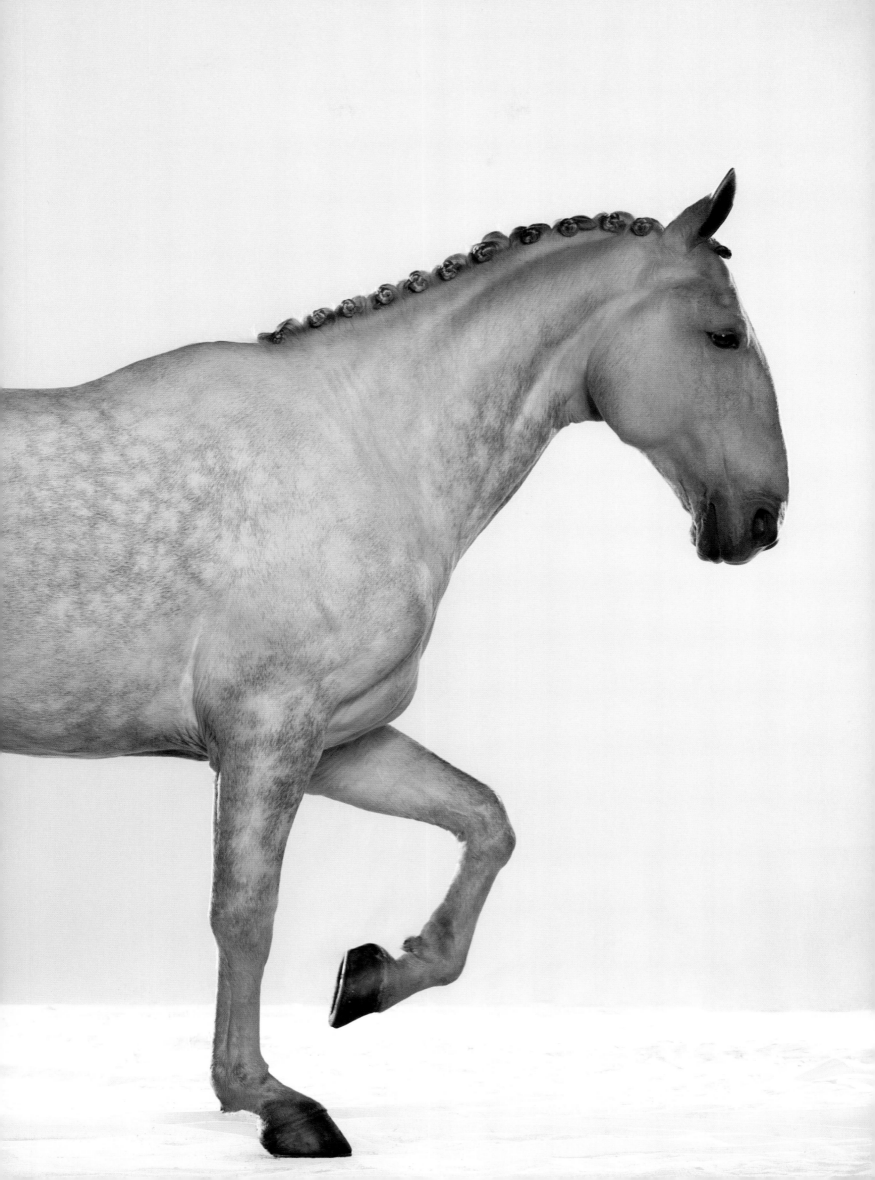

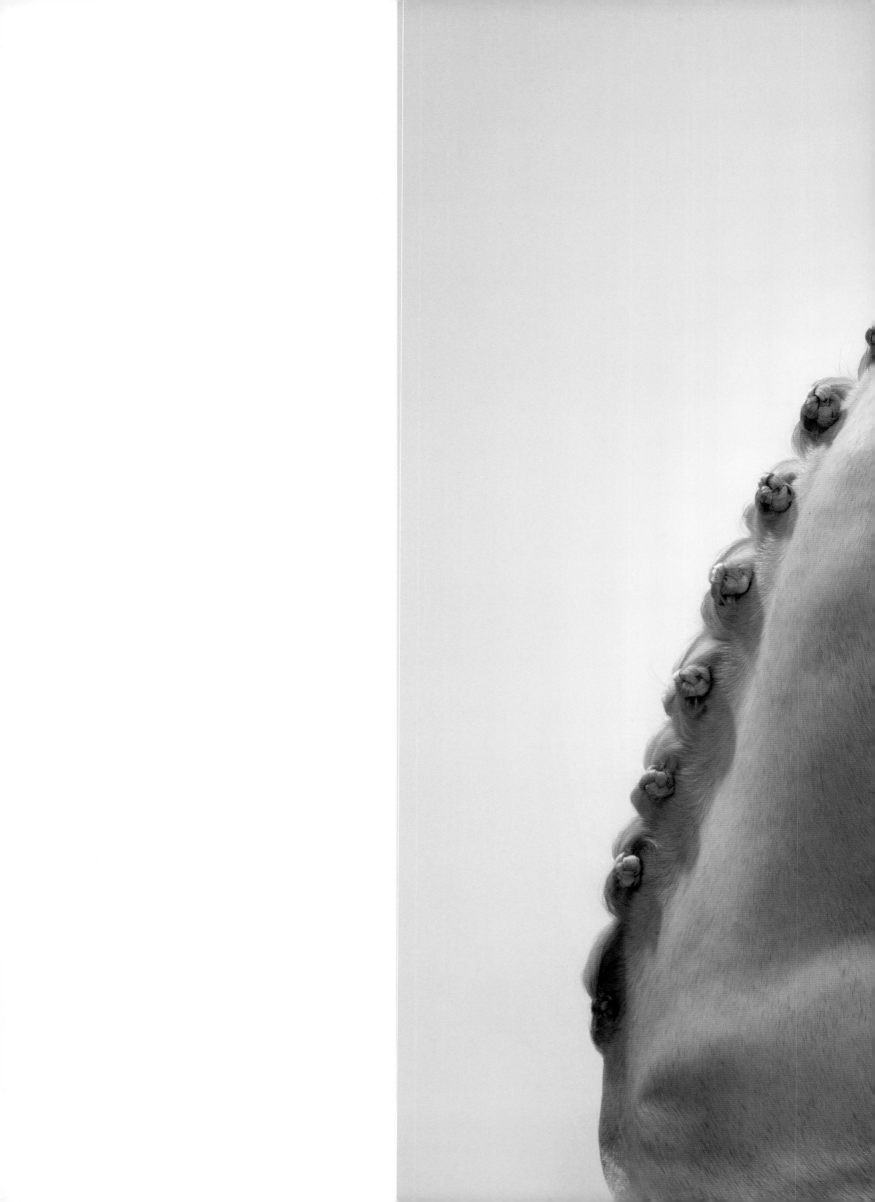

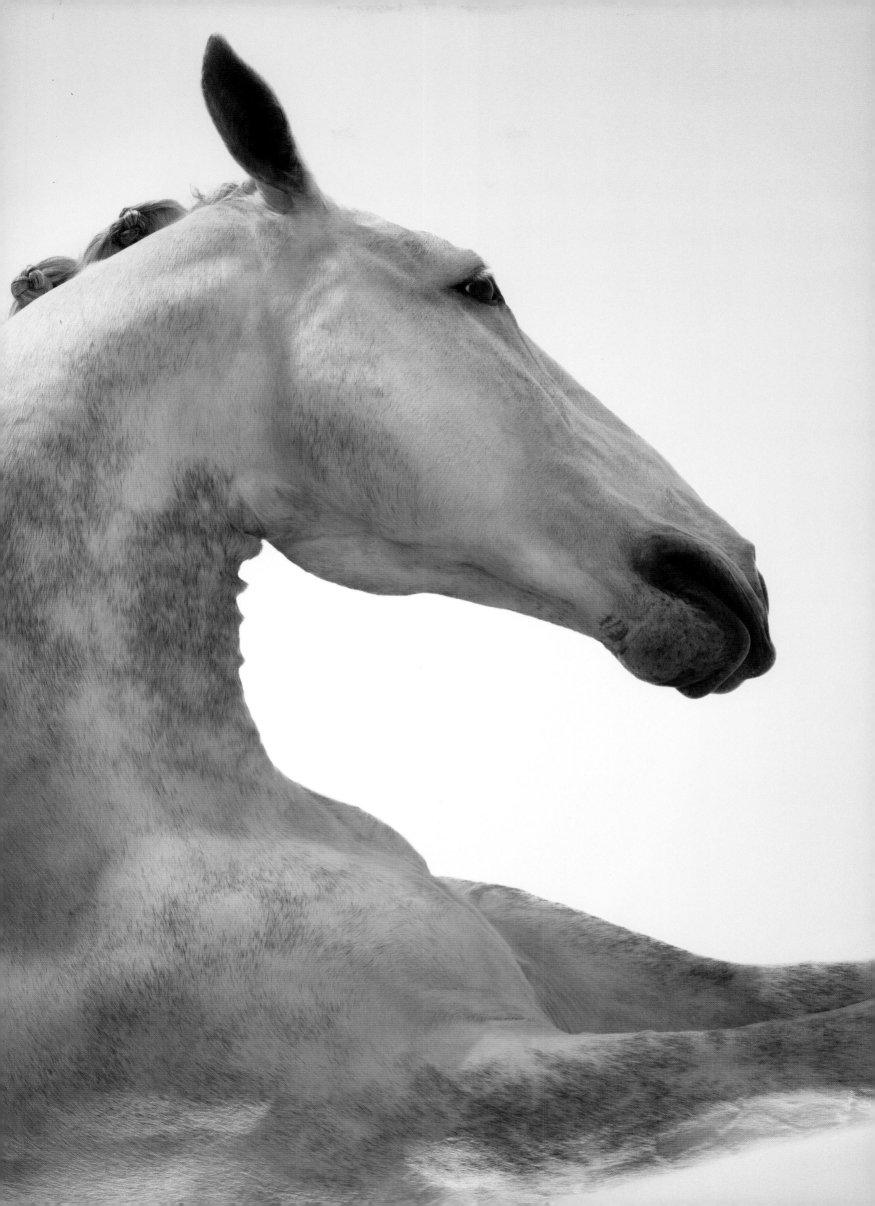

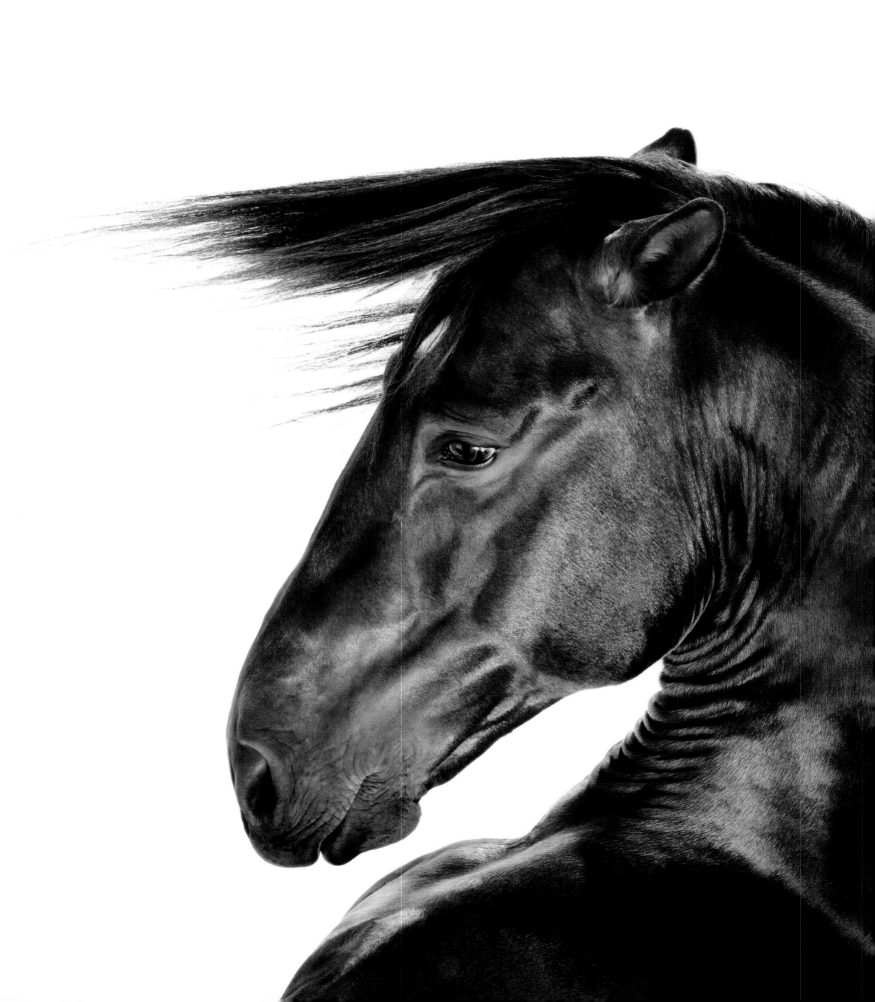

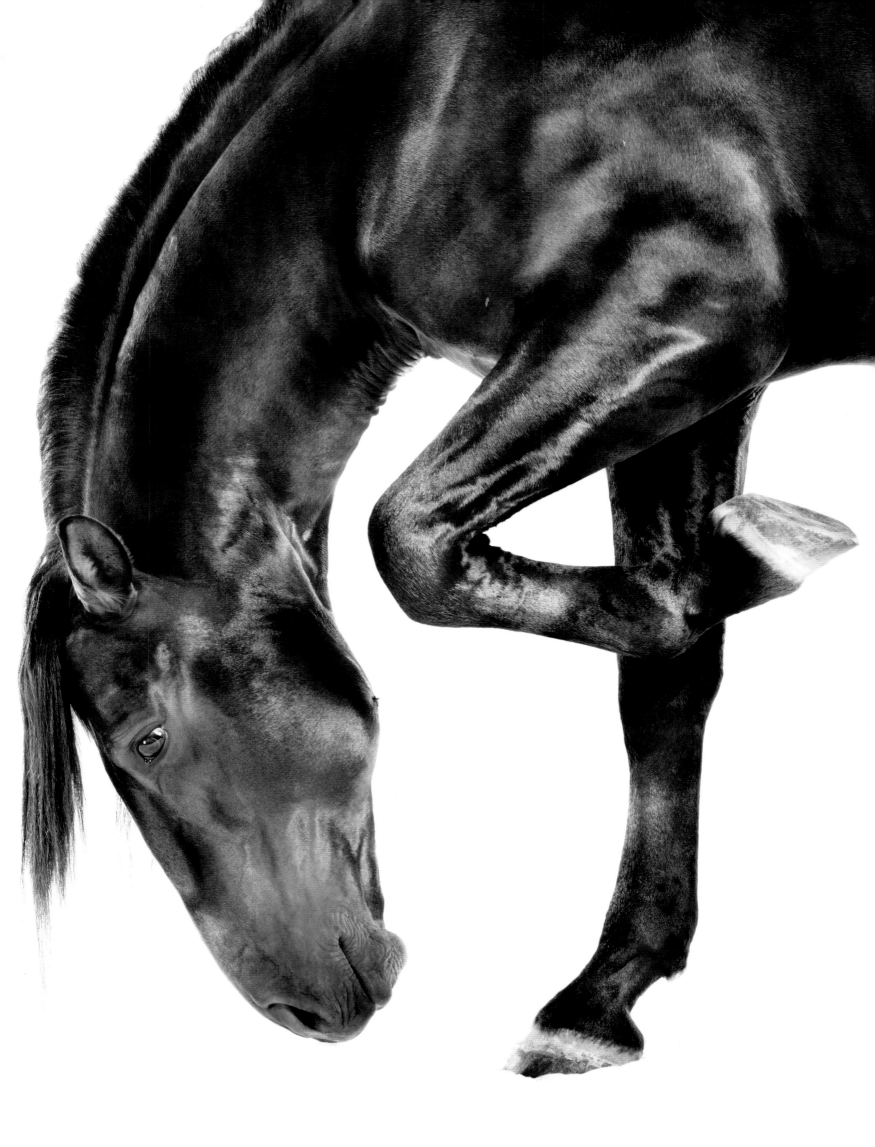

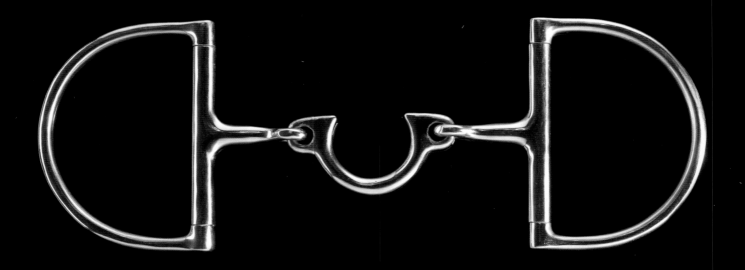
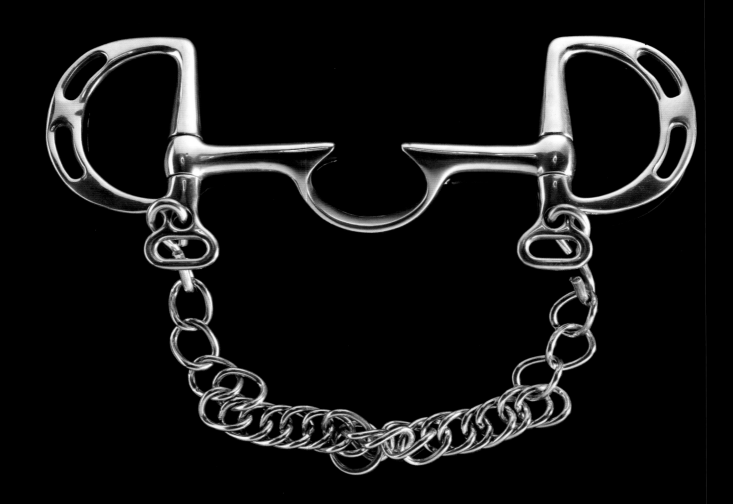

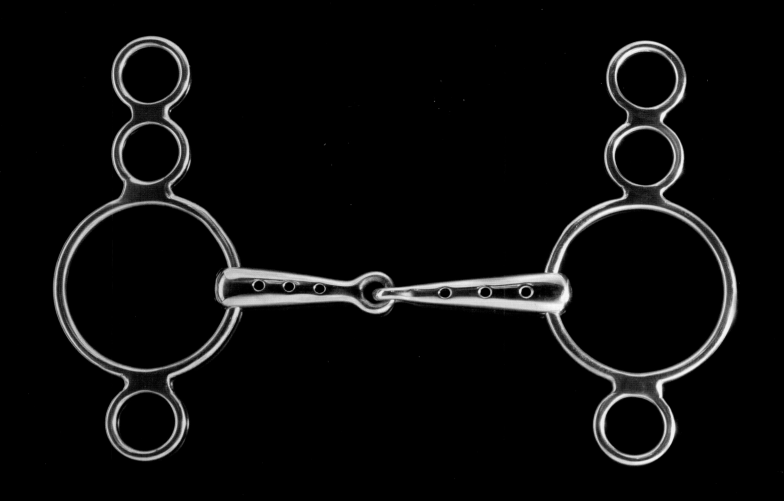
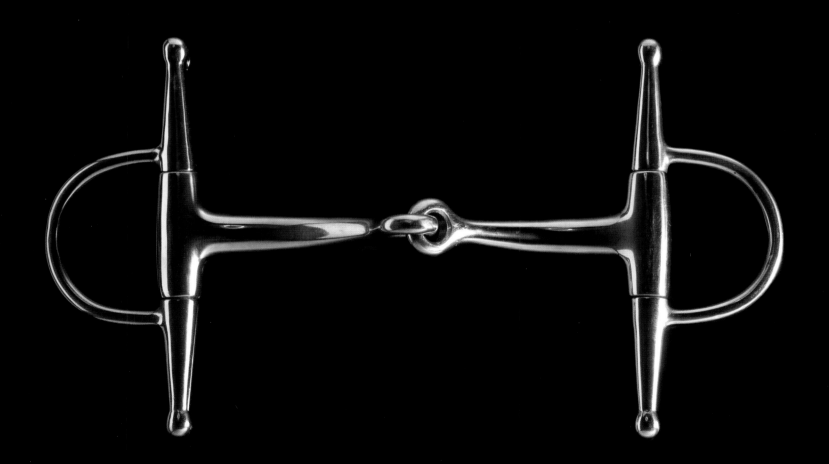

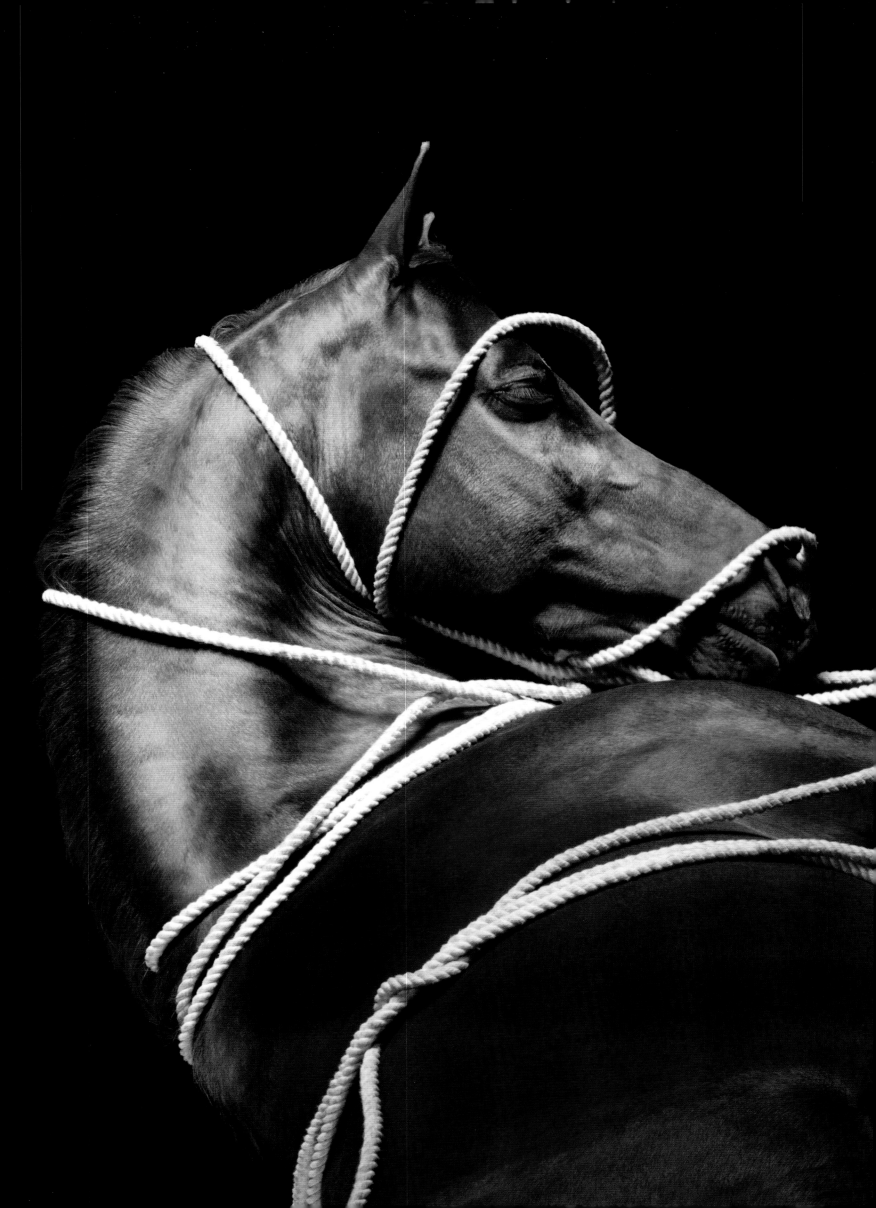

HORSE POWER

Jill Greenberg

MY OBSESSION WITH HORSES BEGAN AT the early age of six. What is it that makes young girls project so much onto these gorgeous animals? I drew them, painted them, sculpted them, collected plastic models of them, read stories about them, and rode them. When I saw the same happening with my young daughter, I decided it was time to return to my primary muse. It had been more than thirty-five years since my first attempts to capture the grace and musculature of these animals, and I finally had a black beauty in the studio and the skill to render him completely. Just to see the magnificent creature standing outside his trailer was beyond exciting. Those of us who live in cities easily forget the scale and power of large animals.

The horse project is not only an homage to the physique of these sexy beasts but also an exploration of the paradoxical gender identities cast onto this unique animal. We see them as masculine, strong, muscular, even phallic. Yet they have been made subservient, so their position in the world relates to the role women continue to occupy. Horses are both masculine and feminine, dominant and submissive, mastered and wild. Their raw power and their innate sexual energy are harnessed by both men and women. My photographs focus on the animal's body; on cut, striated muscles under shiny, cropped hair; on crimped manes and windswept forelocks; on the strong shoulders and hindquarters of Baroque breeds like the Friesian and the Andalusian. The colors I digitally hand-painted are associated with the feminine, yet the formal approach and strength portrayed is decidedly masculine.

But the horse's rich history of ownership and usefulness to humankind comes out of an equally long history of forced submission. Horses must submit to the bit. Until quite recently, it was universally accepted that horses needed to be "broken" by their owners. The bit is a piece—or multiple pieces—of metal that interface with the tongue and mouth. An aggressive rider will yank the reins, which pulls the bit deeper into the mouth, gagging the animal. Items of tack called martingales, which tie the head down and force it to stay low, with the neck arched, are used to win points in dressage tournaments. This is called rollkur, or hyperflexion. Several images in this book show rollkur, but the position had been prompted by no tools save a carrot to encourage and direct the horse's head. There are special bridles for jumping events that even shut horses' mouths completely.

21

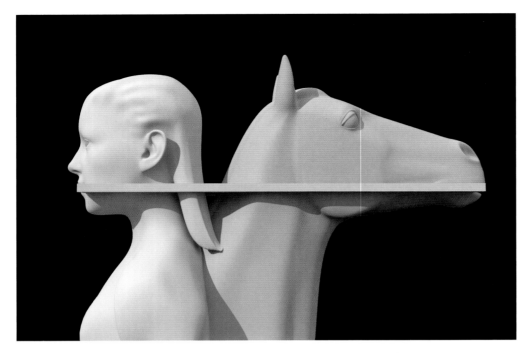

Above: Sketch for *Woman-Horse Bridled;* Below: Sketch for
The Collision of Emily and Anmer, the King's Horse (1913)

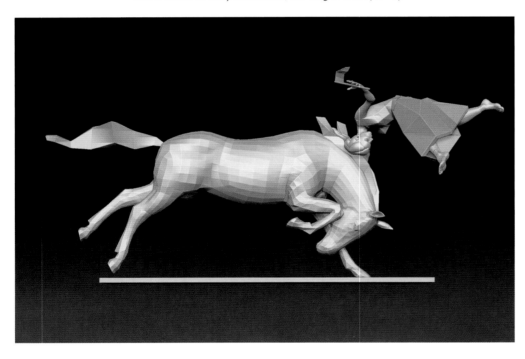

The bits and bridles are used to control and manipulate raw, natural power, much in the same way that women's movement-restricting apparel, supporting undergarments, and especially high-heeled shoes can be painful and limiting. The bits I photographed, viewed out of context, suggest the appearance of sadomasochistic bondage gear, which is, in fact, what they are.

My research into the harsh practices of equestrian oppression led me to discover a similar tool for use on women dating to the 1600s, called a scold's bridle, designed to punish and silence mouthy women. The bridle was equipped with not only a serrated piece of metal to be inserted into a woman's mouth but also, at times, with large ears so that the woman resembled an animal, to further the victim's humiliation as she was paraded around on a lead in public.

British scholar Gavin Robinson has written about the accoutrements of horseback riding as central to power in past cultures:

Some punishments were very heavily gendered. The scold's bridle symbolized the idea that women were like animals, because horses were made to wear bits and bridles. But there was also the practical effect that the bridle stopped a woman from speaking. Speech was said to be one of the main things that set humans apart from all other animals. By taking away her power of speech the bridle made a woman more bestial in practice as well as in theory.[1]

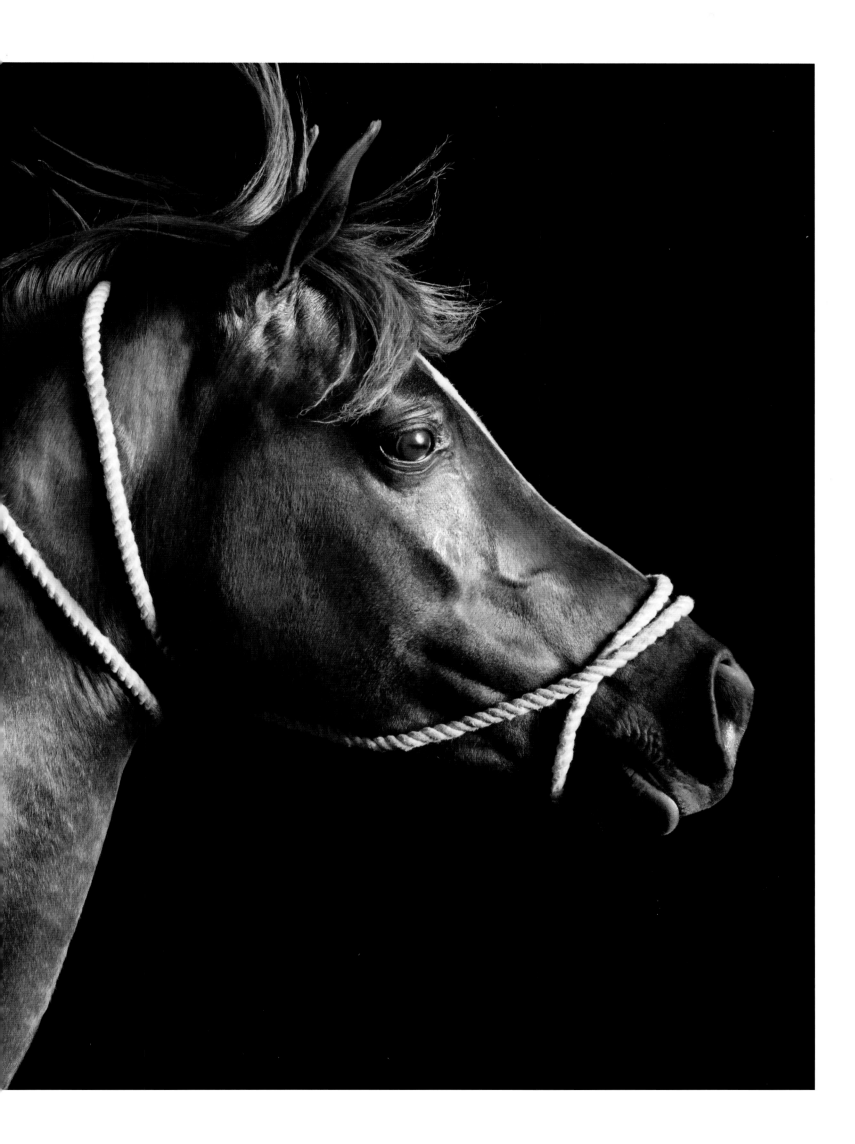

Ultimately, I uncovered a historical incident that both signifies and transcends: a moment that has become a locus in my work, spotlighting the intense emotion associated with the continued failure of feminism. The account is that of Emily Wilding Davison, a highly educated British suffragist. In 1913 she walked onto the Epsom Derby racetrack in the midst of a horse race in an attempt to pin a symbolic suffragist flag on a horse, but collided with and was trampled by Anmer, King George V's horse.

In that one visceral moment, the idea of the horse and the idea of feminism manifested itself for posterity, in a woman's failed effort to halt the forward motion of the animal of the most powerful man in the land—his surrogate, his racehorse. Recent work has led me to sketches for a sculpture—a monument to the failure of feminism—to commemorate this event. Interestingly, a life-size statue commemorating Emily Wilding Davison would also serve to remind us that, in the United States, only one in five statues celebrates a woman's achievements (*Harper's Index*, July 2011).

But more on the form of the horse. Their heads and necks are remarkably phallic, and I have chosen to exploit this in my photographs. I have long been concerned with "exposing the phallus" in a playful, mocking way. The horse's neck is presented as a confrontational image. In general, the shapes and features in the photographs are not manipulated at all. The extent of the digital imaging work that I do varies, but it is primarily concerned with changing color, shading, and shine. These animals were photographed in makeshift studios set up in the ring at stables in and around California and outside Vancouver, as well as running free outside their barns. I used a camera better suited for studio portraiture so as to capture the highest-quality image possible. Chasing untrained horses with multiple flashing strobe lights popping wasn't the safest way to take photographs, but I survived, and it was worth it.

1 Gavin Robinson, "Social-Political Animals: Humans and Non-Humans in Early-Modern Society," *Investigations of a Dog* (blog), May 30, 2008, http://www.investigations.4-lom. com/2008/05/30/social-political-animals.

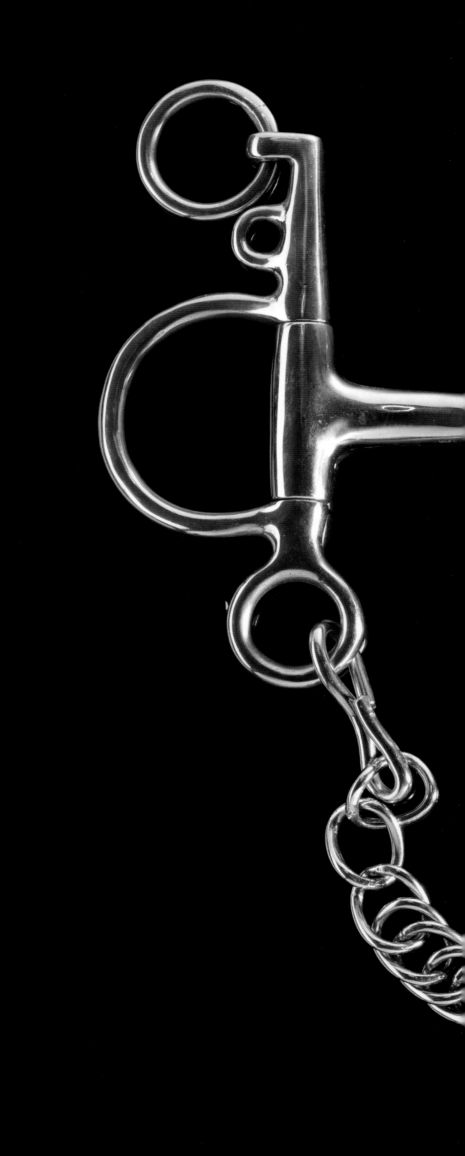

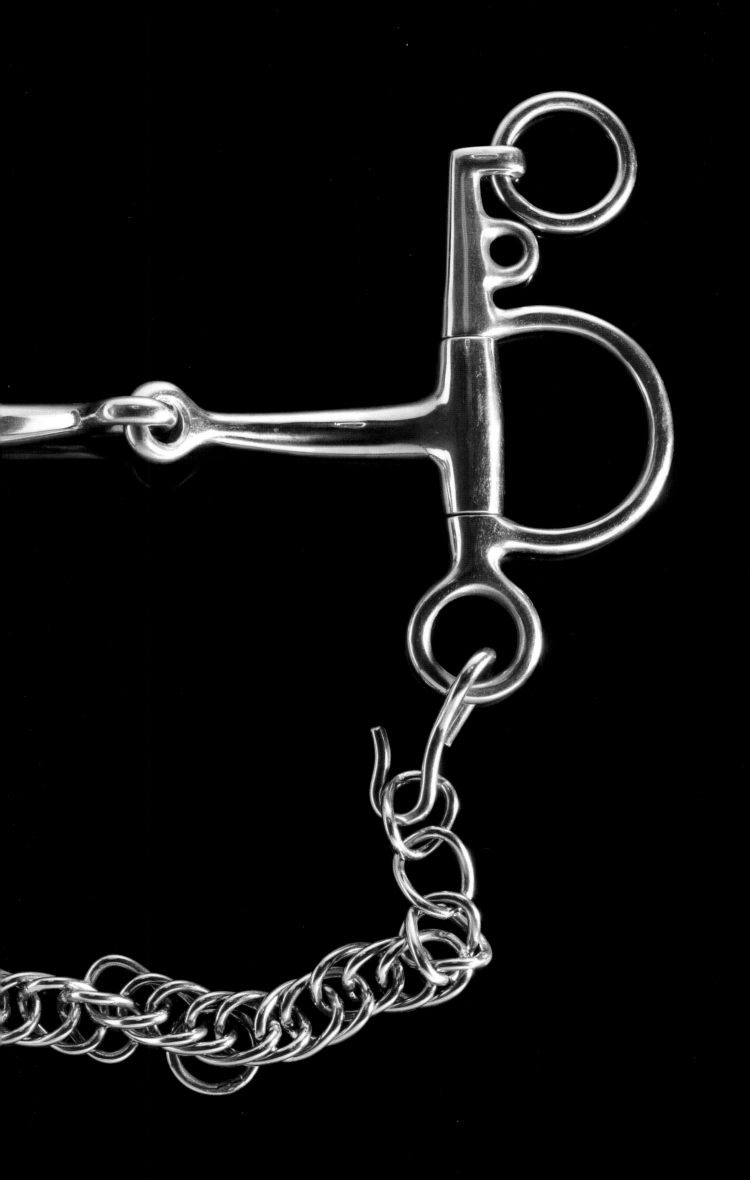

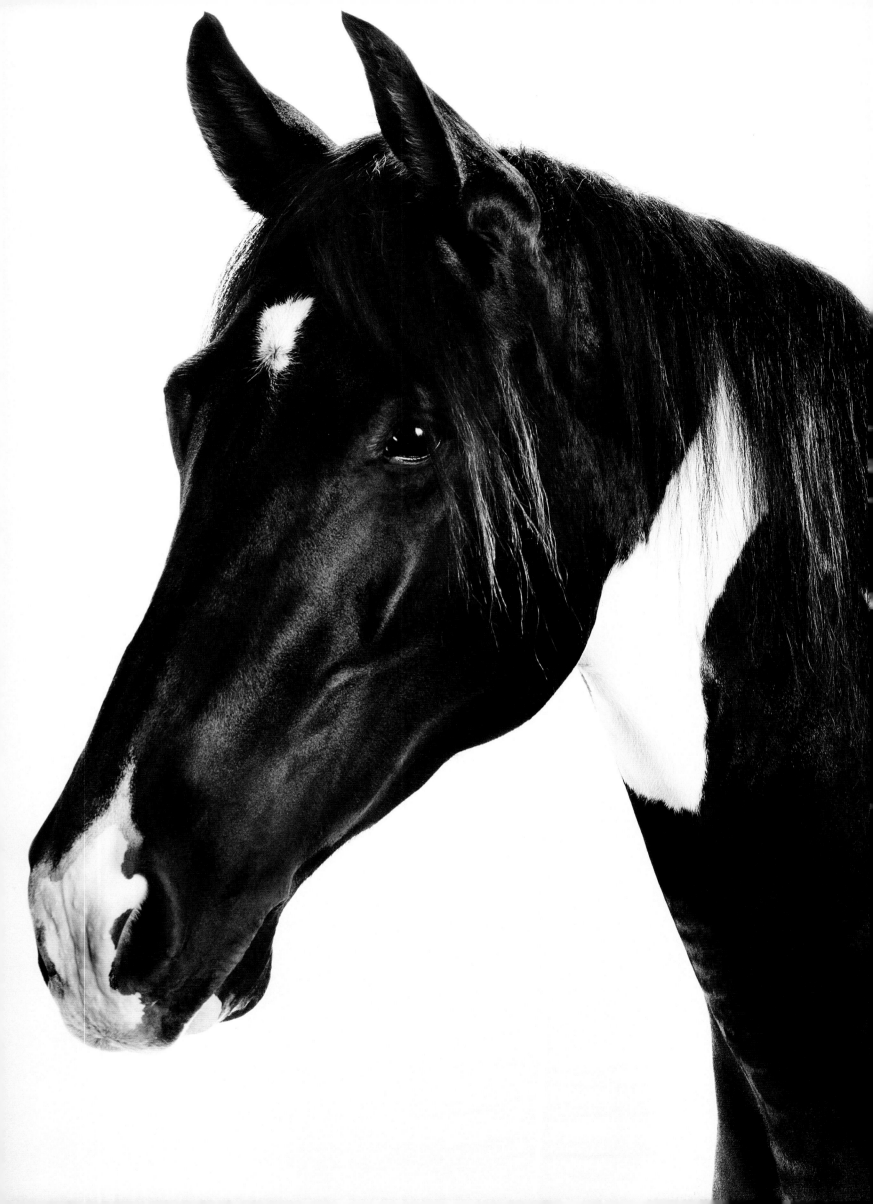

EQUUS FERUS CABALLUS— HORSES

A. M. Homes

THEY ARE THE STUFF OF MYTHS, OF FAIRY tales and dreams. They are elegance and strength. Determined yet capable of being led by a rope as thin as a string . . . when they want to be.

Beguiling, sensual—their bodies are strong, their hearts loyal. Between humans and horses, there is desire—the tug between our honoring their nature and wanting to tame it, to break it, to make it our own. Their affection is elusive; even owning them doesn't guarantee possession.

They are animals, beasts, yet so are we all. They look us in the eye—they know, their souls vaults of experience of knowing. They draw you in close and nuzzle you. They whisper in your ear—they have something to tell you, something they want from you. Their desire to communicate is almost human.

It takes two to tango, man and his horse; one without the other flounders—lost, powerless—but together the connection is complete. Together they are heroic.

They are what young girls yearn for, lying on the floor drawing them, over and over again, hour after hour, pencils scratching out long, supple necks, strong backs, manes to grip, hold tight.

They are Aronde and Banner, Buttermilk Blaze and Capilet. Flicka, Rocket, and Trigger. Pike and Pokey and Mr. Ed. They are Misty of Chincoteague and all My Little Ponies. They are Silver, Stardust, Stormy, and so many more.

We go in the night to visit Black Beauty in the barn, the scent of the stall, the musky, funky heat, the sweetness of fresh hay, the old salt lick.

We press against the striking stallion, throw our arms around his neck—we kiss him on the nose—and tell him how beautiful and gallant he is. It is all so innocent—and yet we are learning about the elusiveness of affection, about beauty and longing.

At night we dream of rescue, of being delivered from our lives to this more beautiful, more perfect place, the dark knight charging through the forest. The unicorn under a full moon. The raven-haired woman riding bareback by the sea. This is a world where good triumphs over evil. The white horse—be it mare or stallion—is fecund, an end-time savior.

They are enormous and not quite real. They seem to speak of ancient themes, like the immortal winged Pegasus who sprang from the neck of Medusa and, with the help of a golden bridle, became a carrier of thunderbolts for Zeus. In honor of his faithful service, his image was mounted on high—a constellation in the stars. And there is Equuleus, the Little Horse, a tiny and hard-to-find gathering of stars in the autumn sky—some say Equuleus is the mythological child of Pegasus and others muse that perhaps he is a sea horse, born from Neptune's trident.

They brim with elegance, with delicacy and containment. Everything about the animal is exacting, made to measure. They are always about to become something else, to break free, to run wild. They are overflowing with majesty—we mount them—we take off—galloping full throttle into a world of possibility.

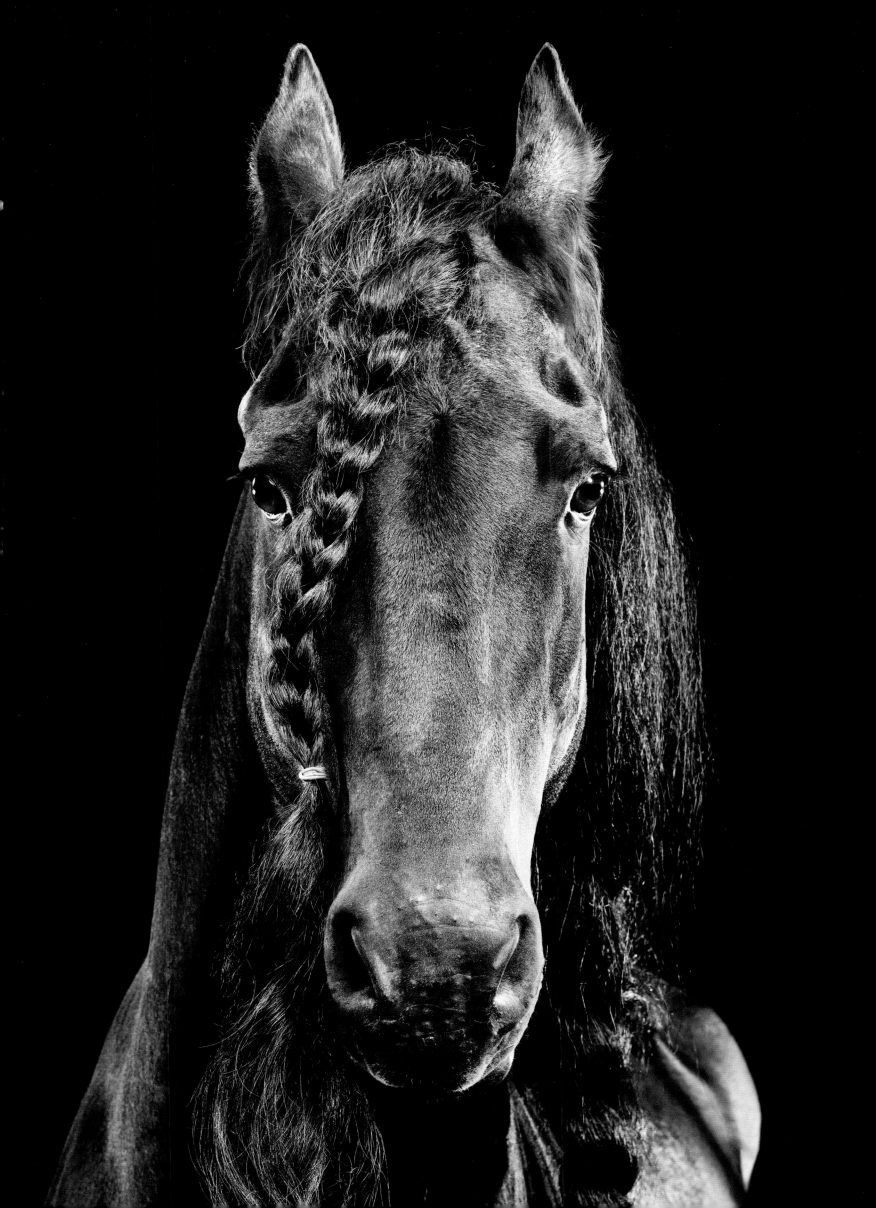

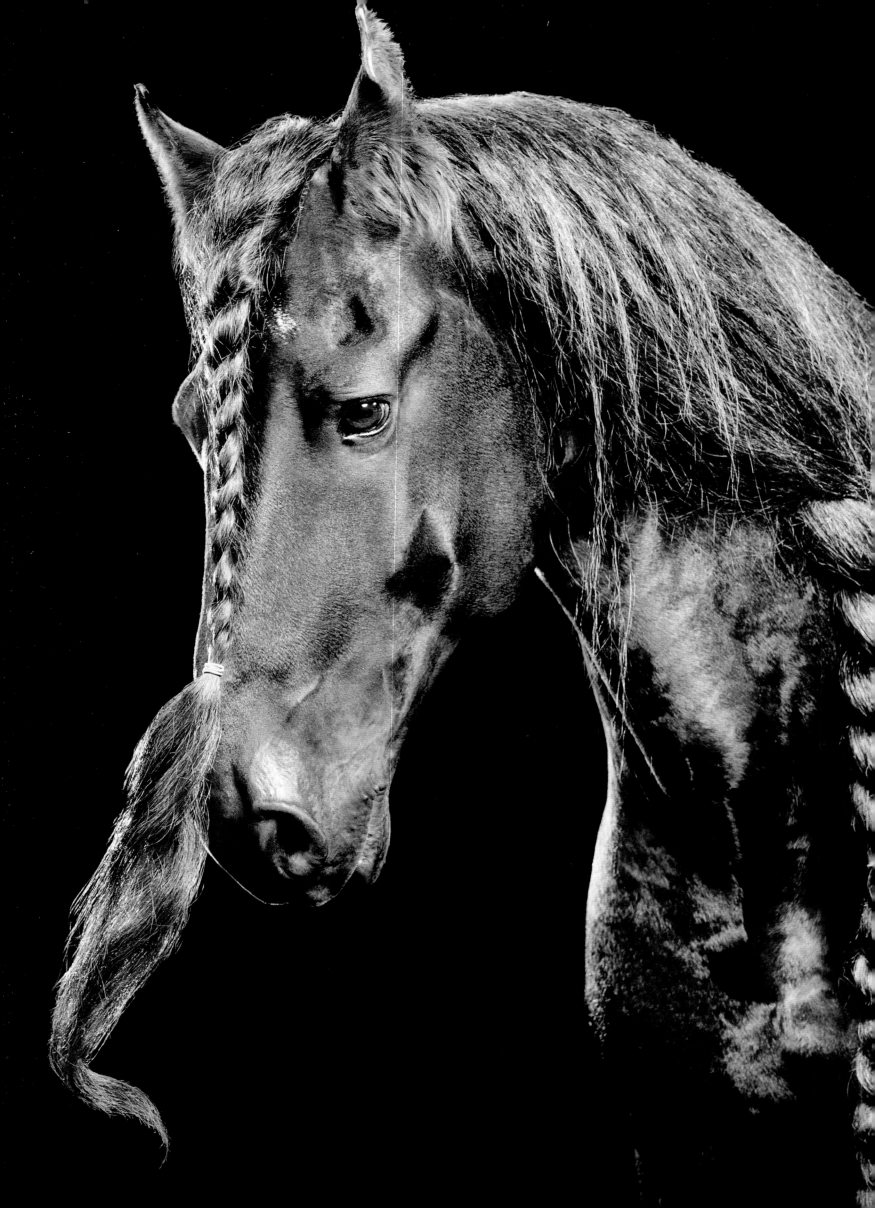

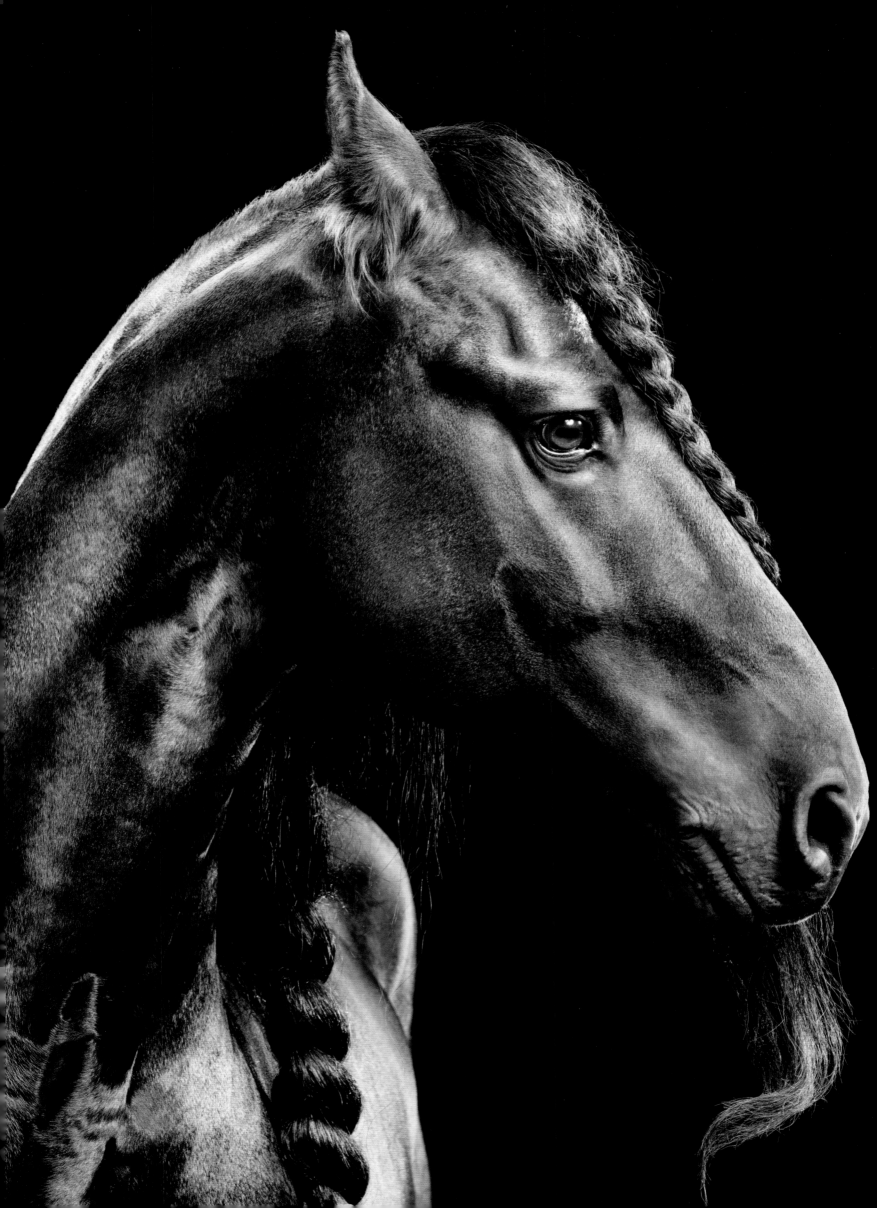

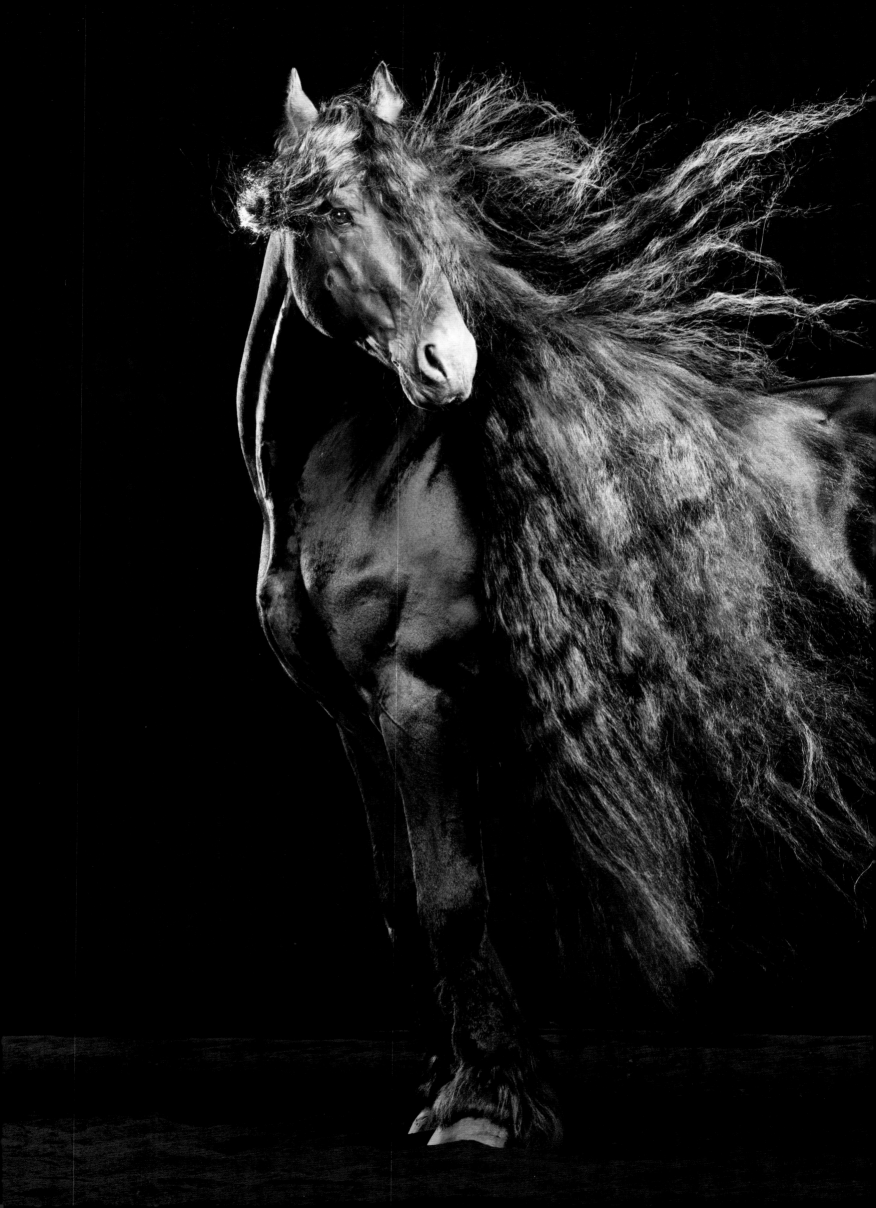

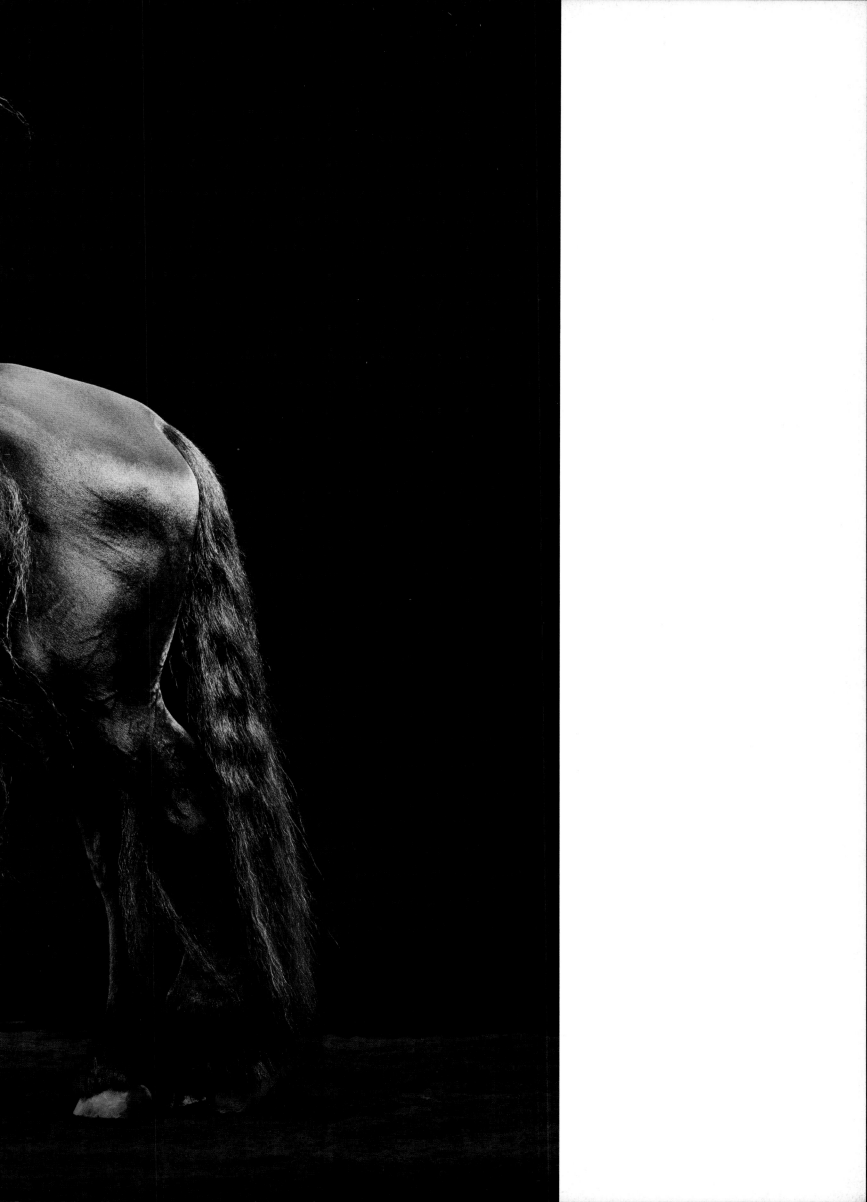

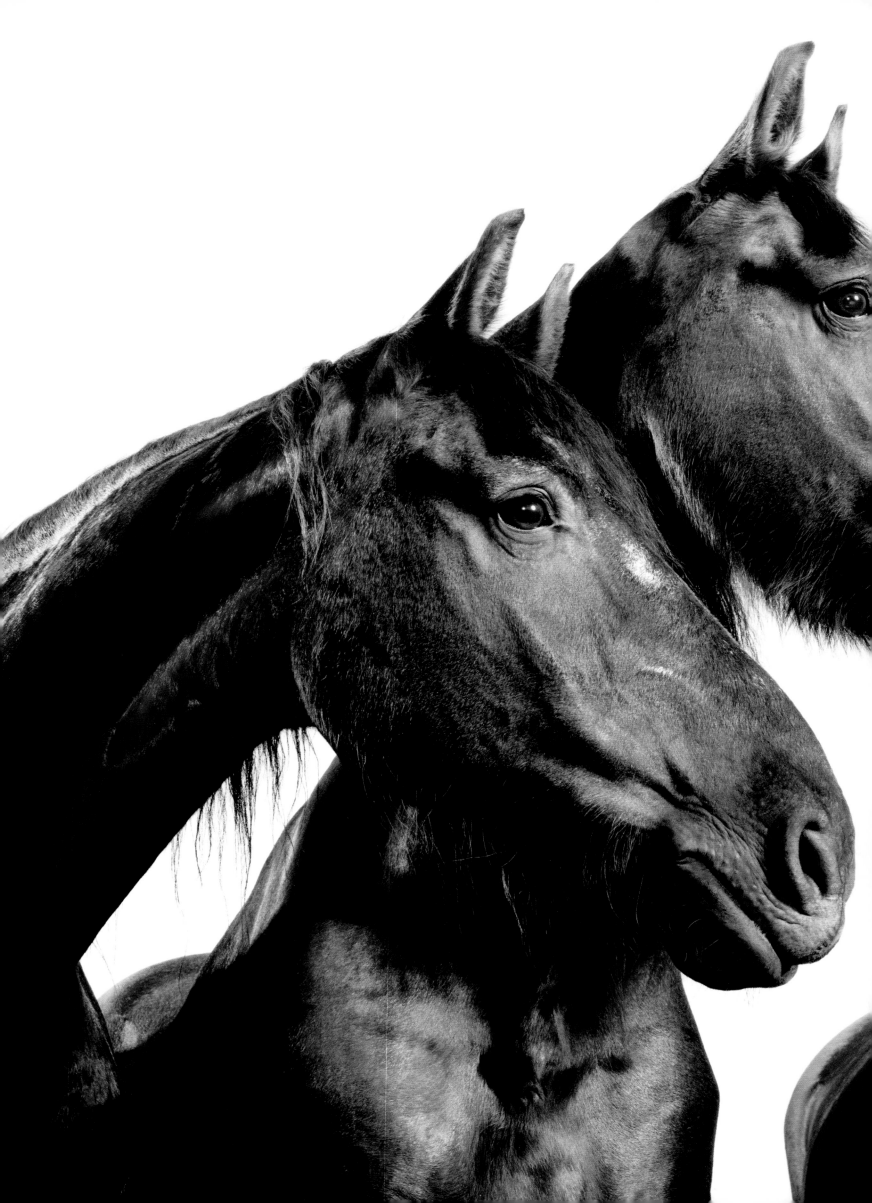

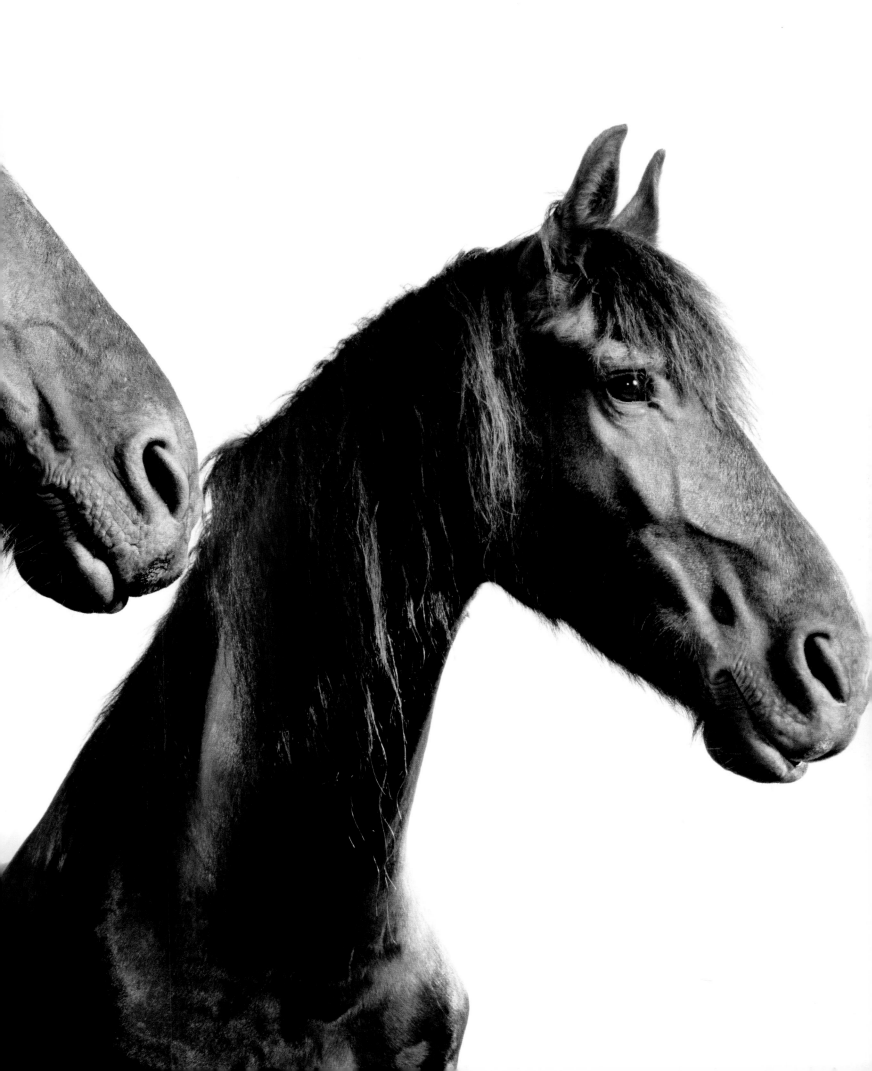

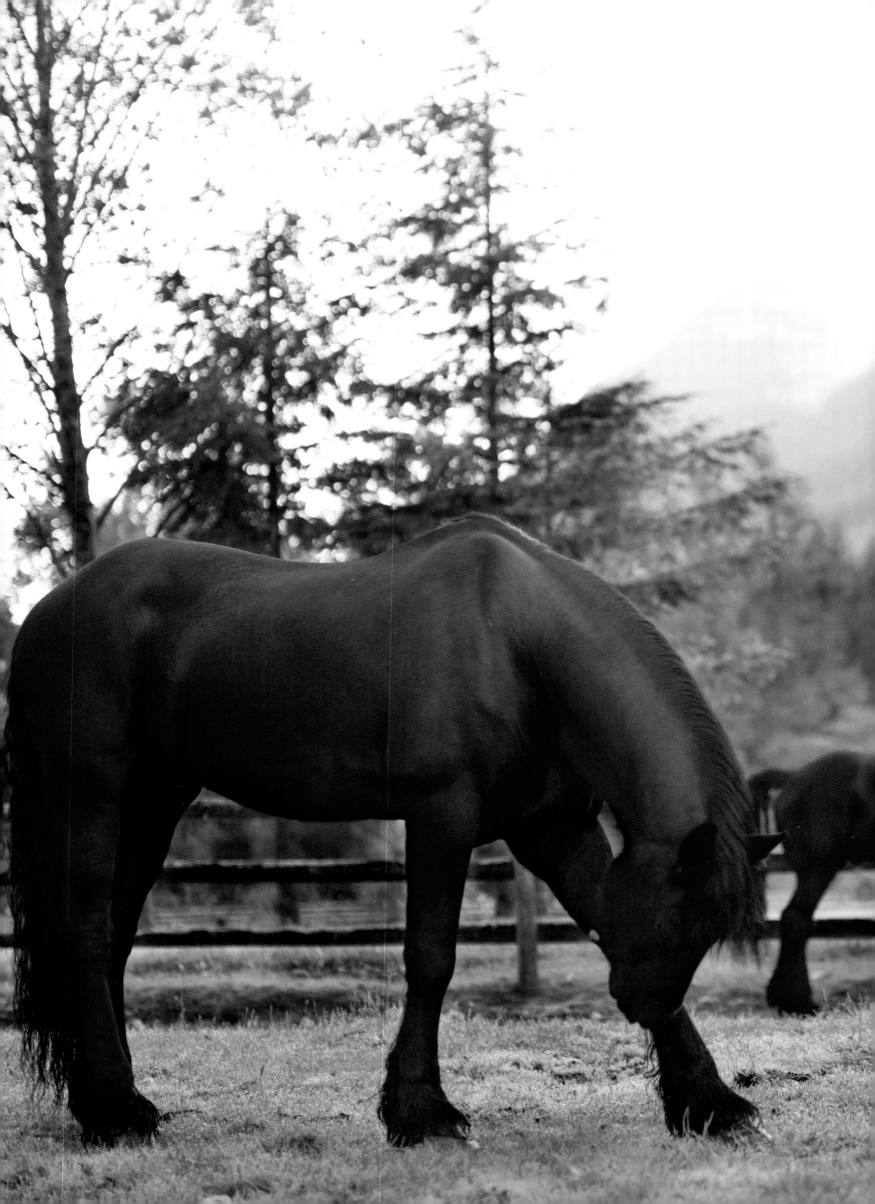

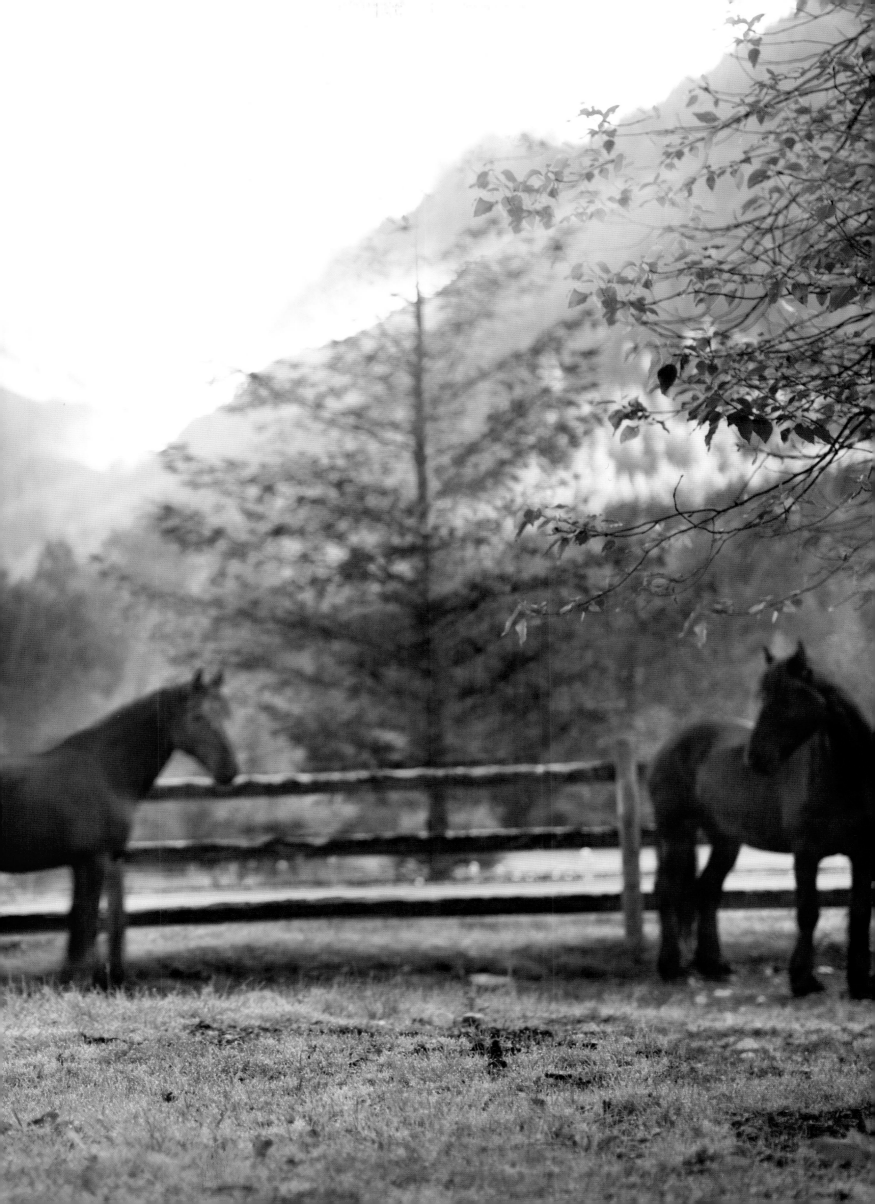

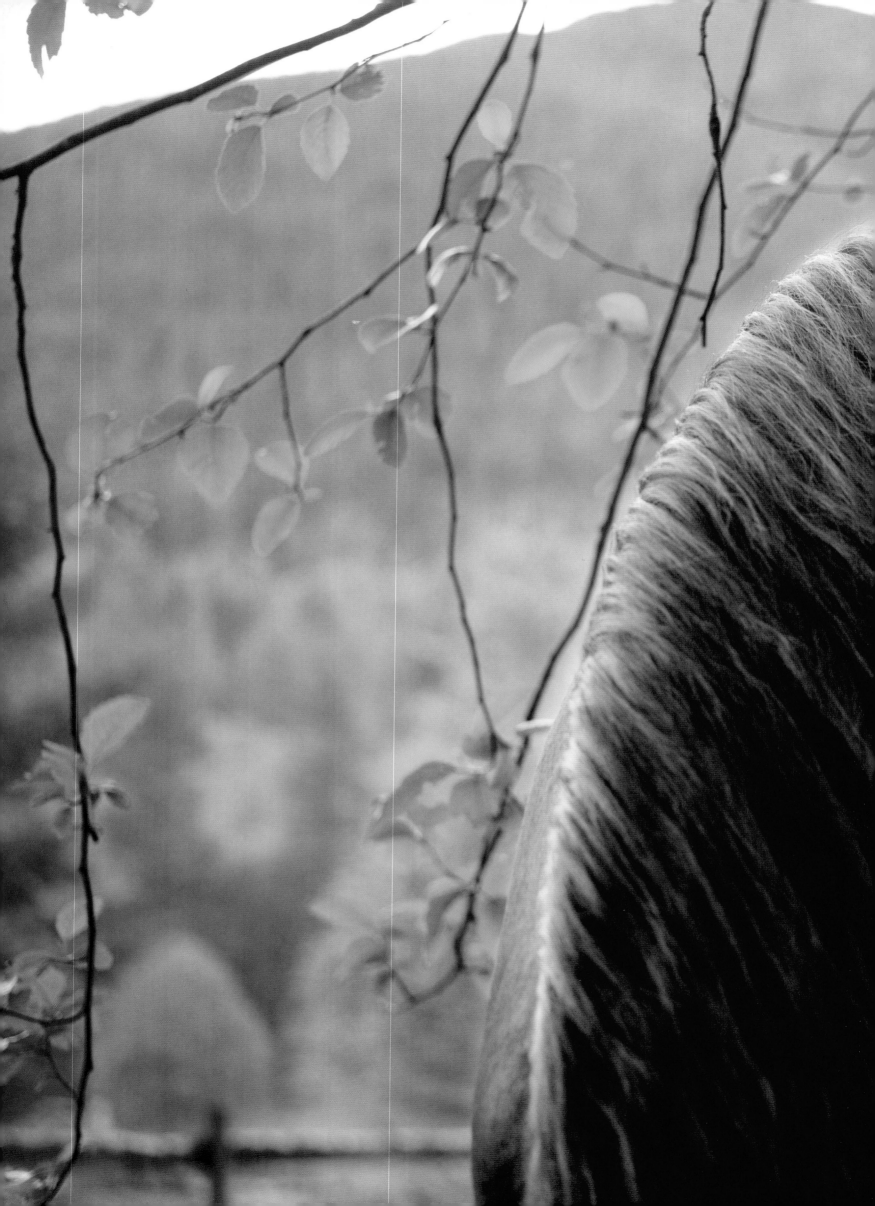

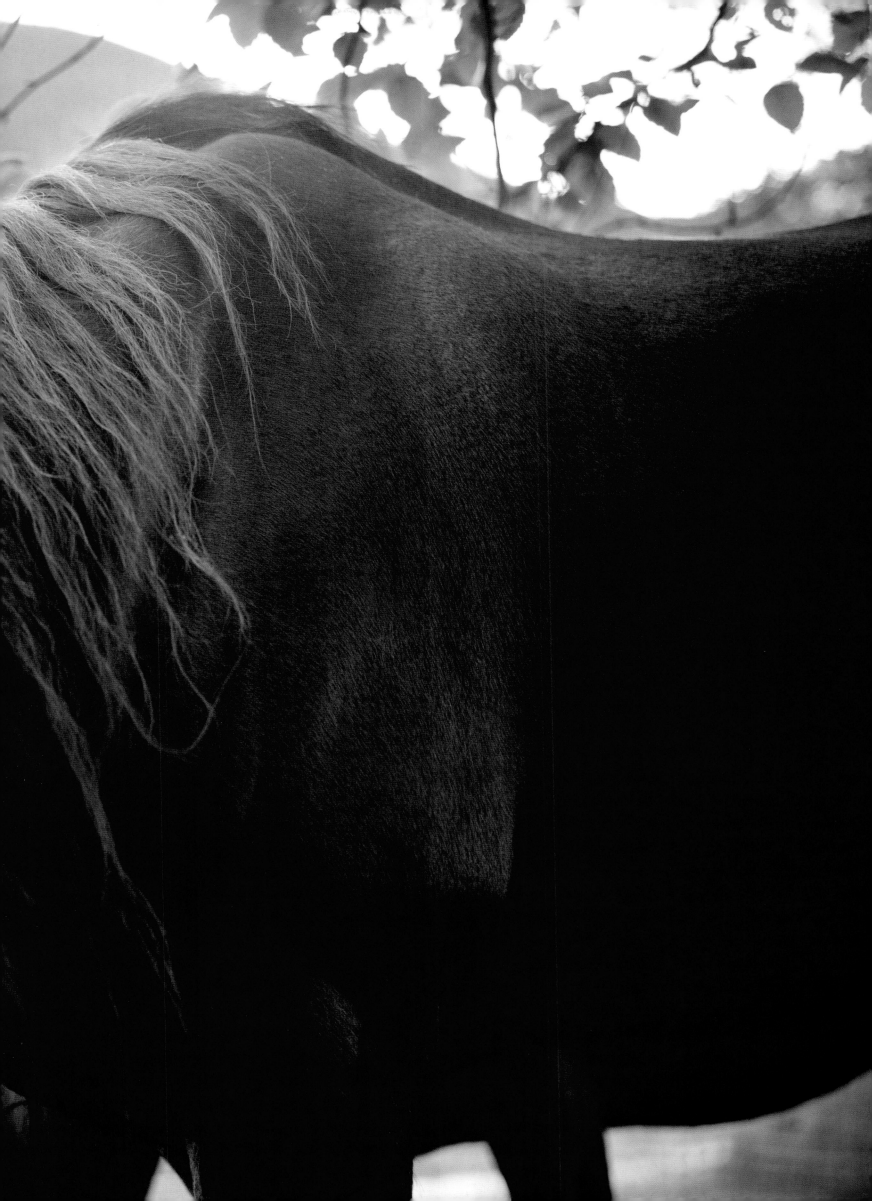

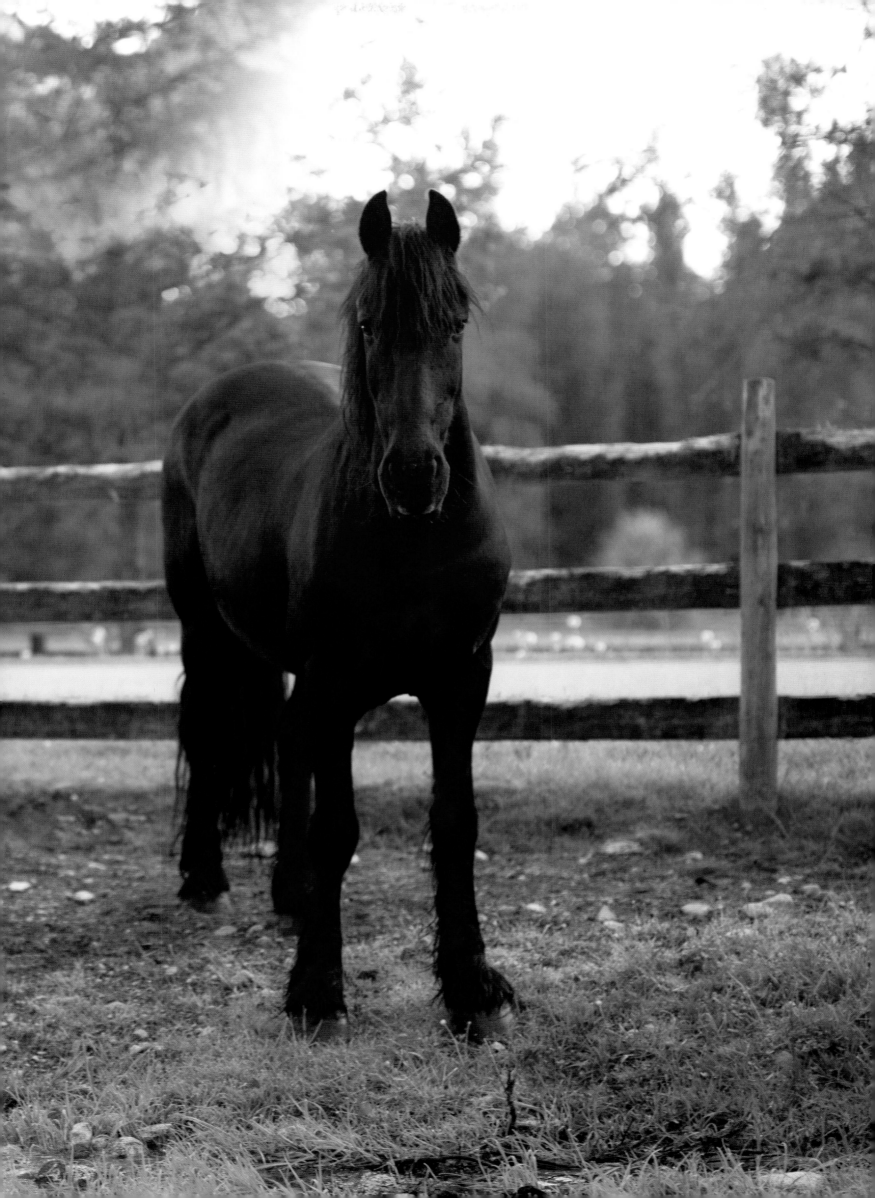

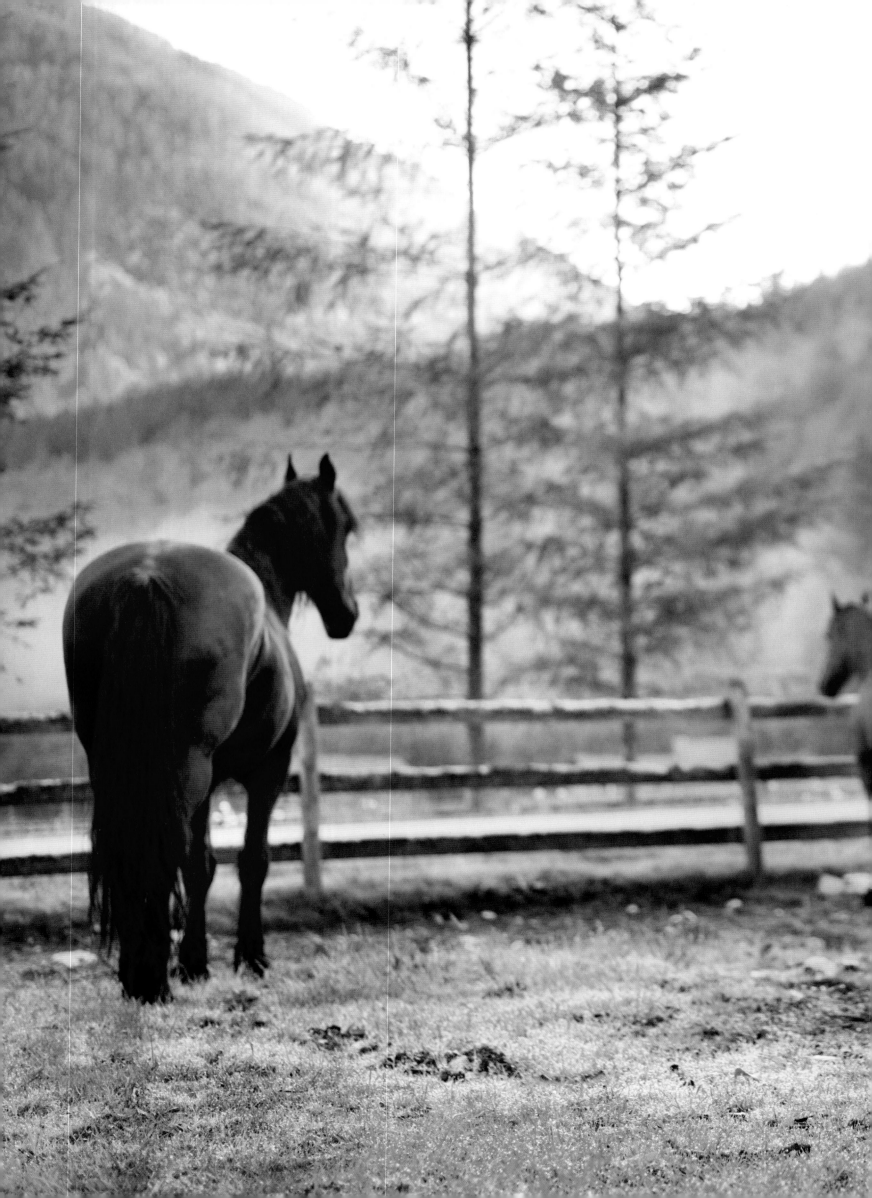

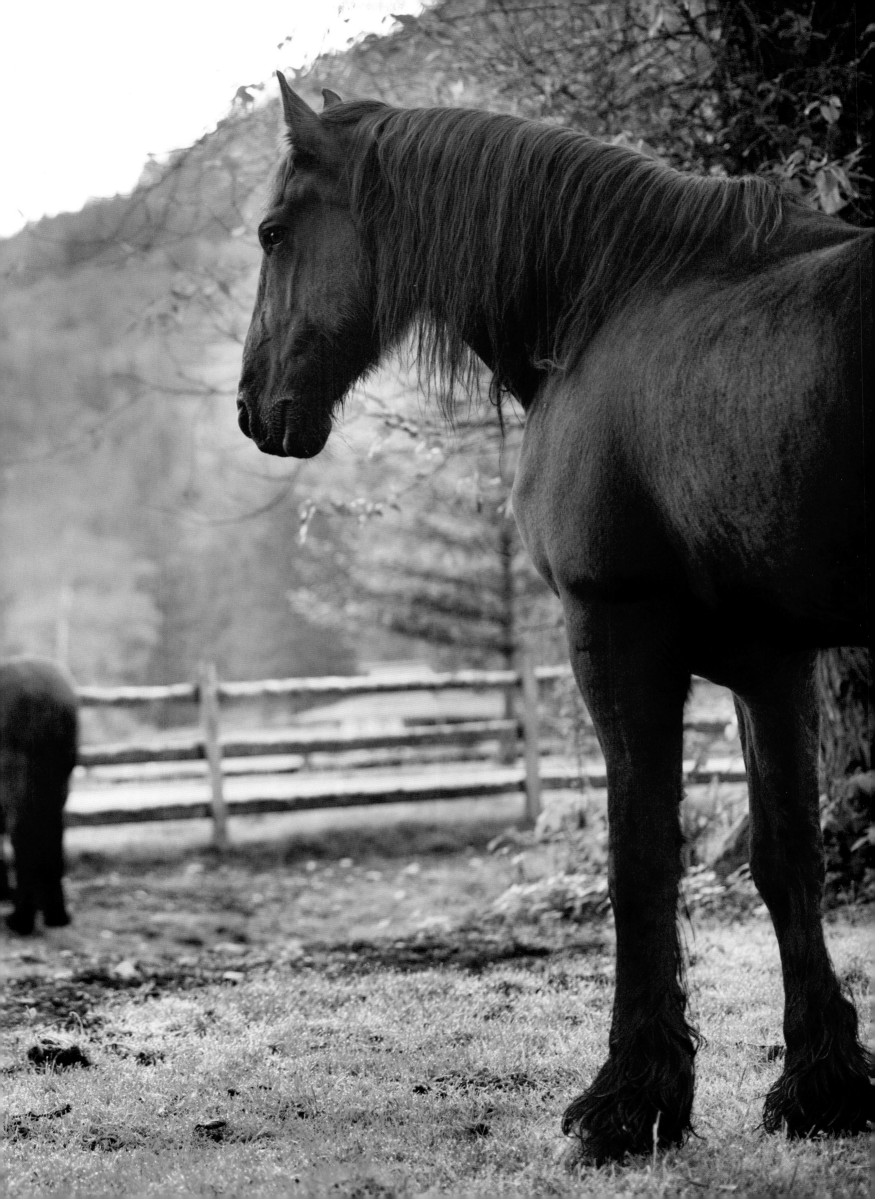

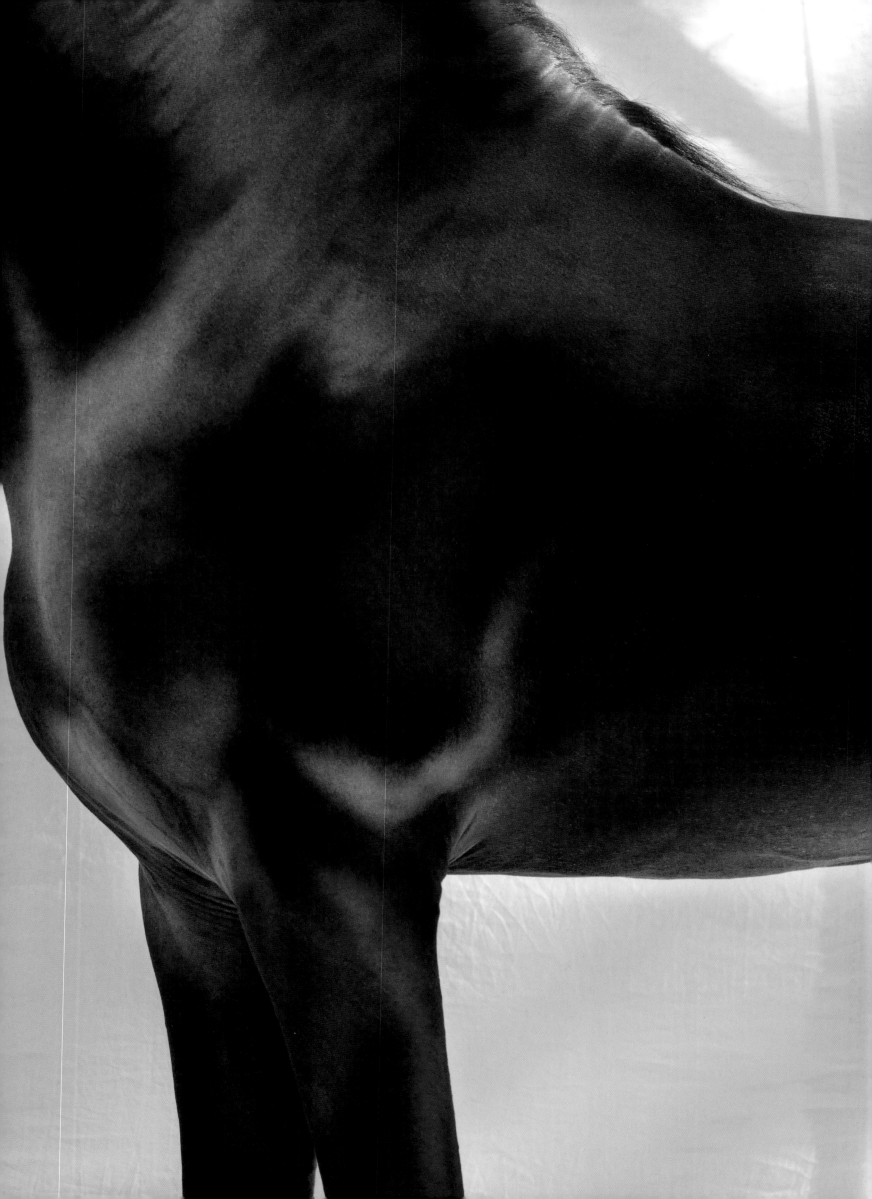

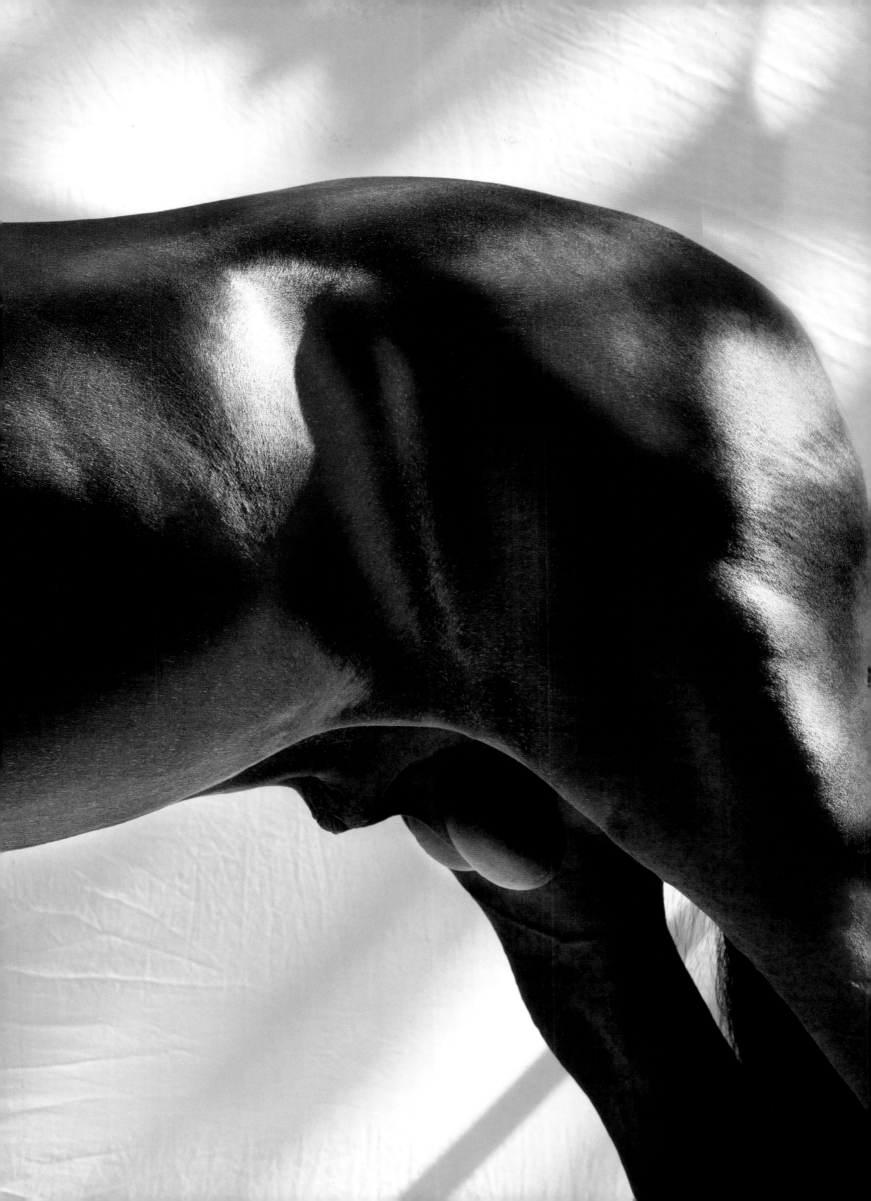

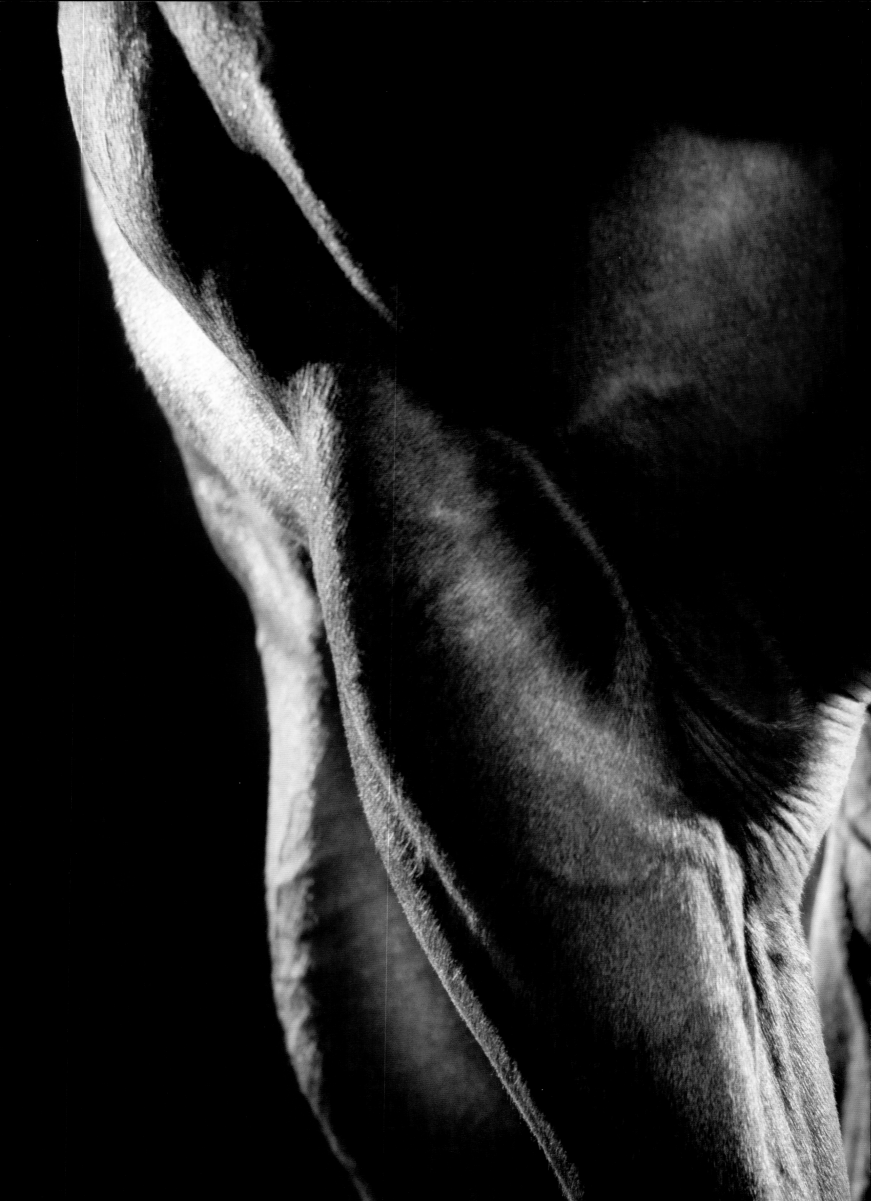

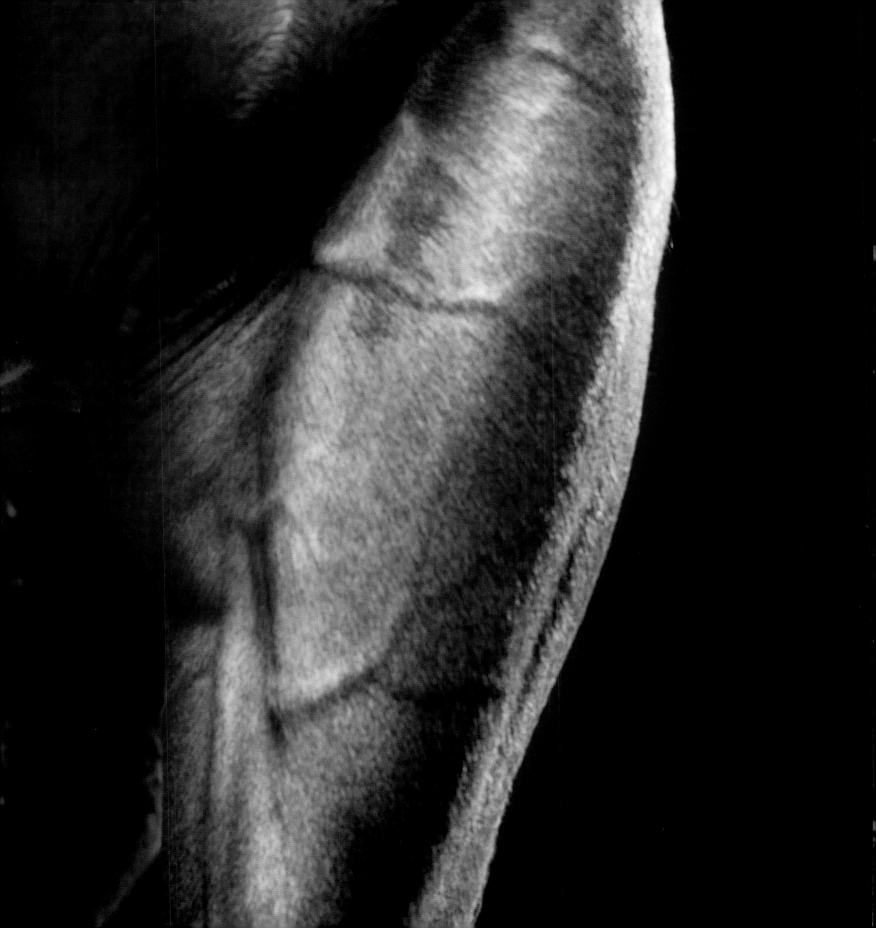

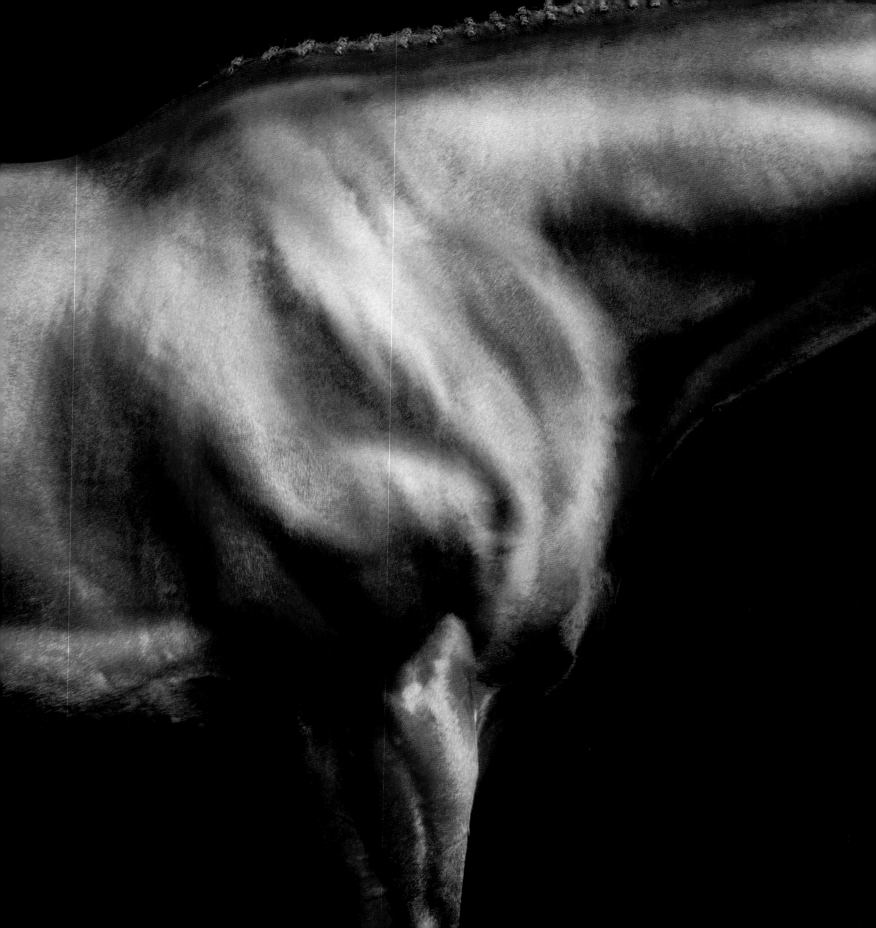

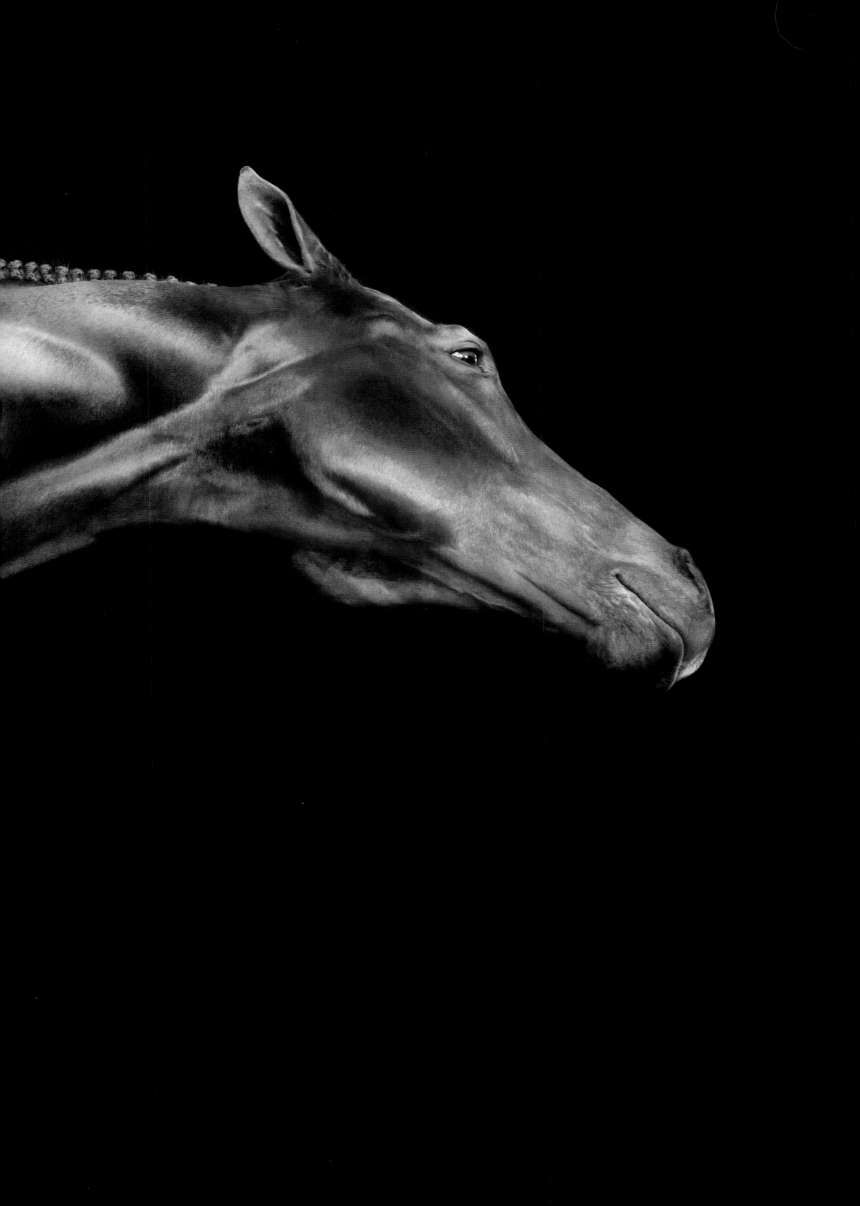

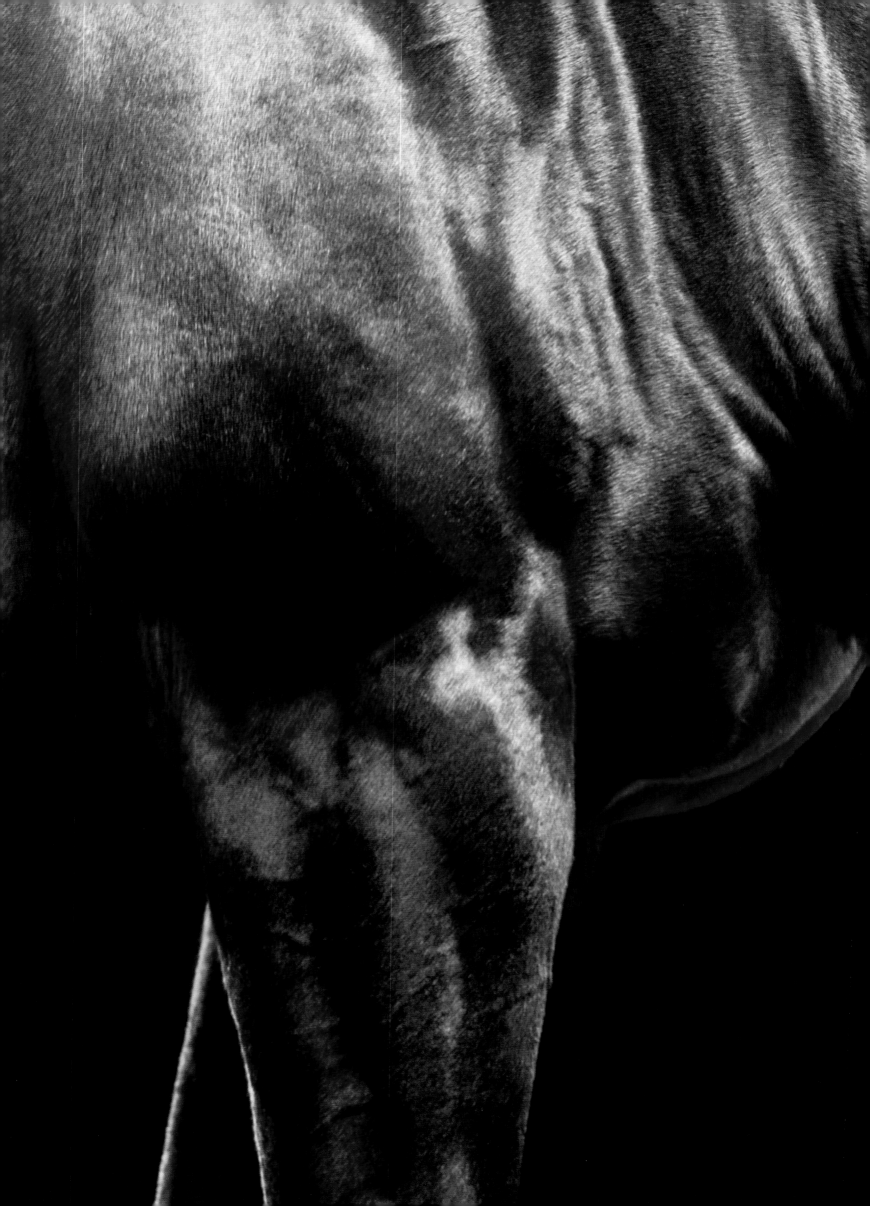

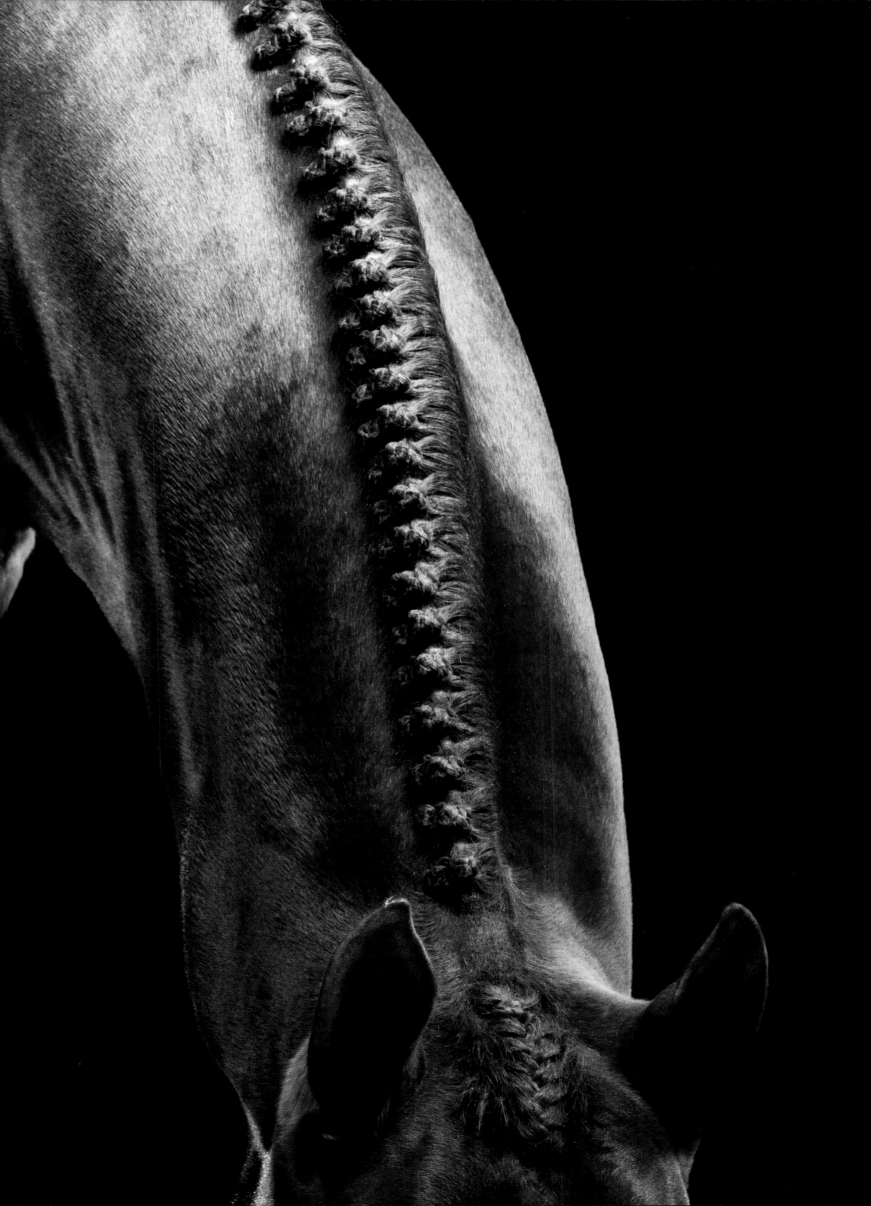

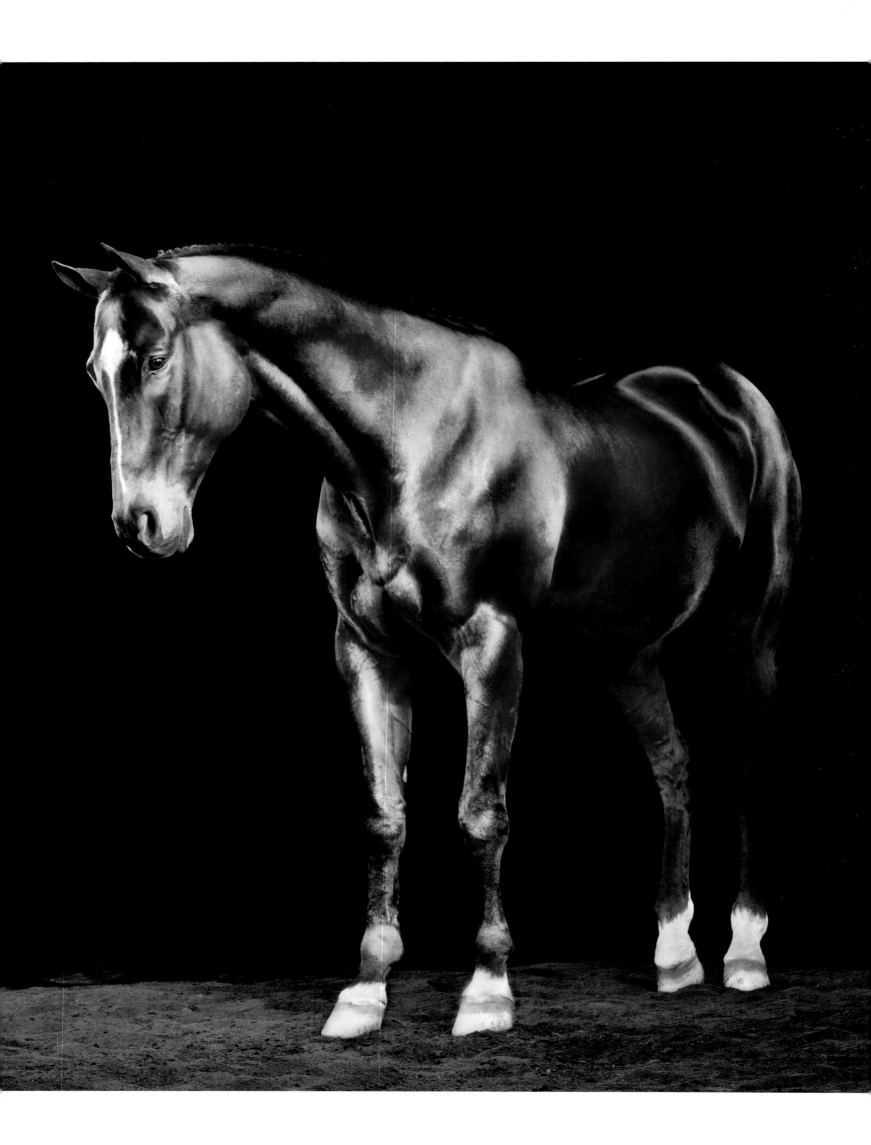

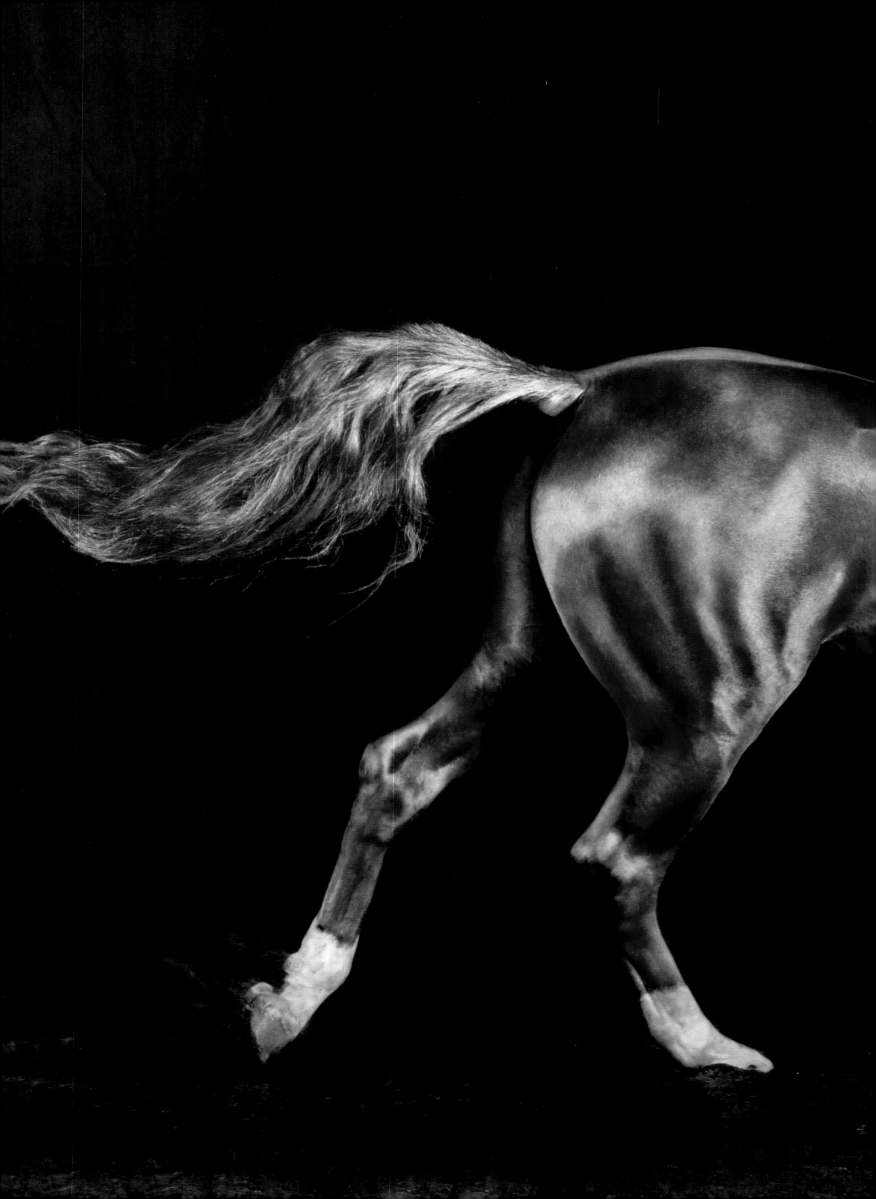

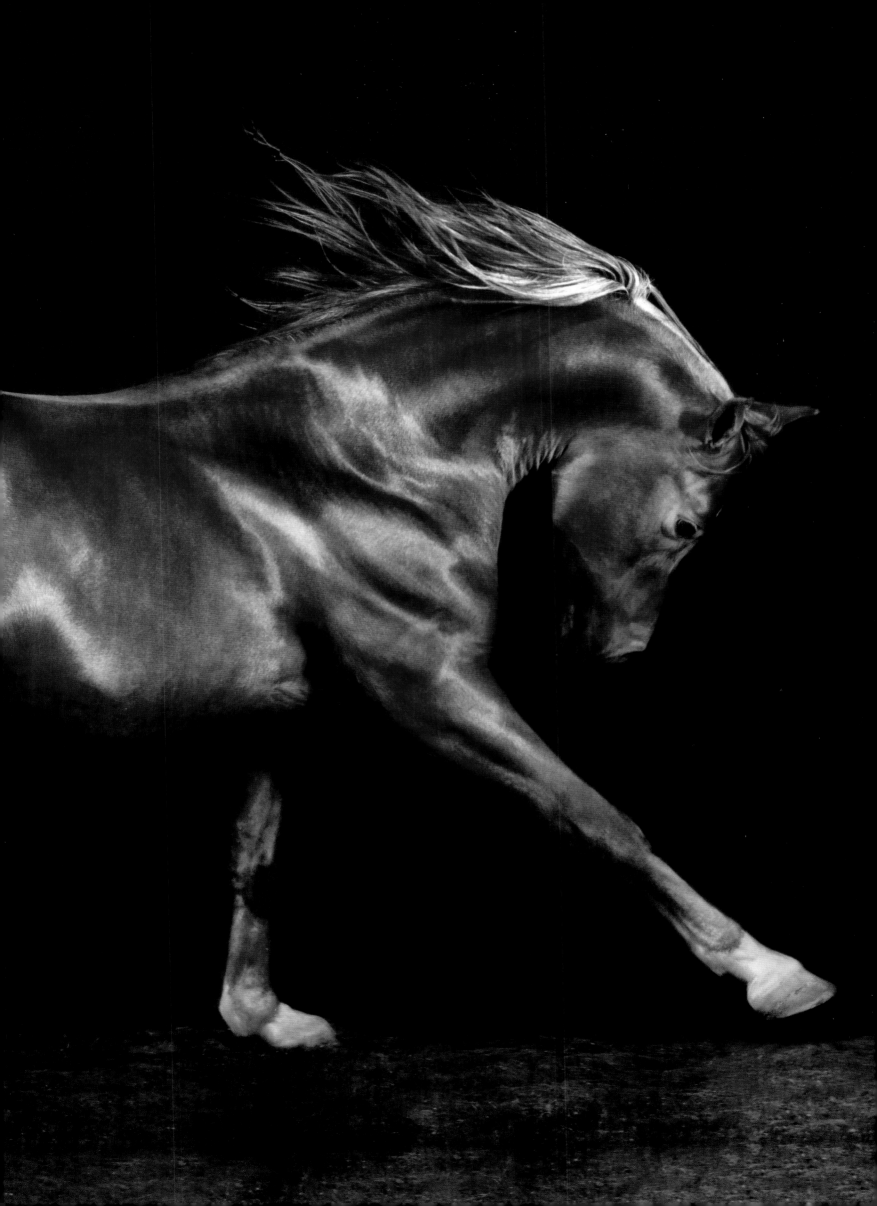

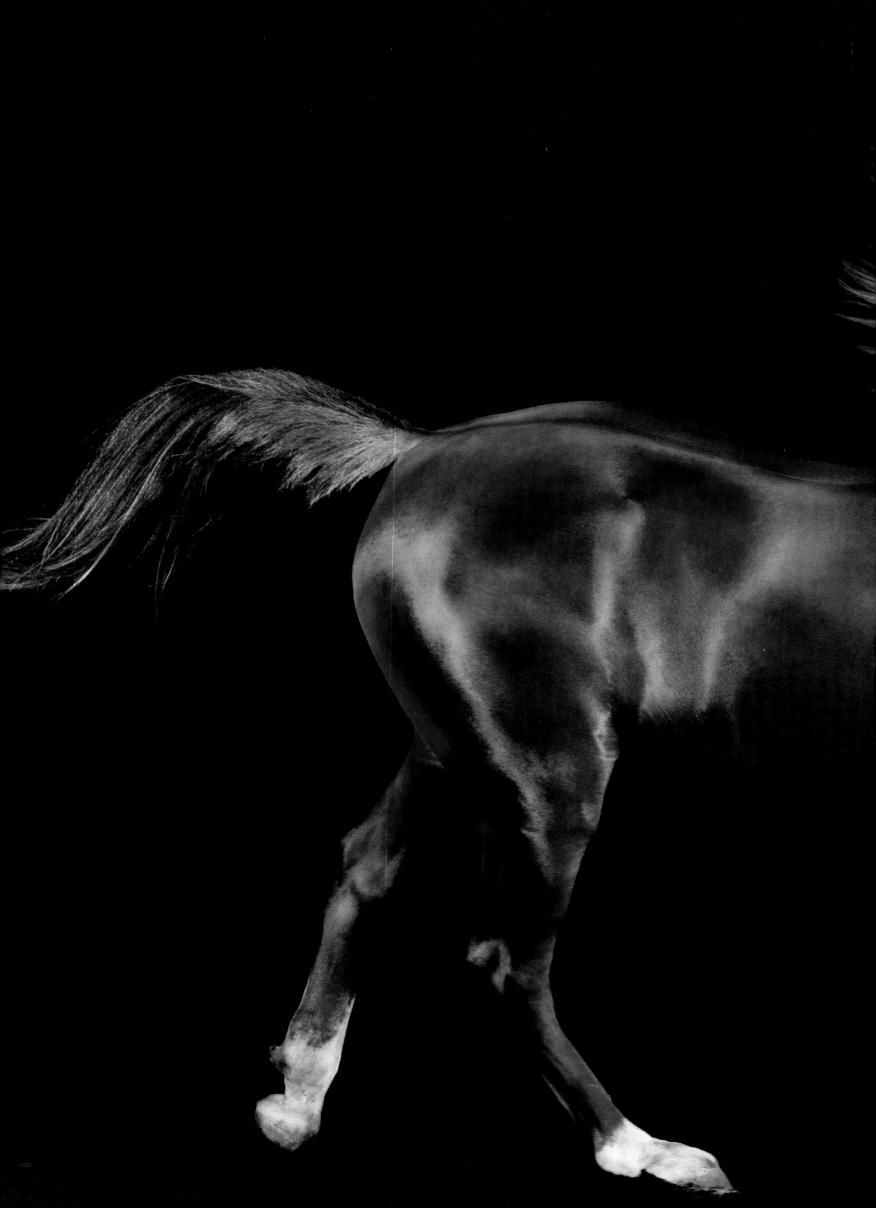

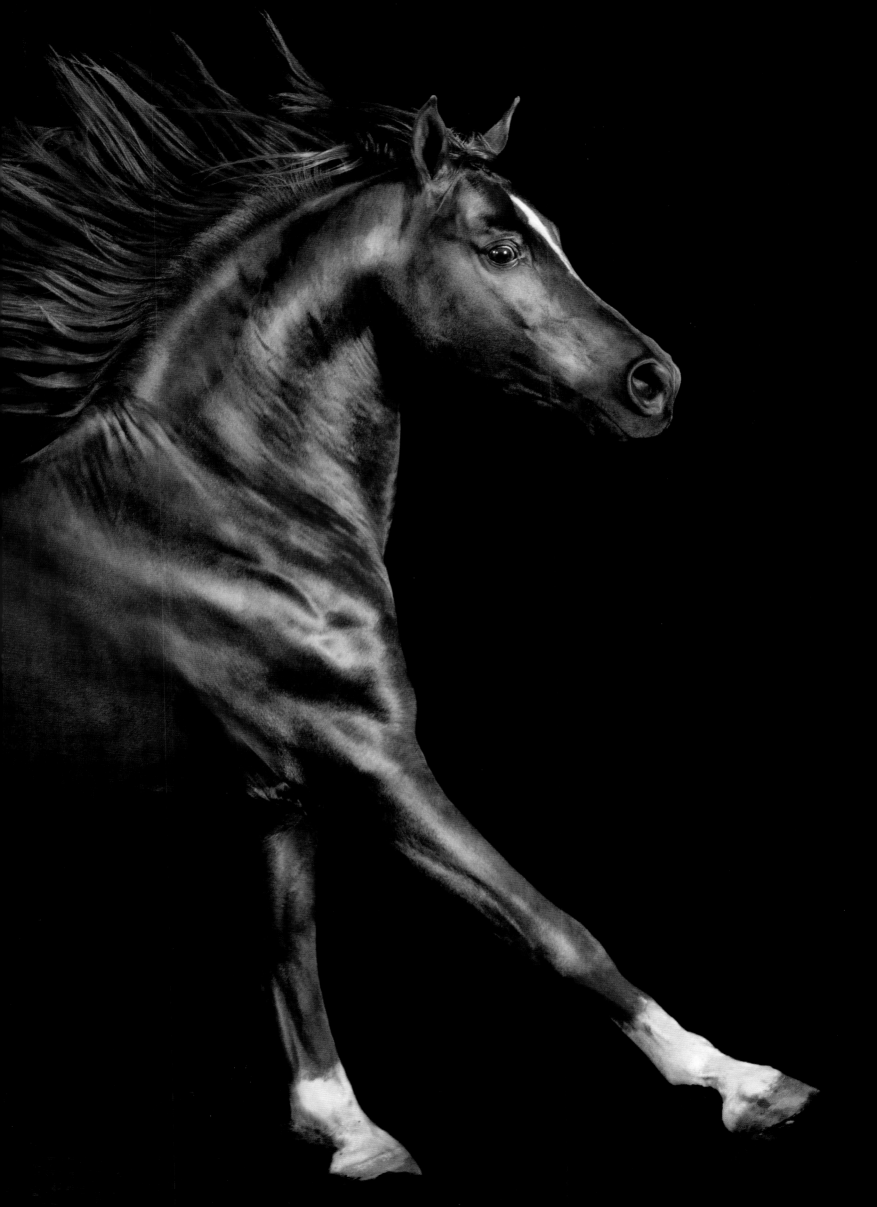

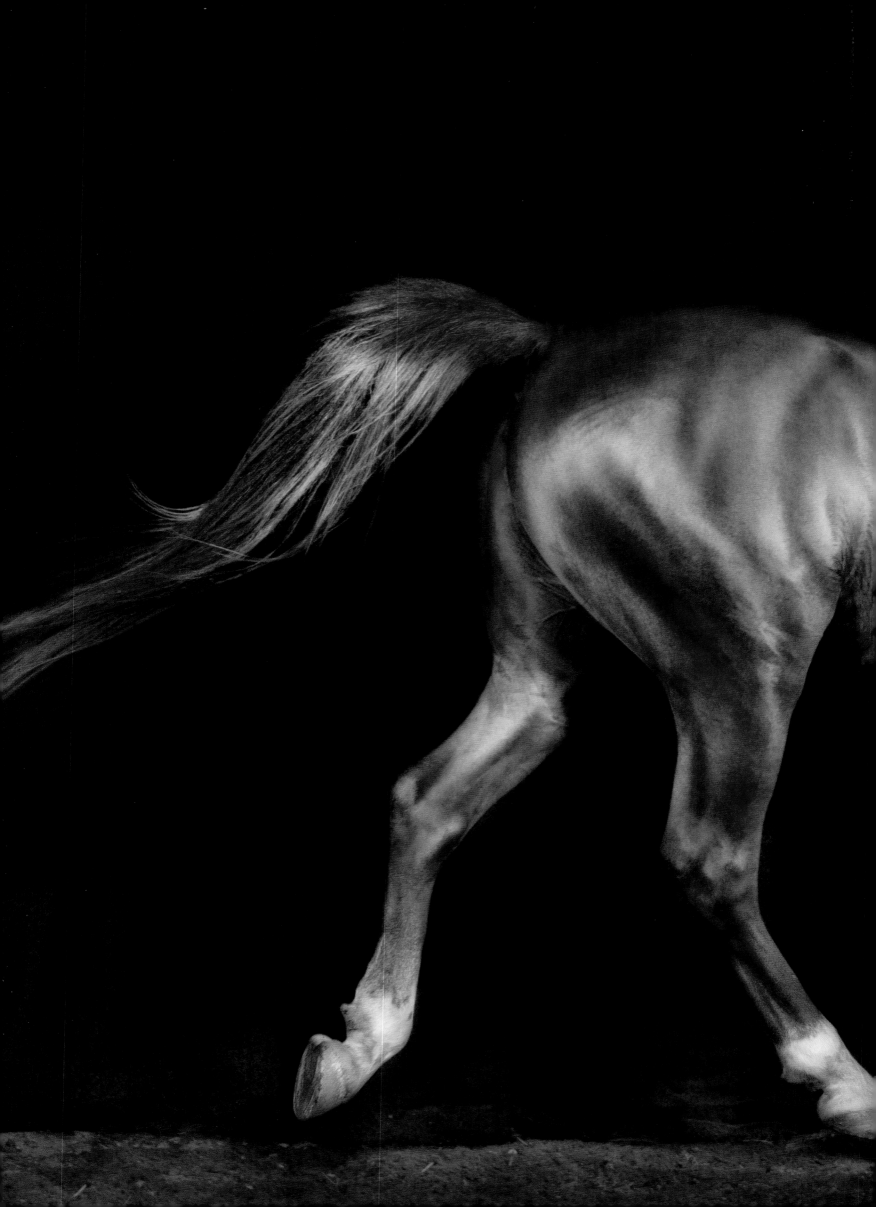

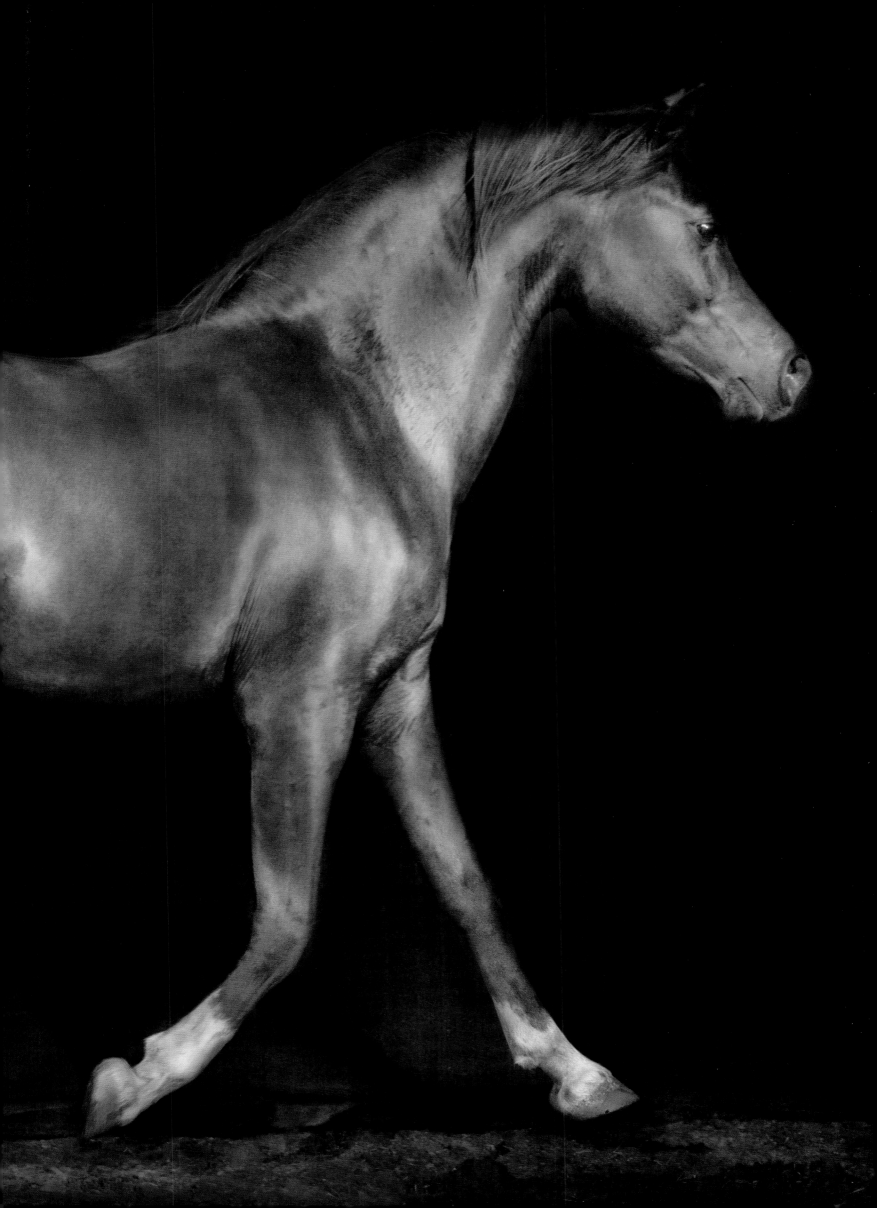

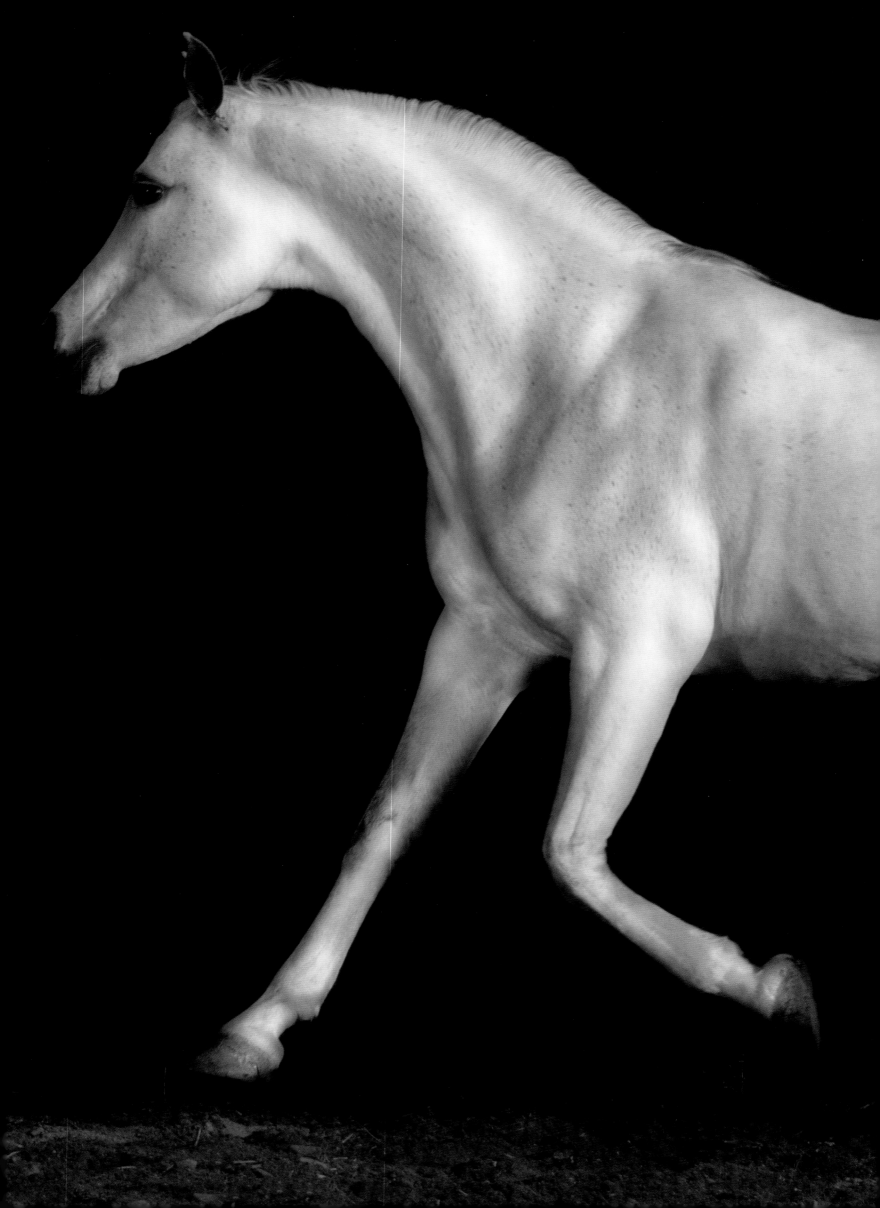

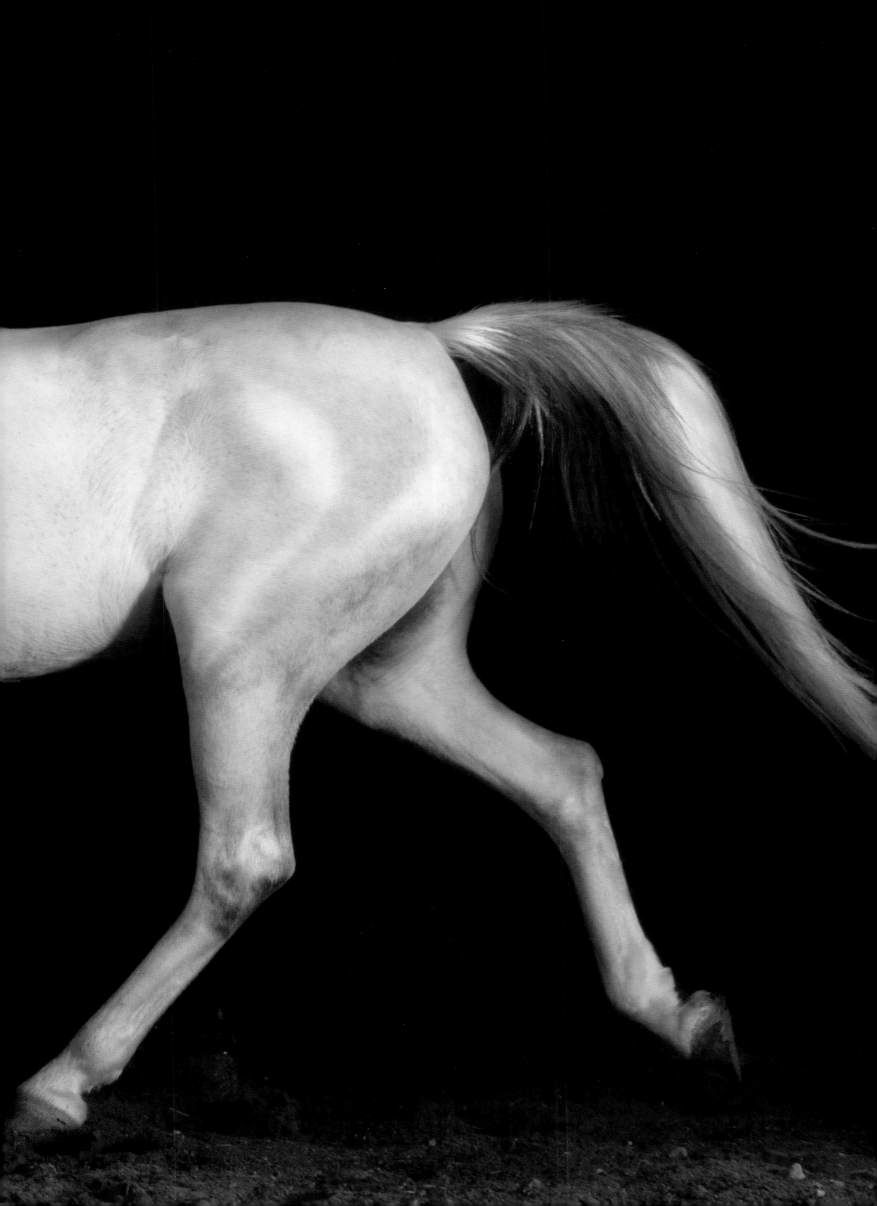

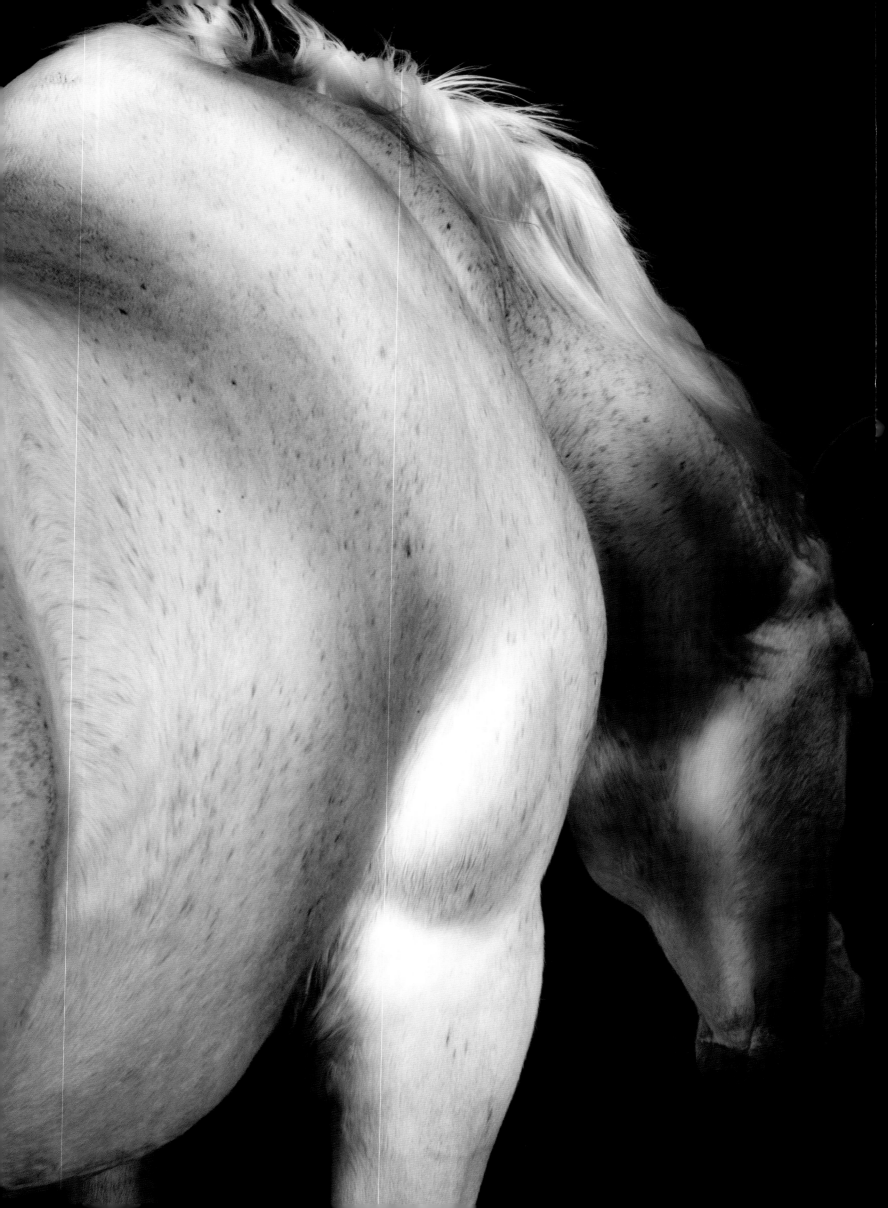

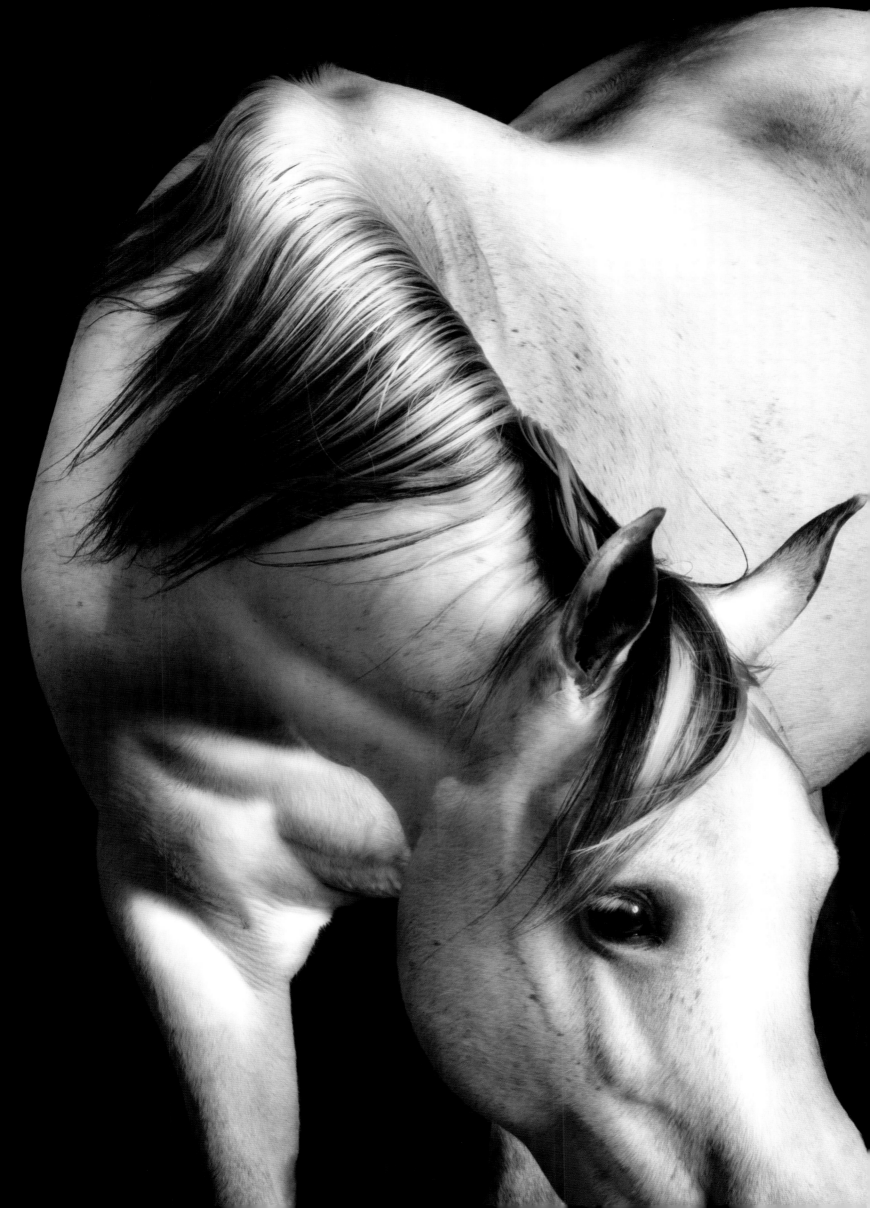

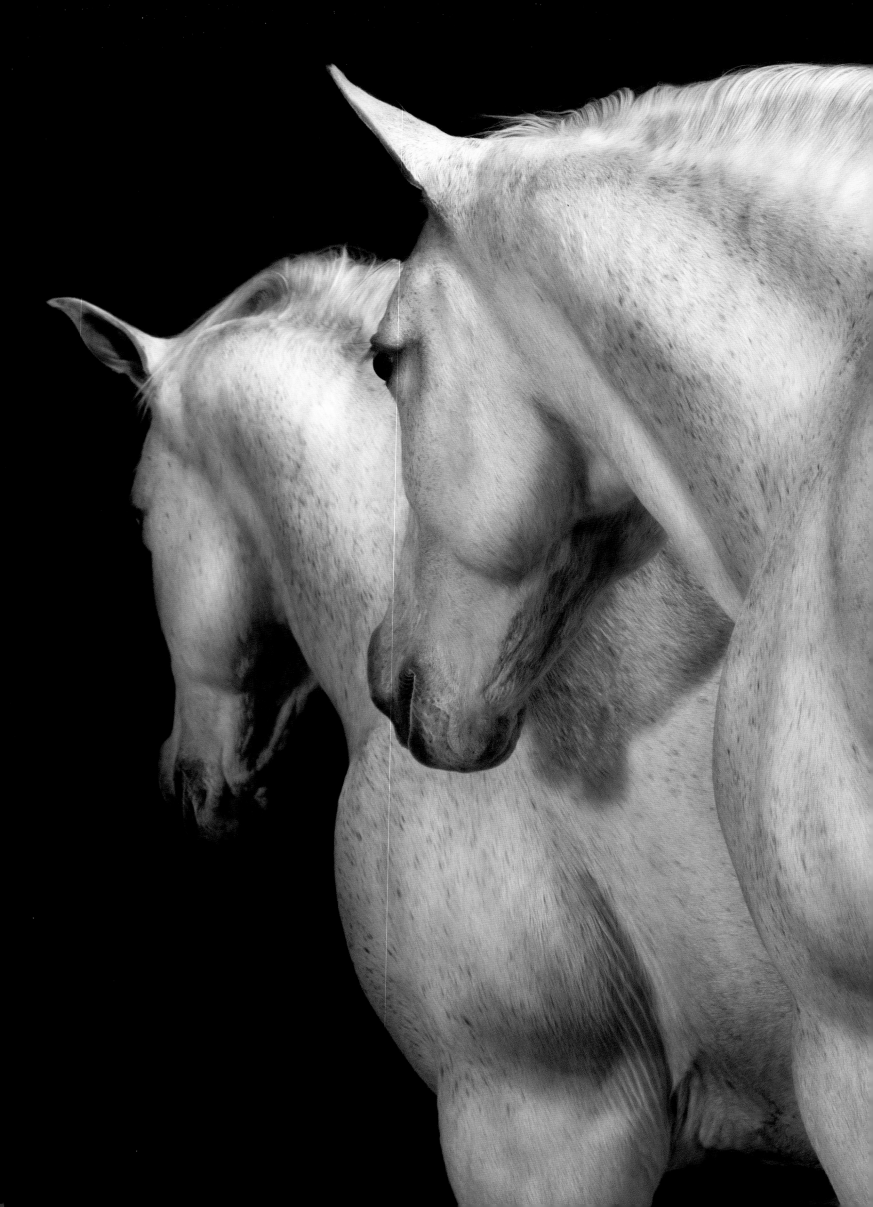

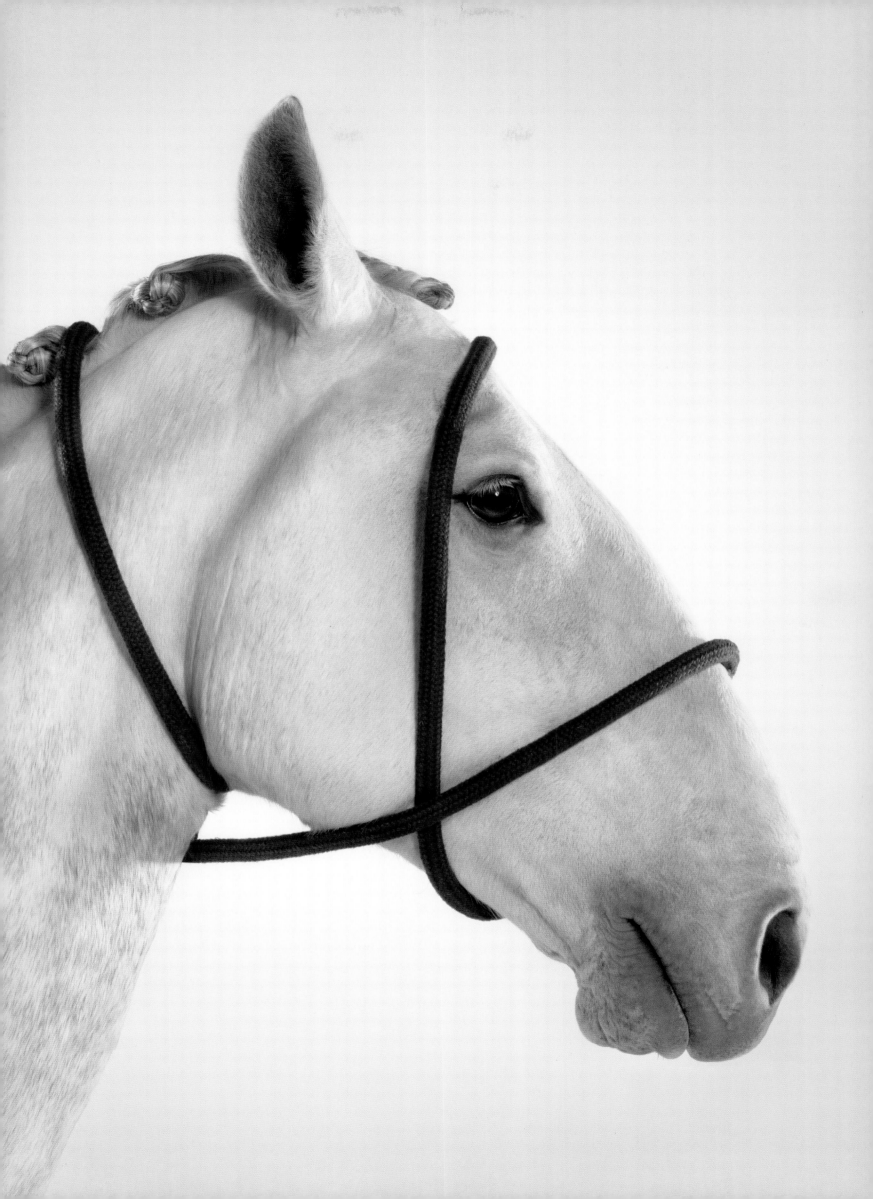

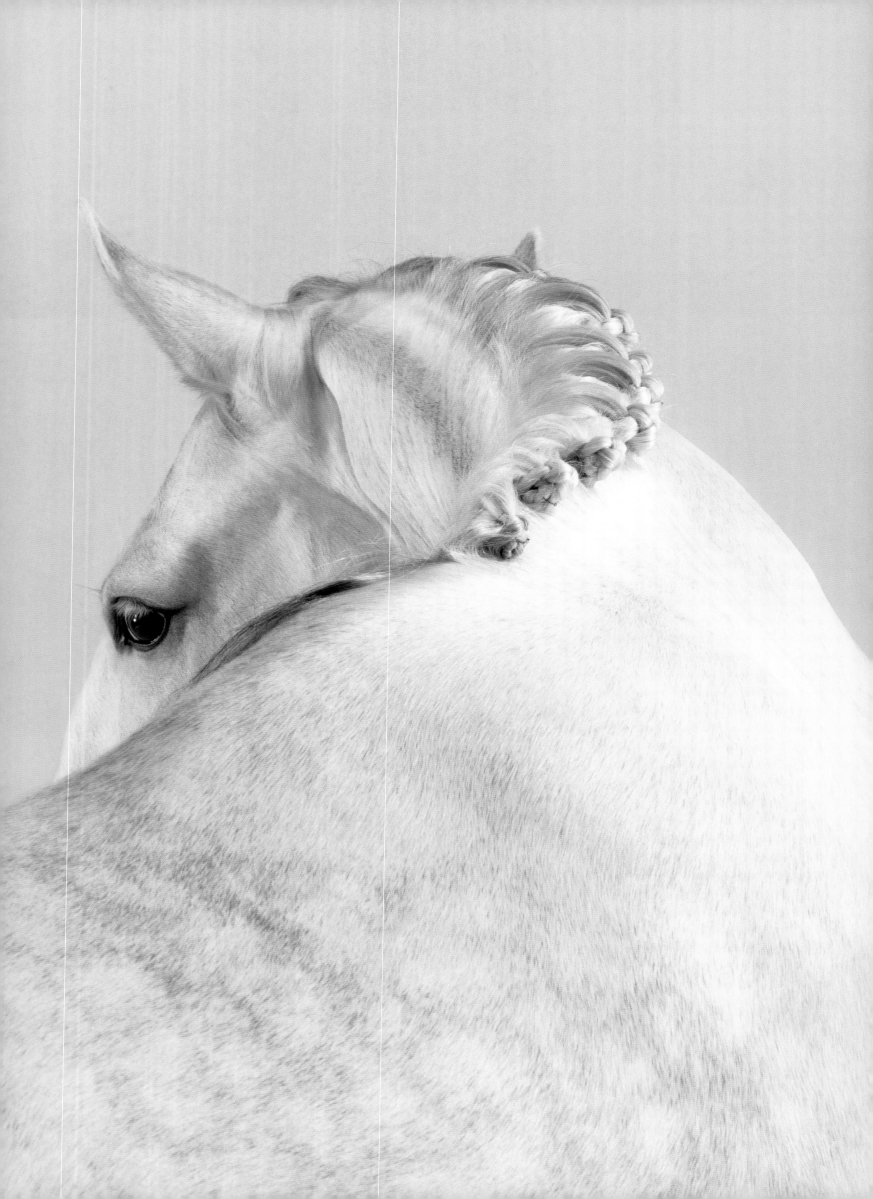

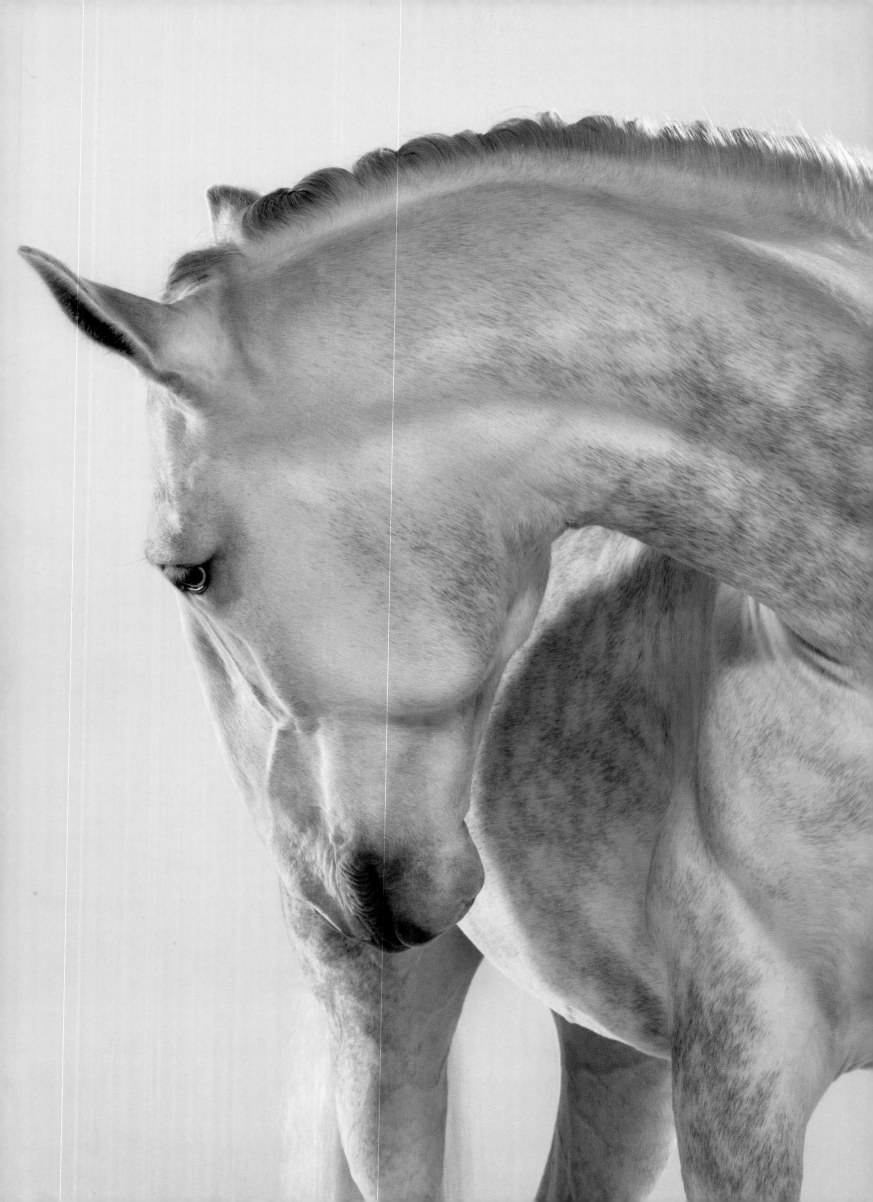

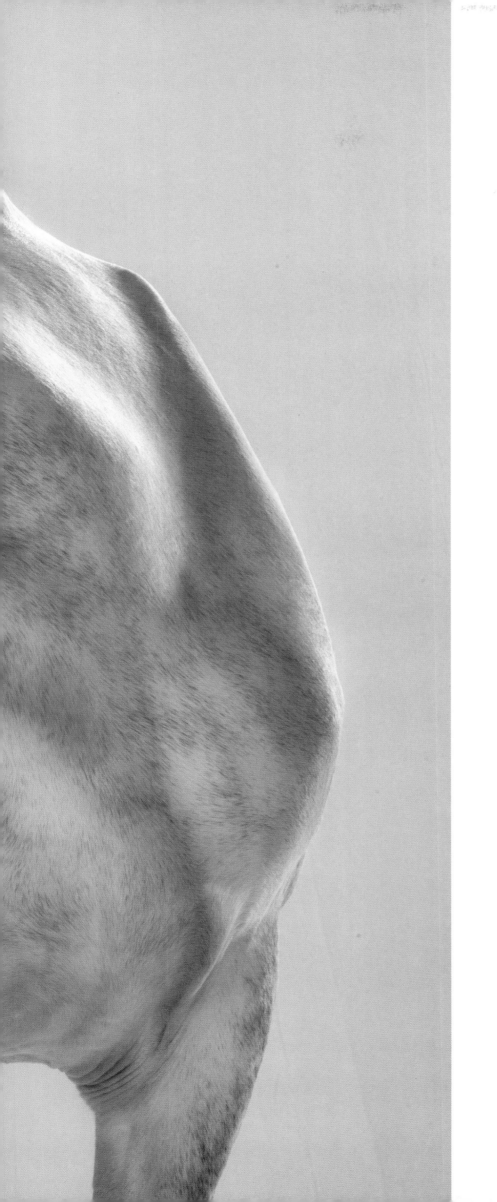

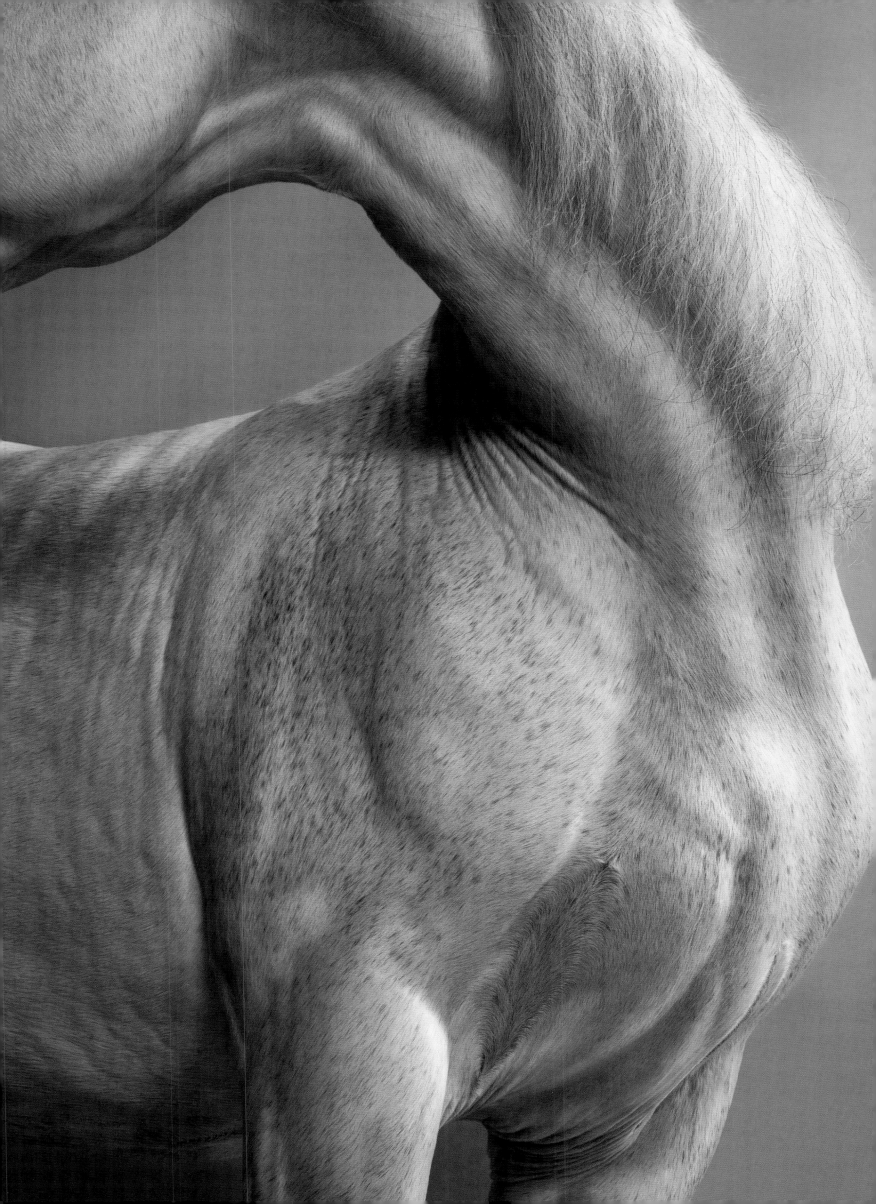

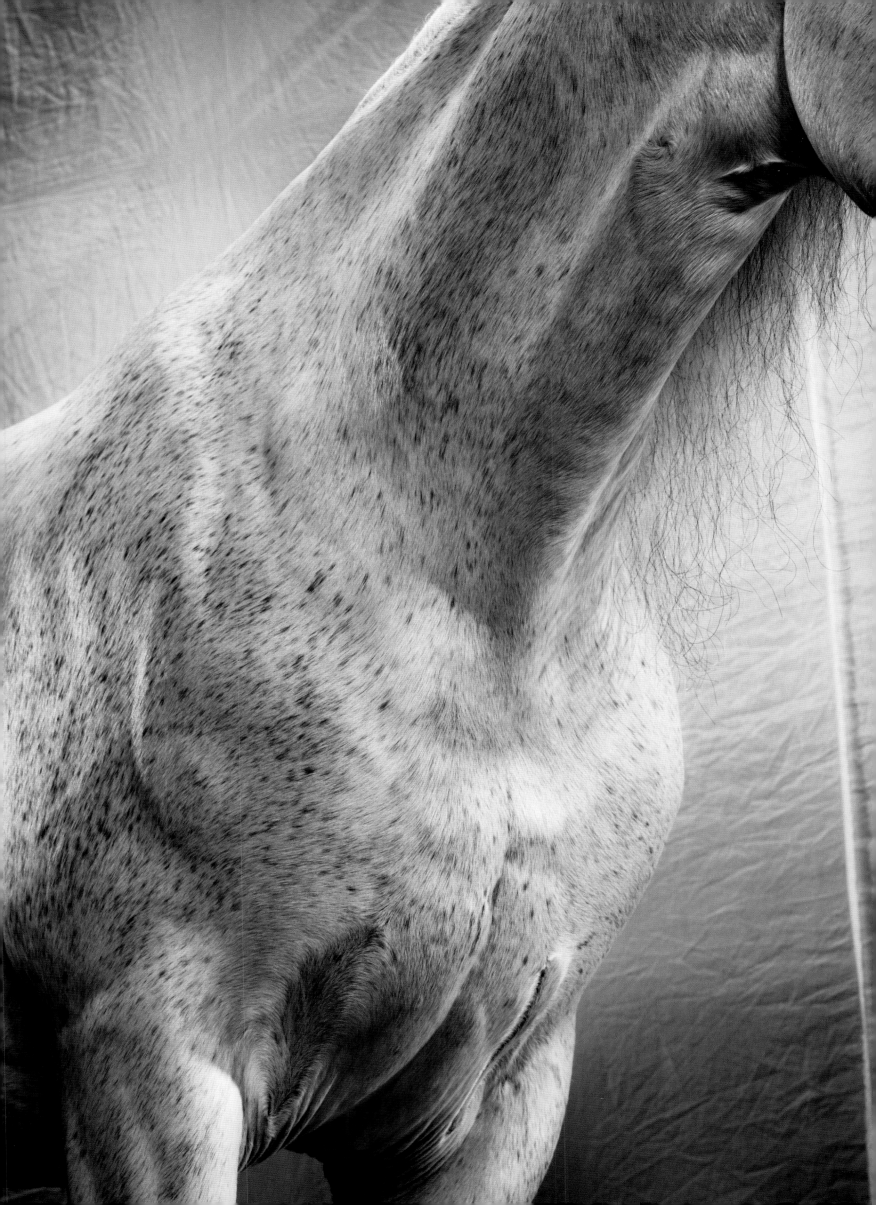

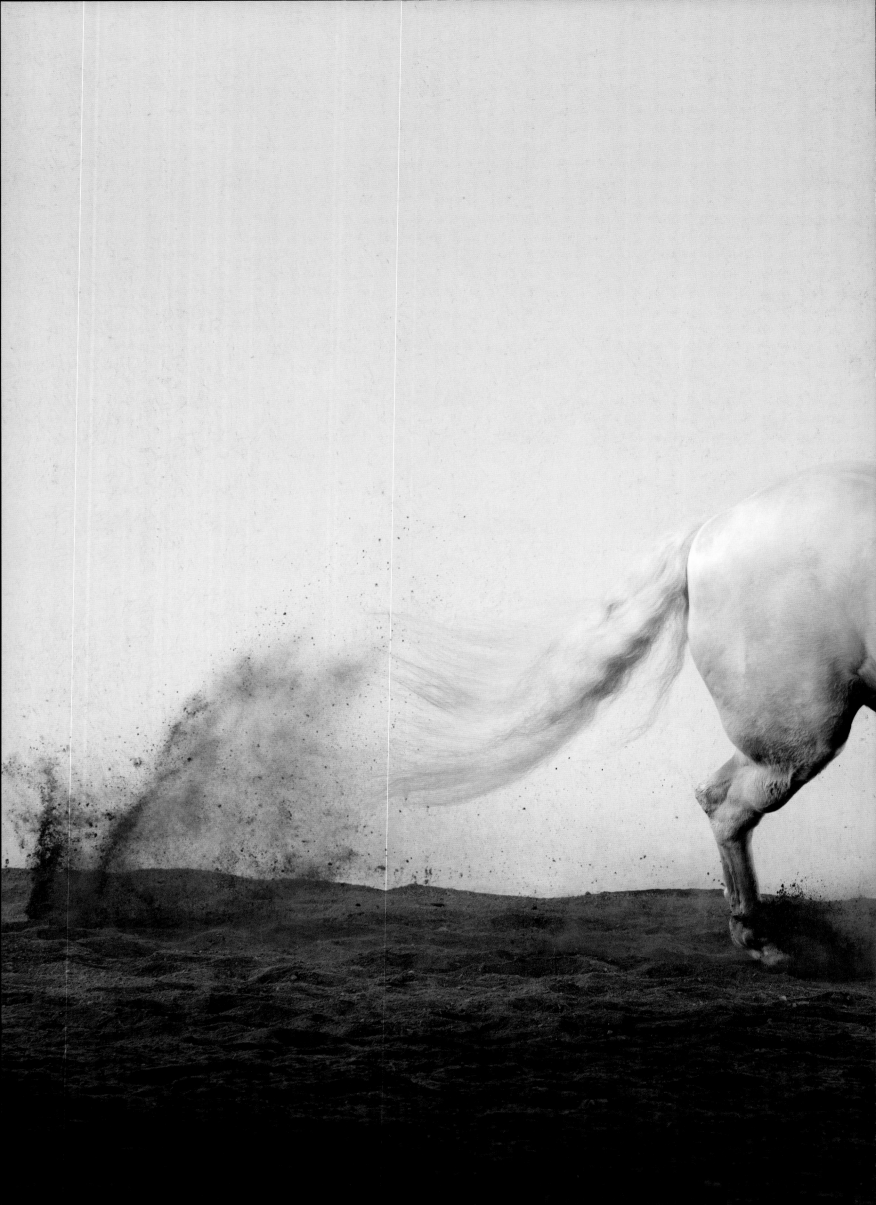

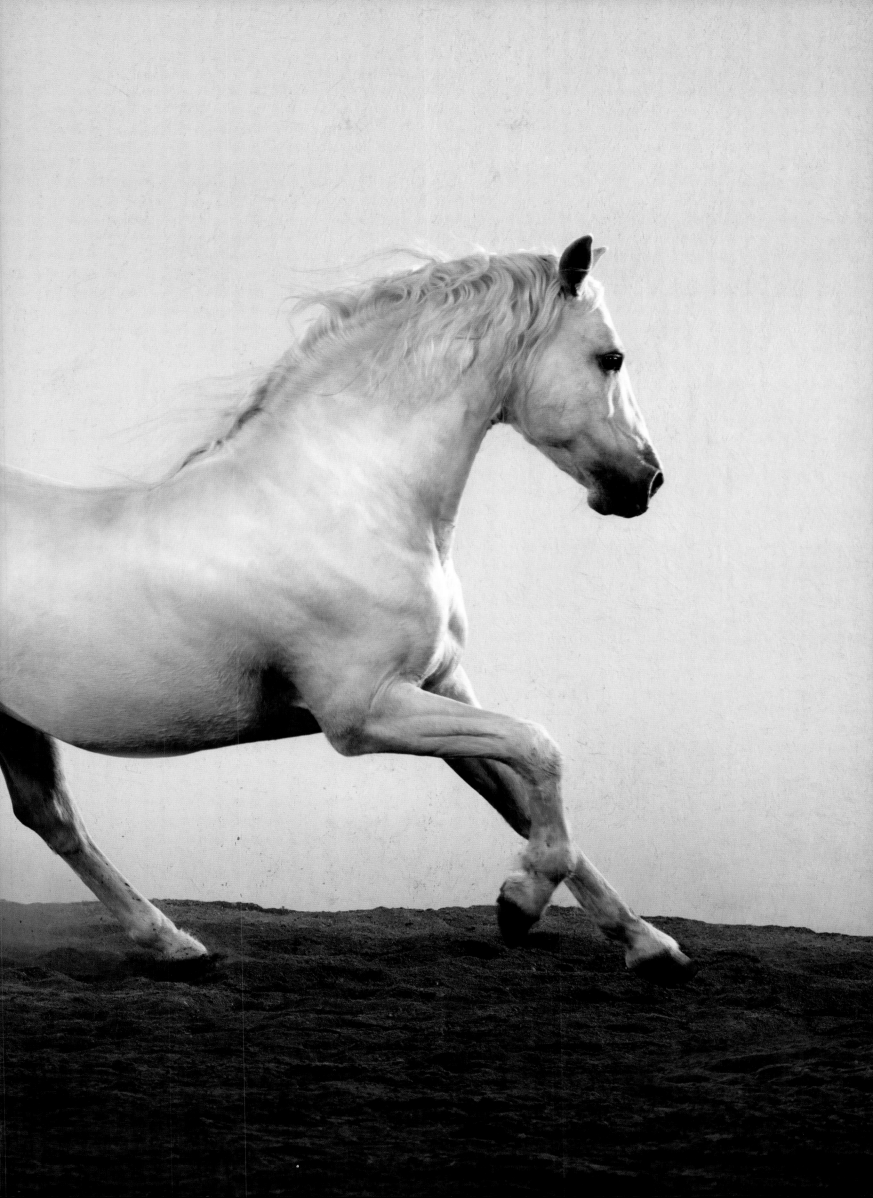

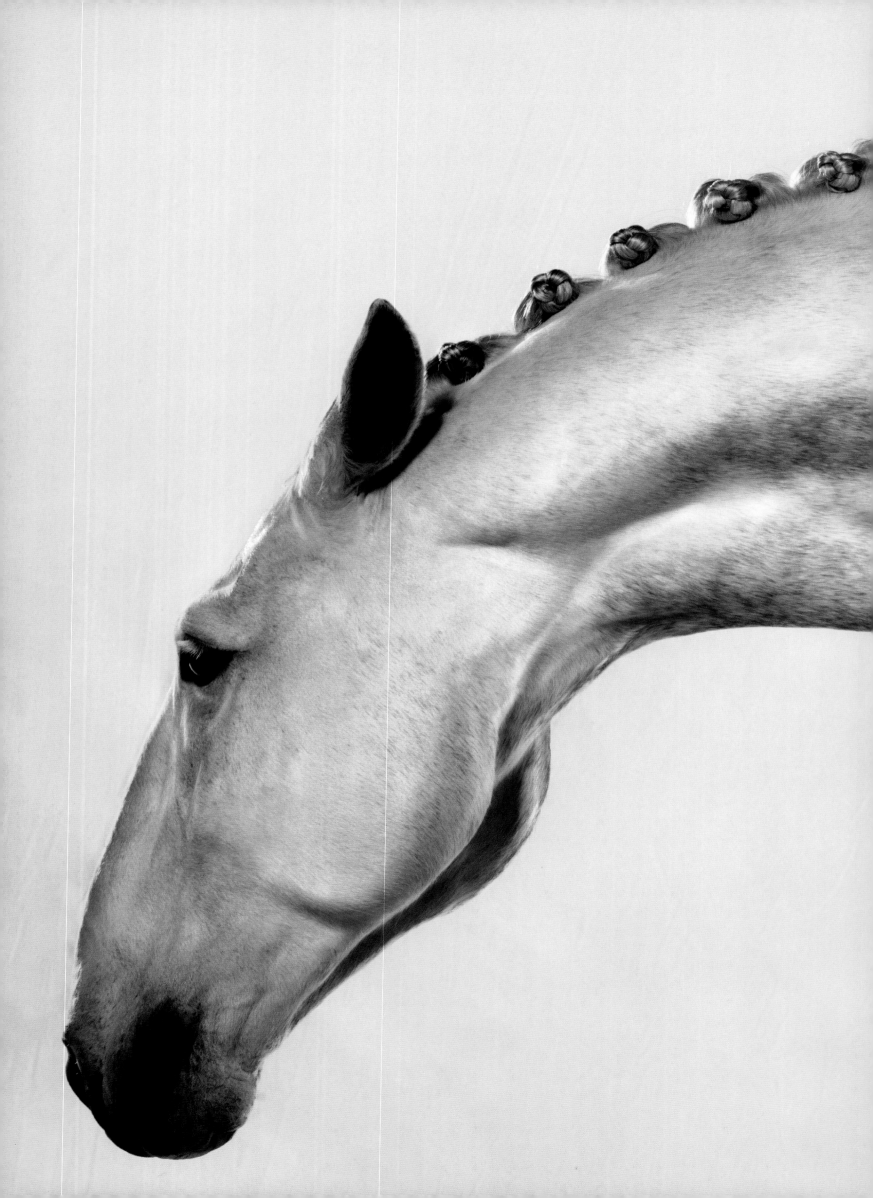

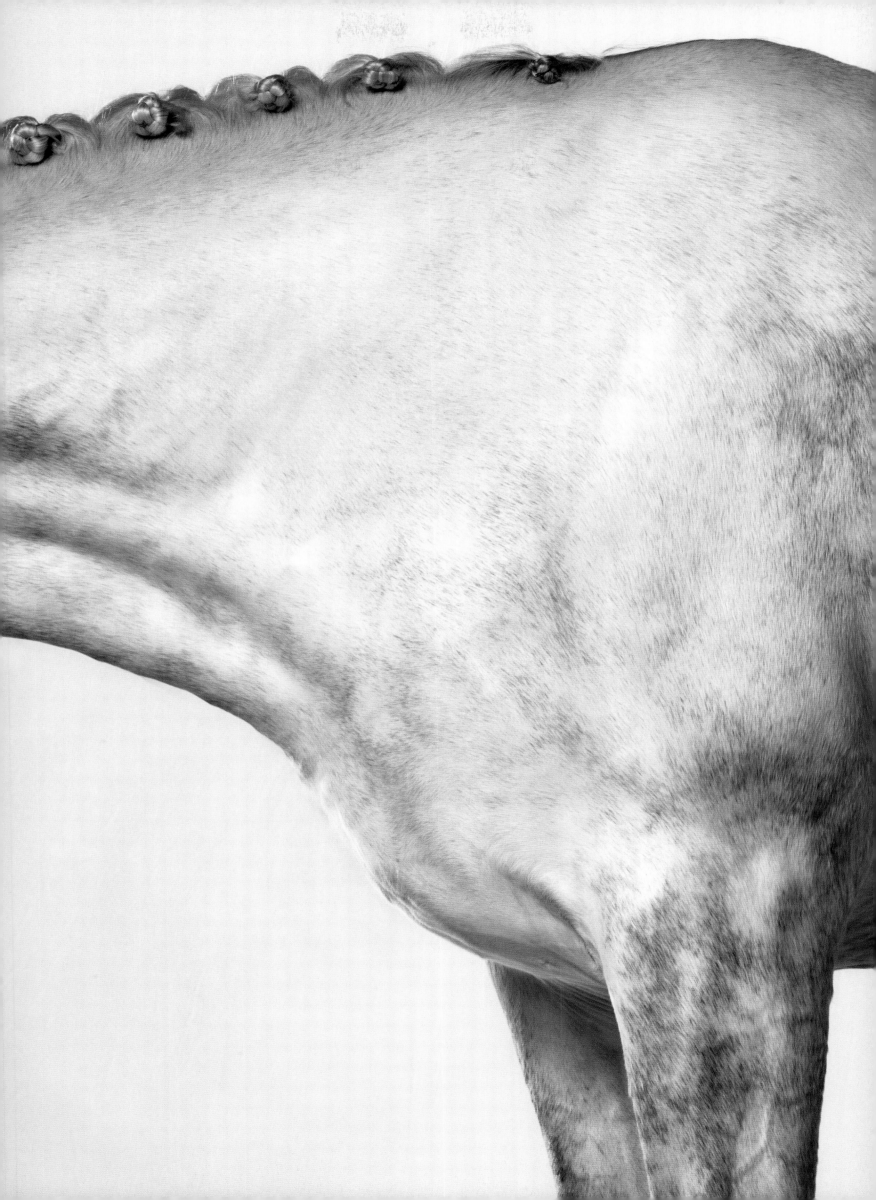

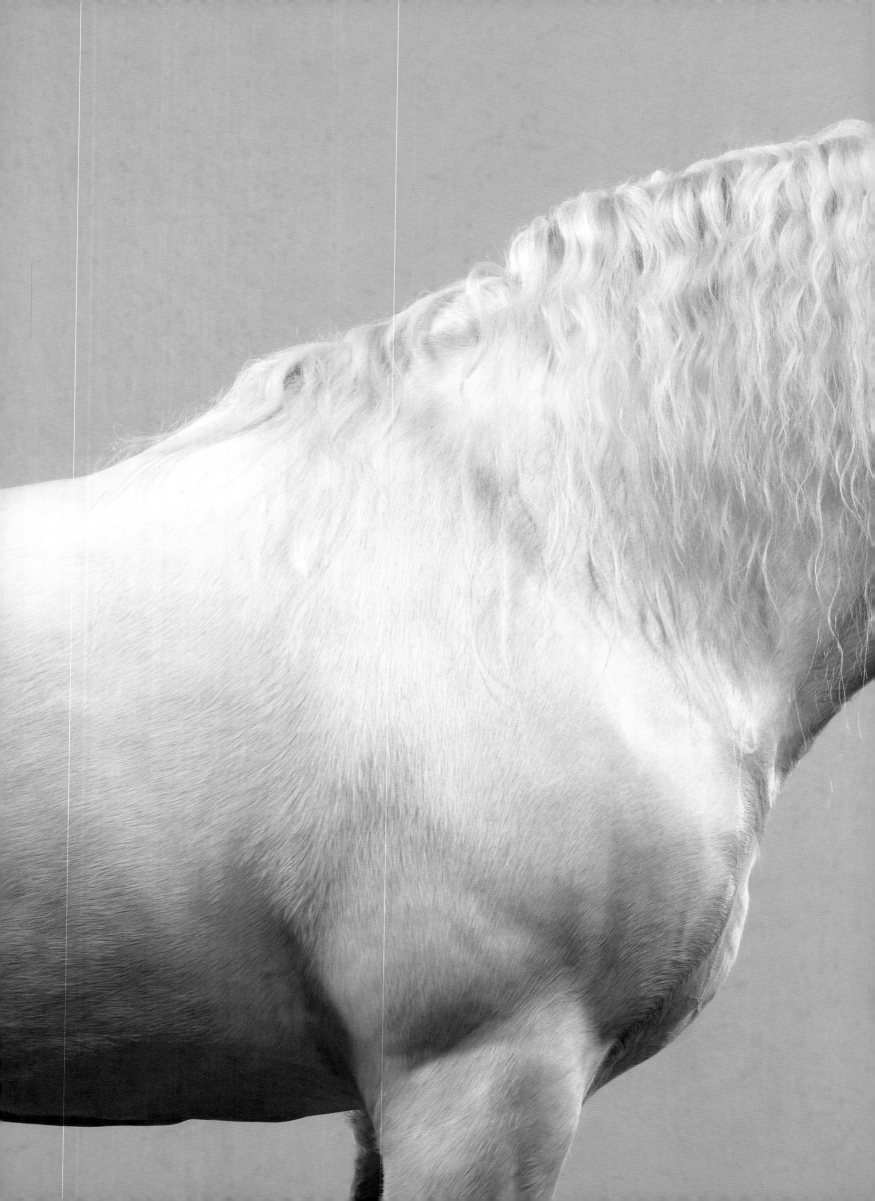

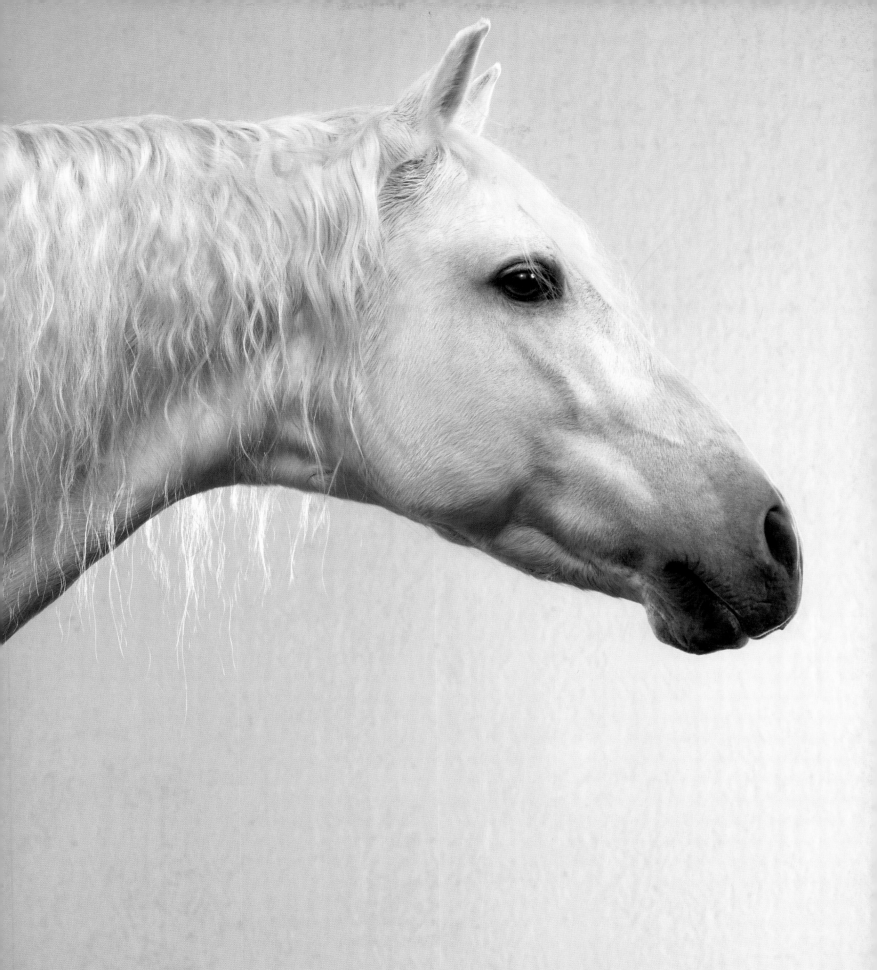

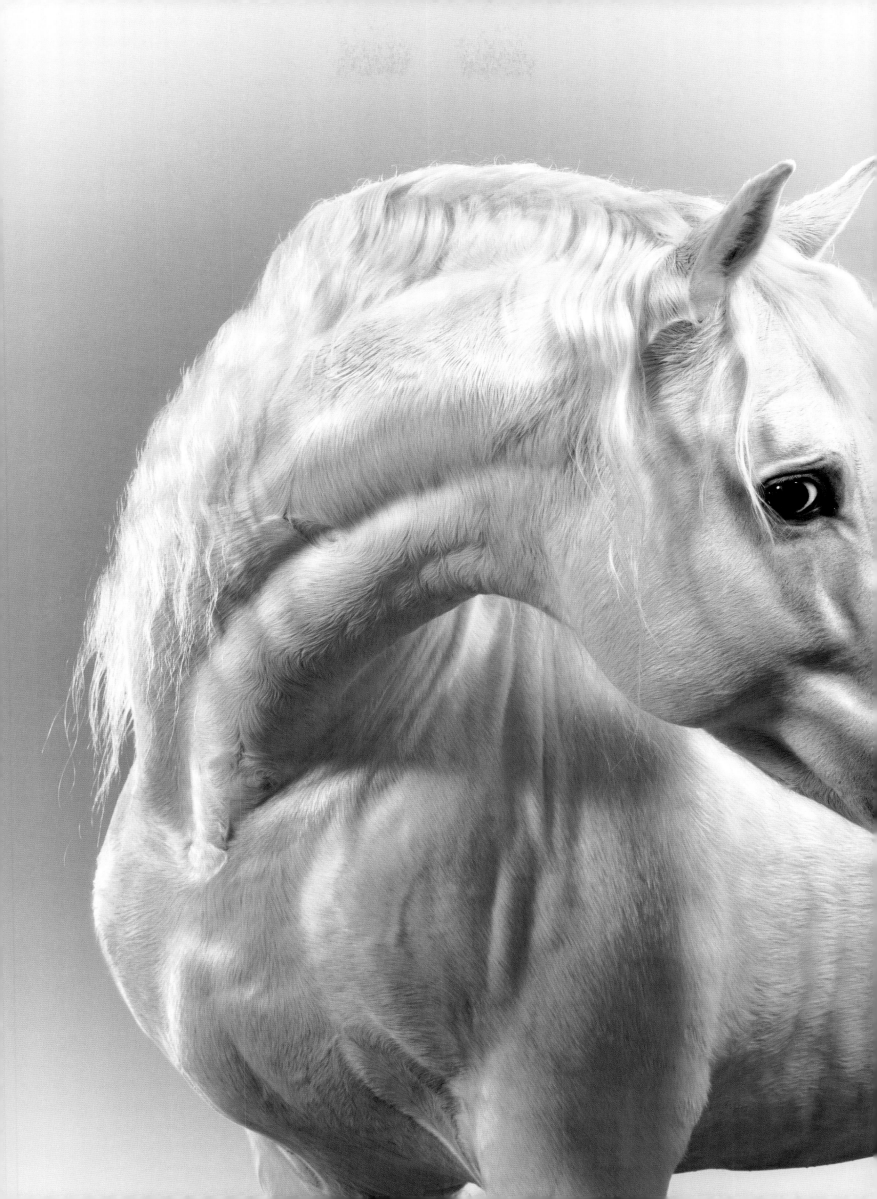

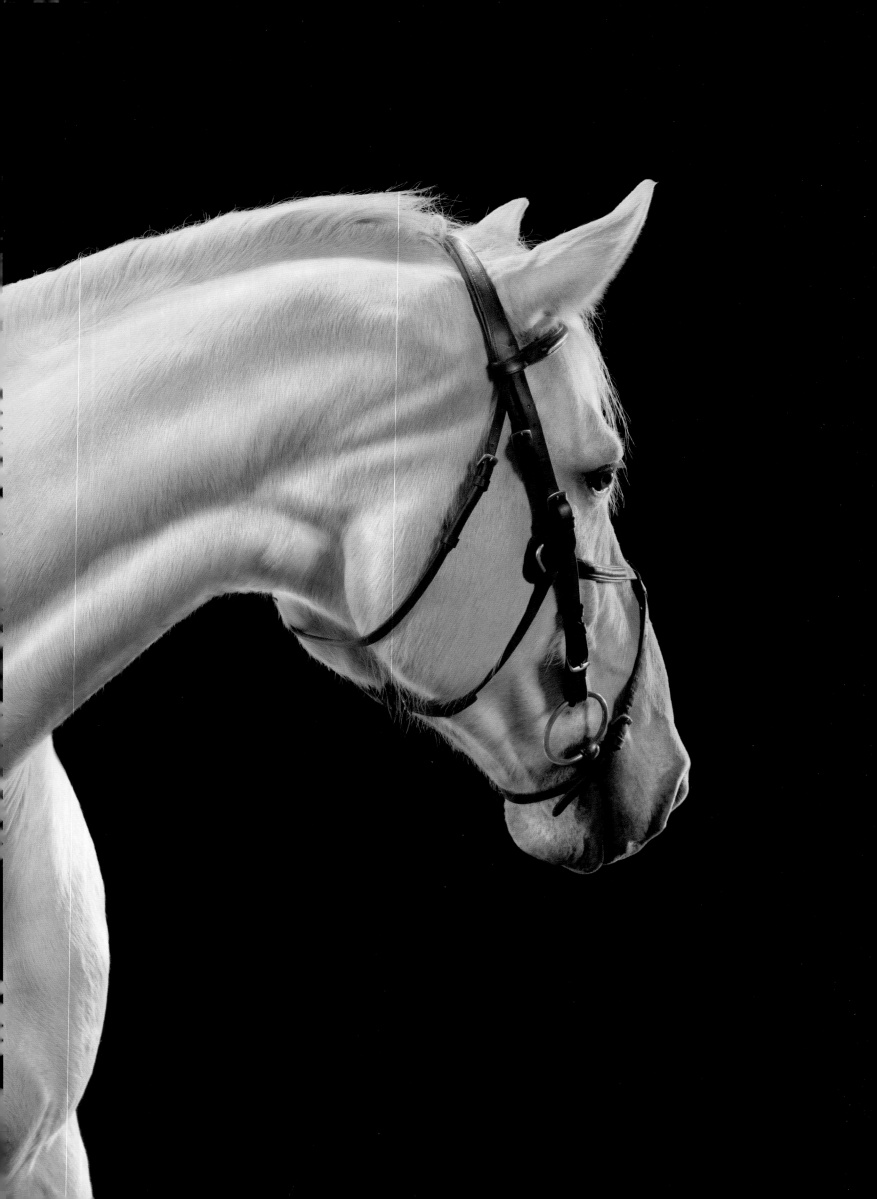

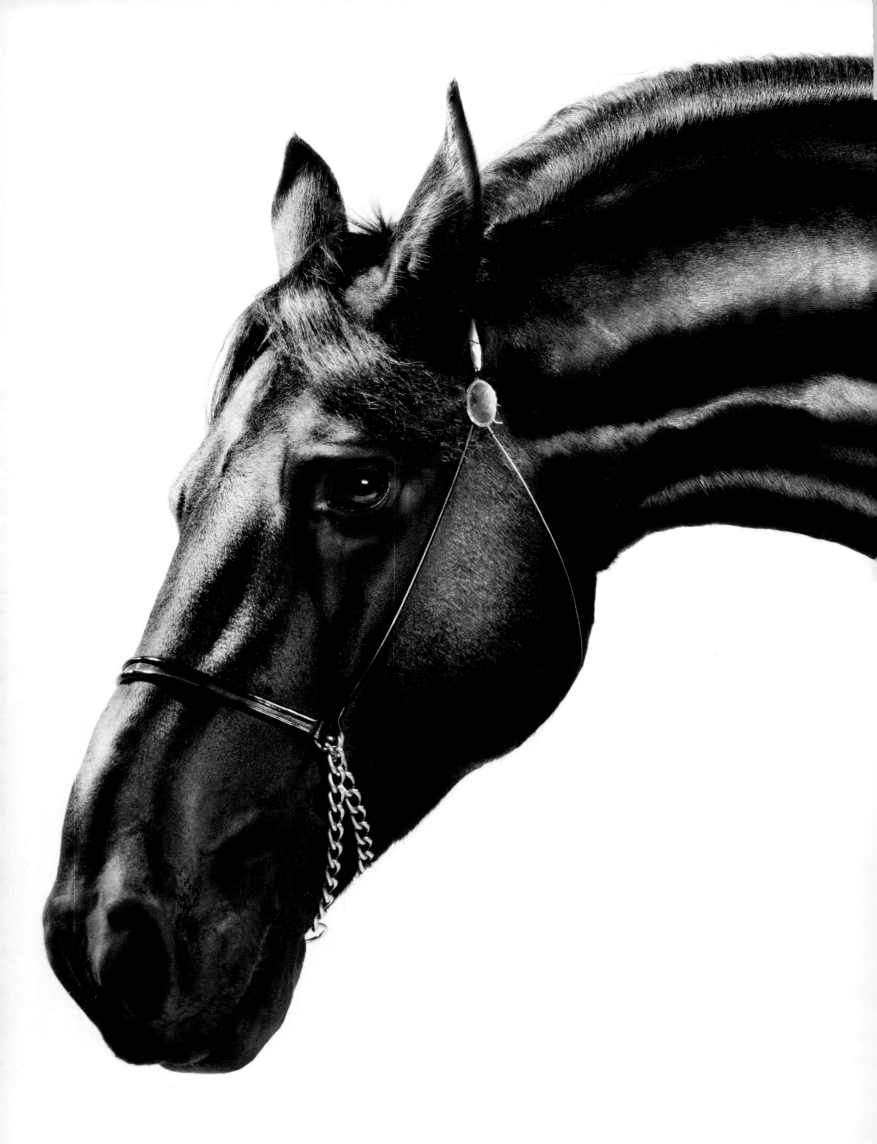

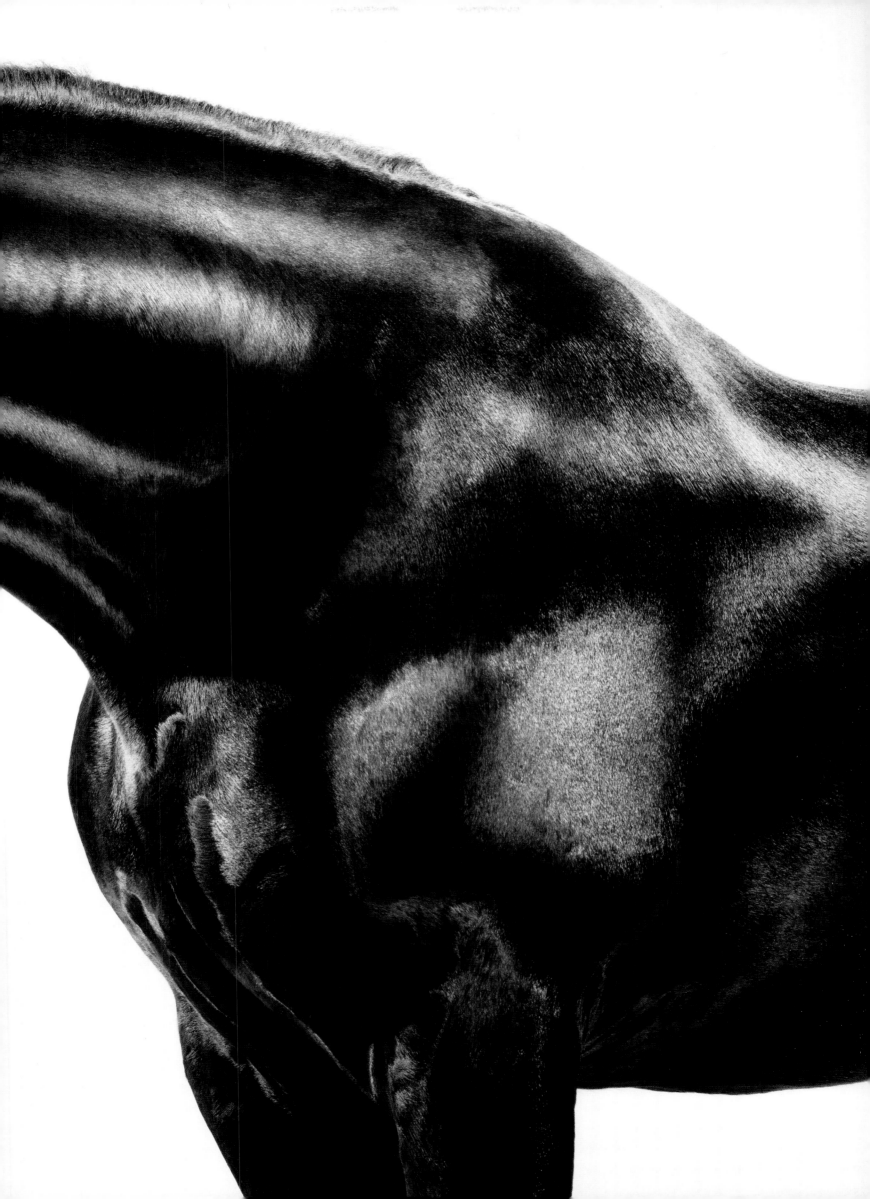

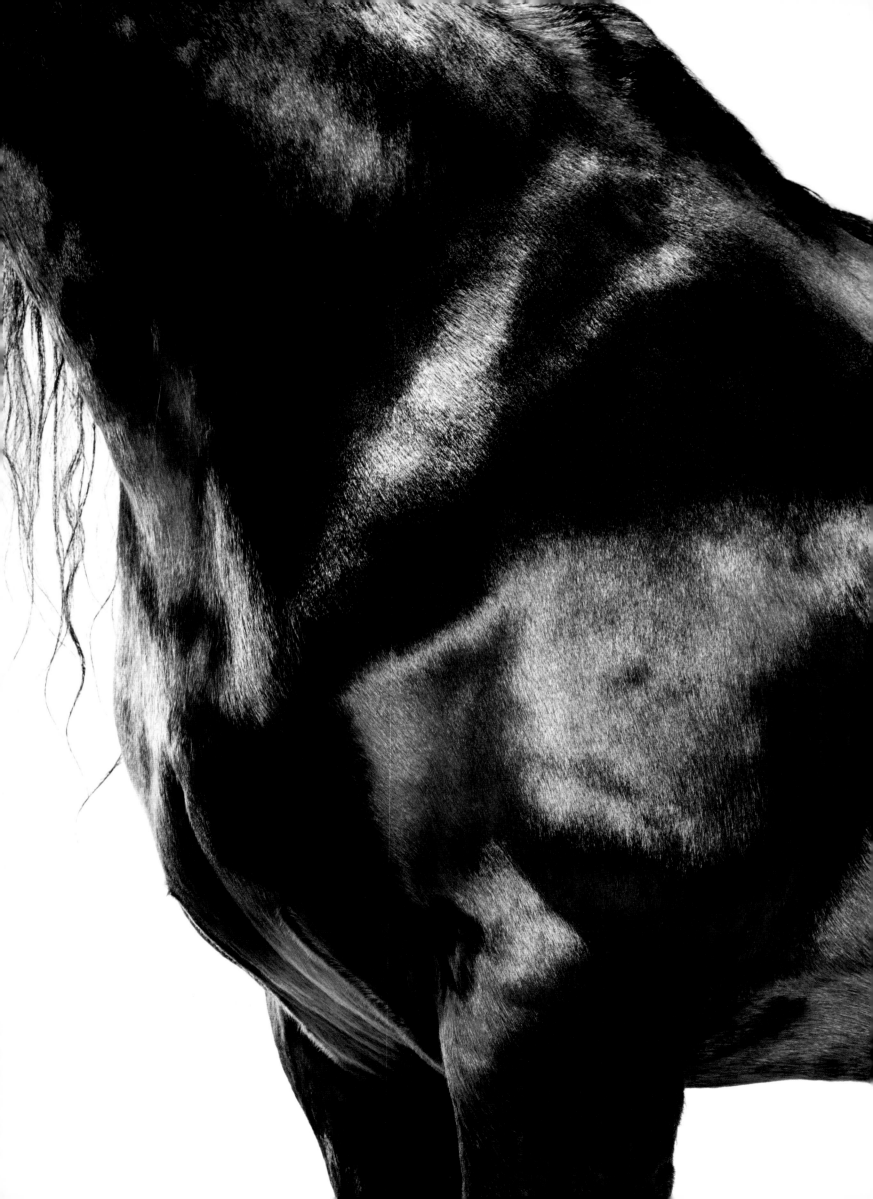

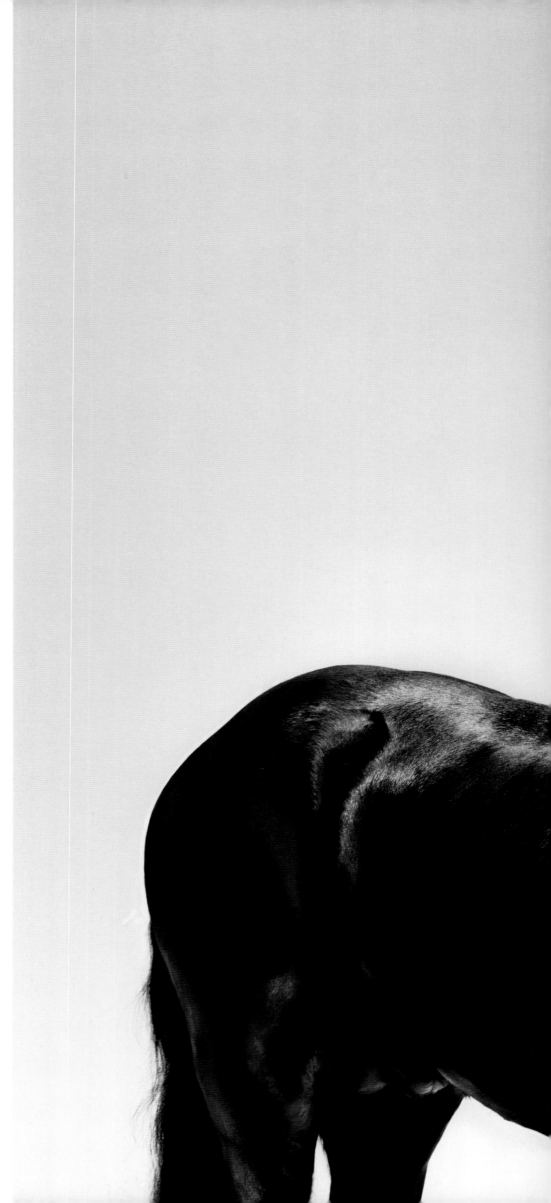

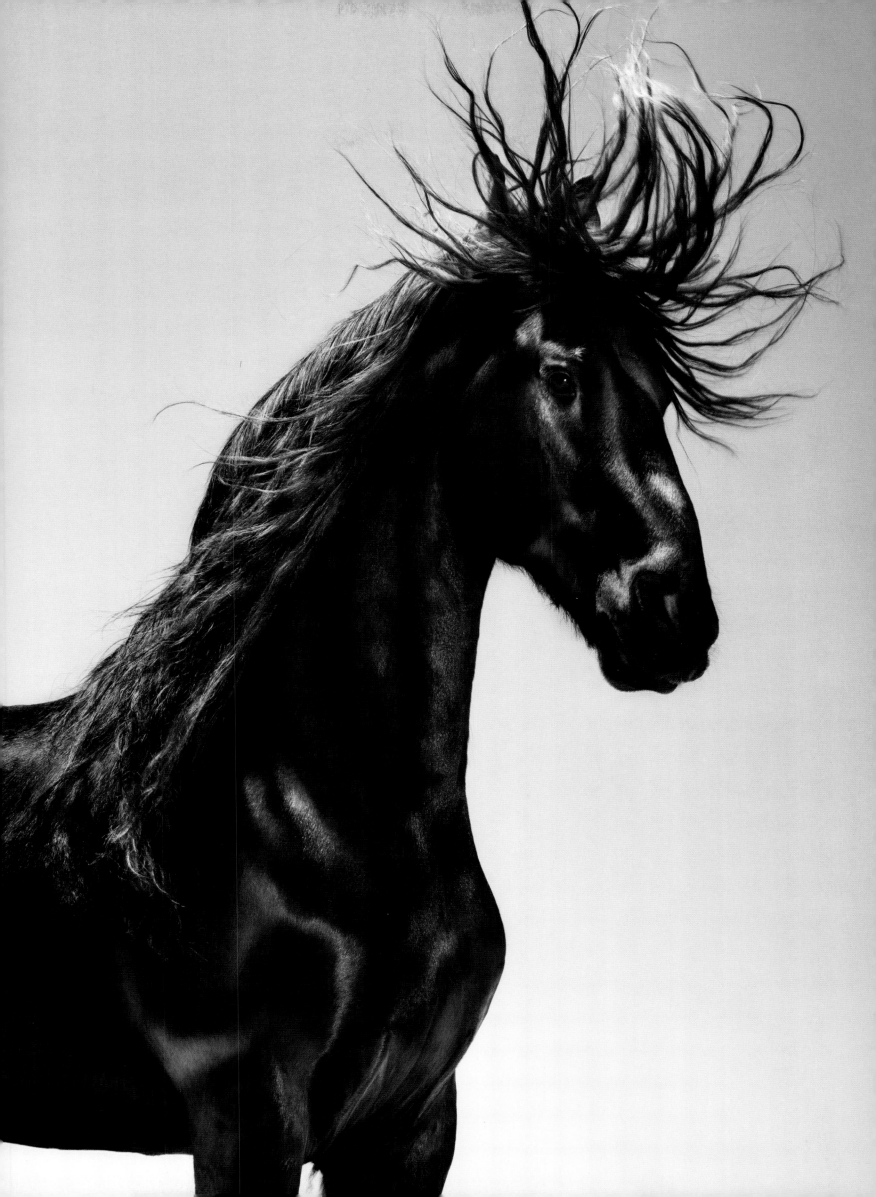

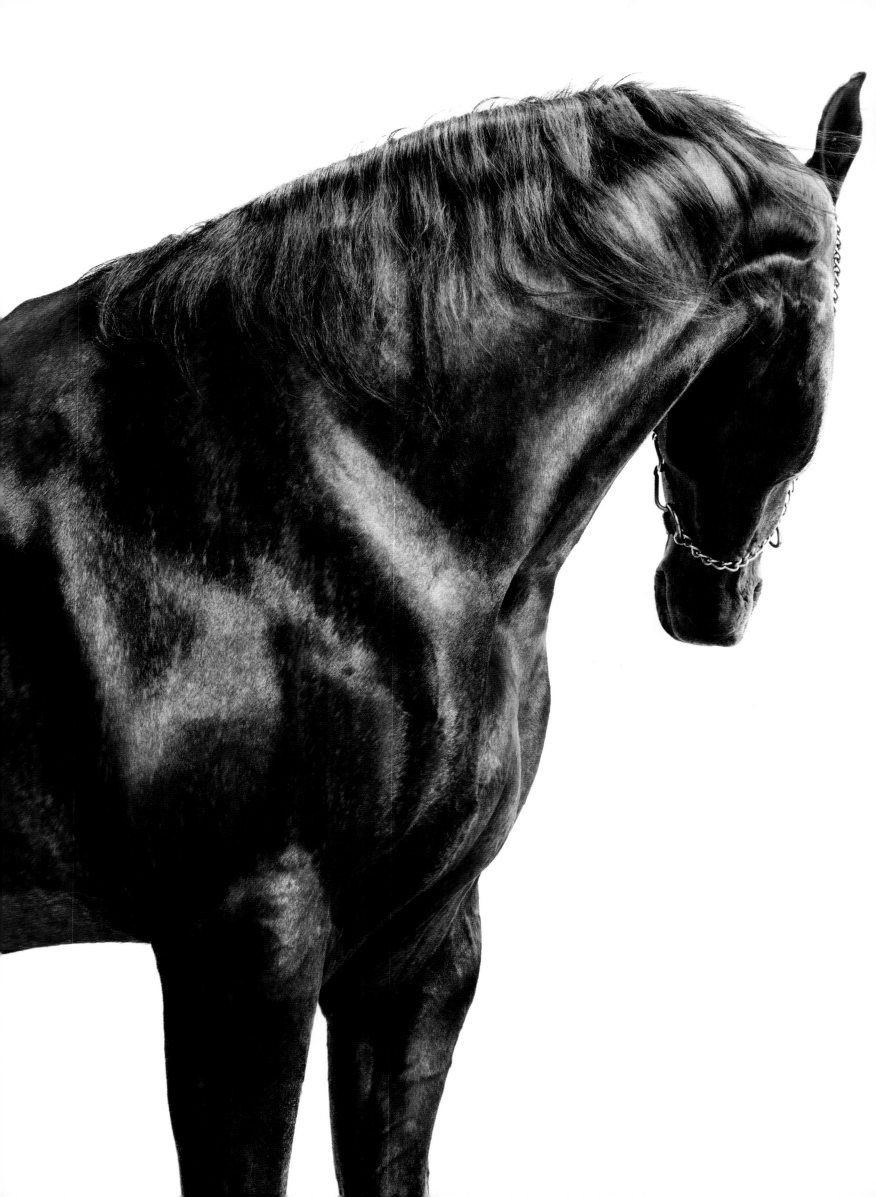

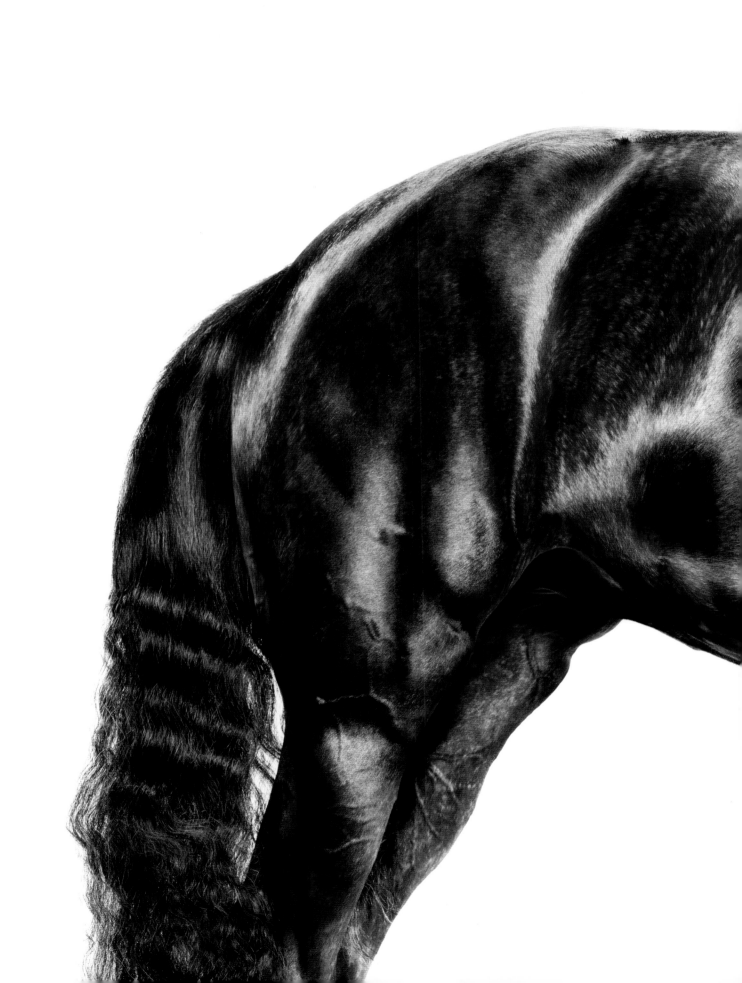

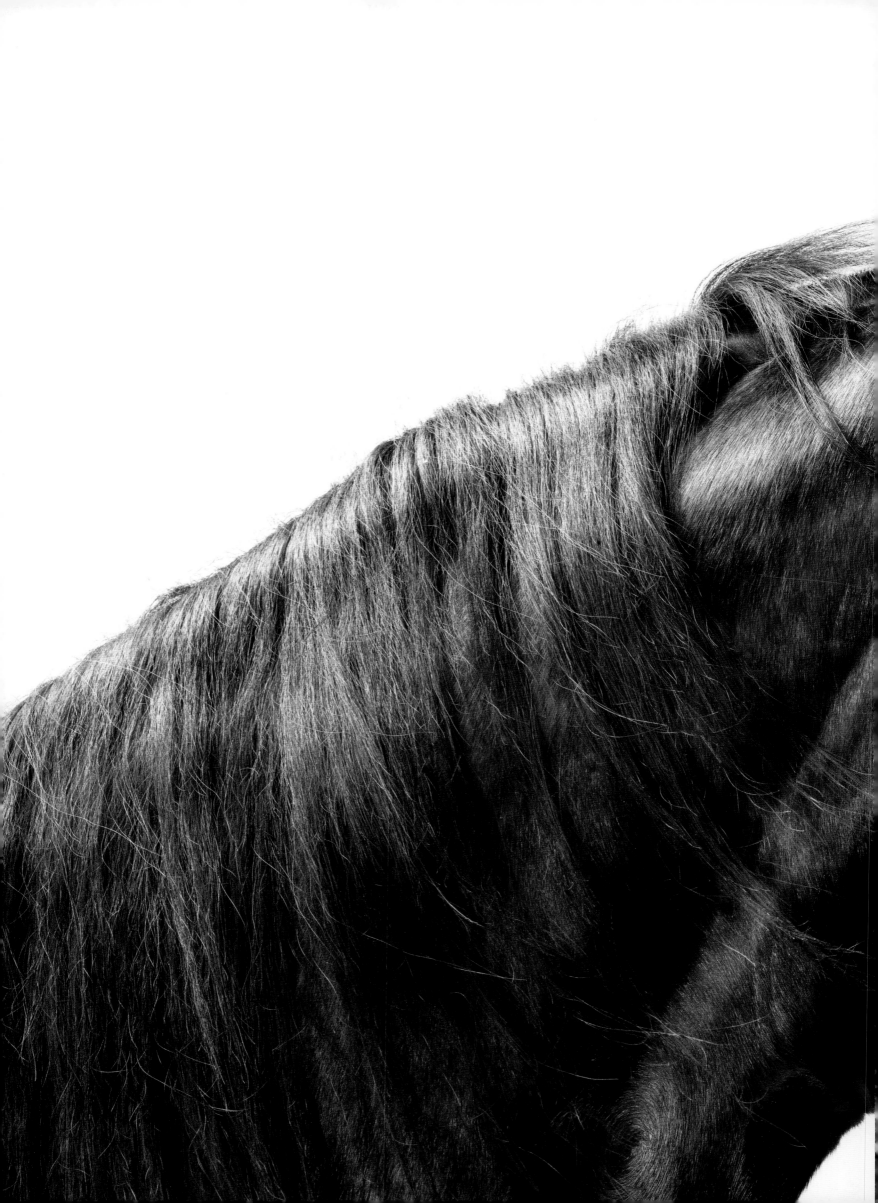

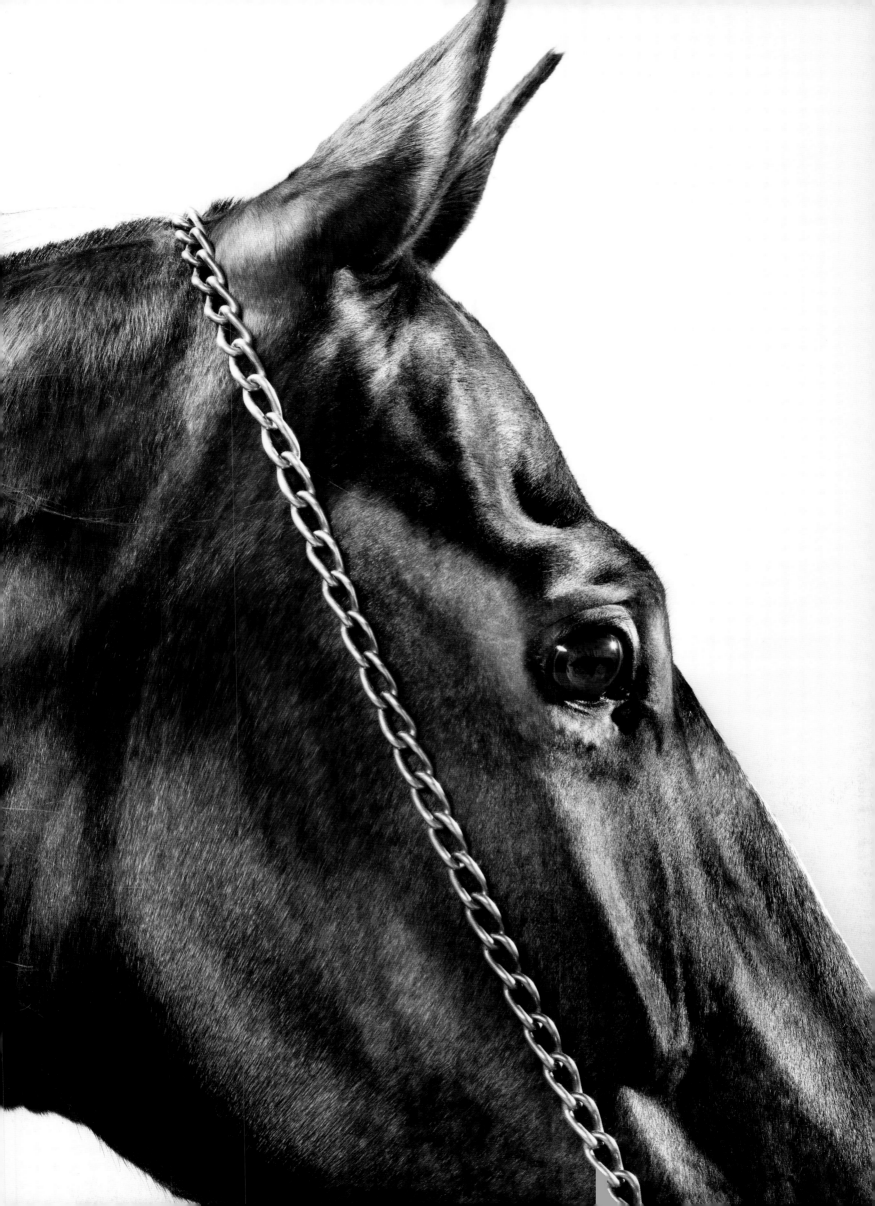

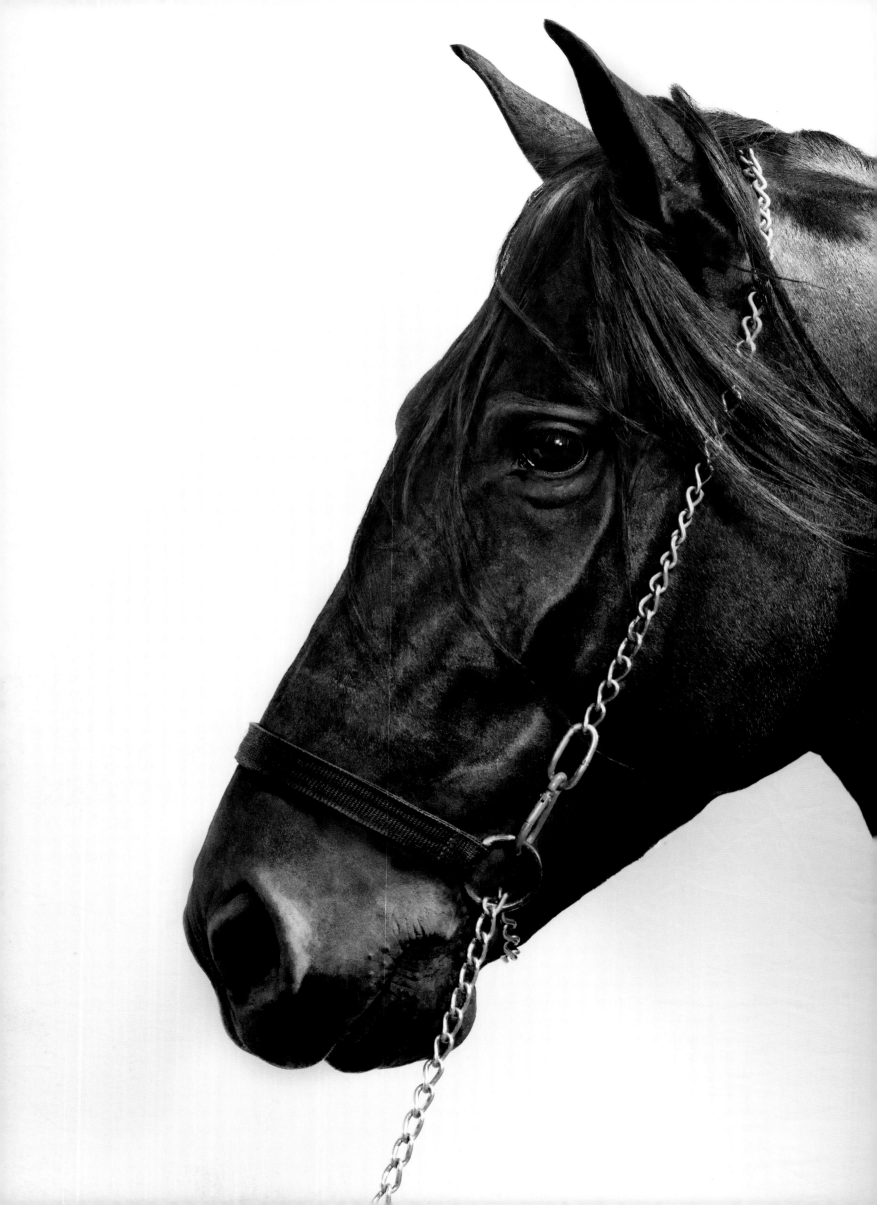

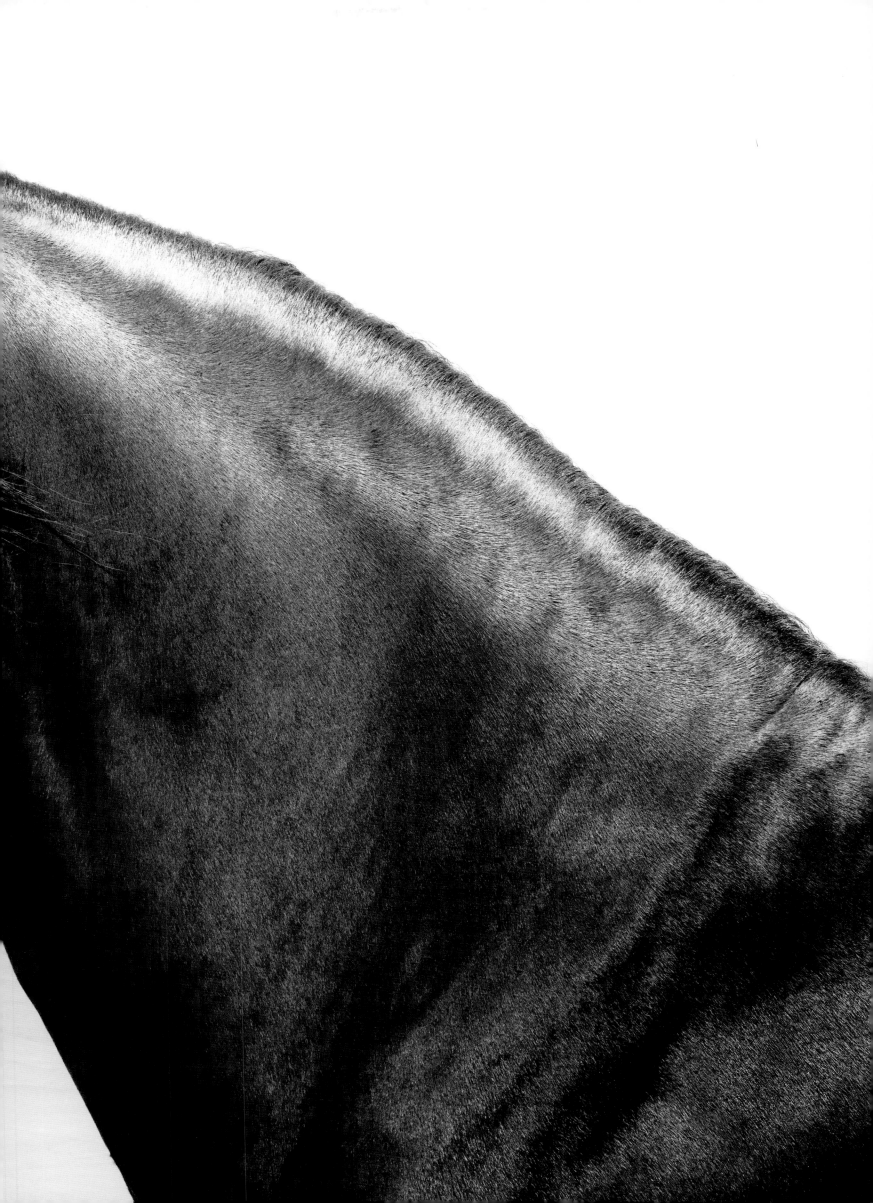

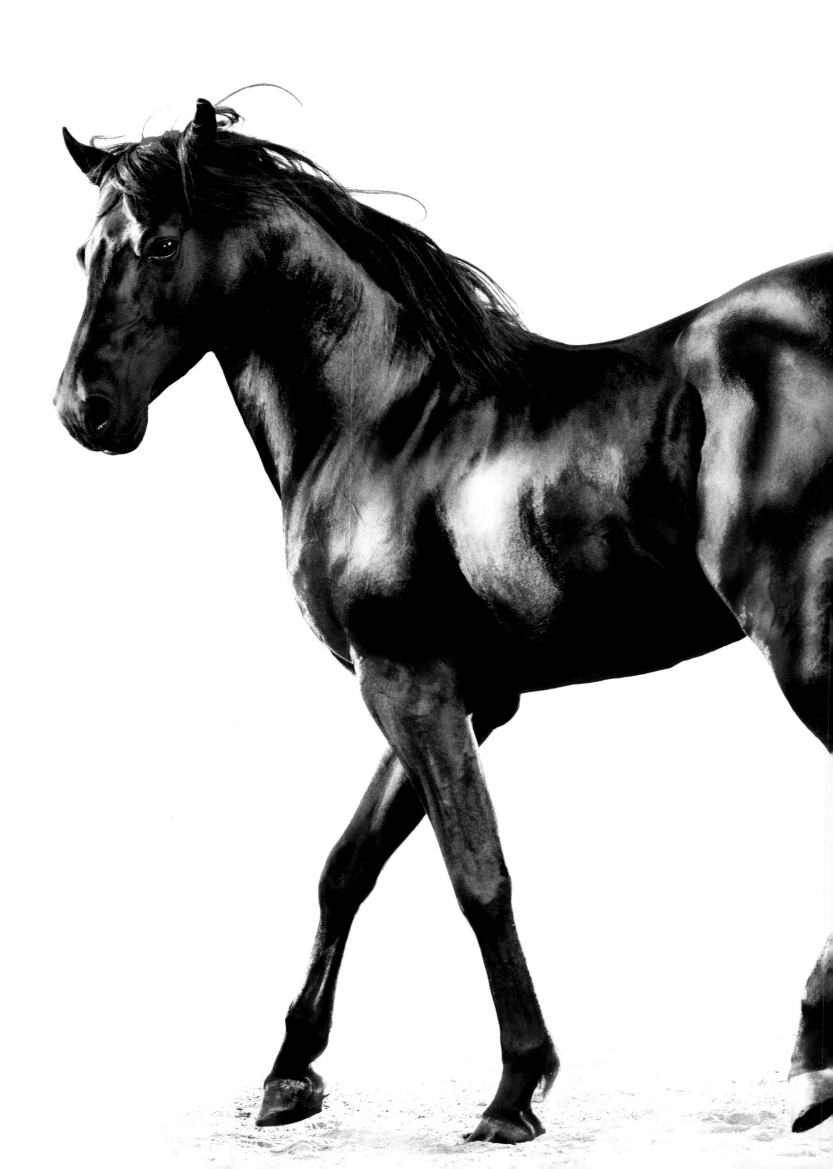

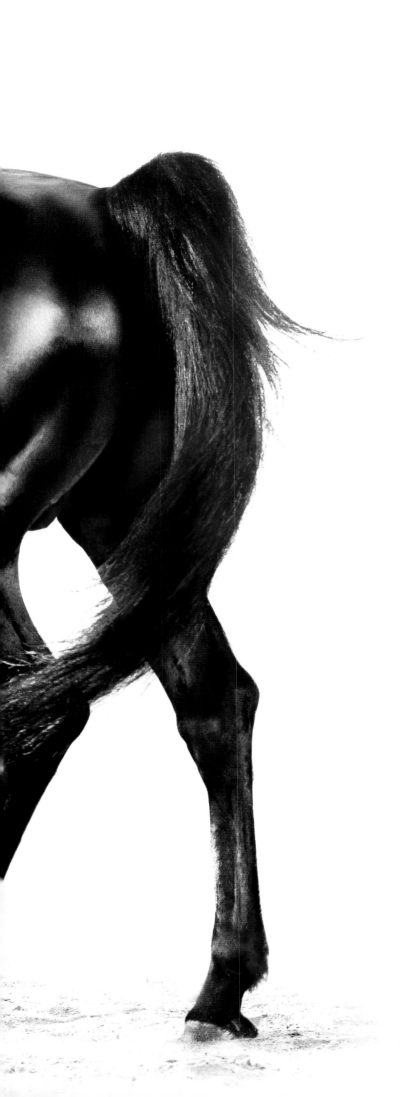

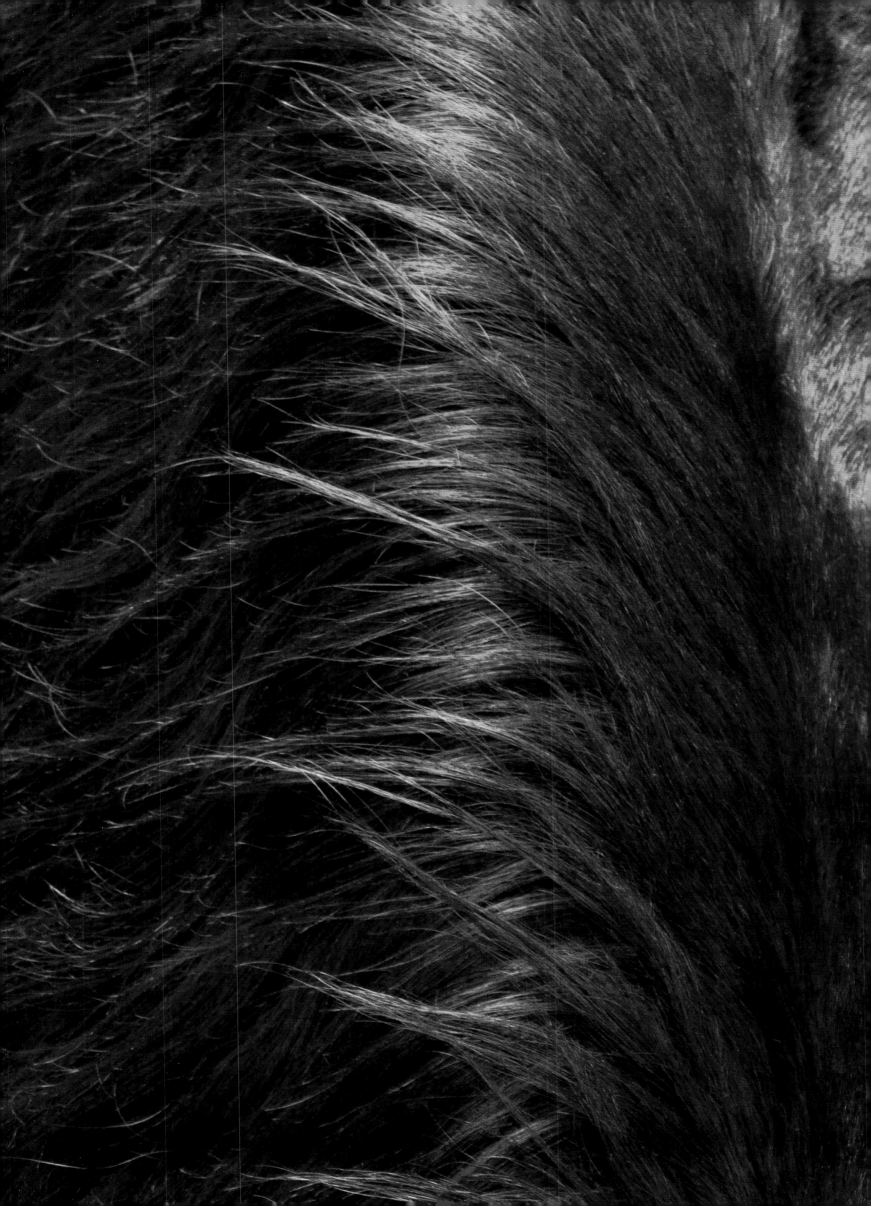

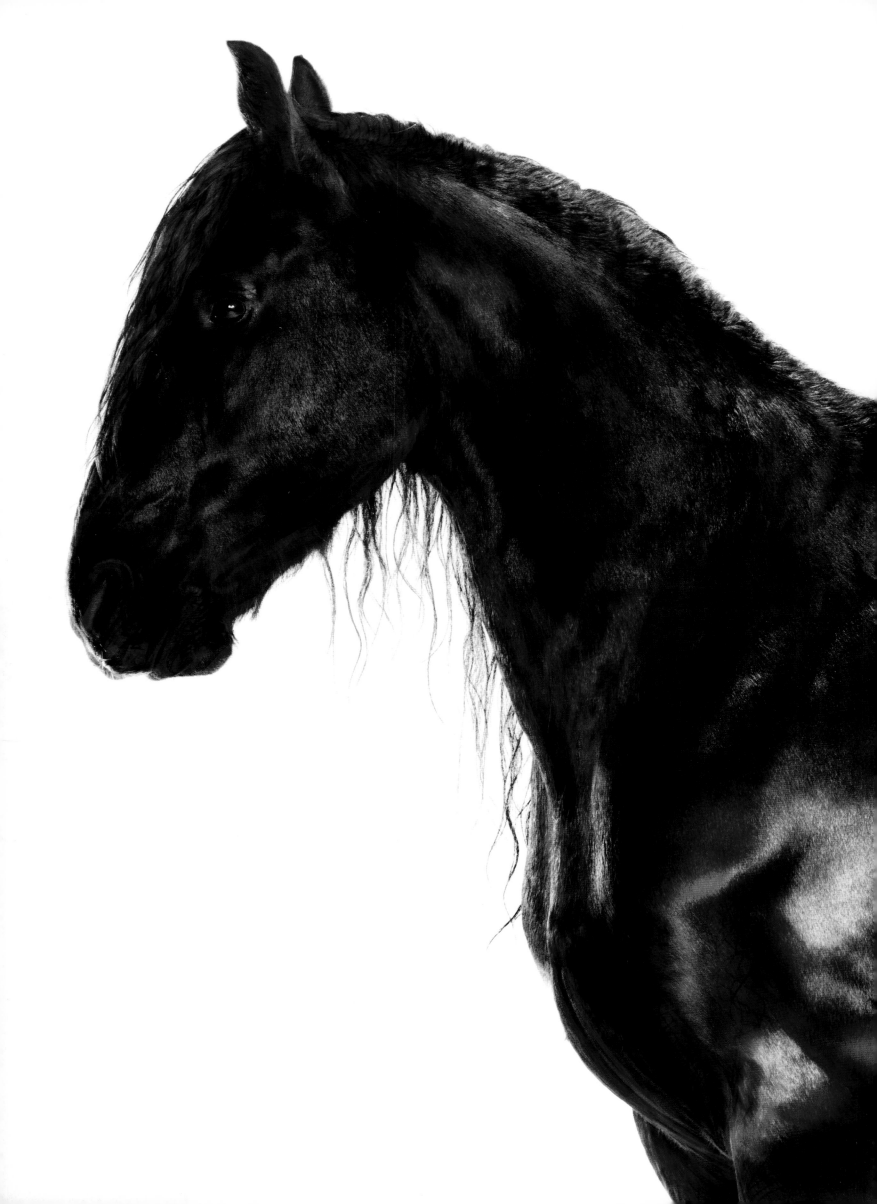

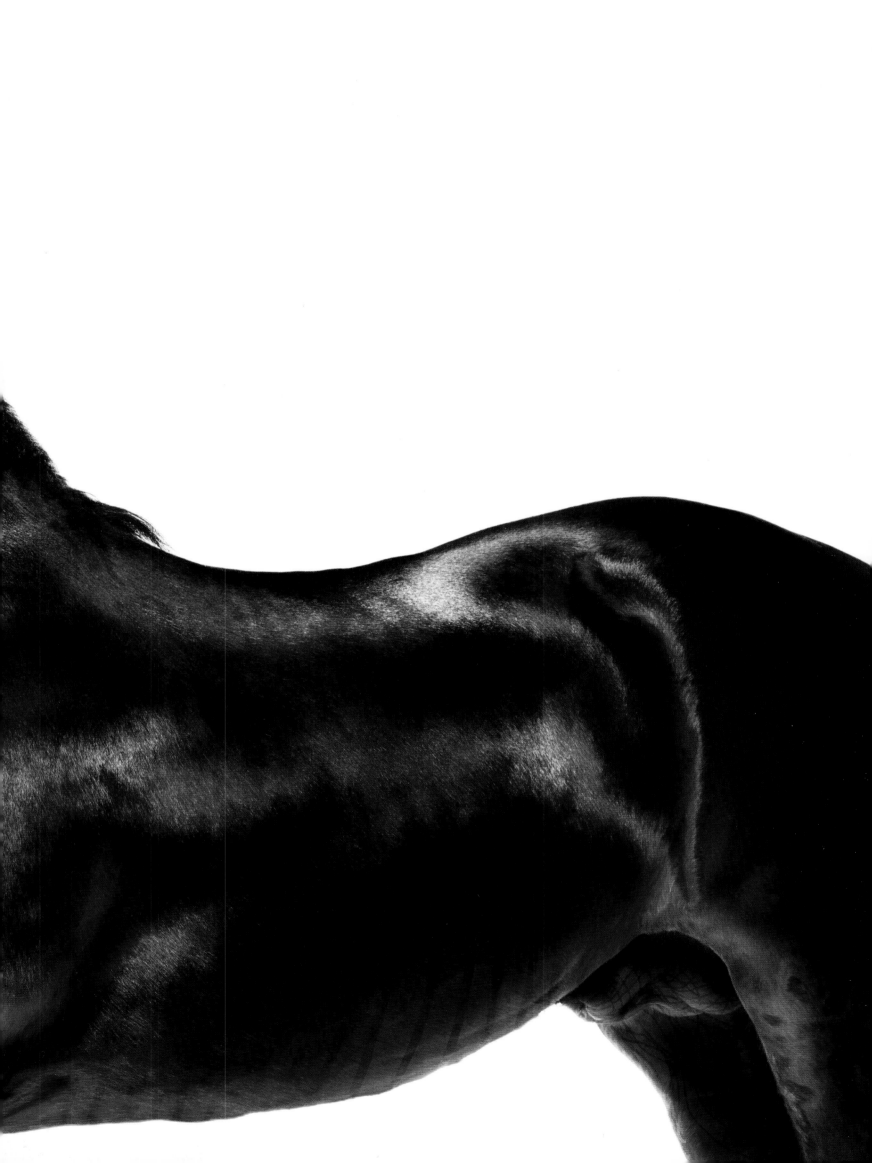

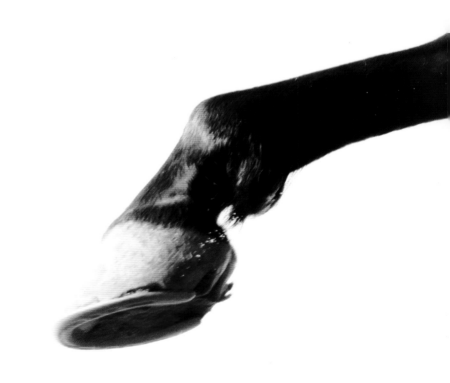

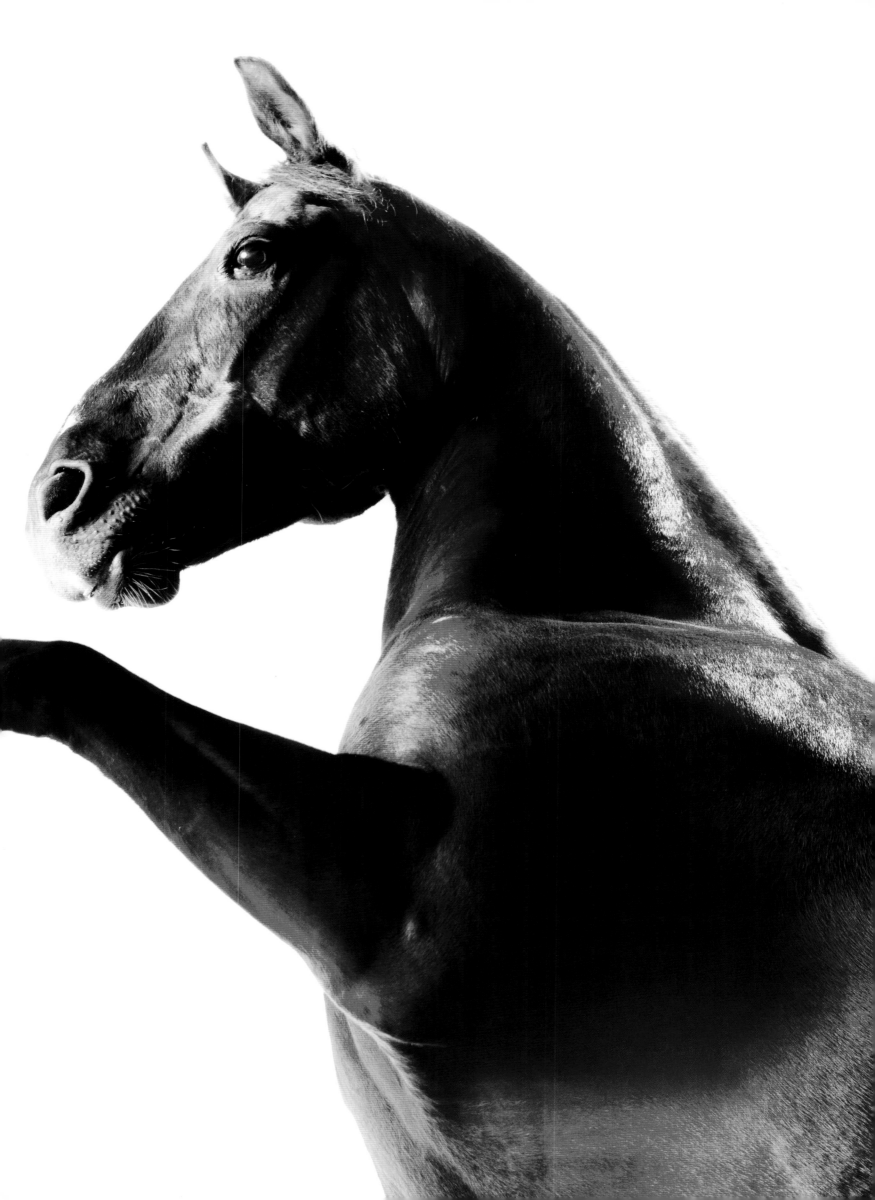

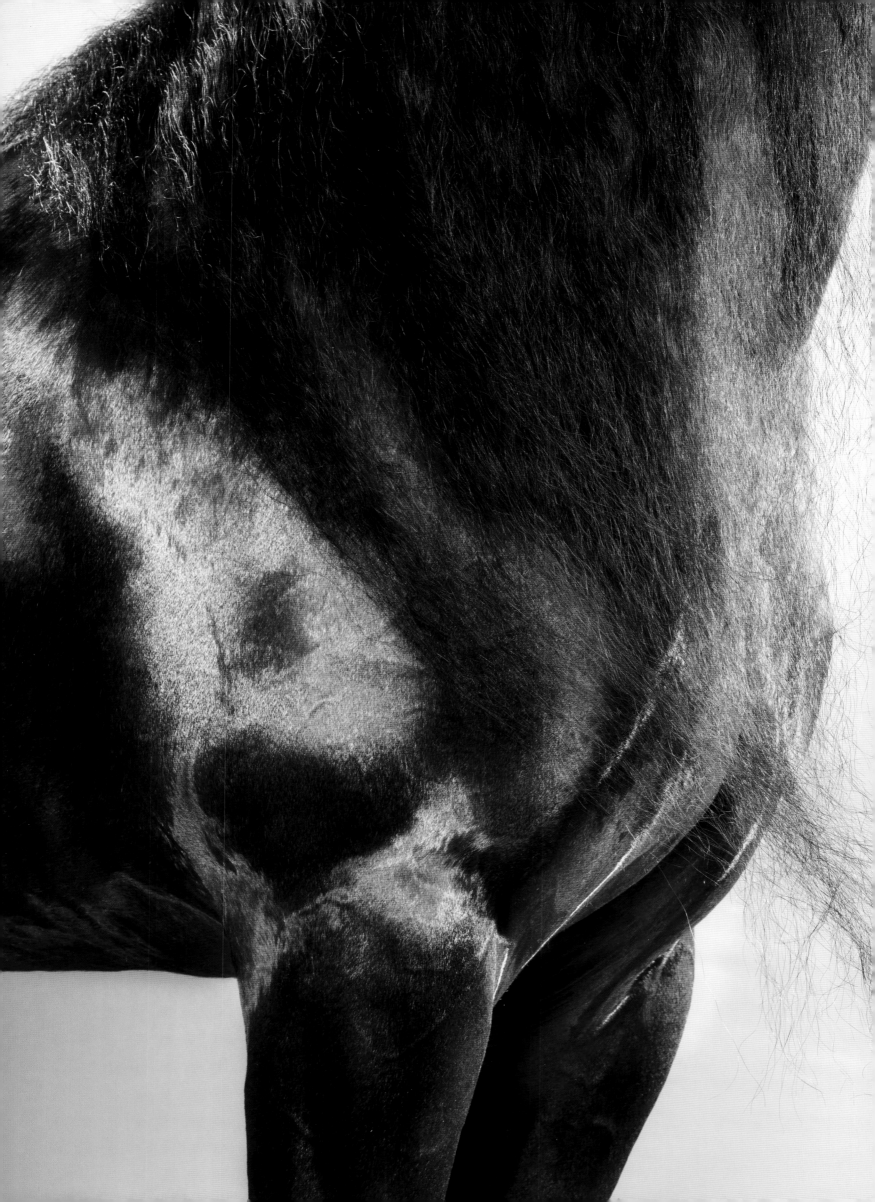

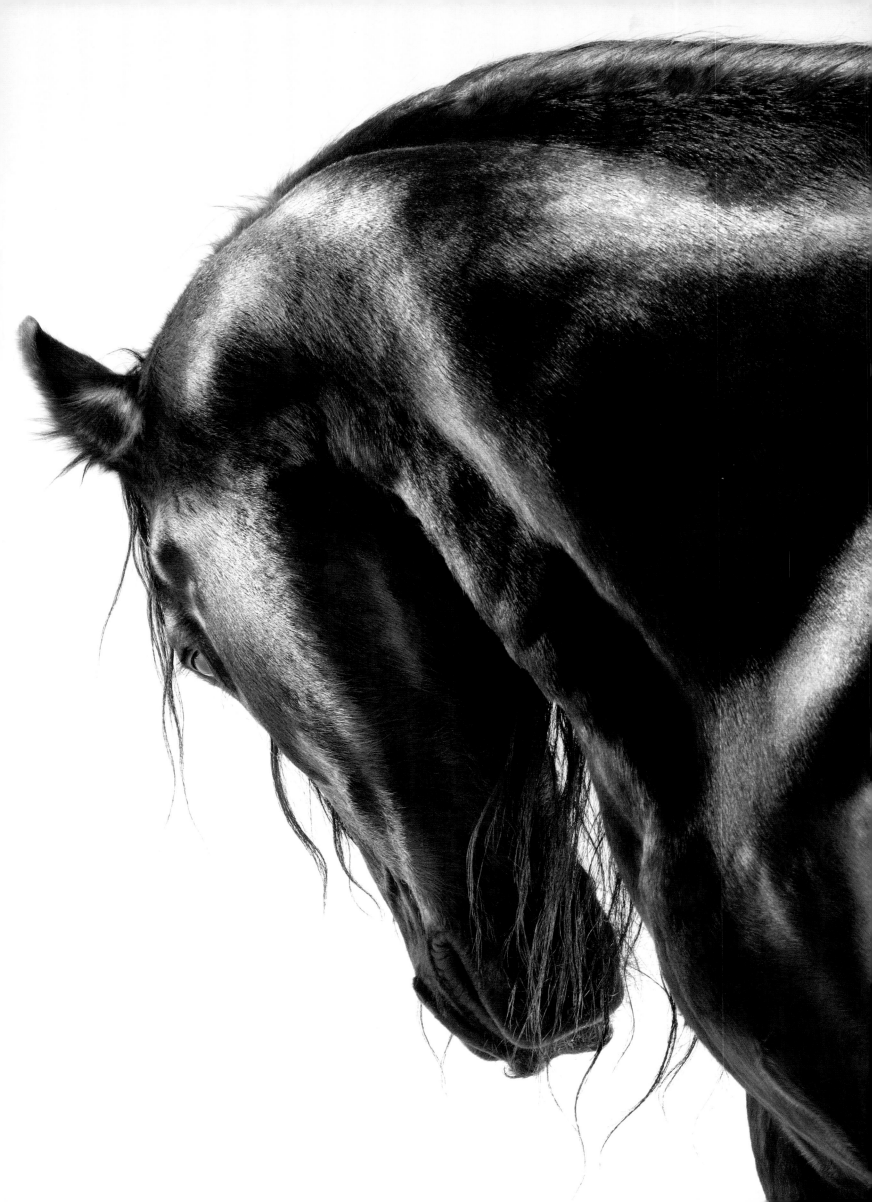

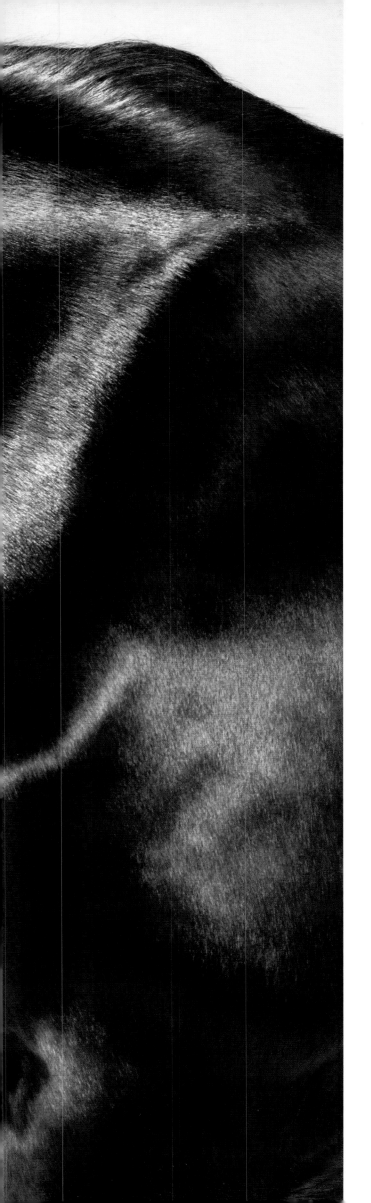

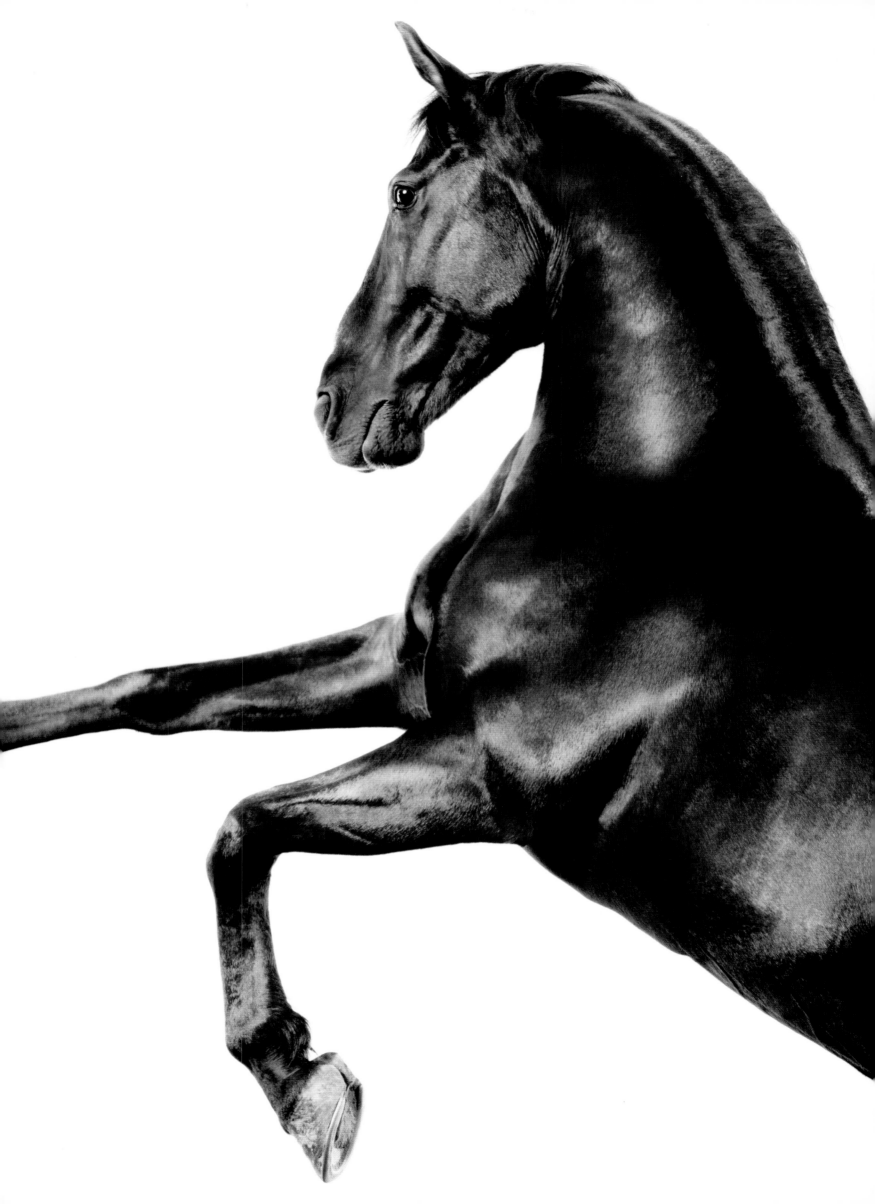

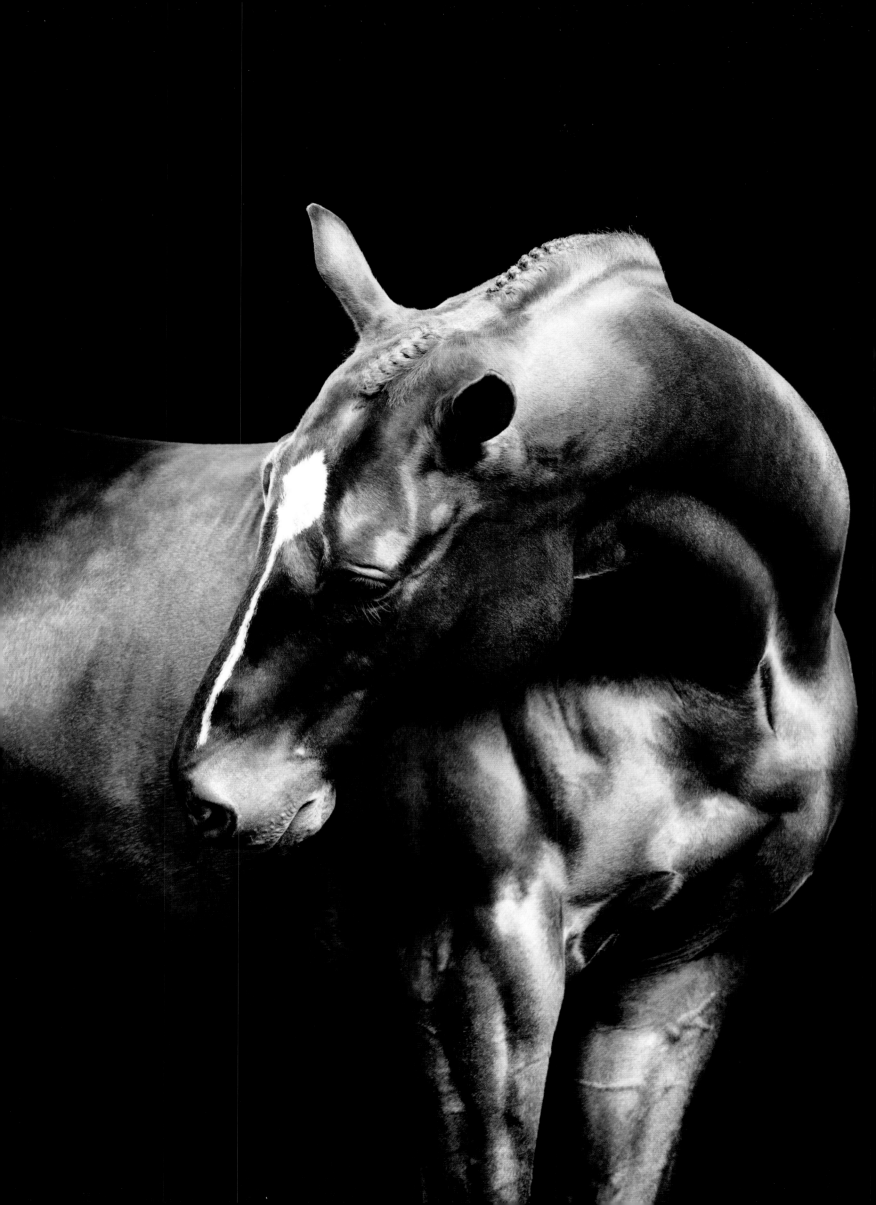

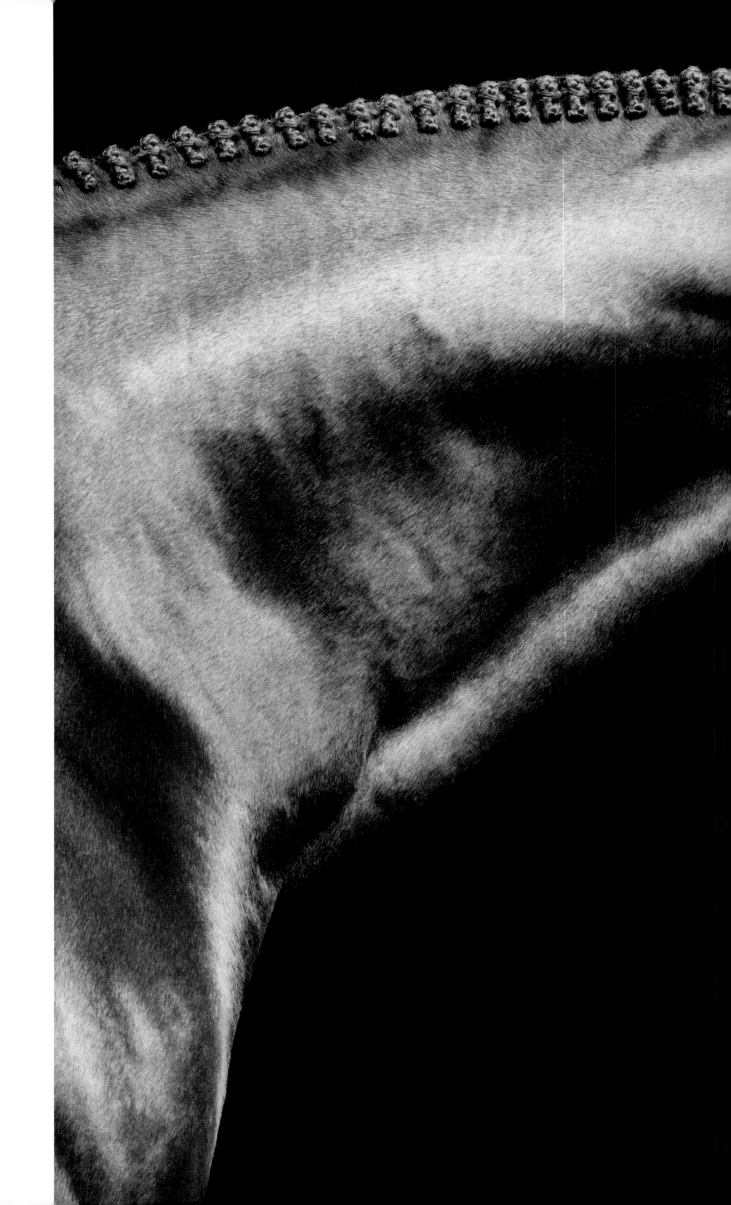

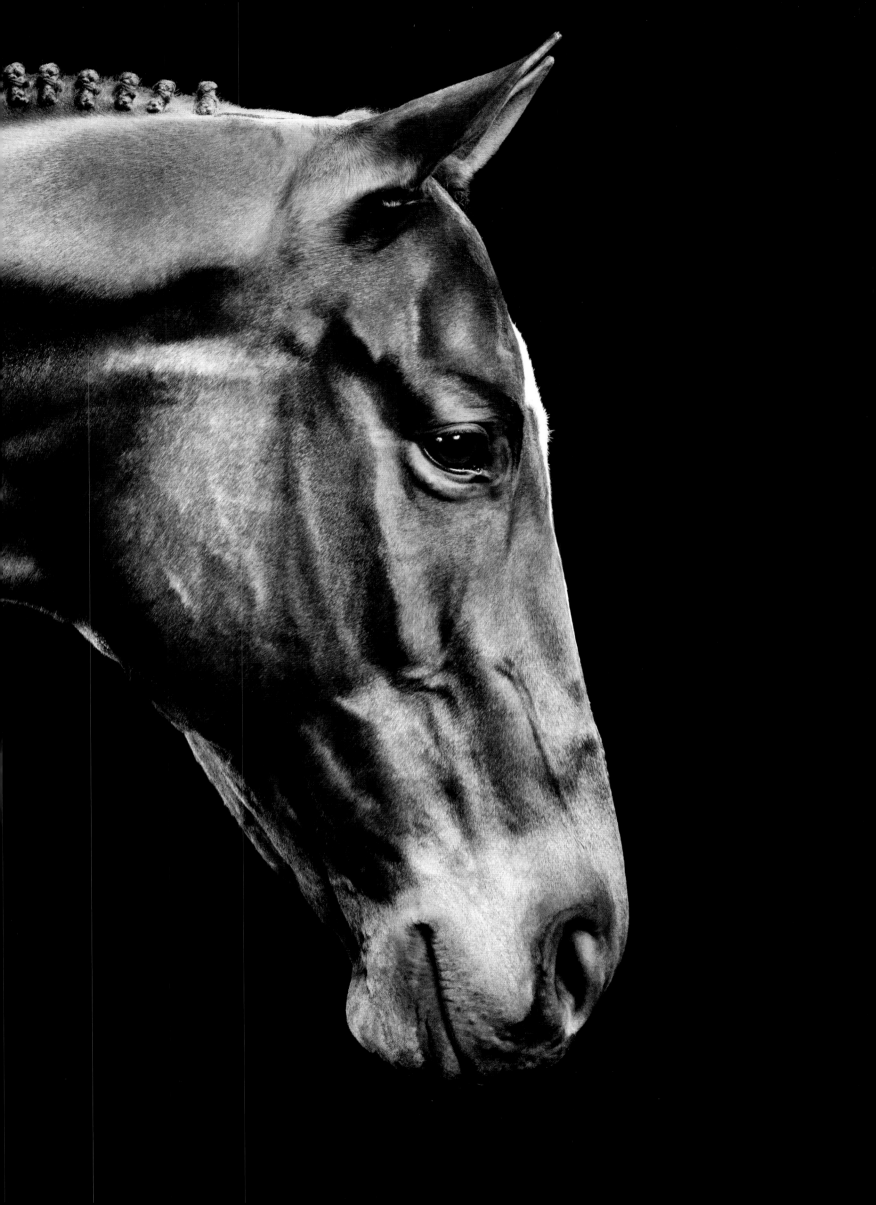

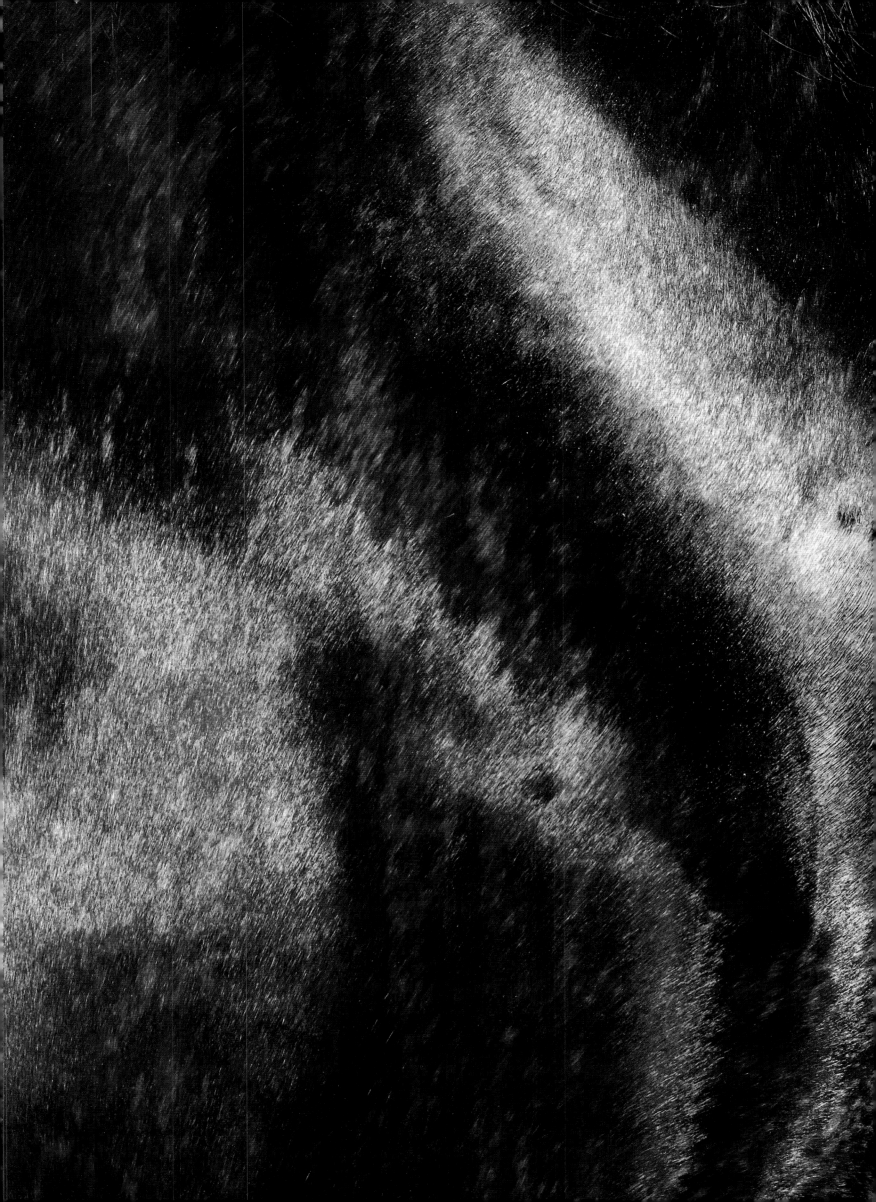

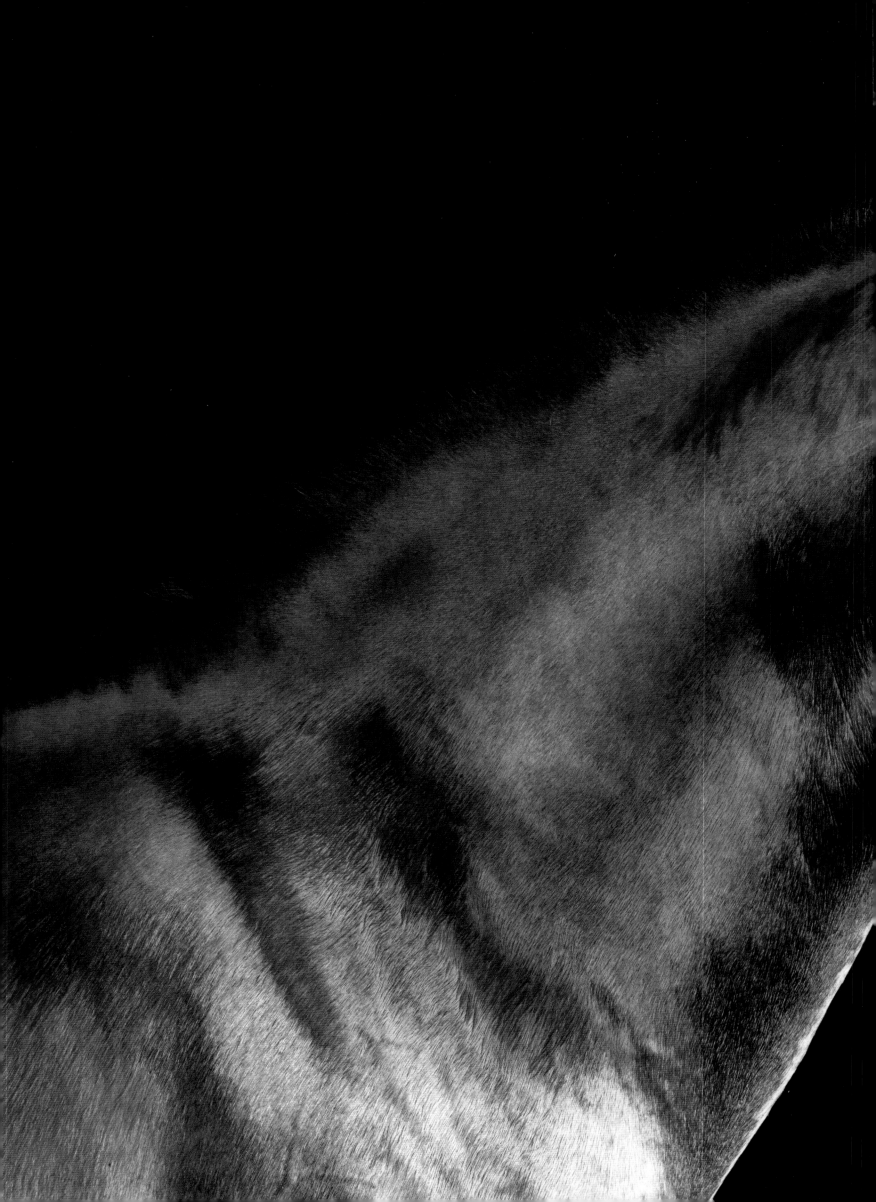

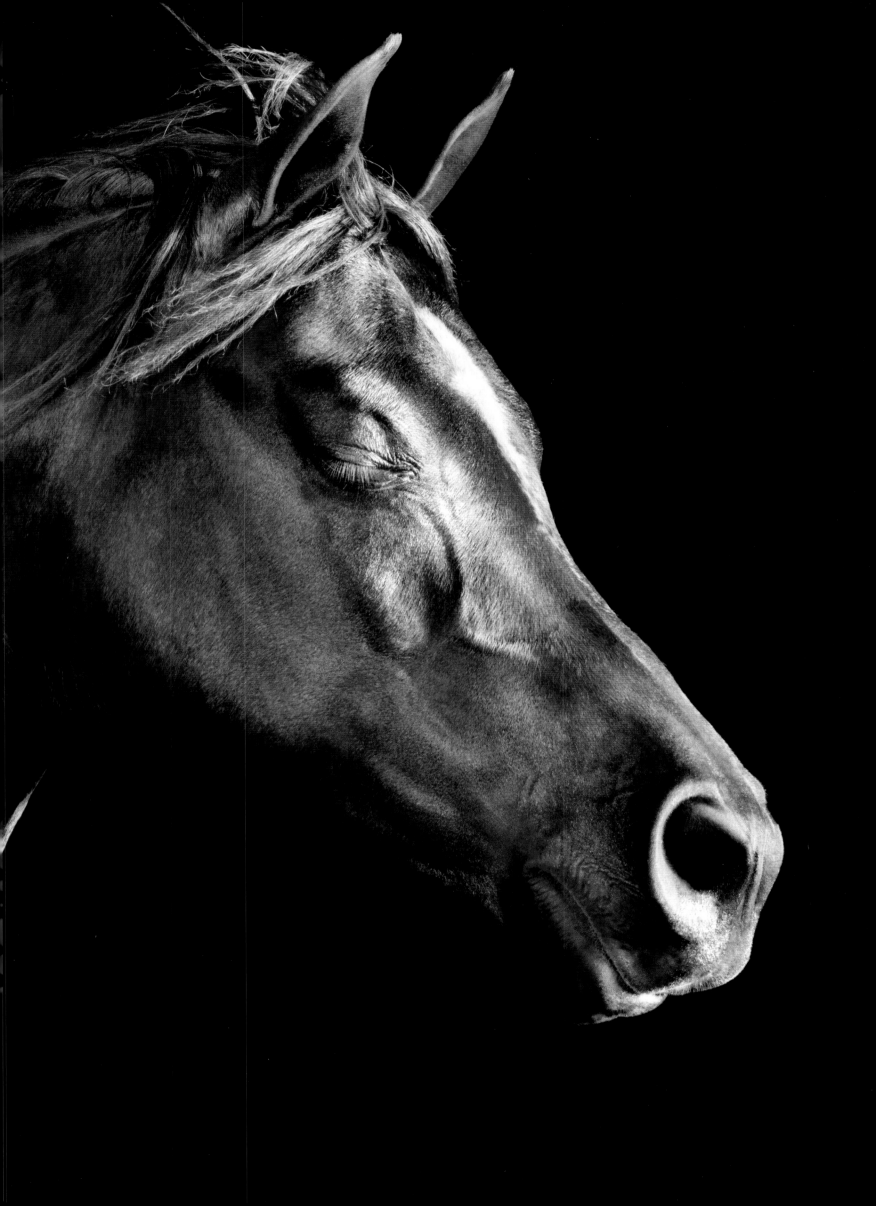

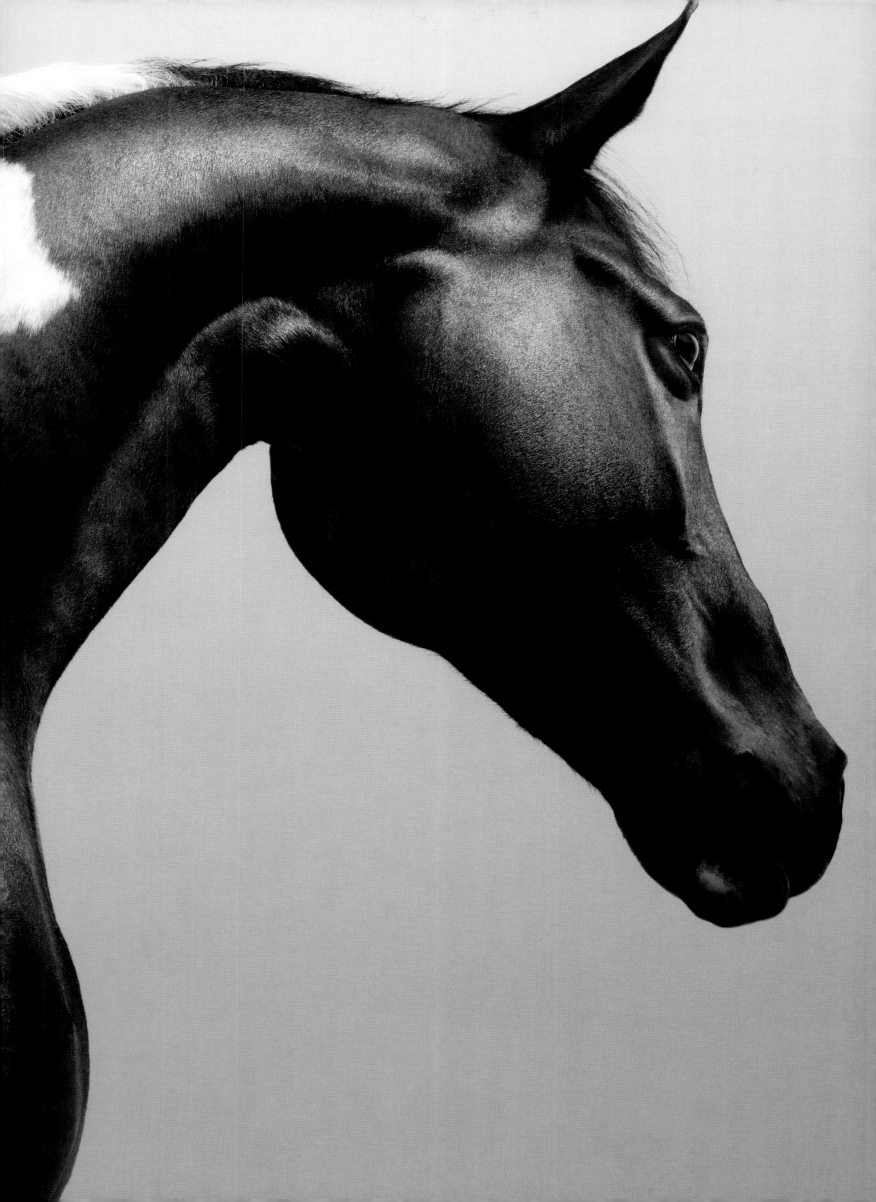

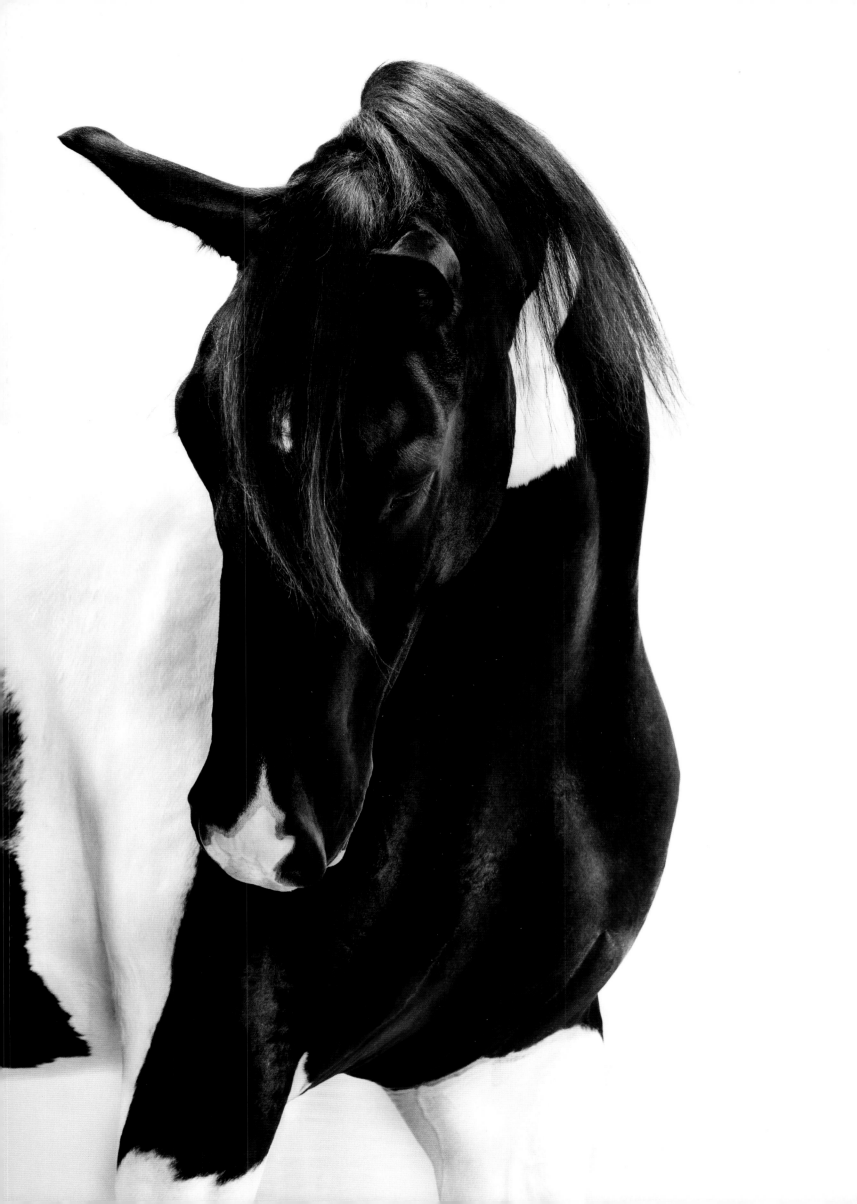

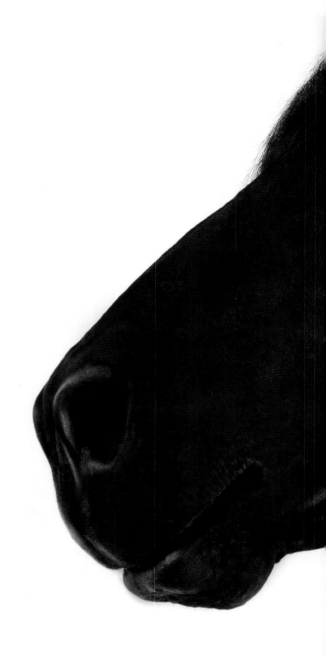

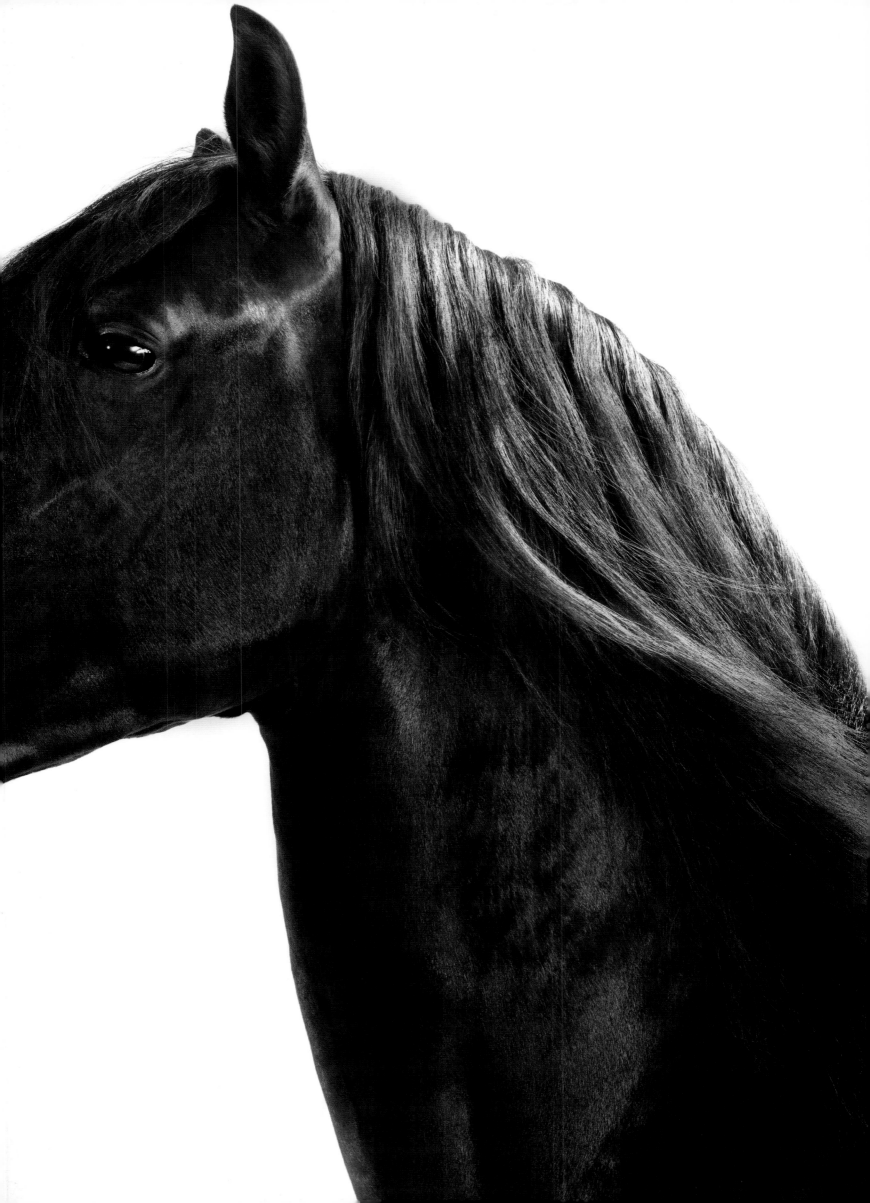

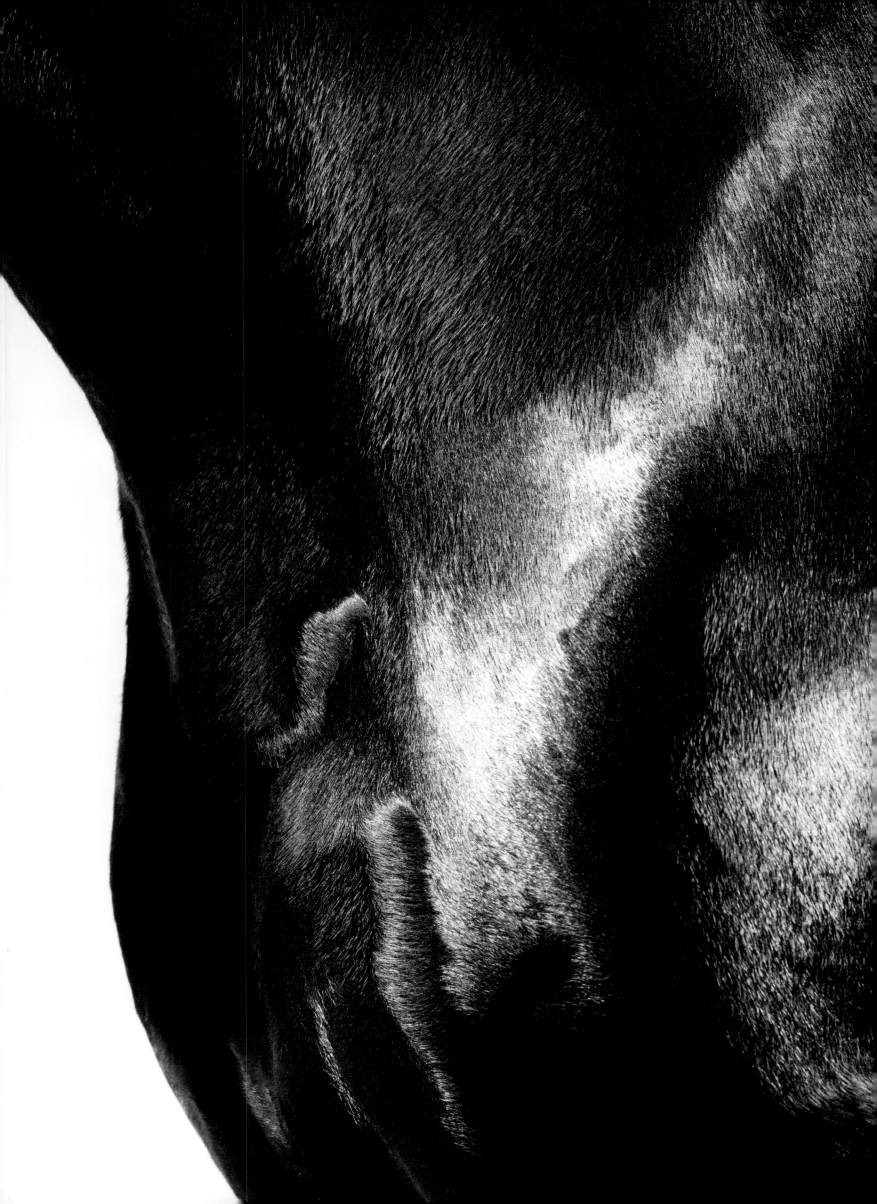

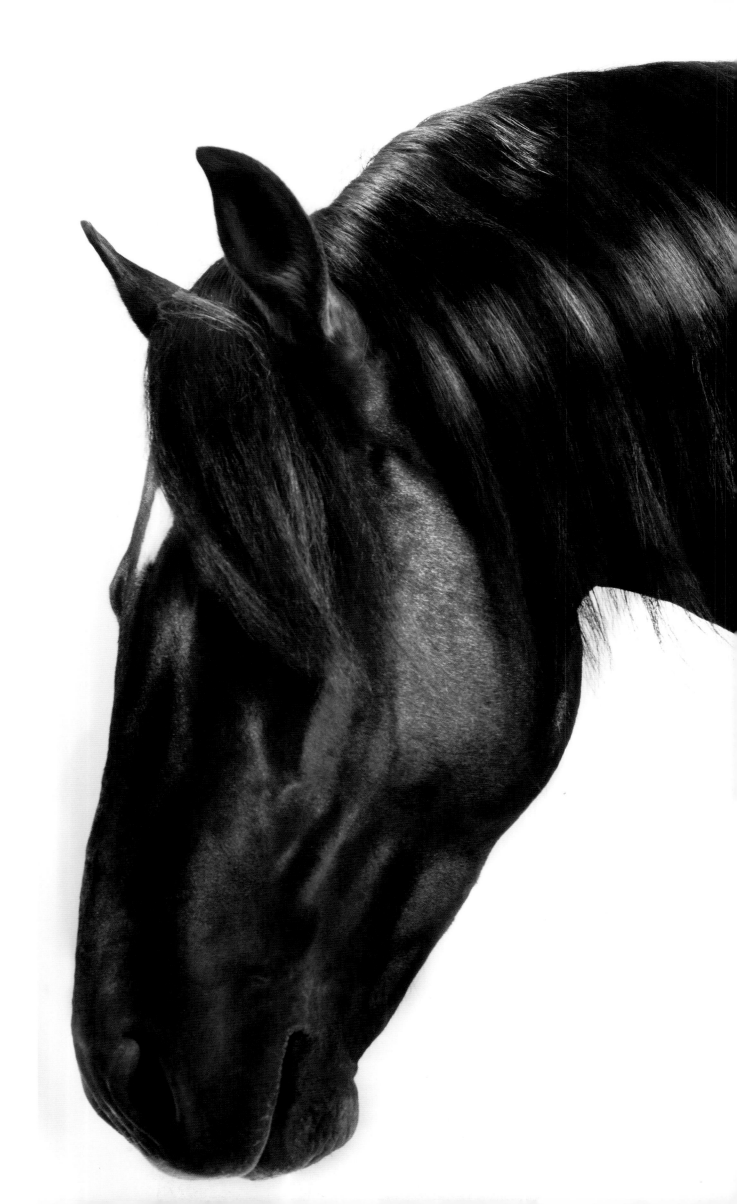

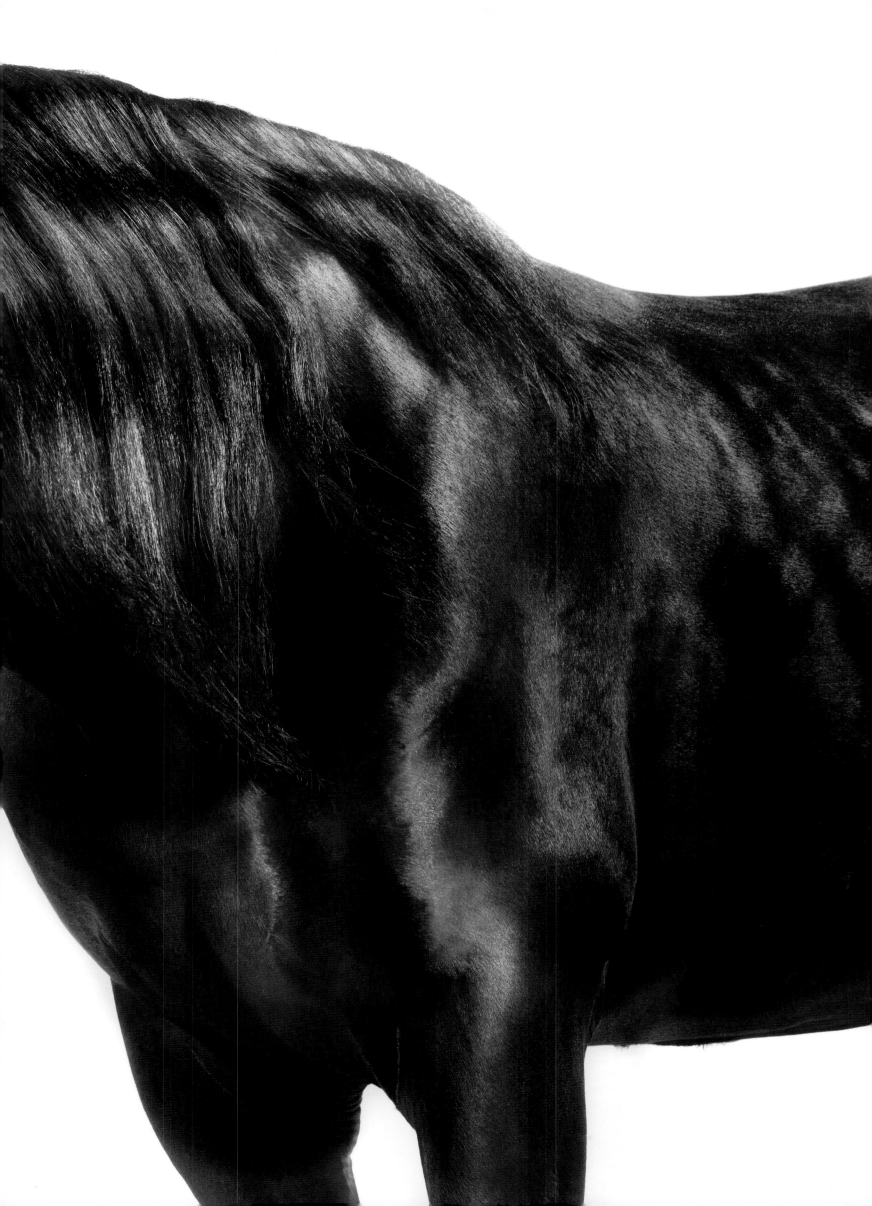

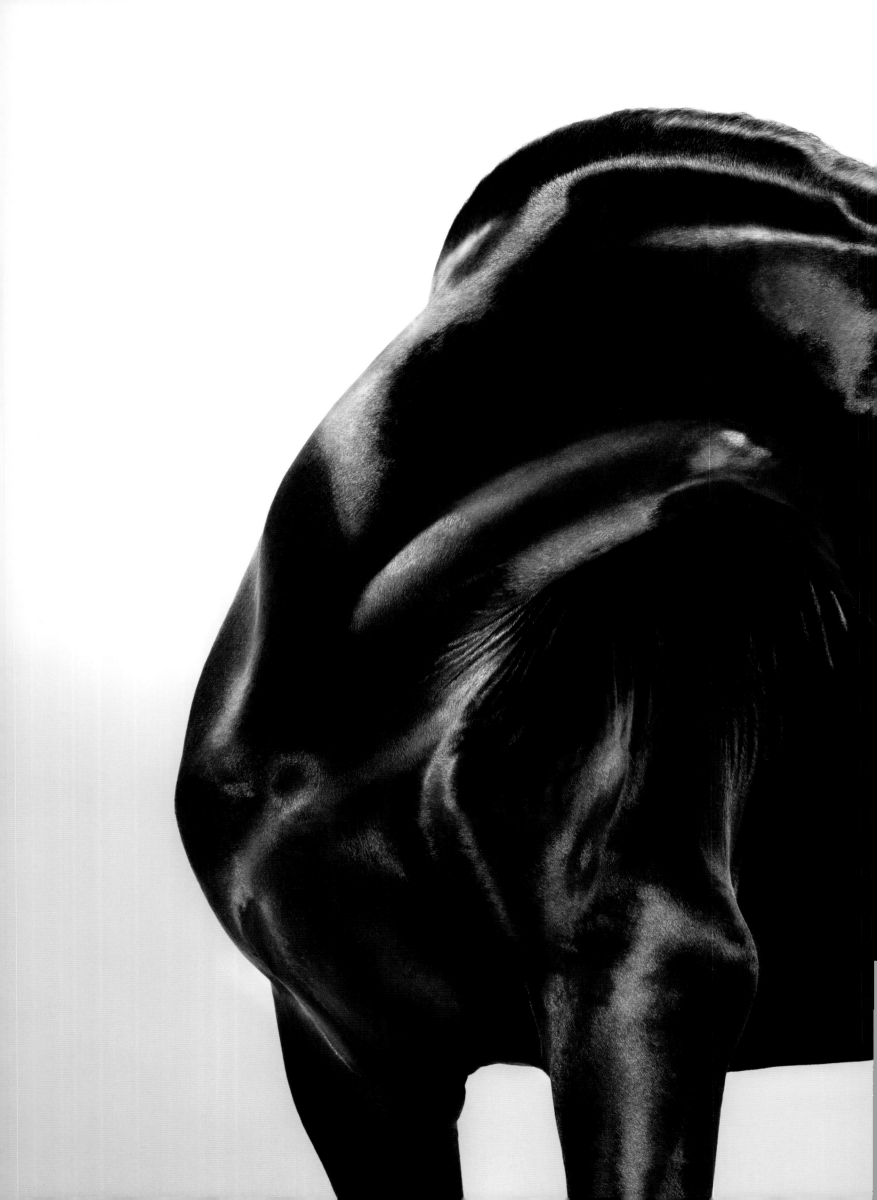

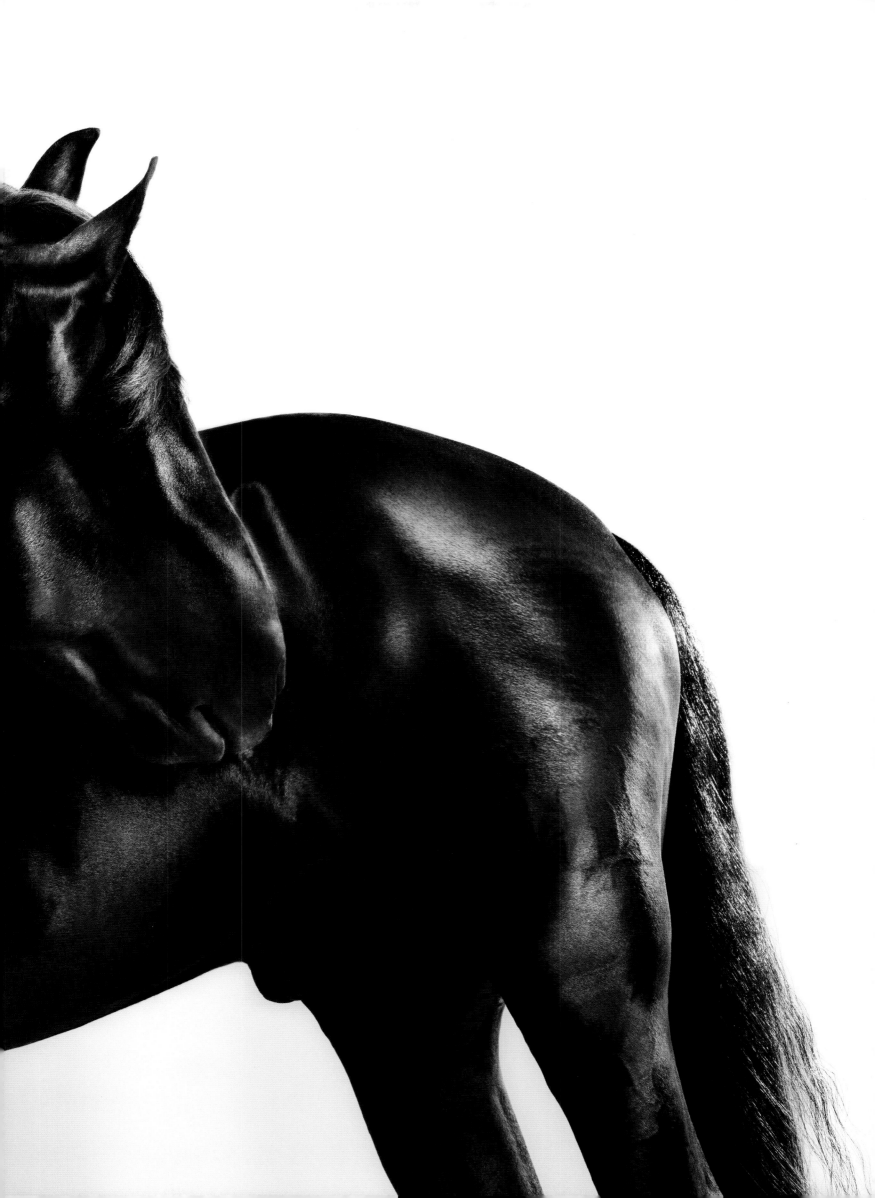

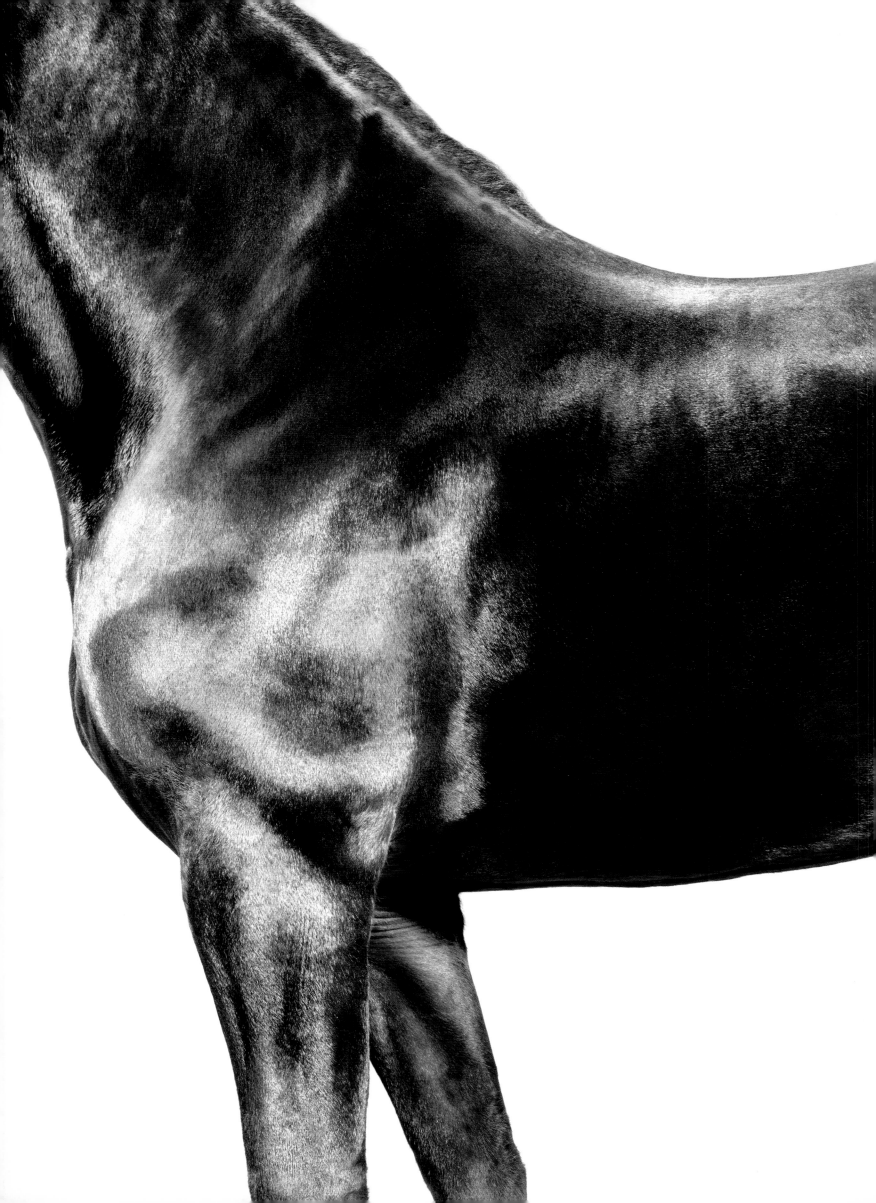

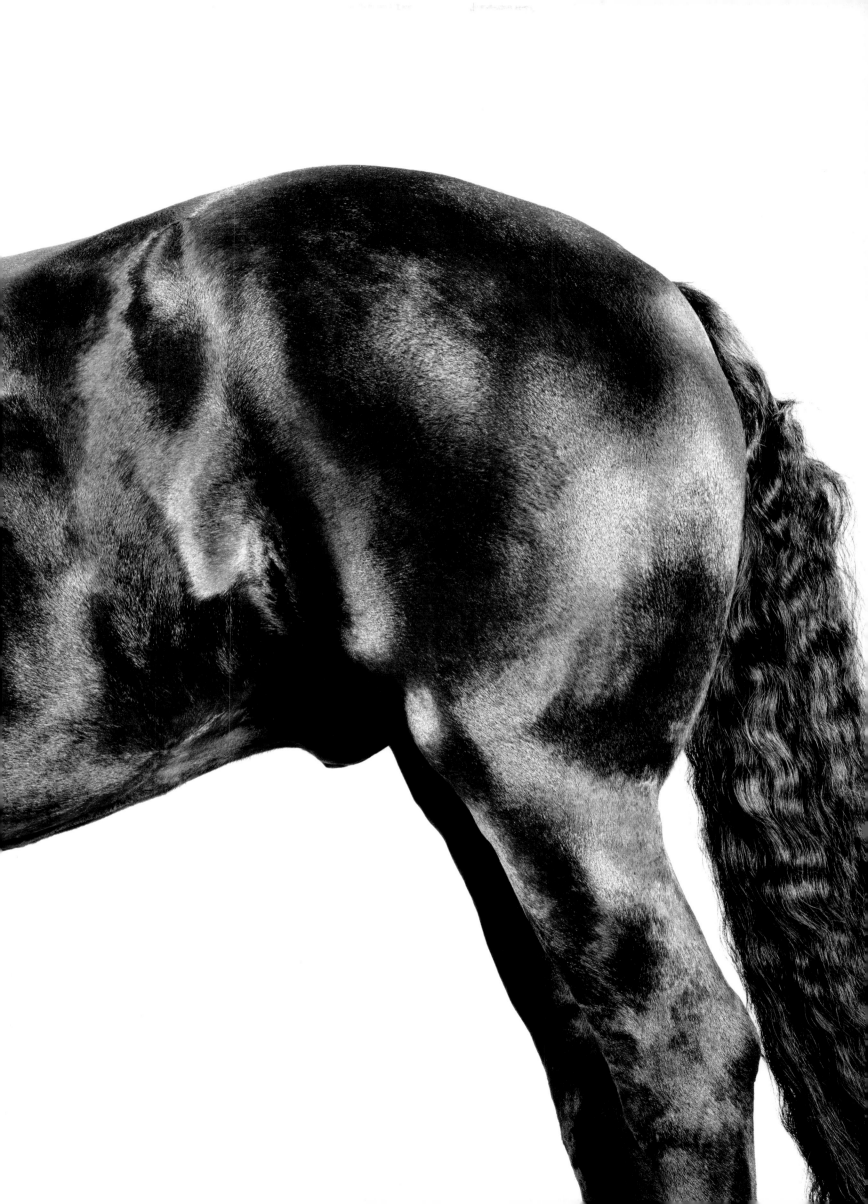

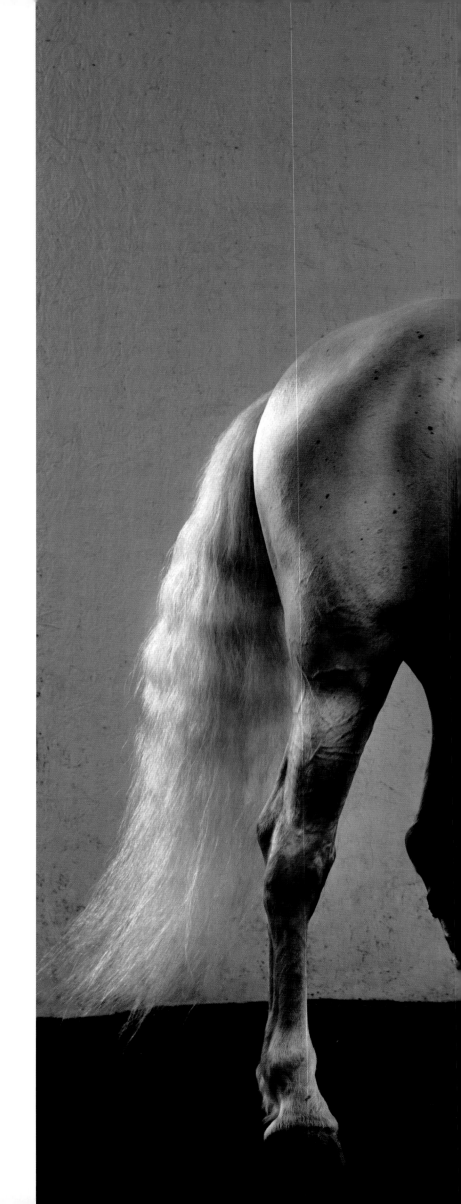

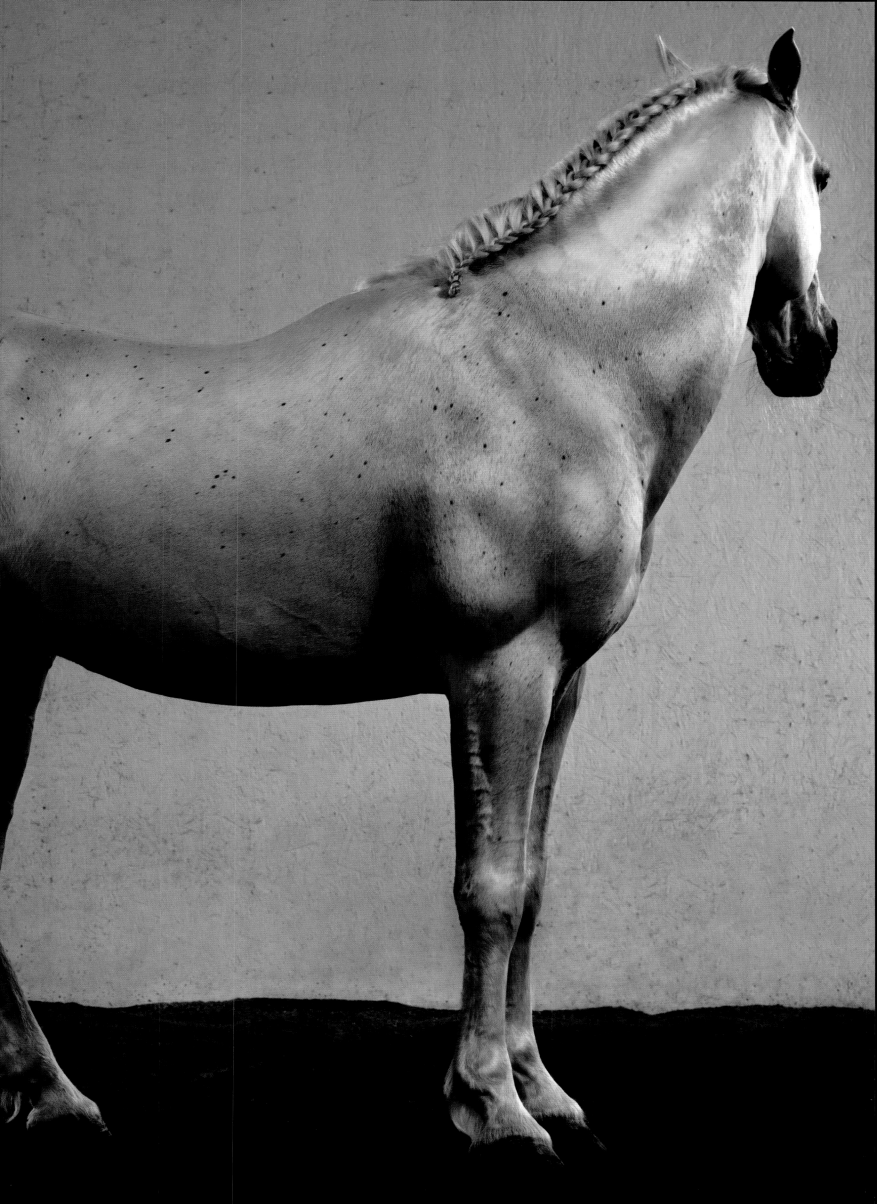

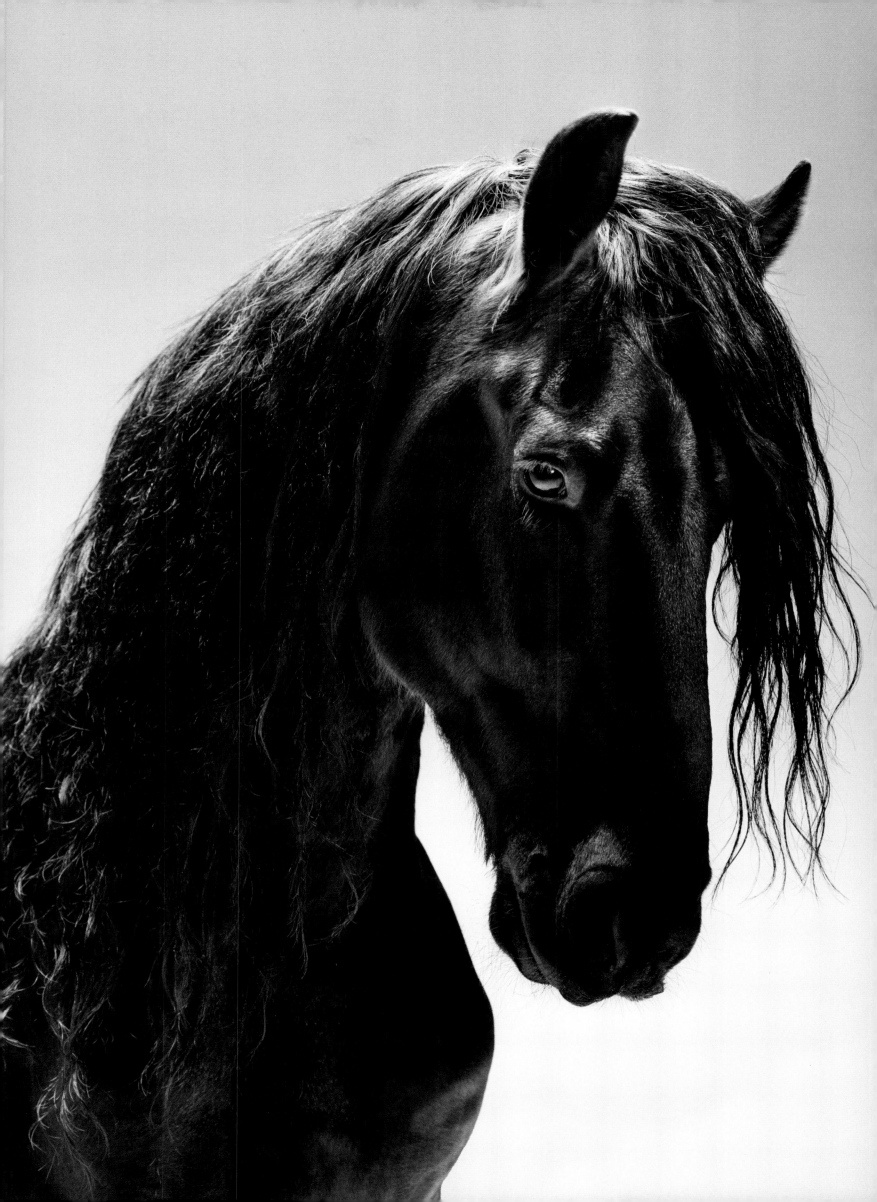

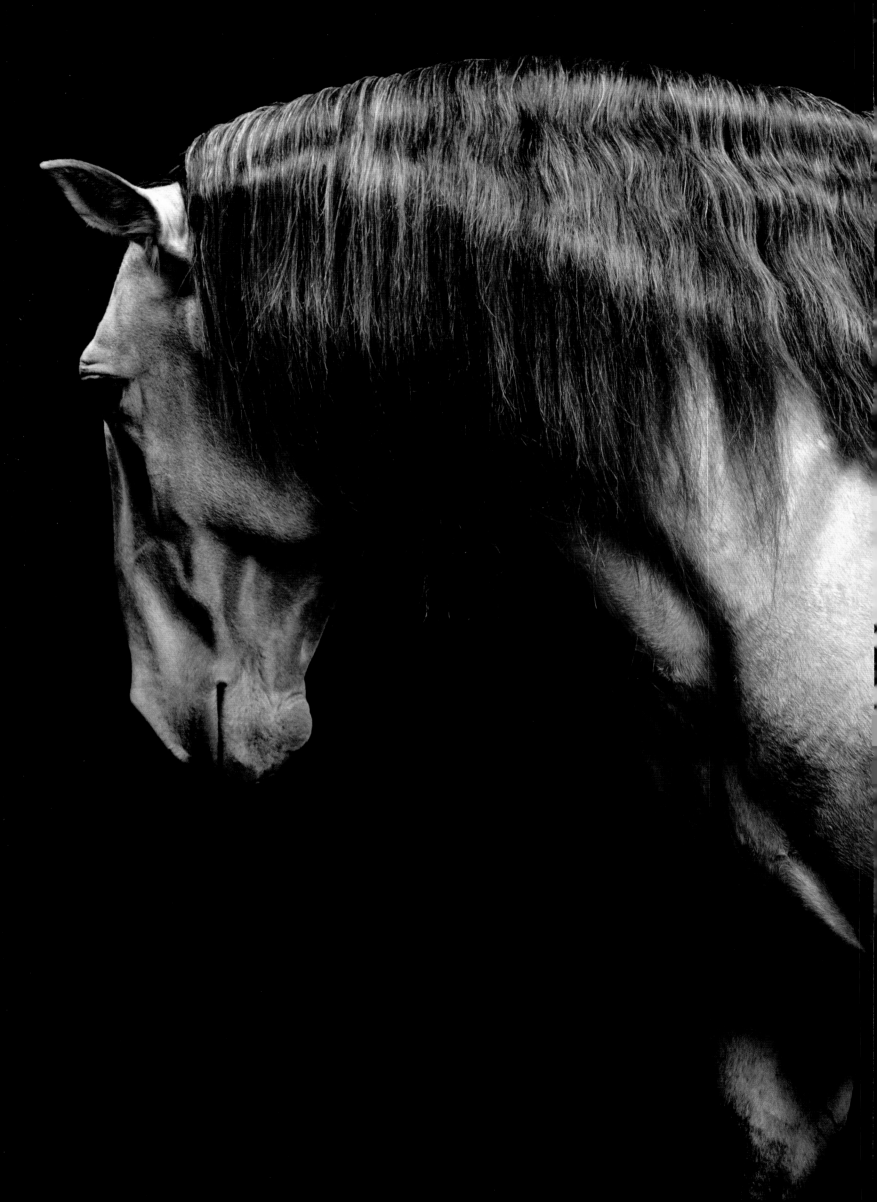

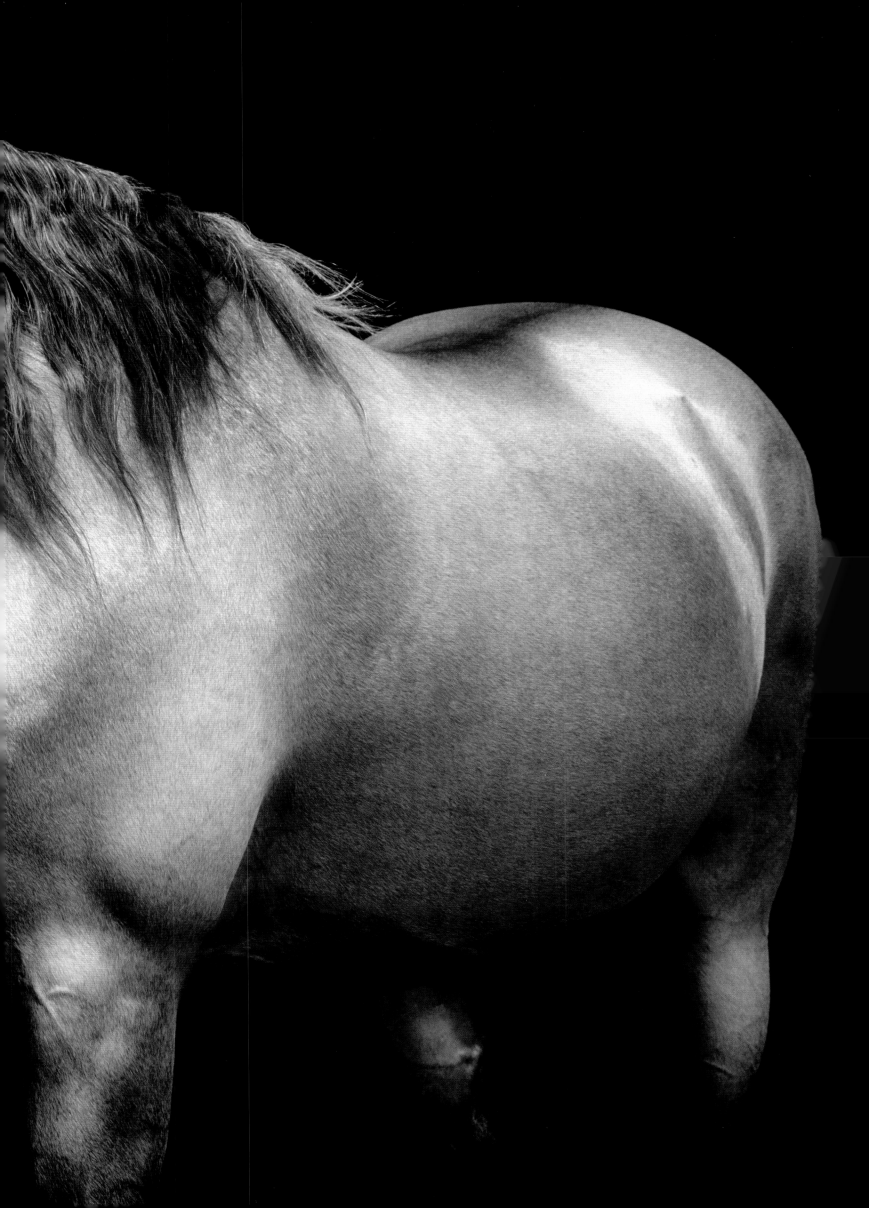

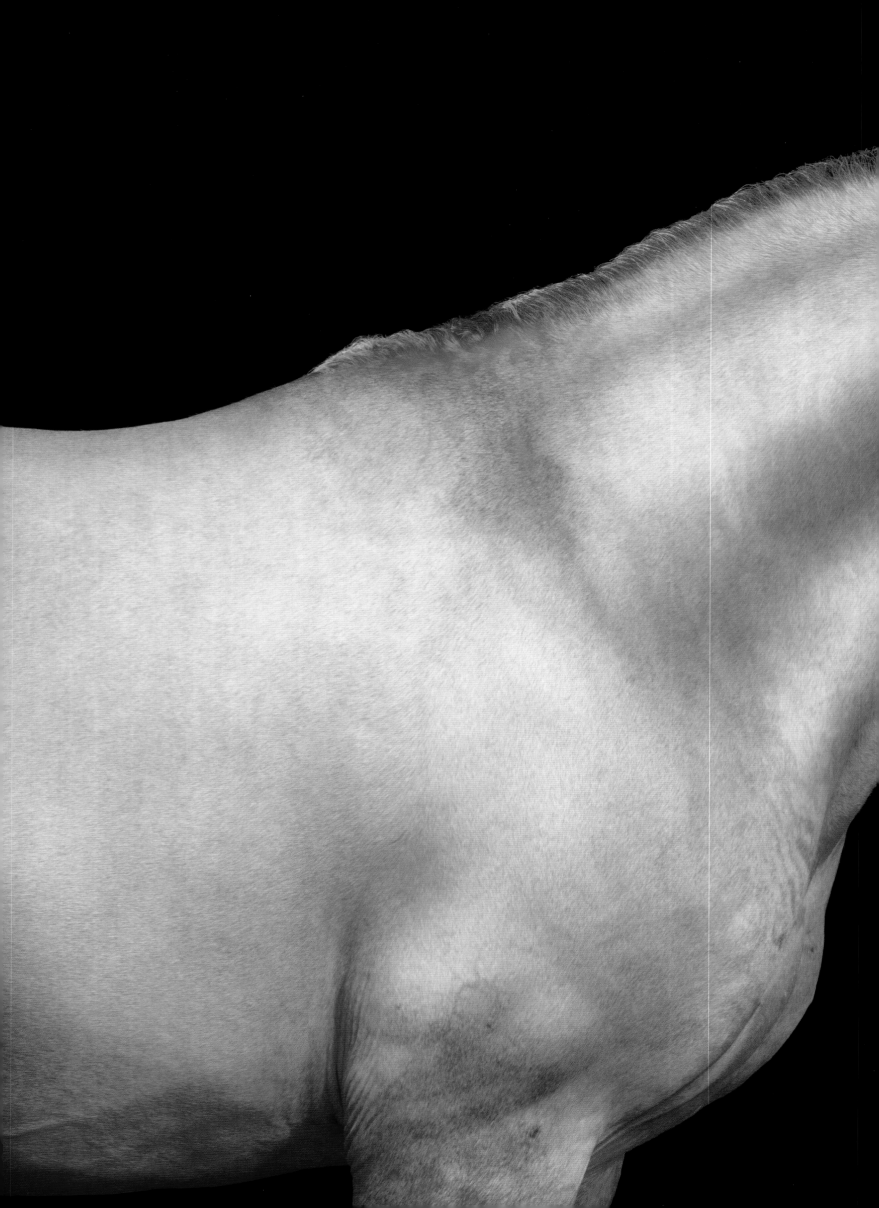

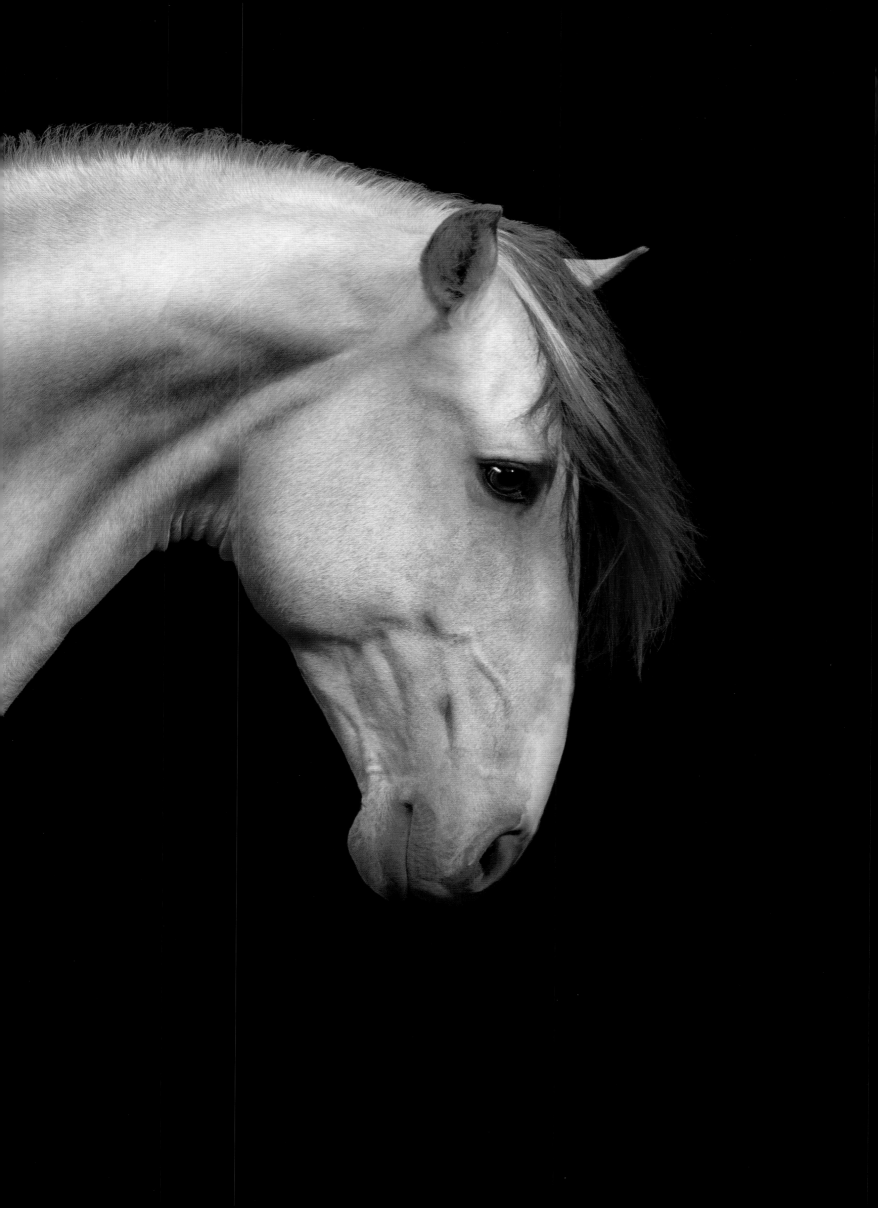

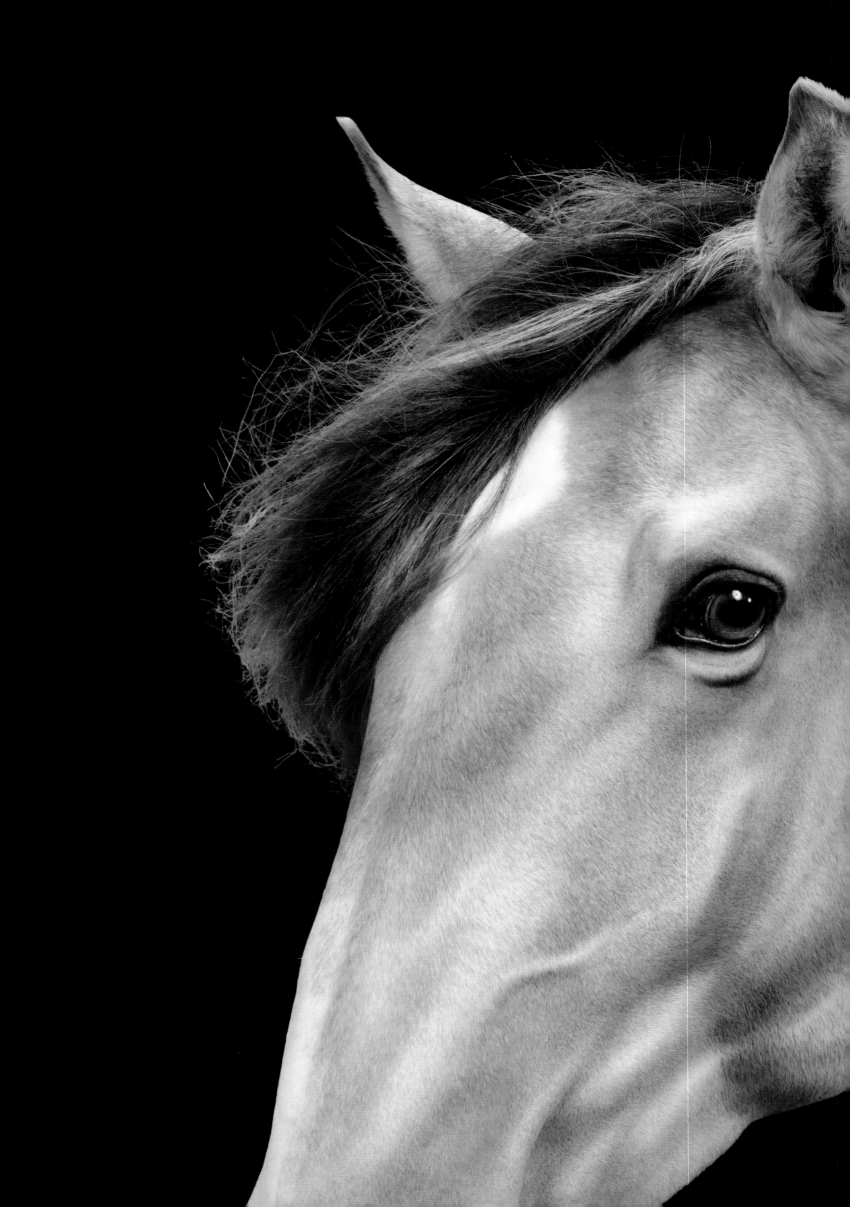

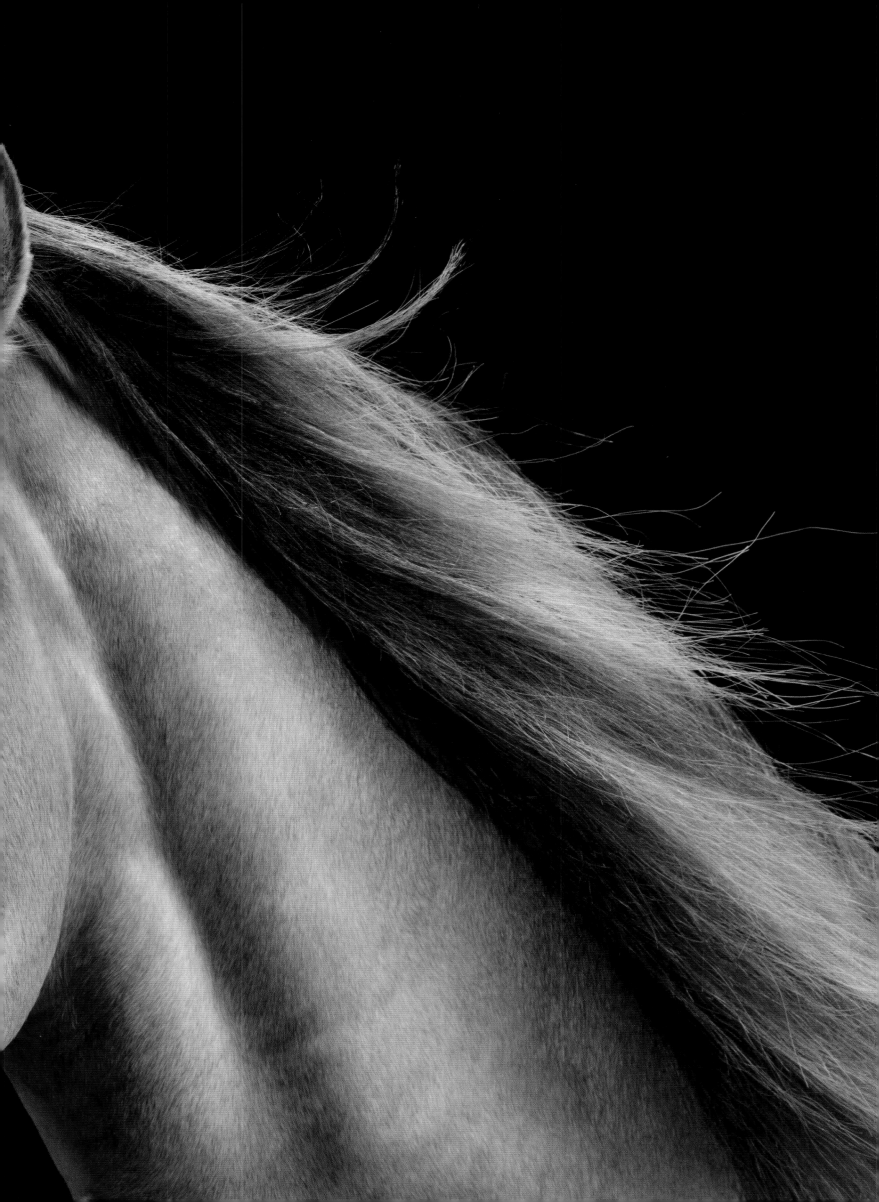

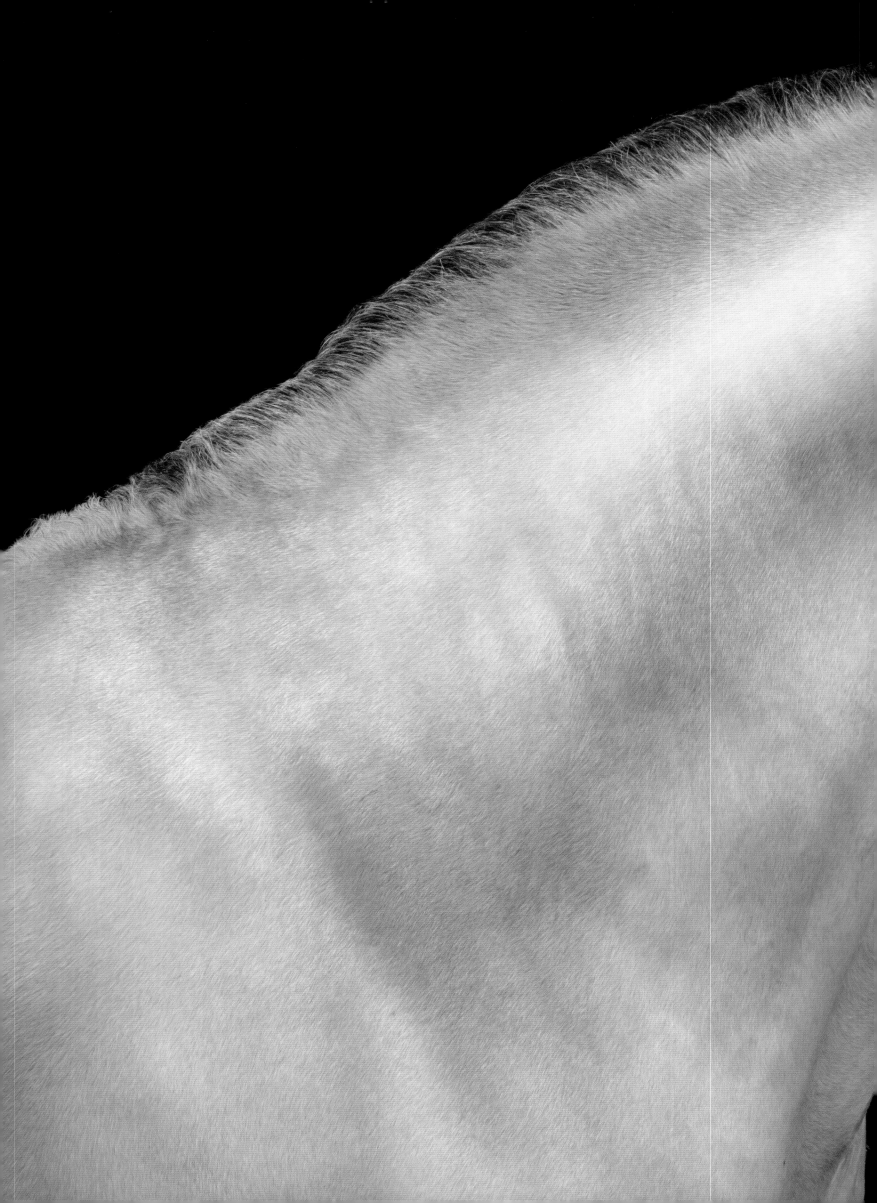

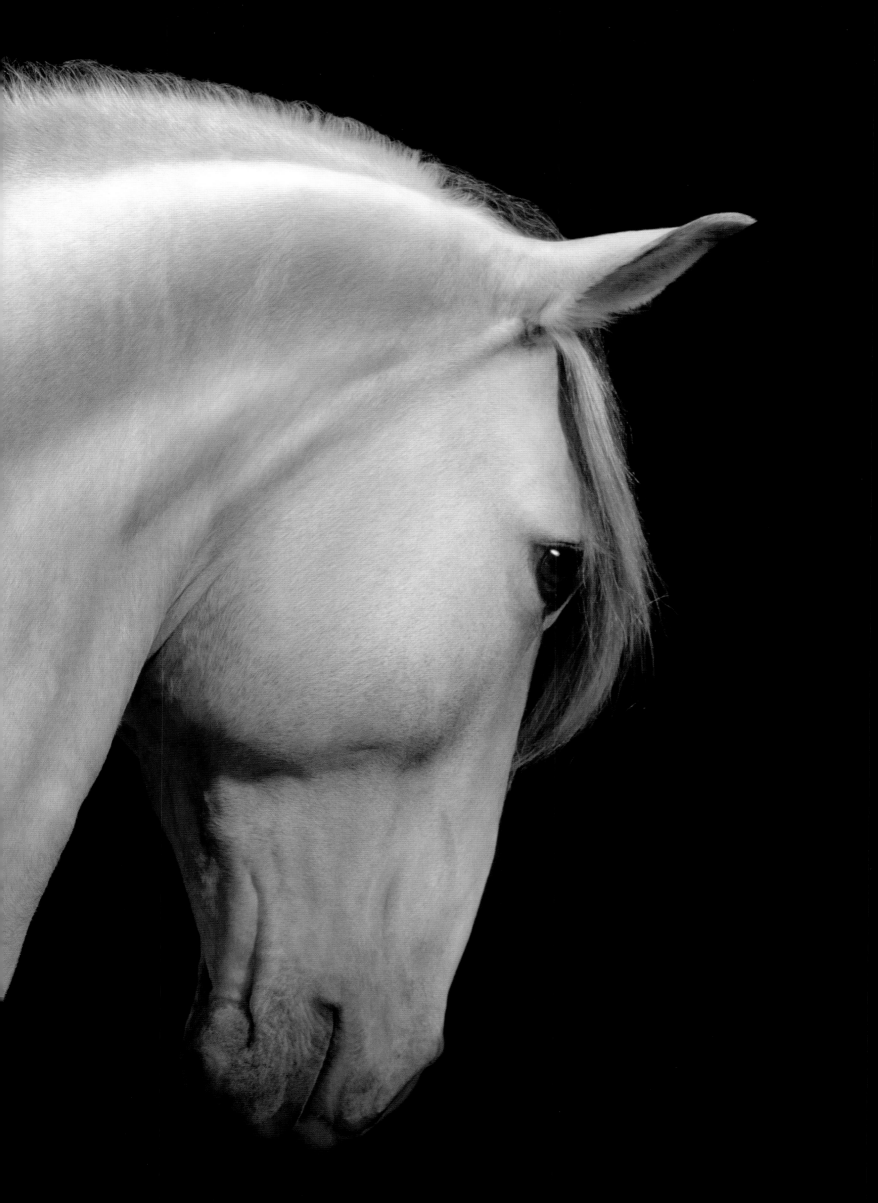

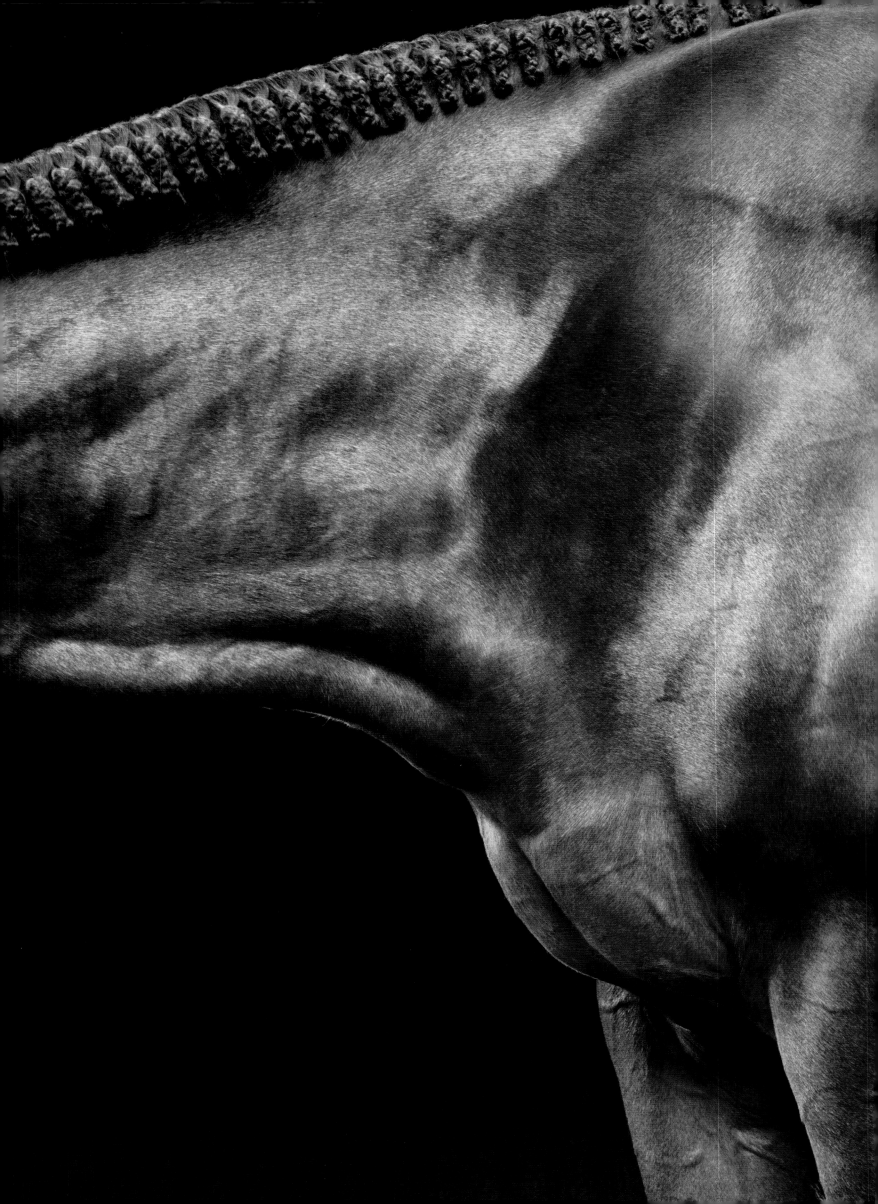

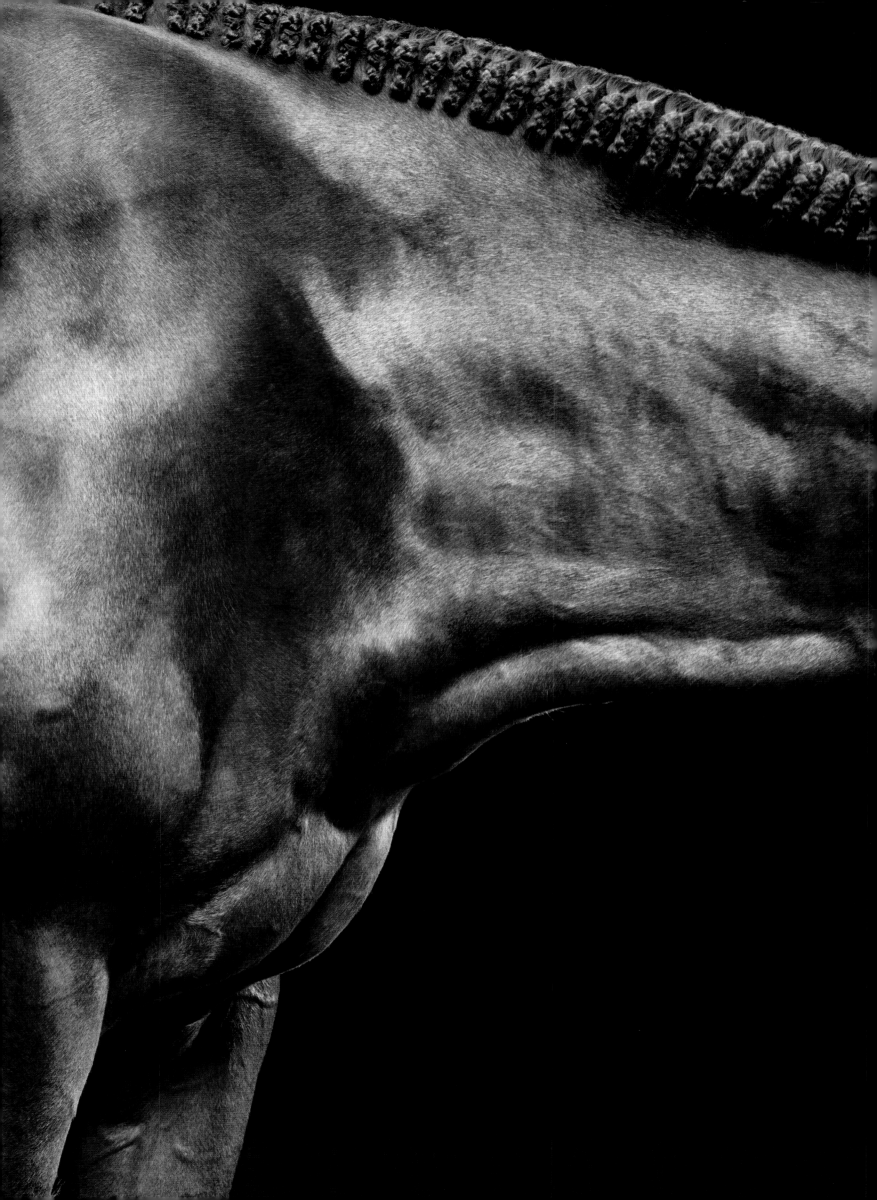

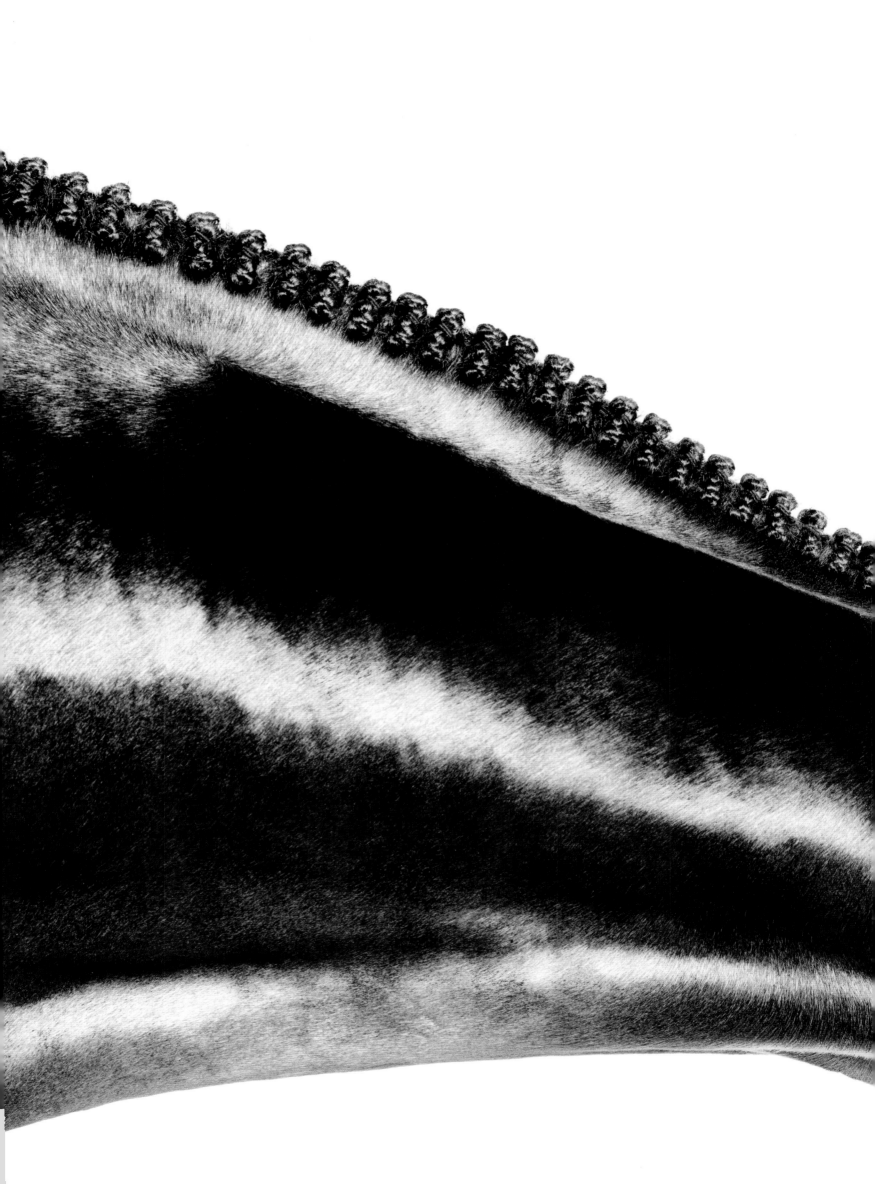

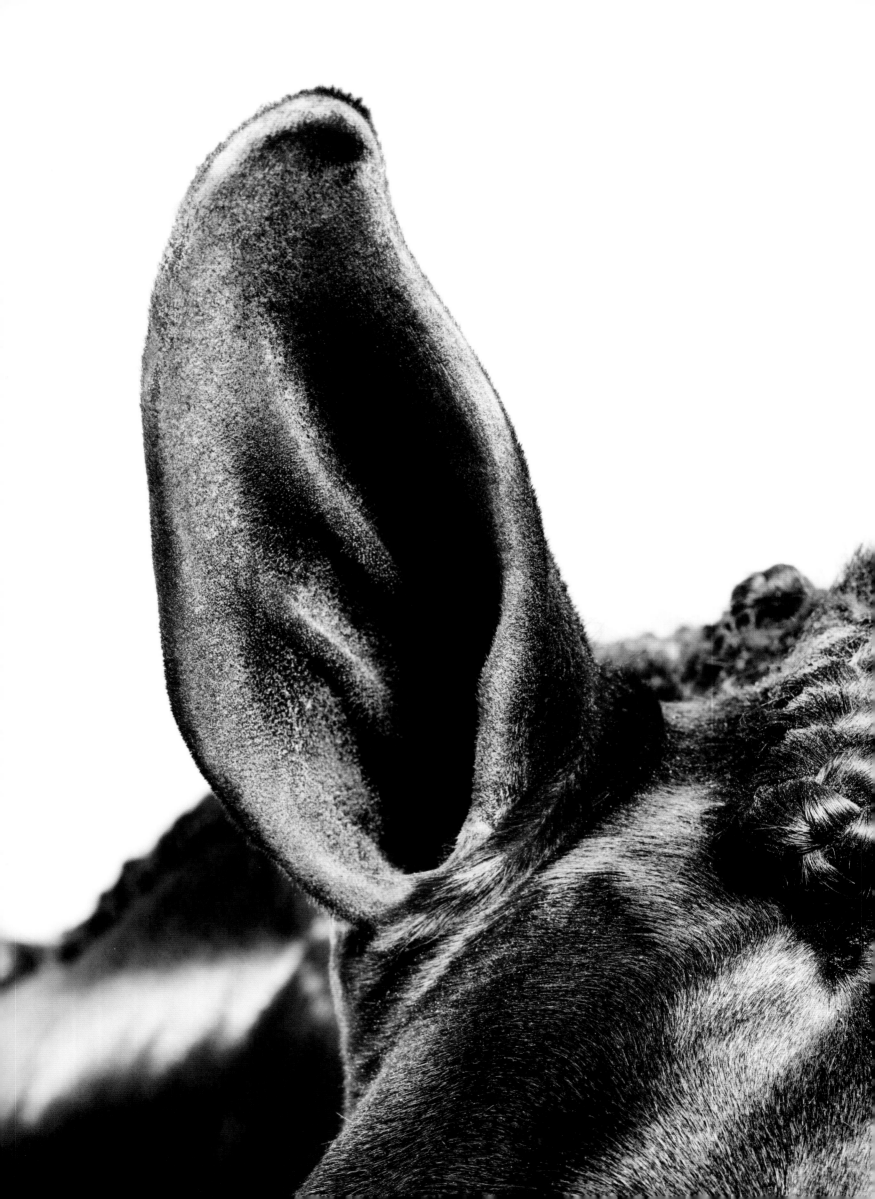

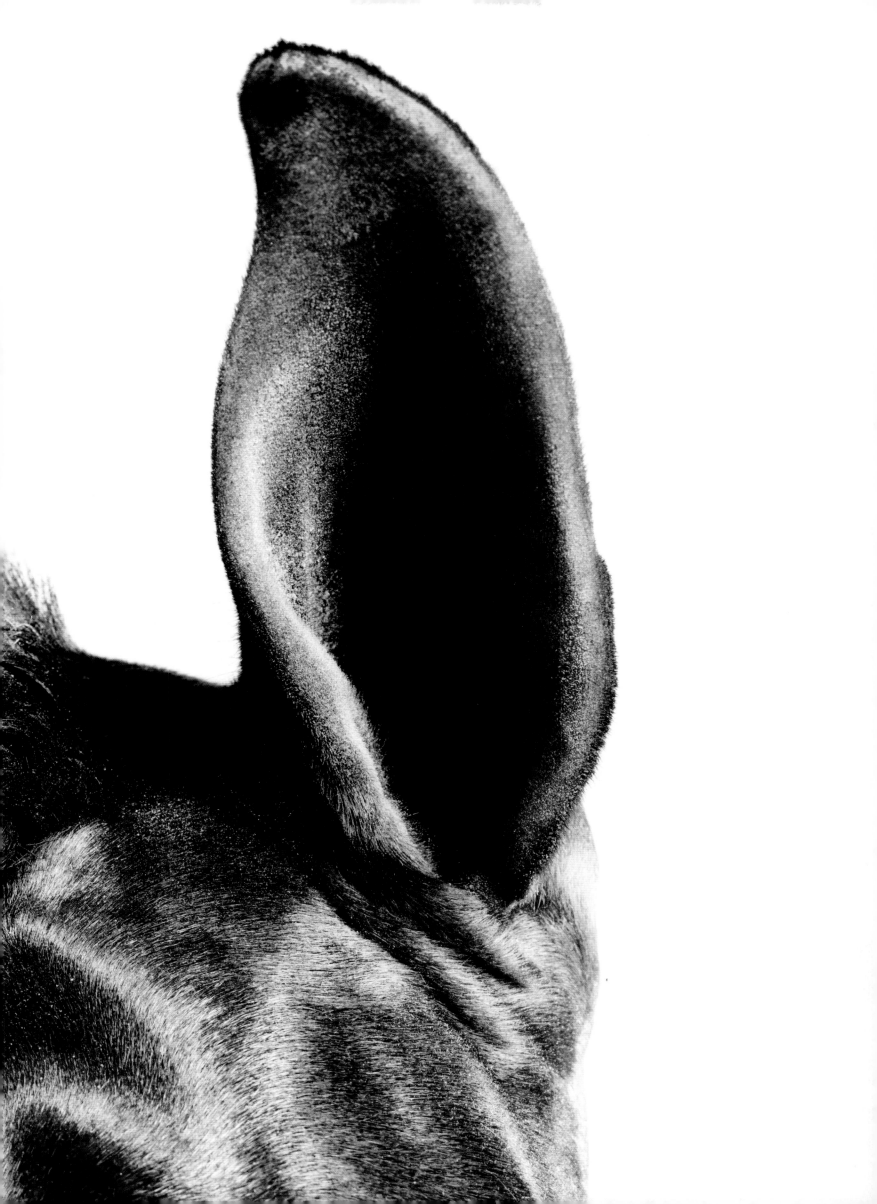

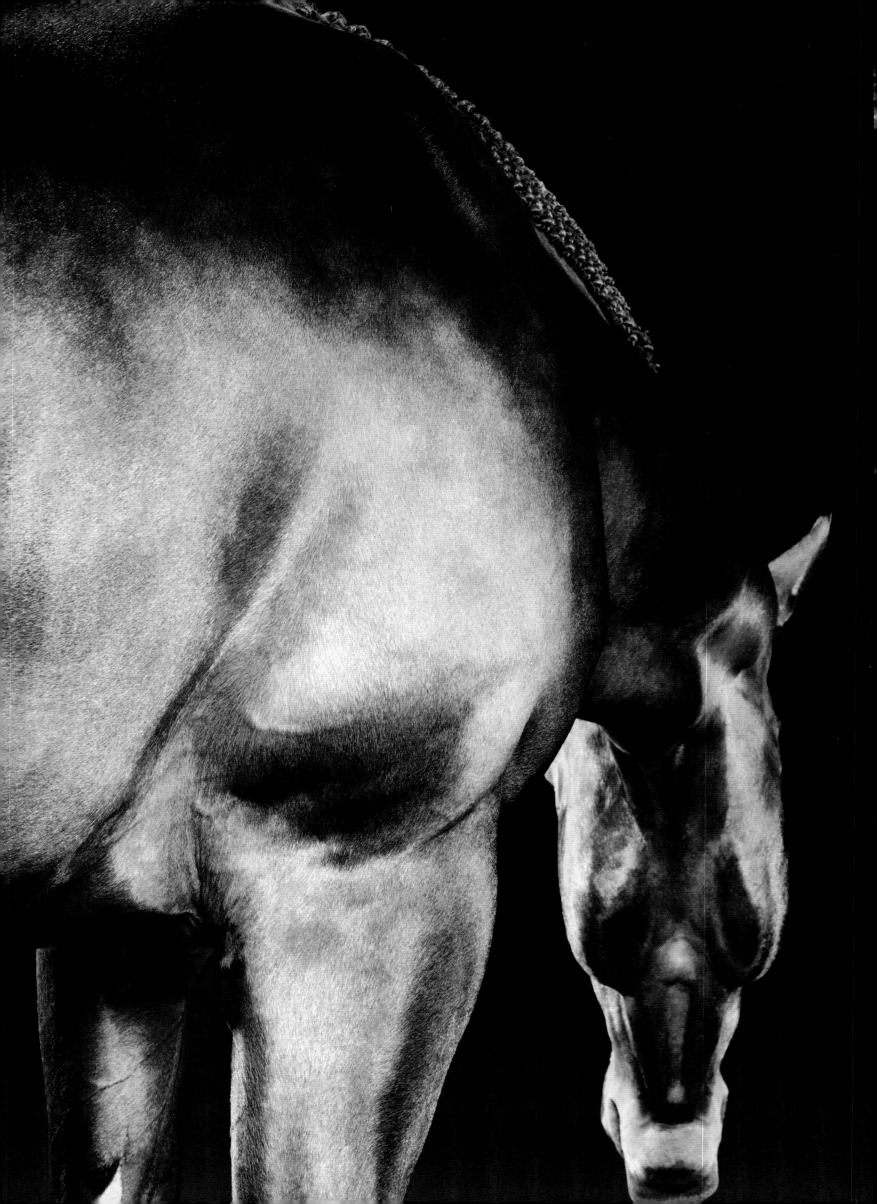

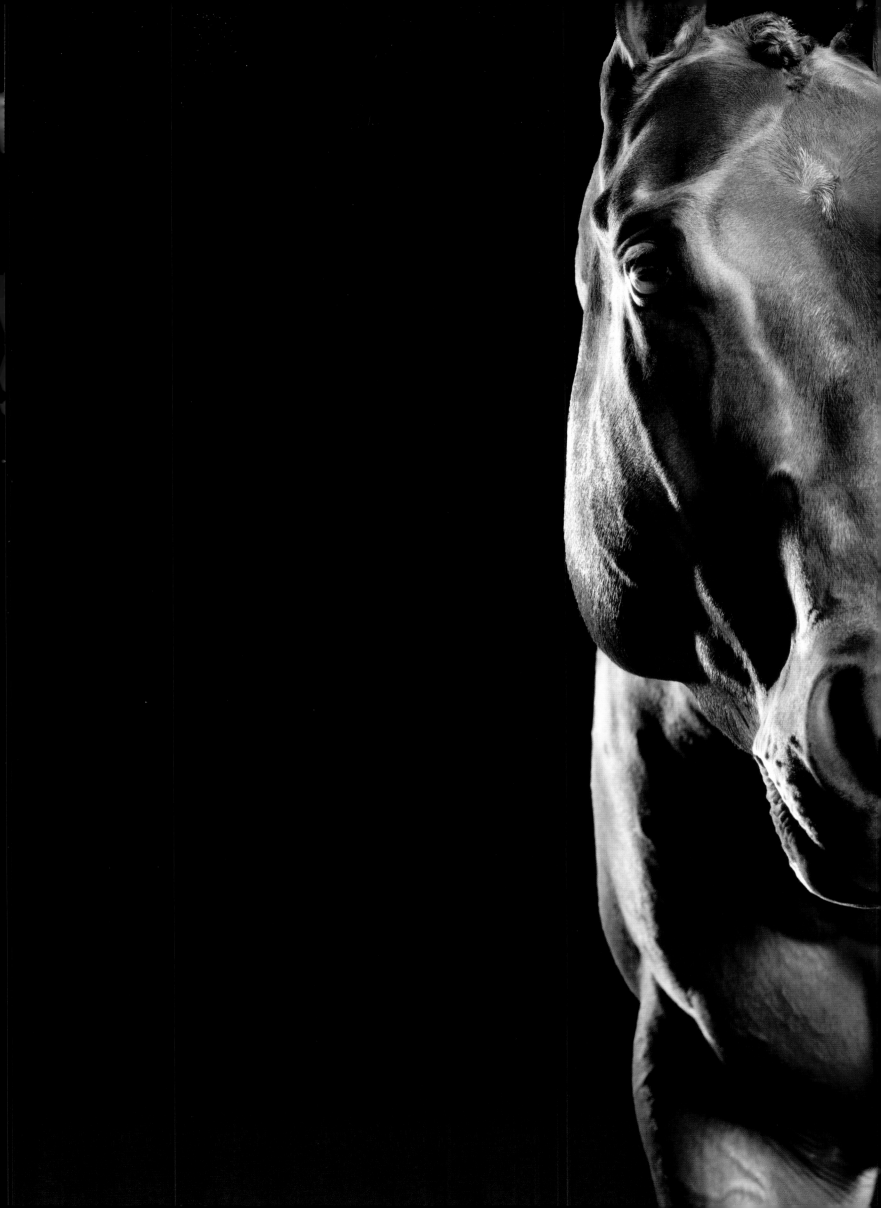

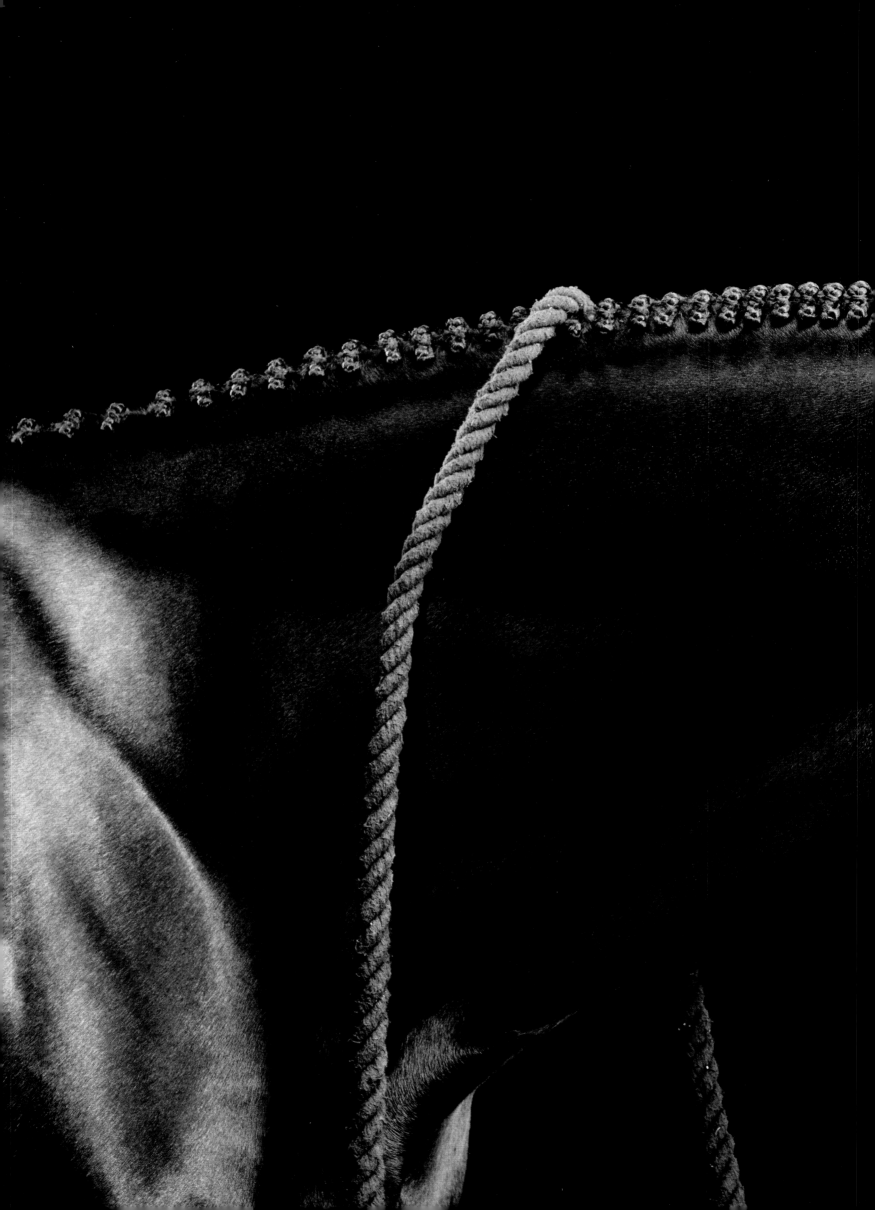

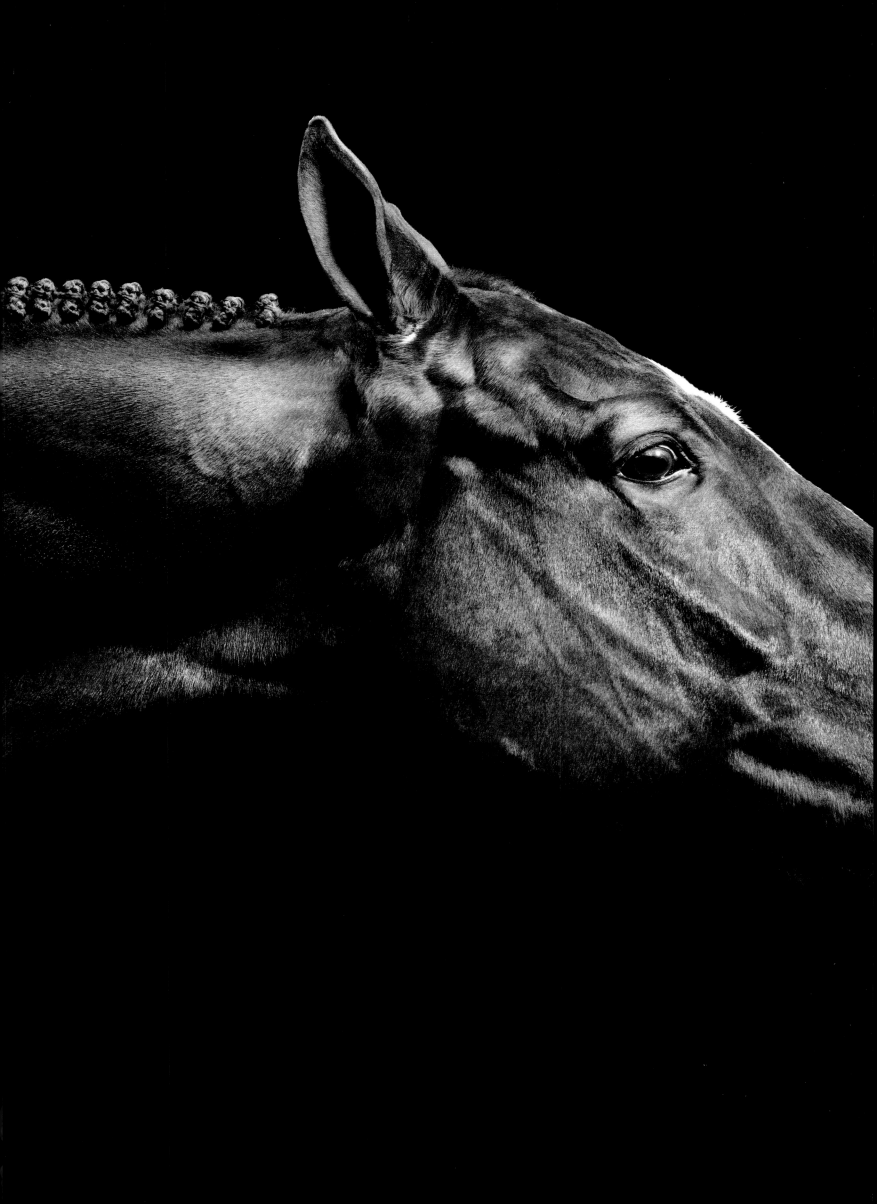

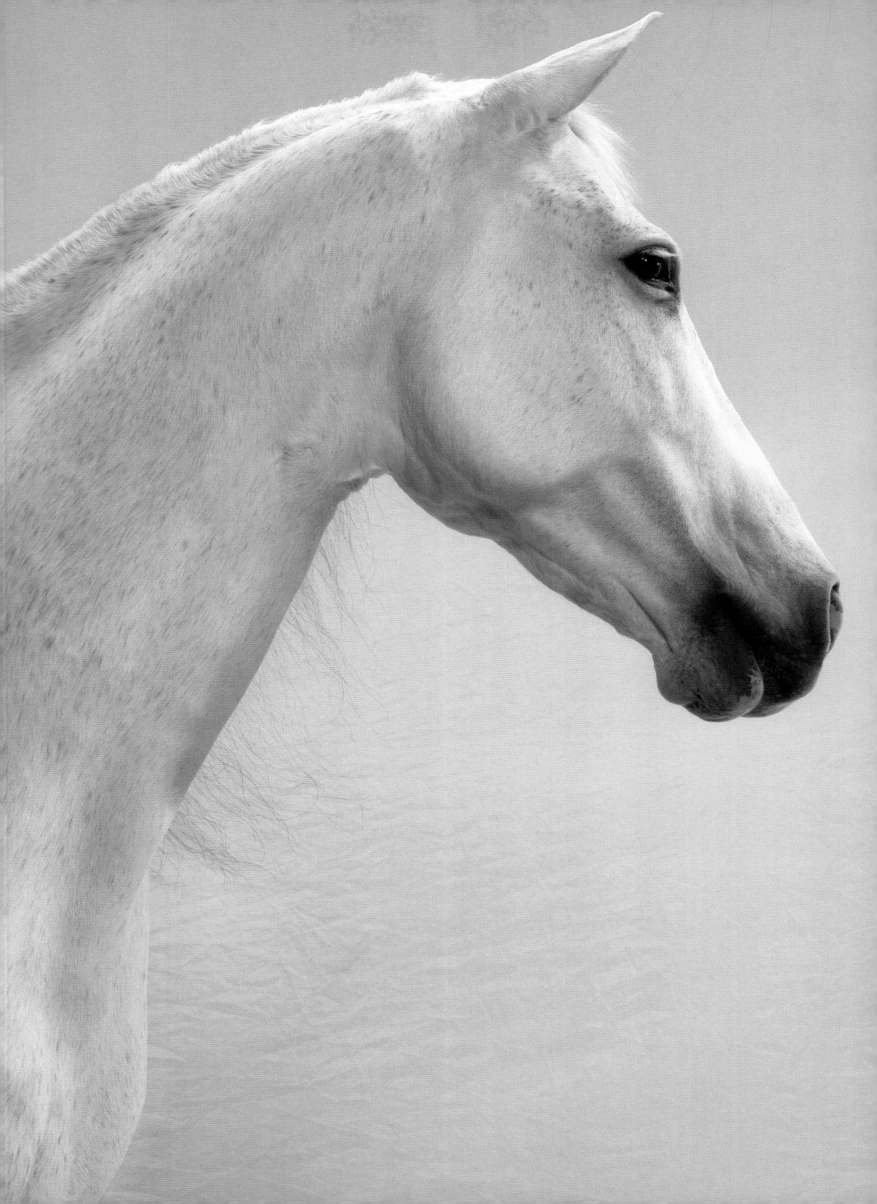

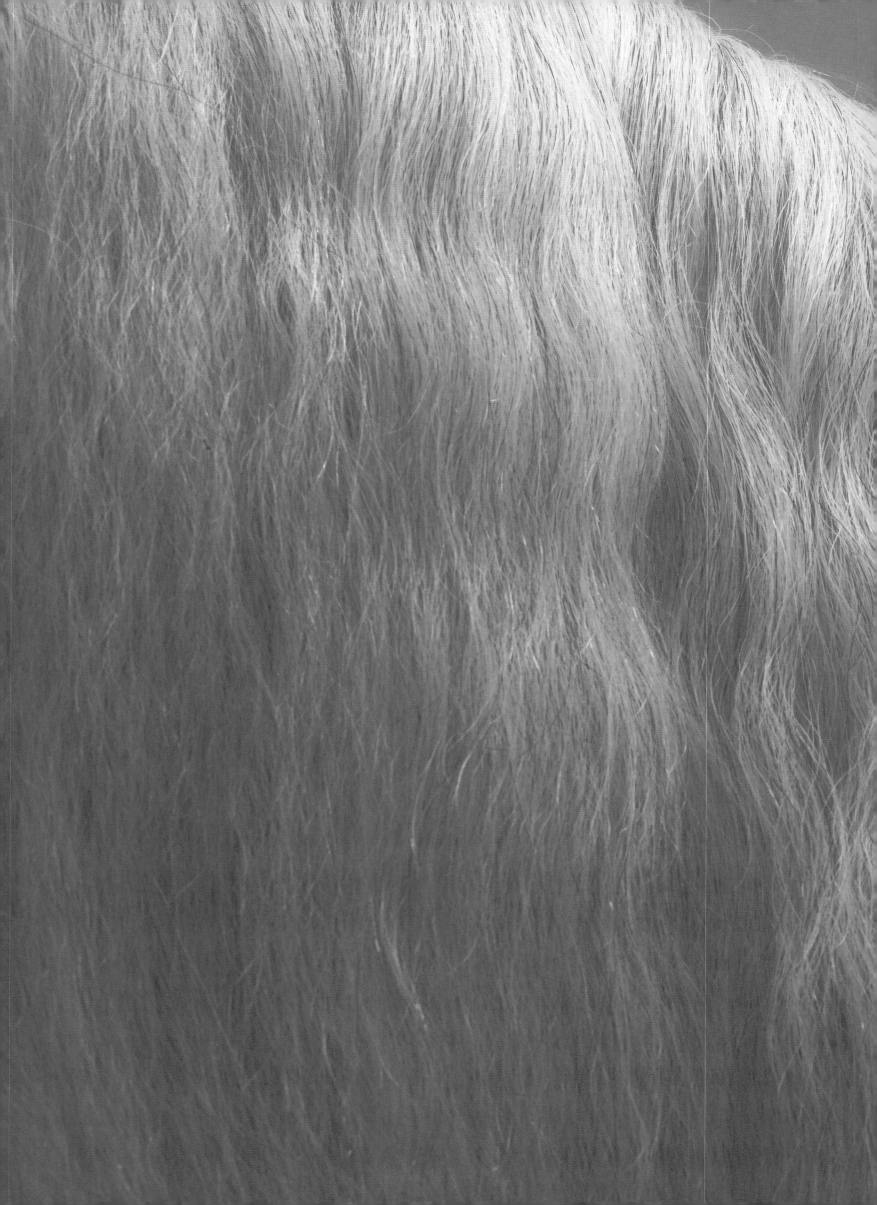

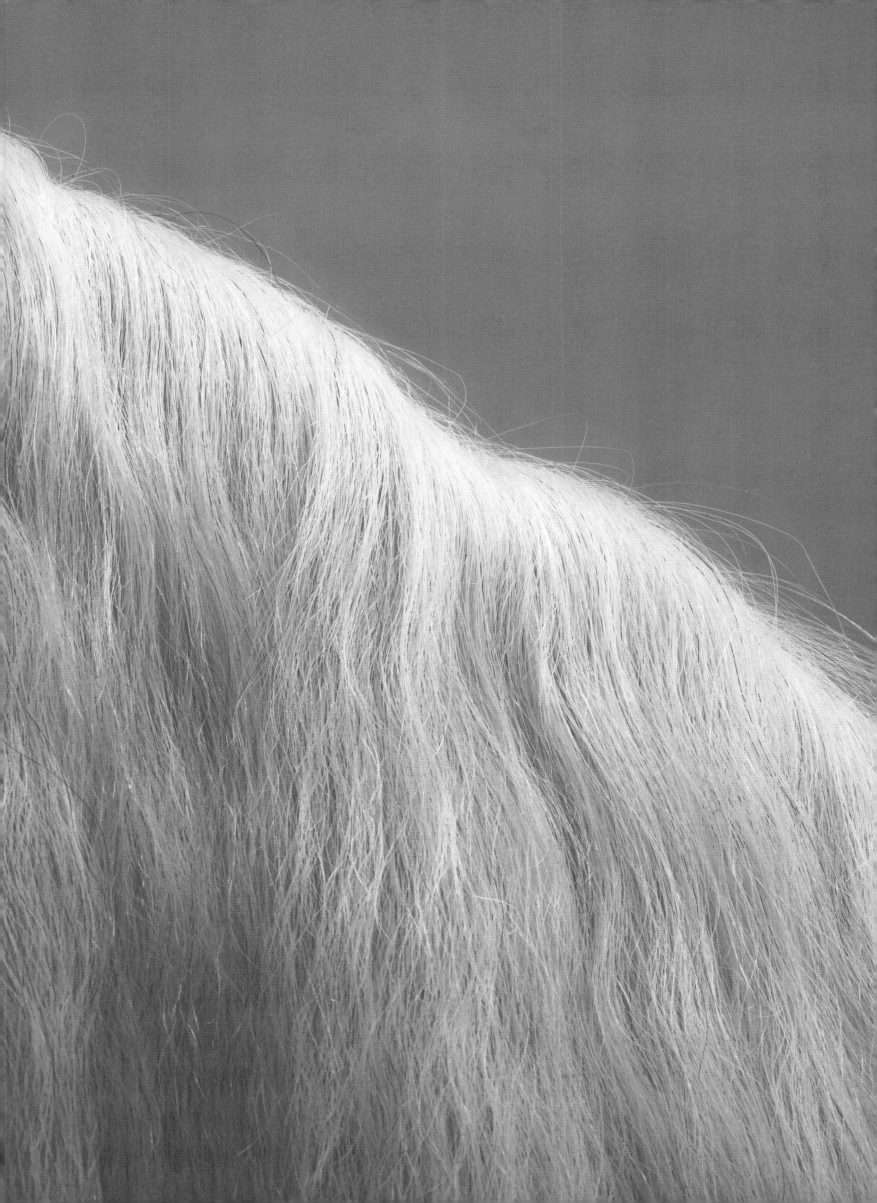

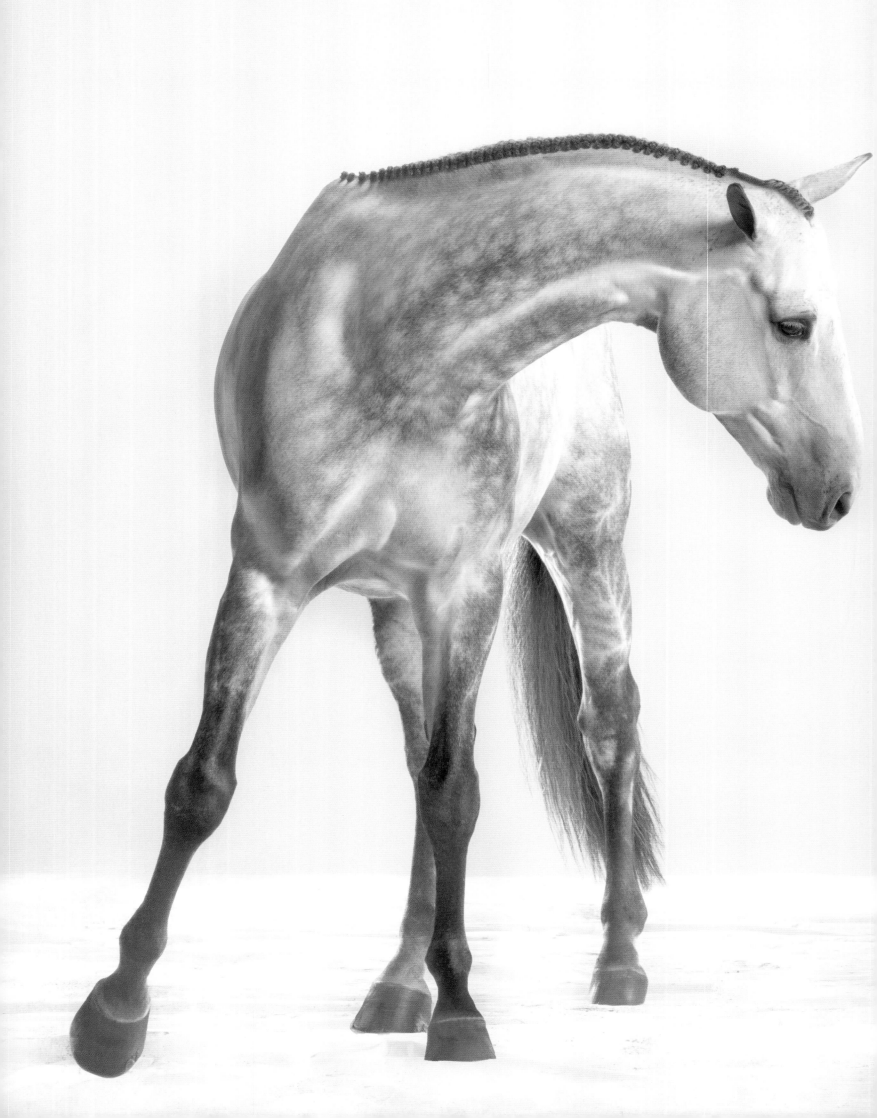

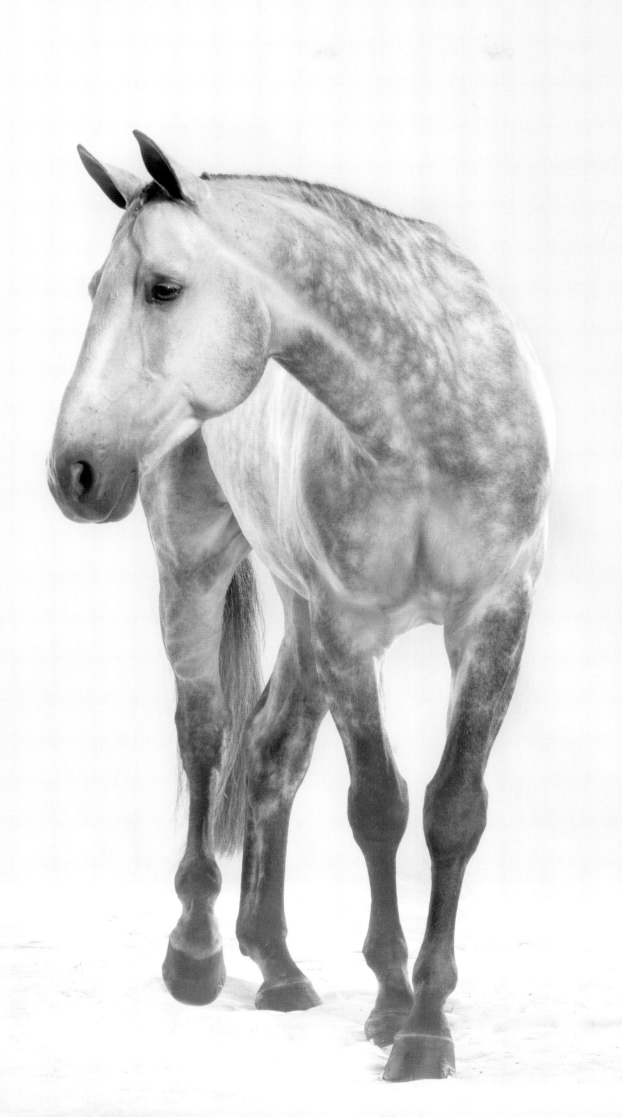

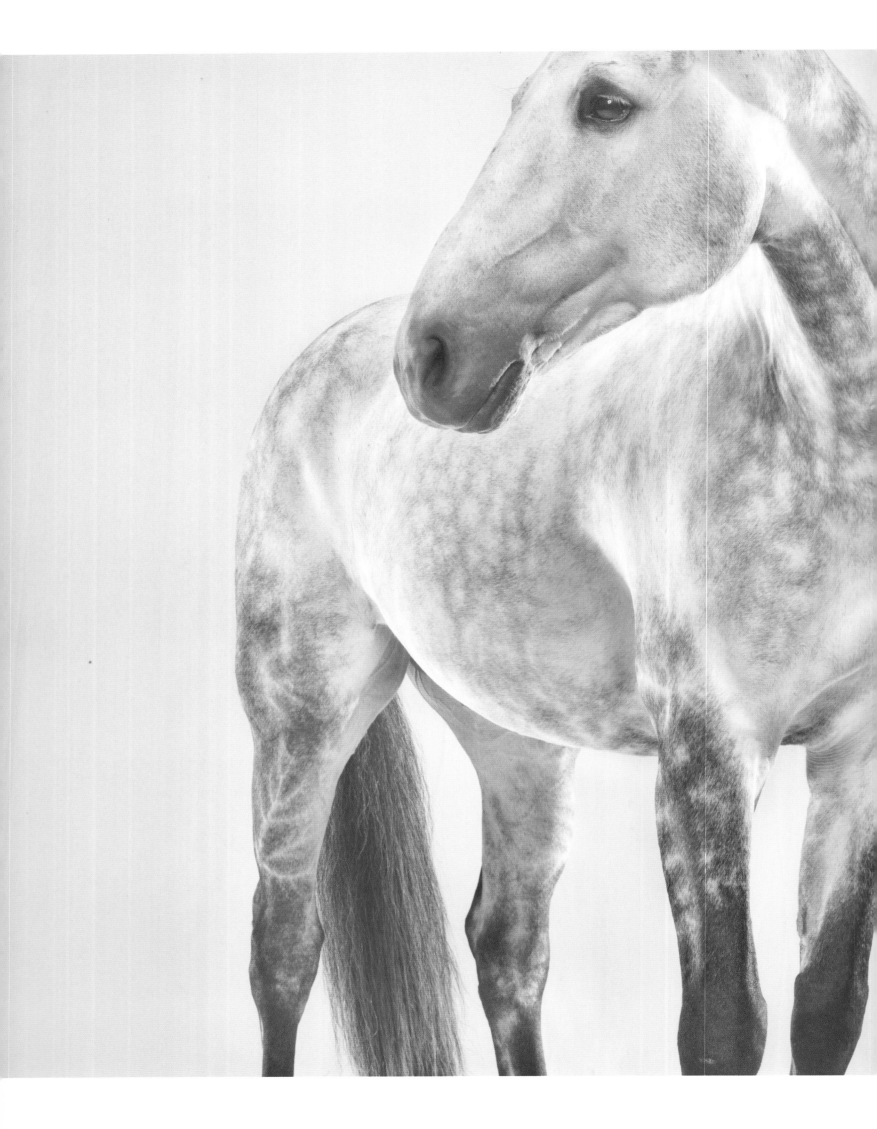

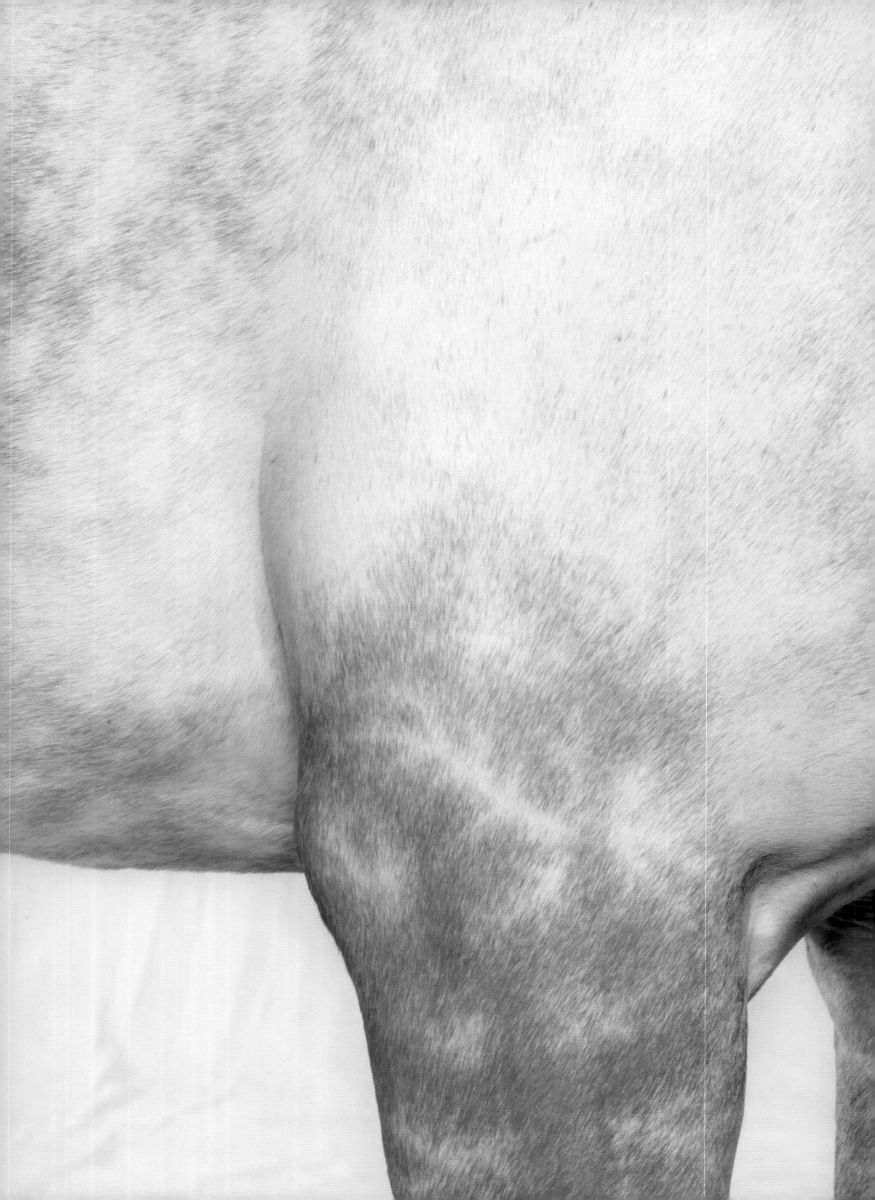

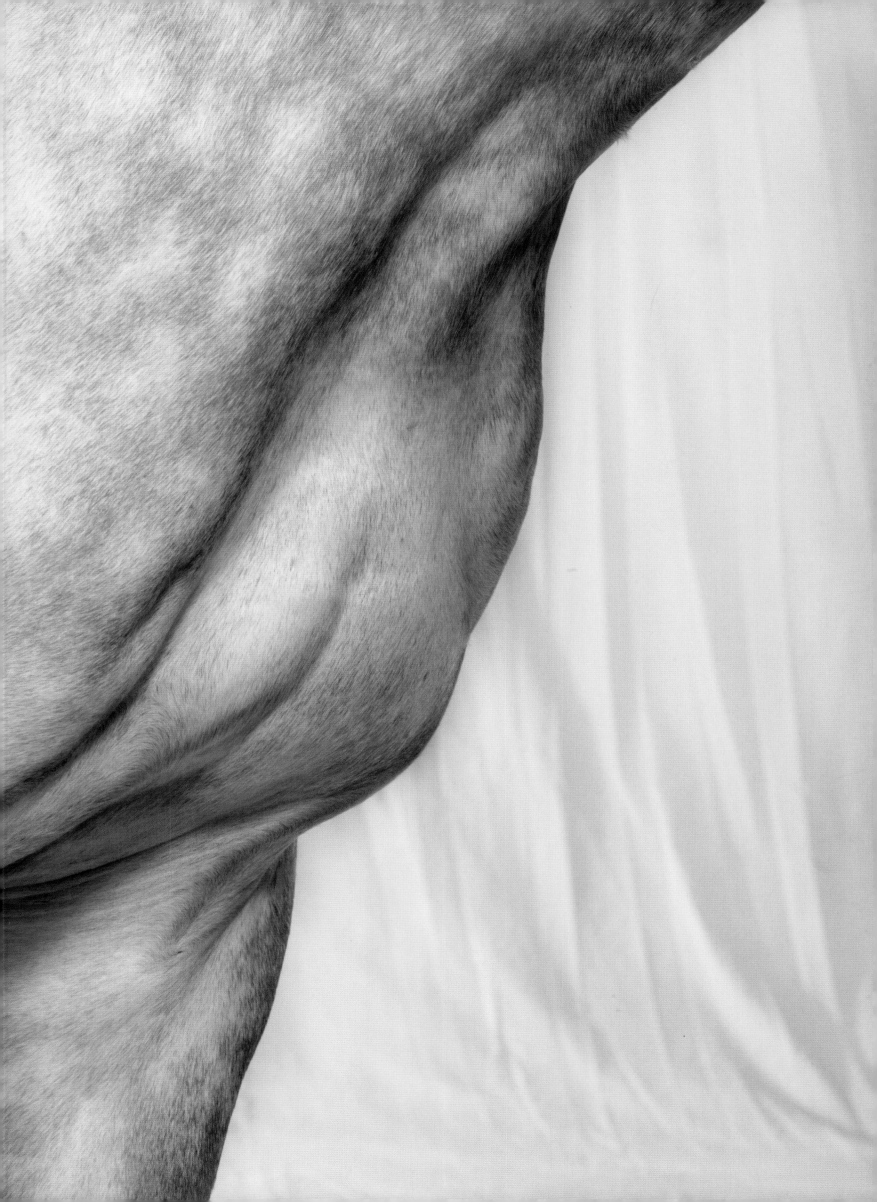

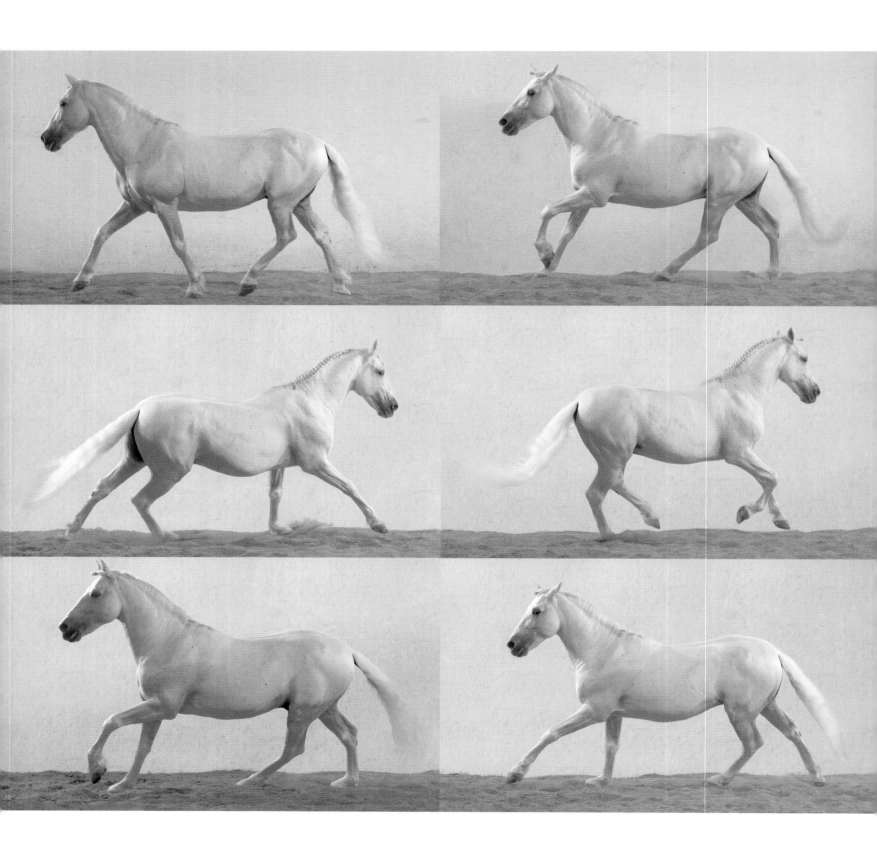

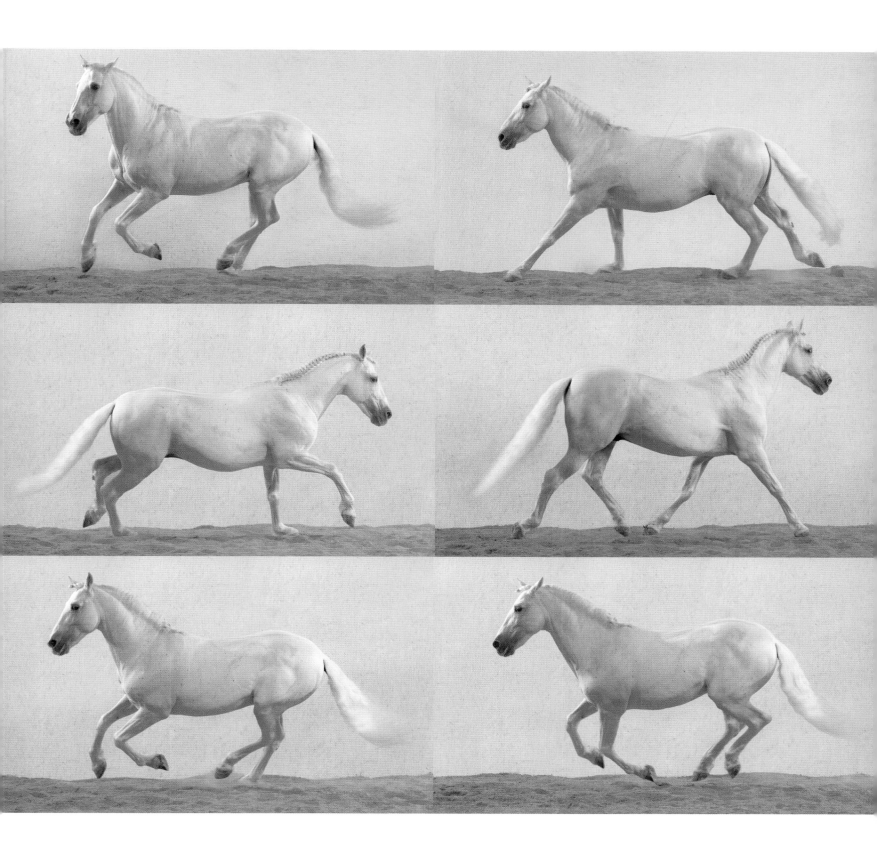

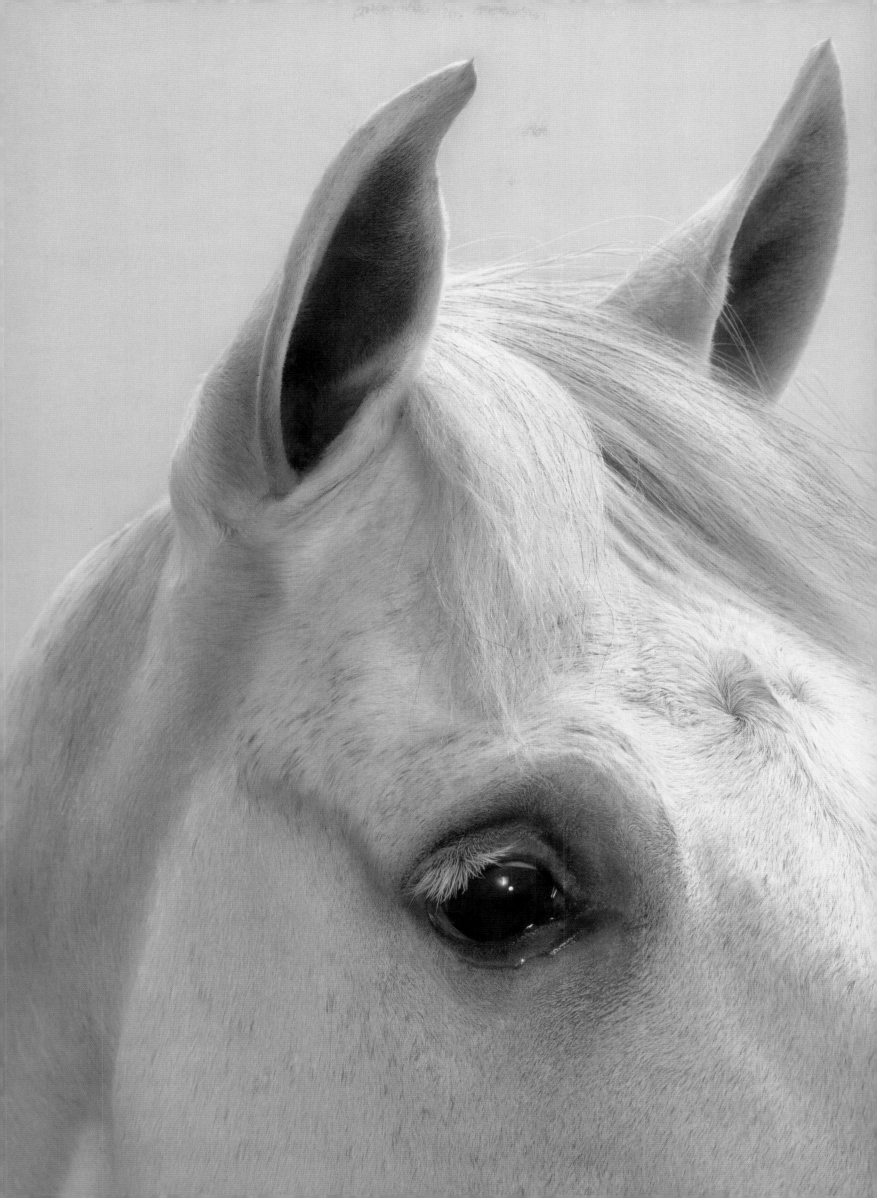

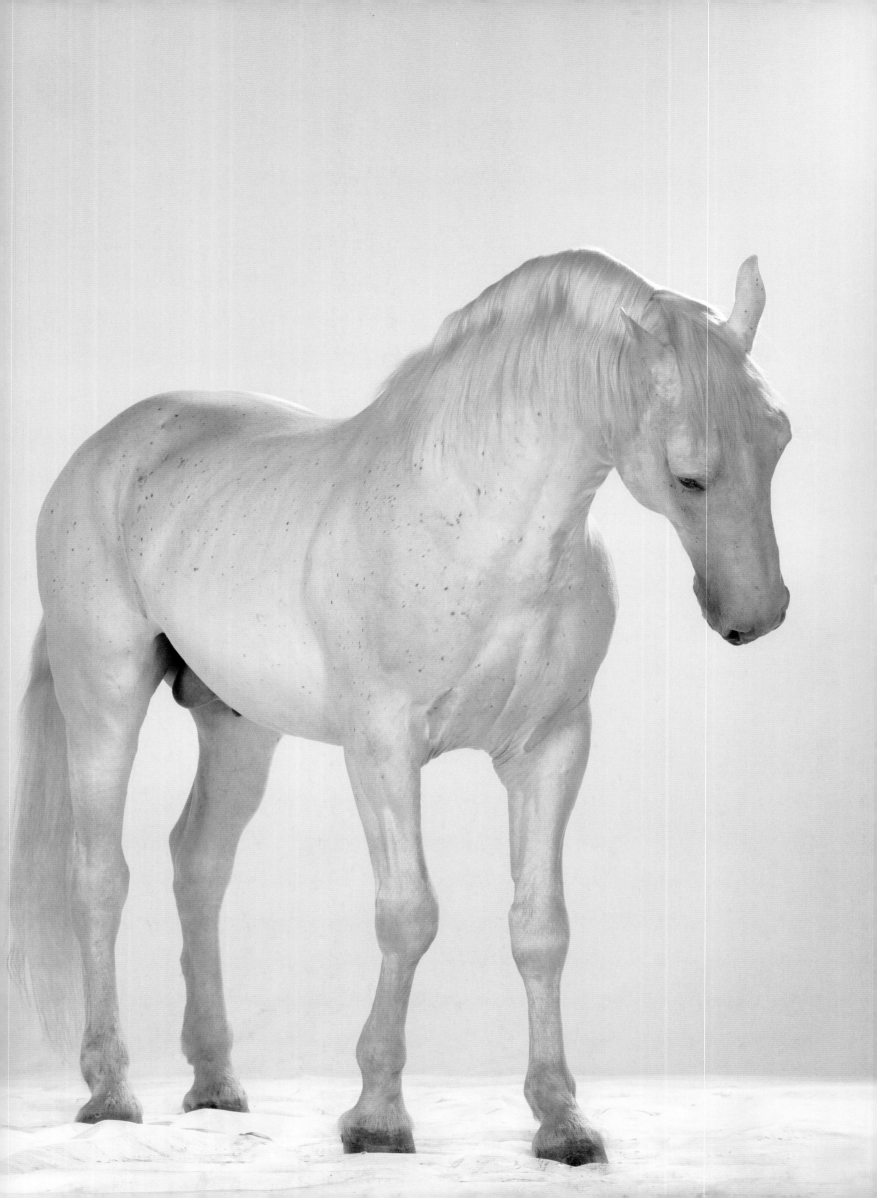

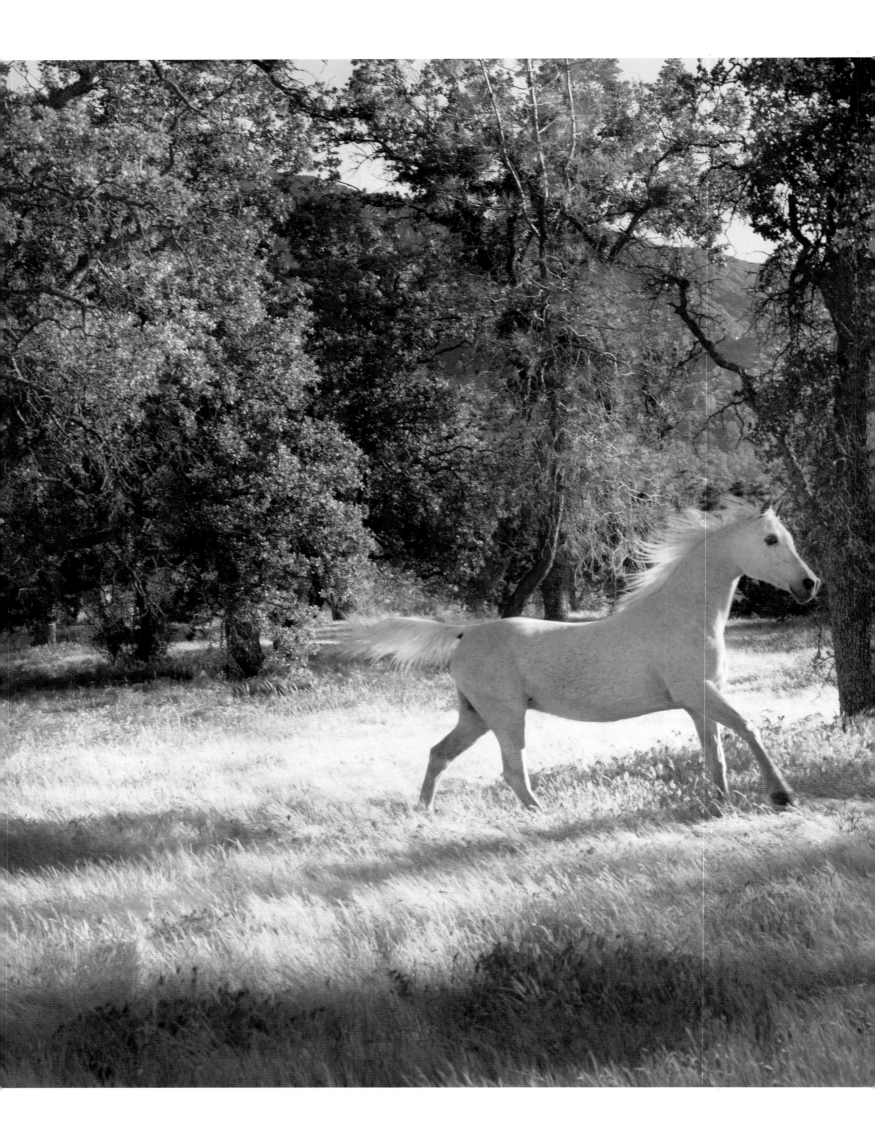

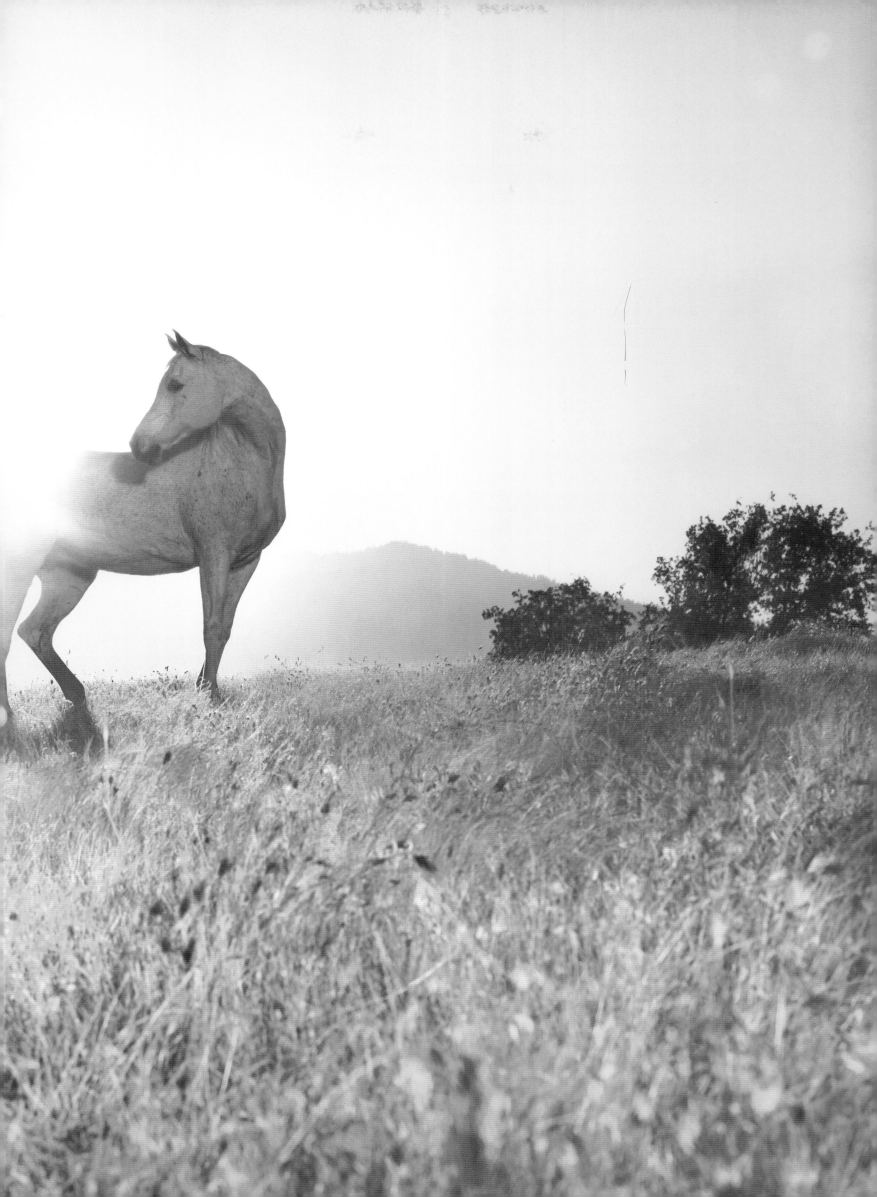

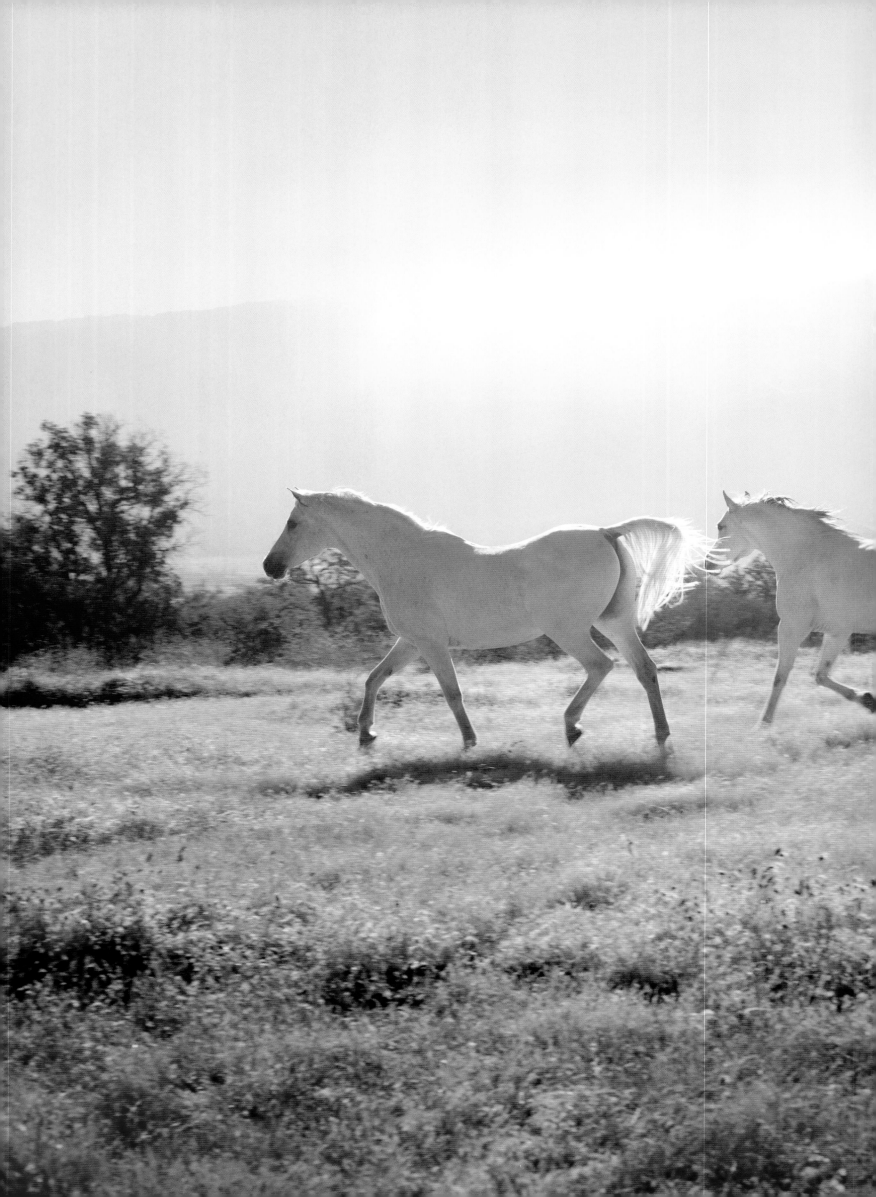

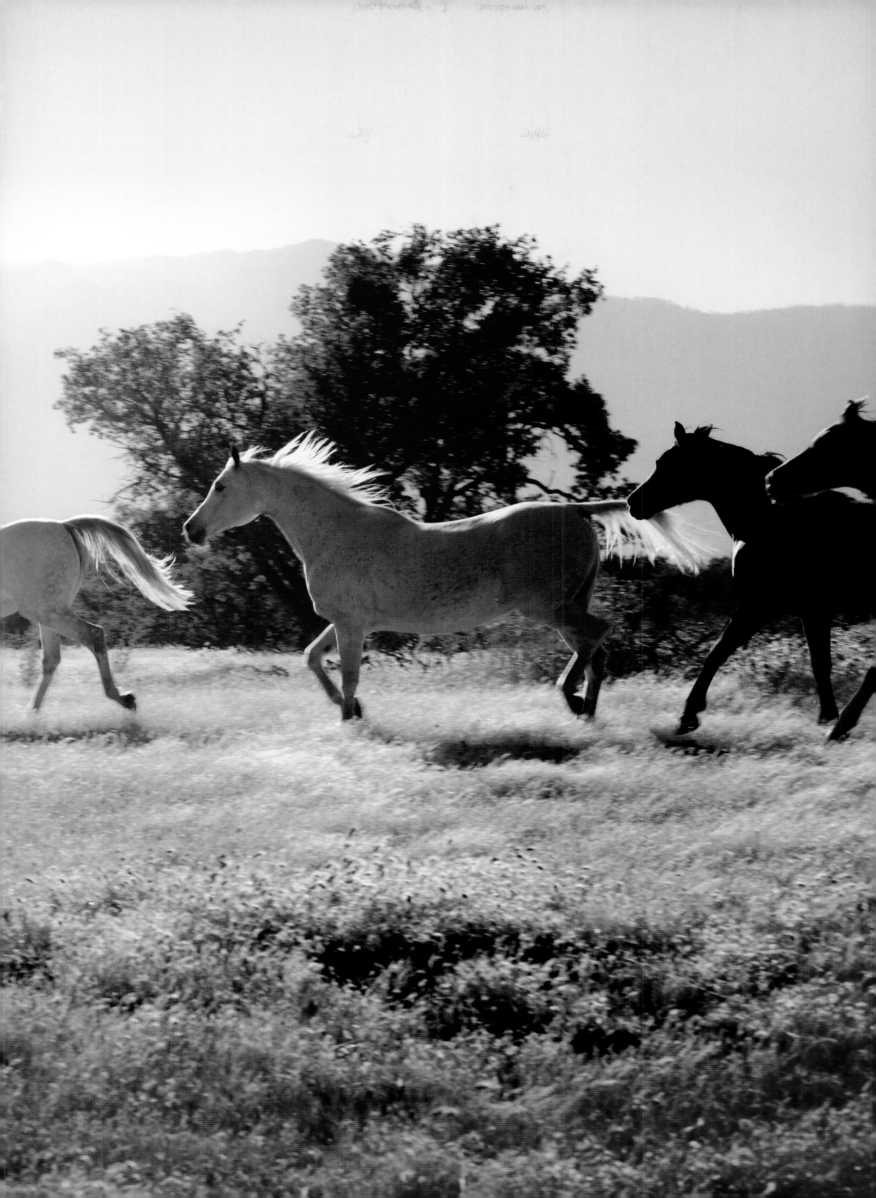

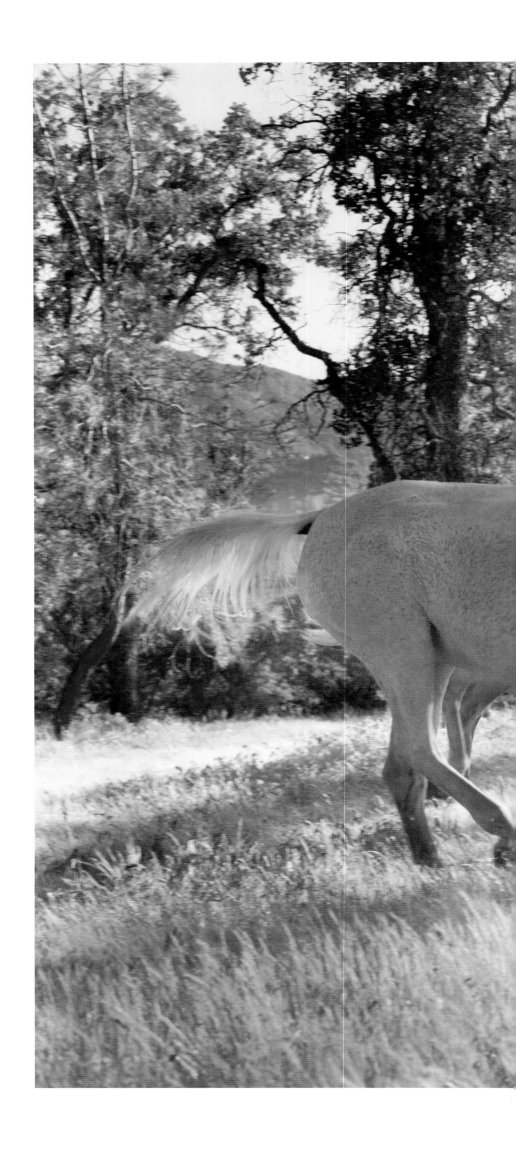

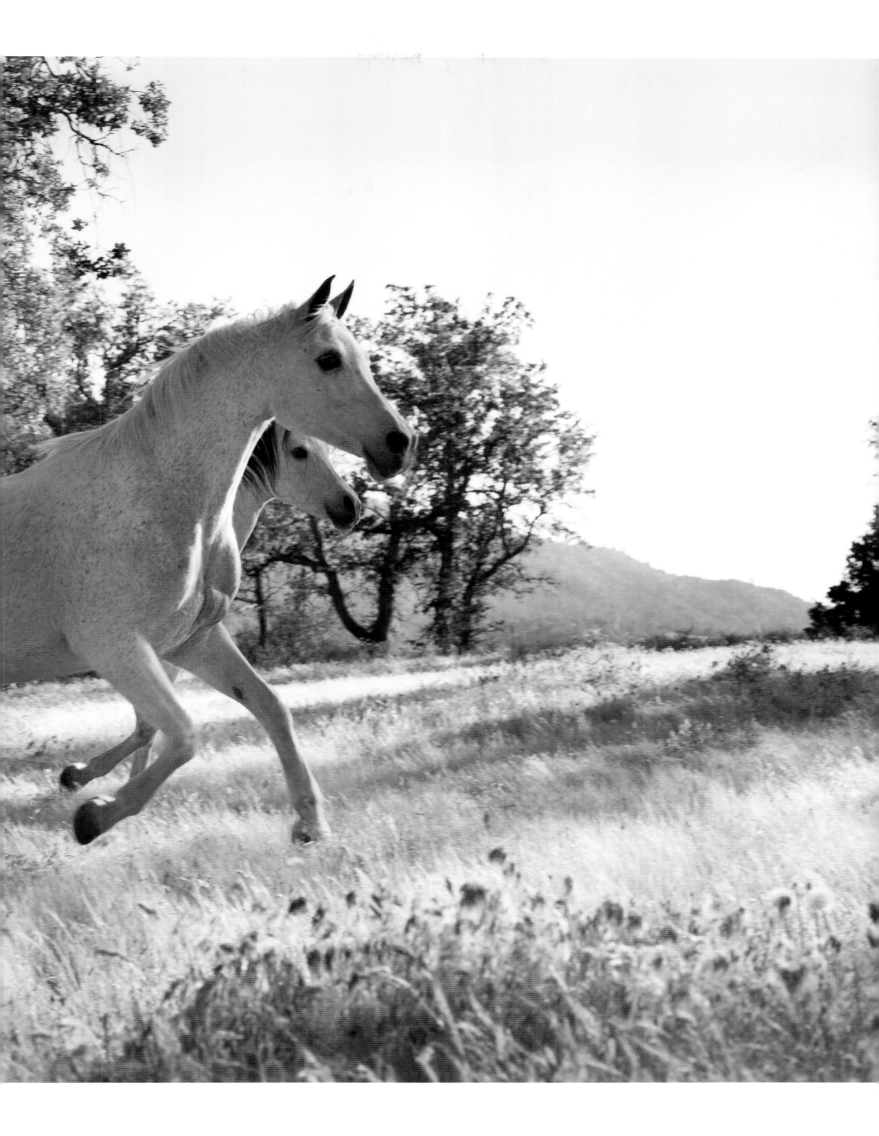

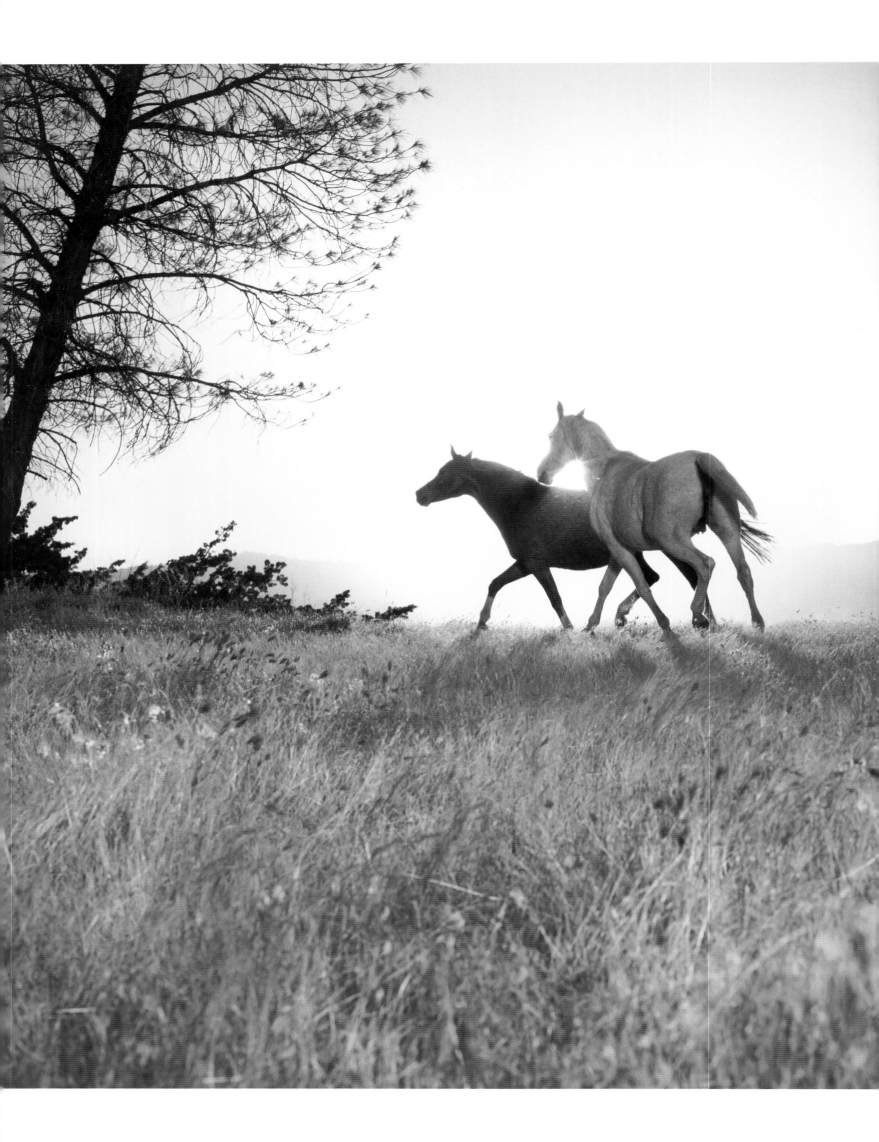

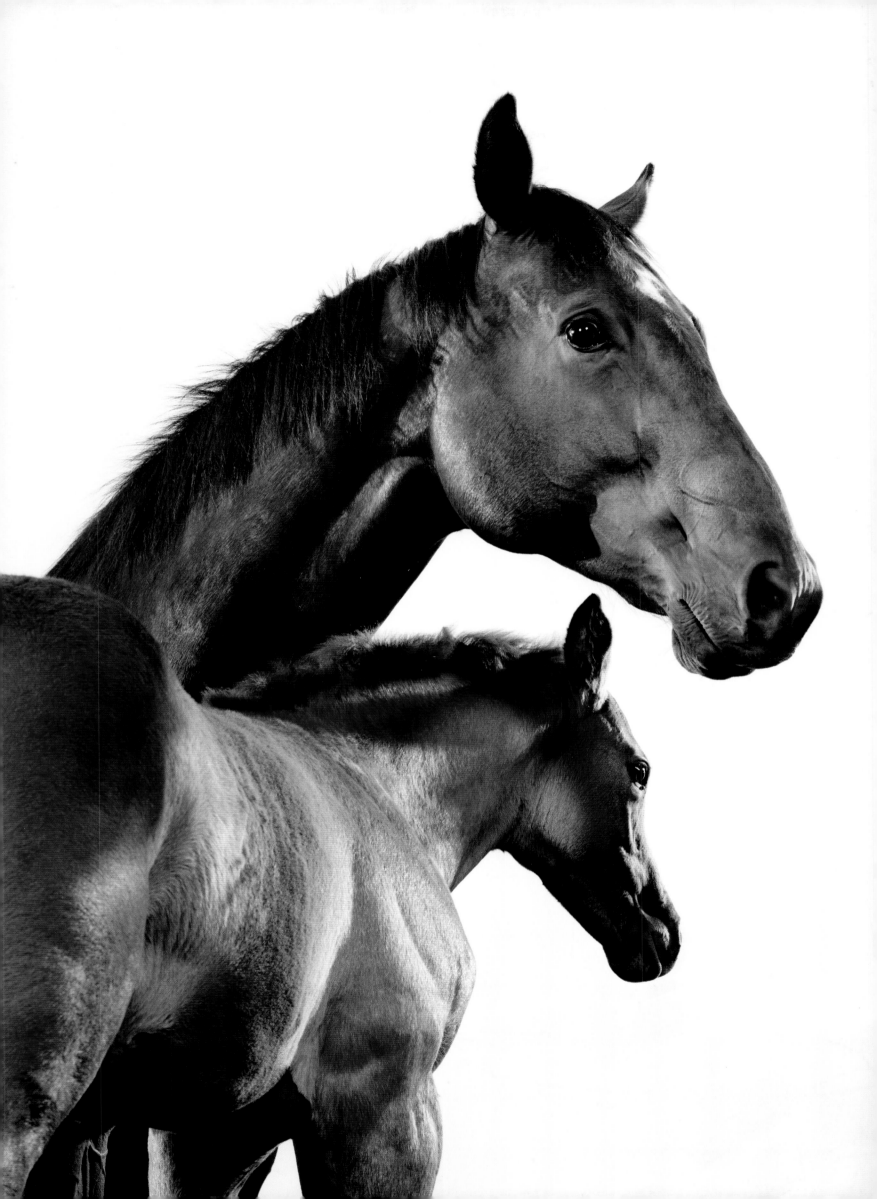

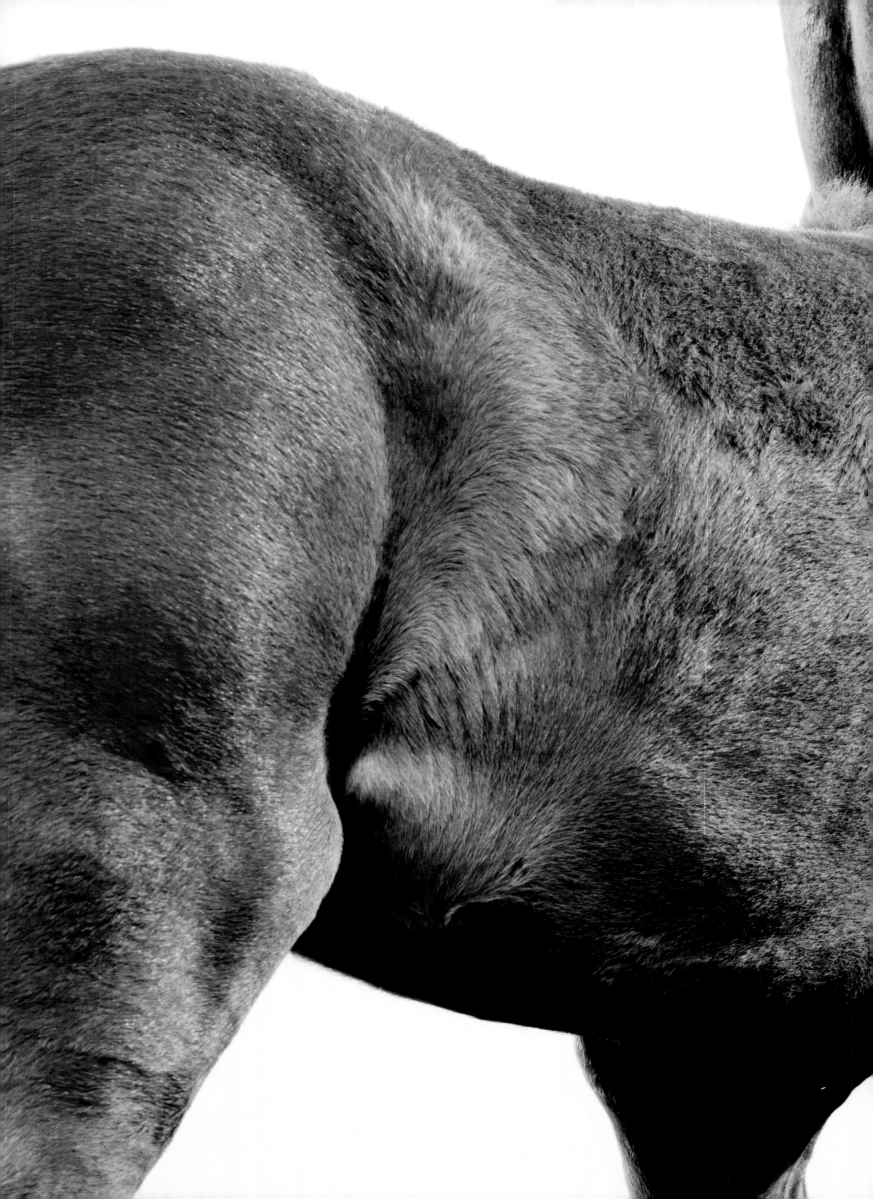

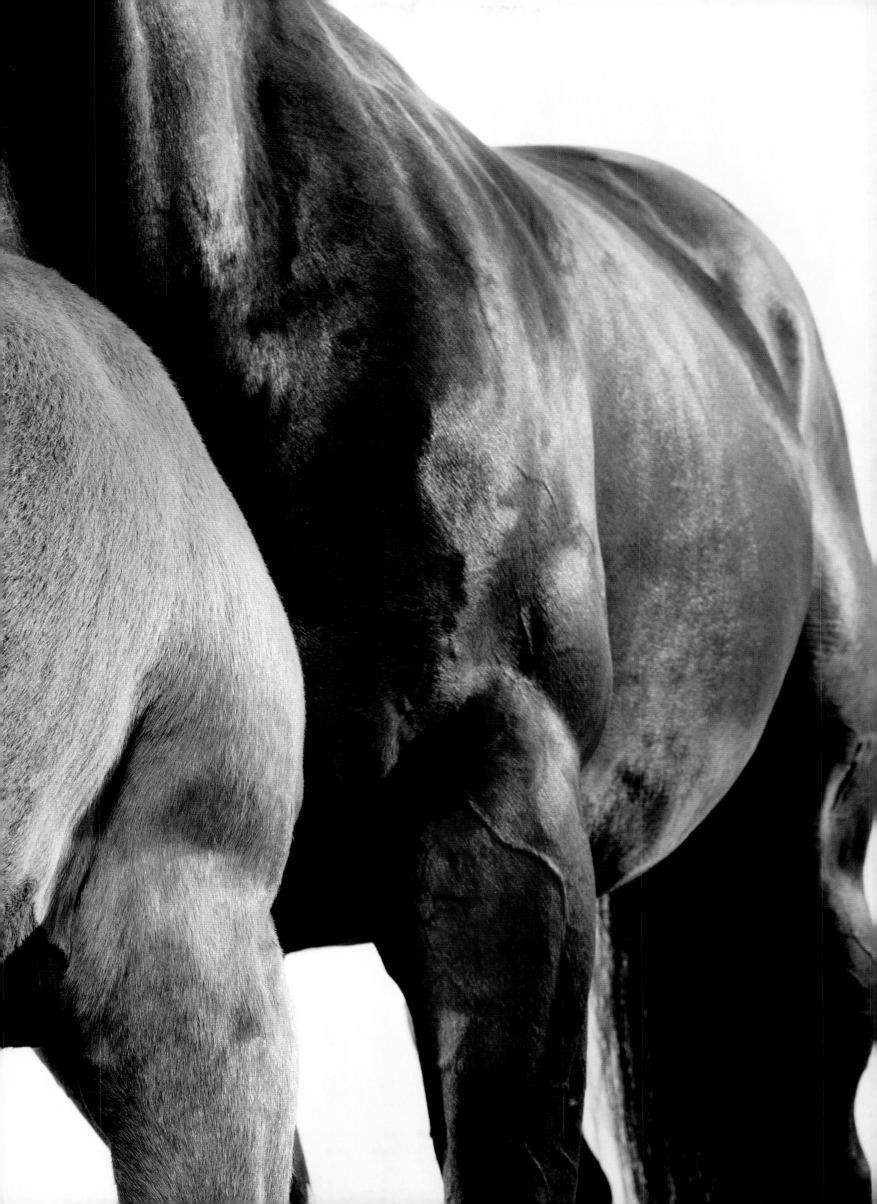

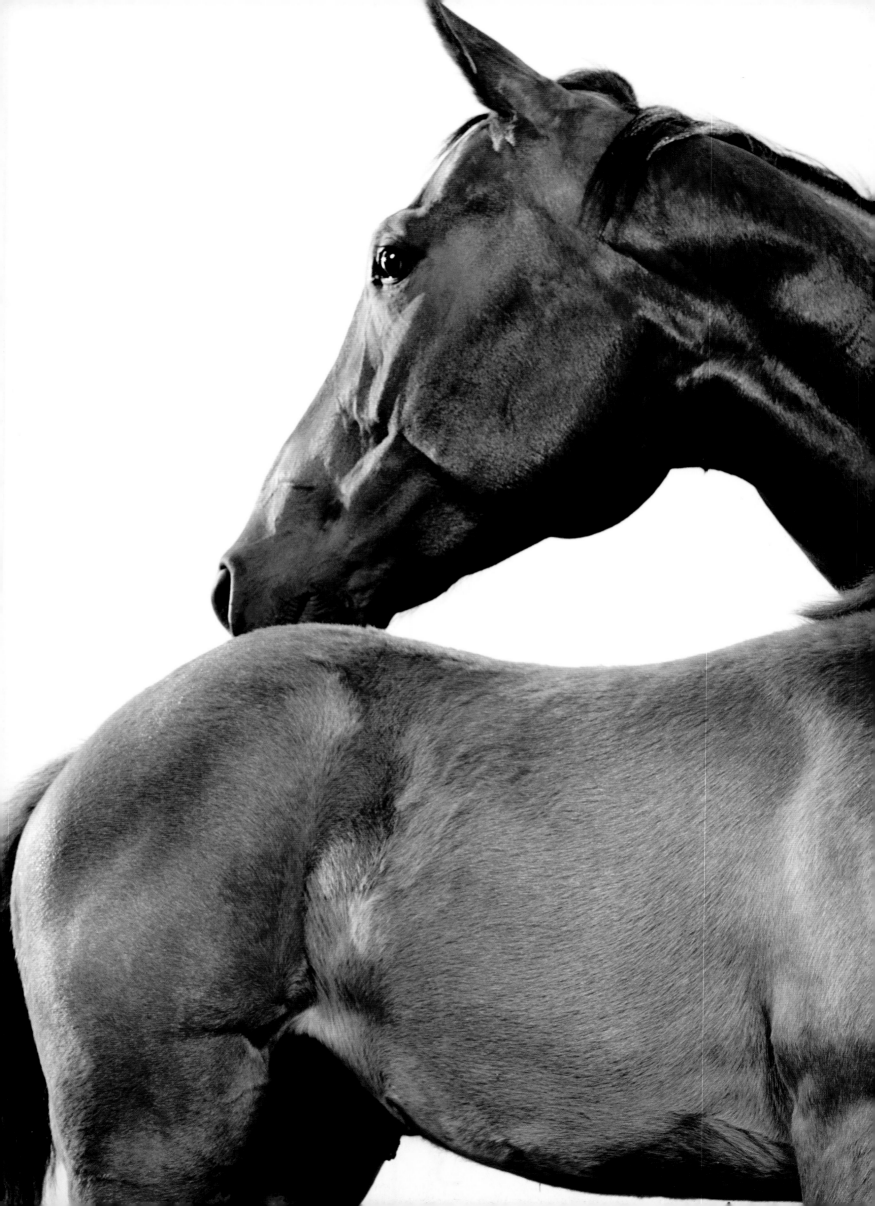

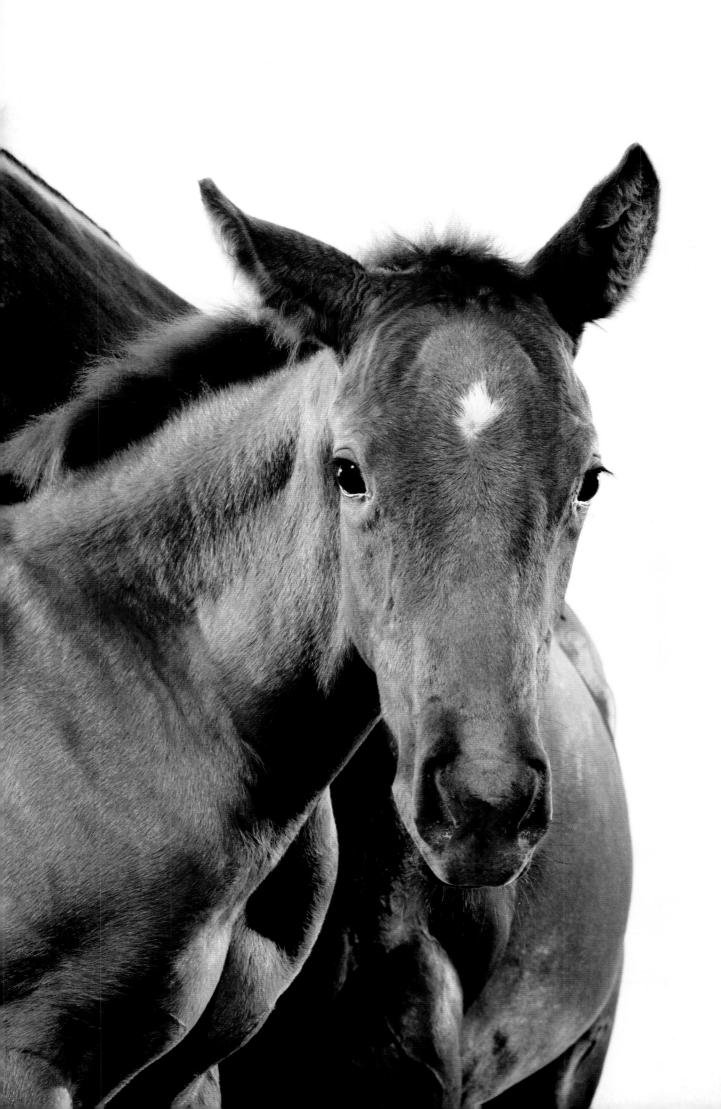

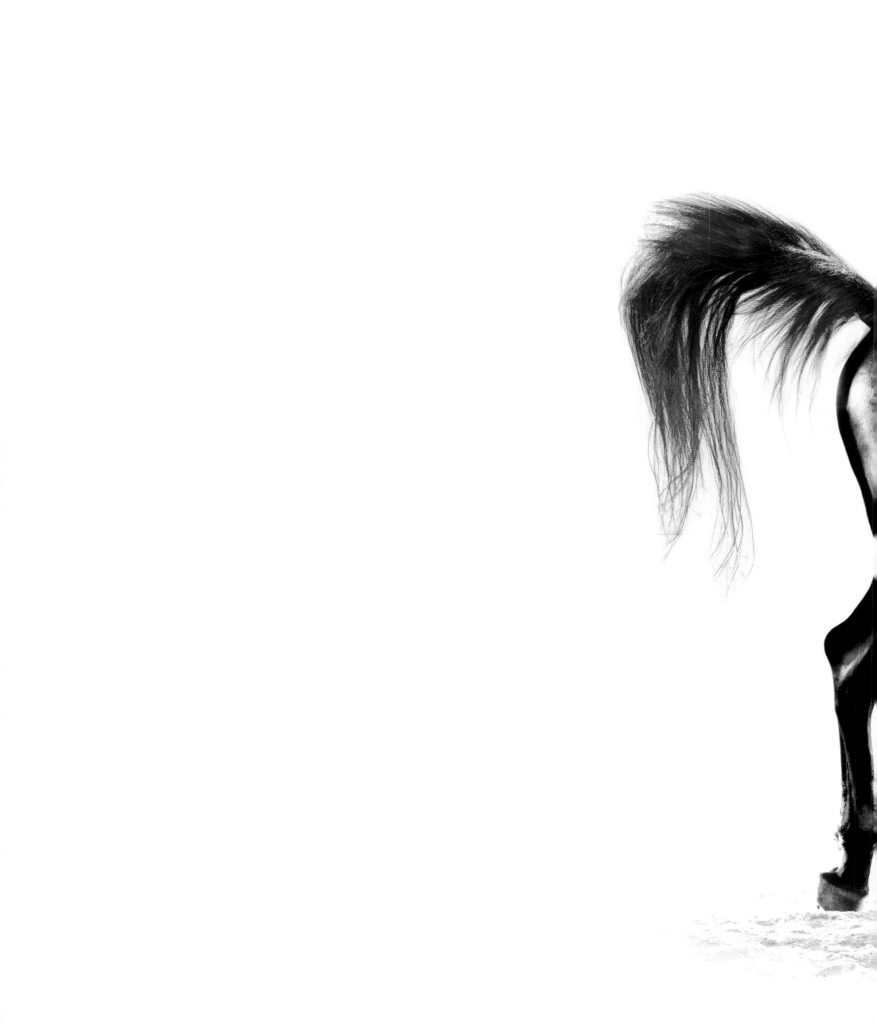

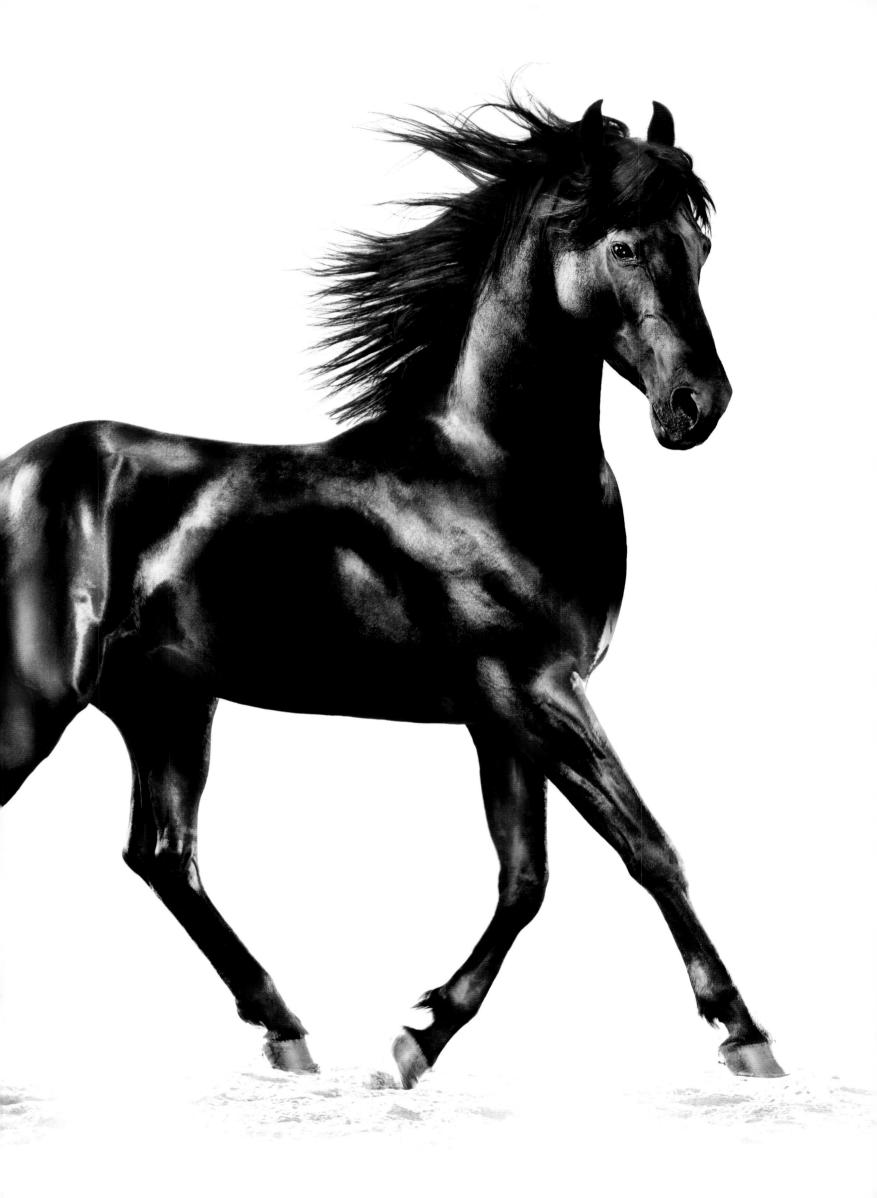

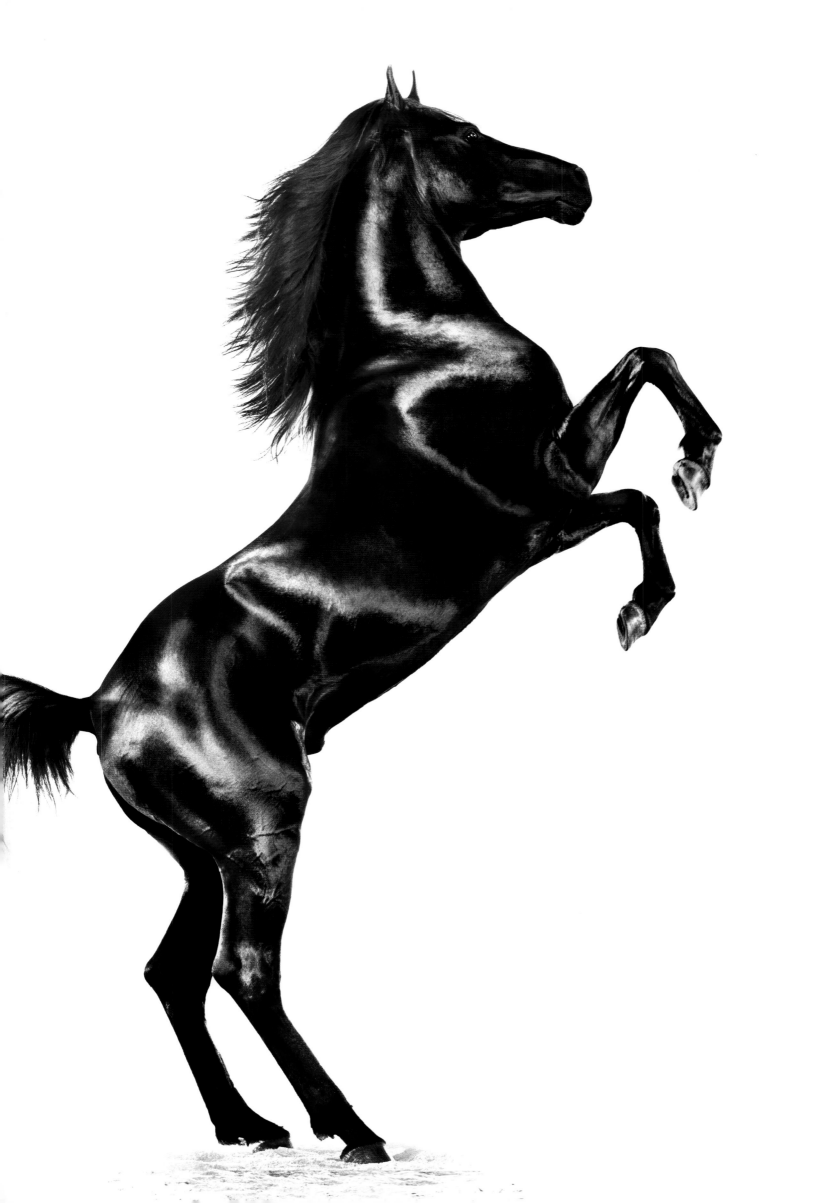

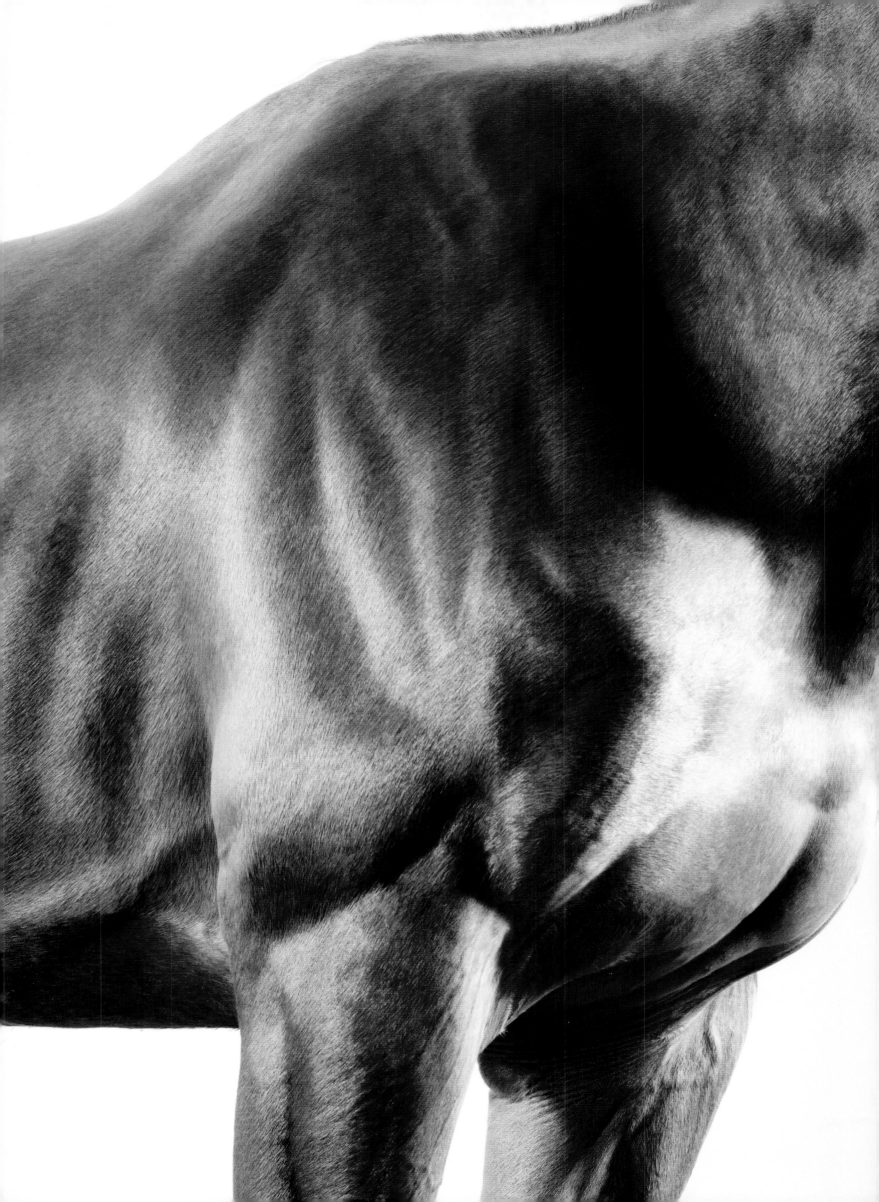

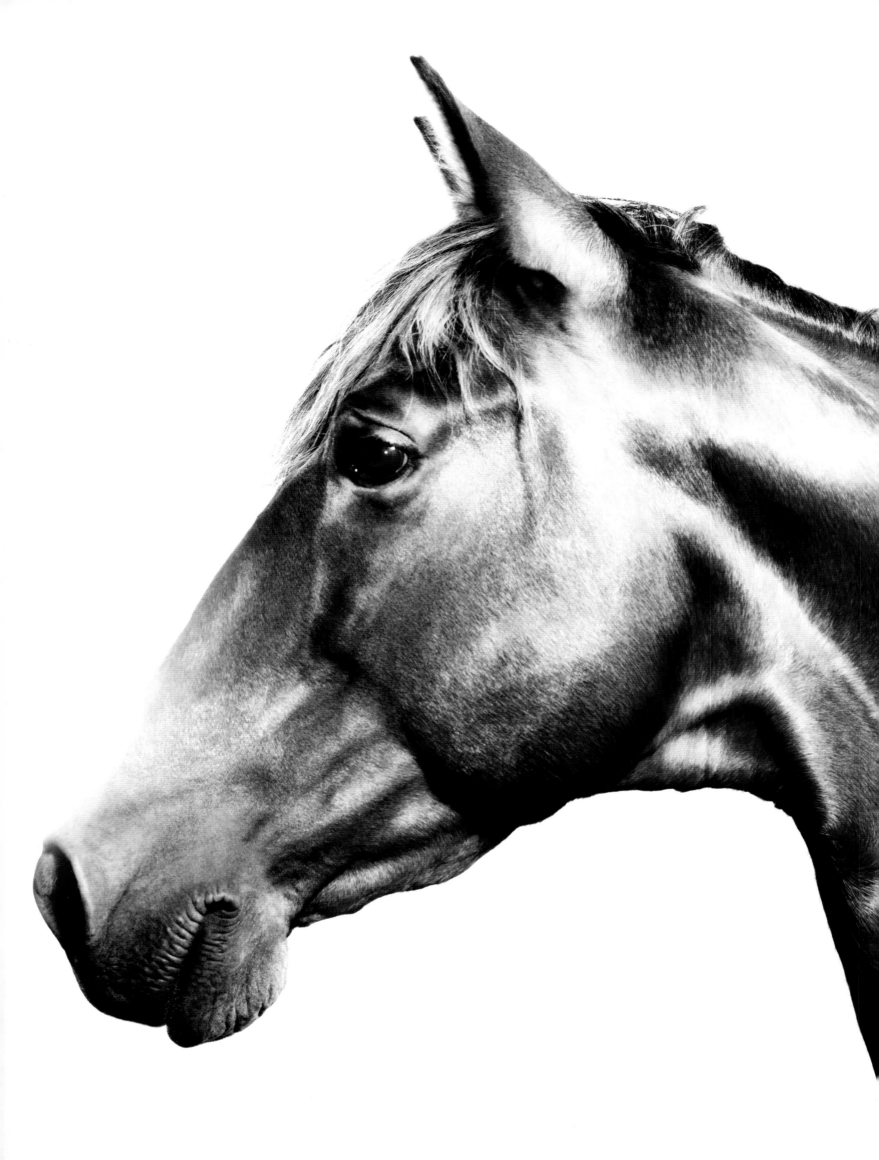

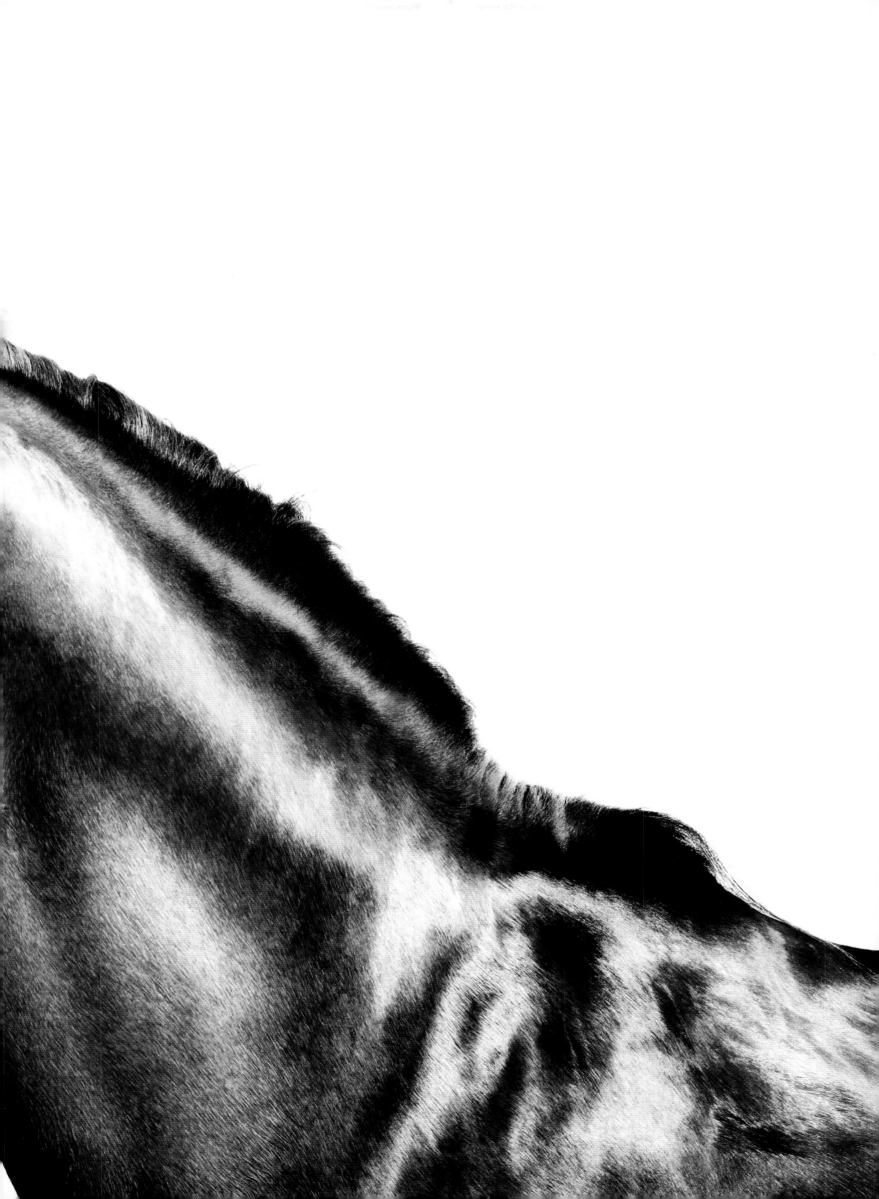

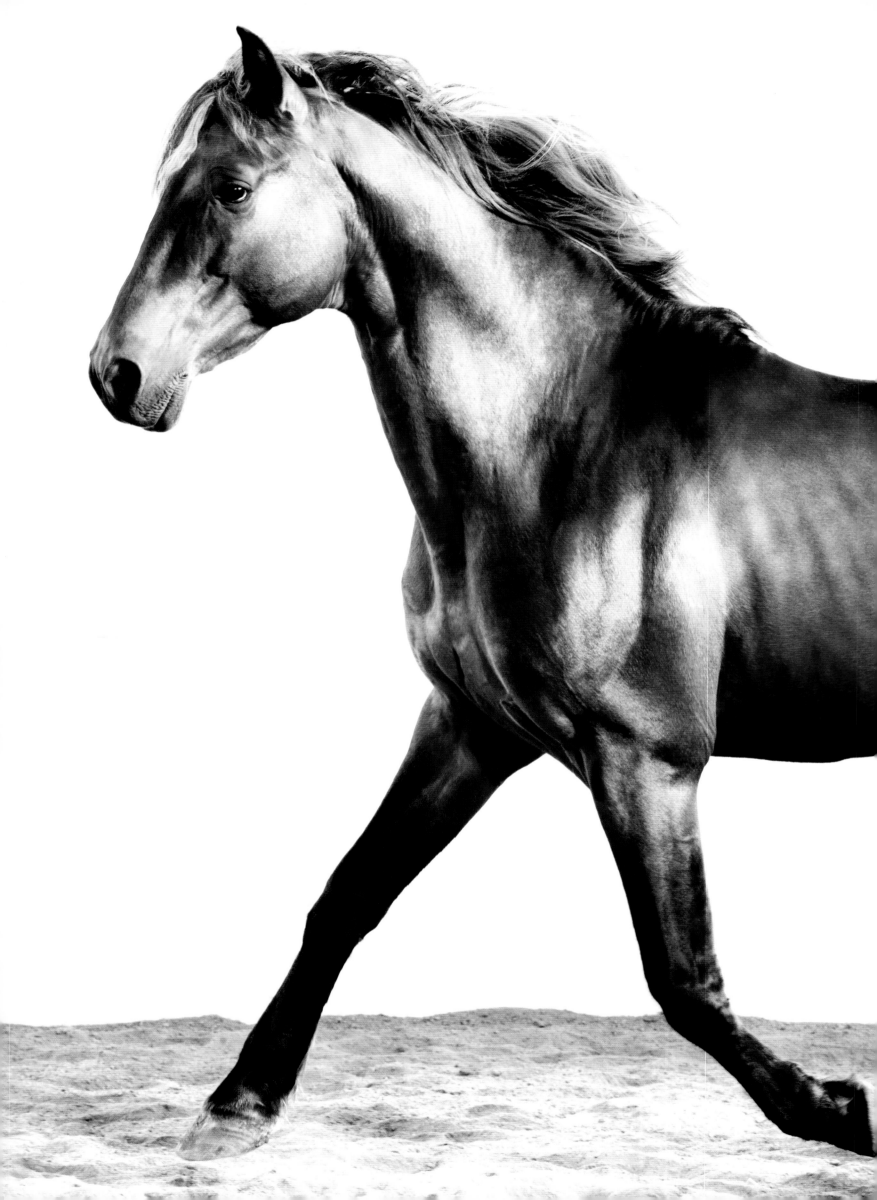

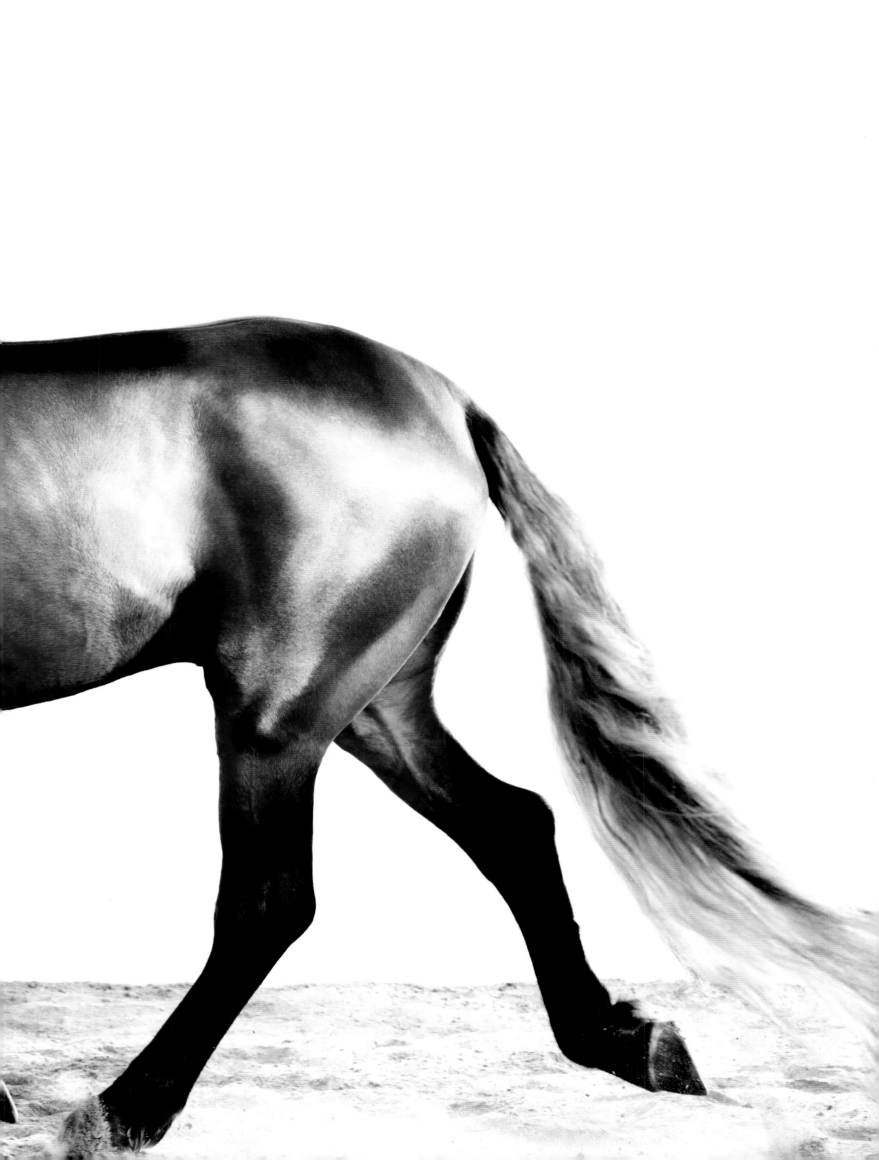

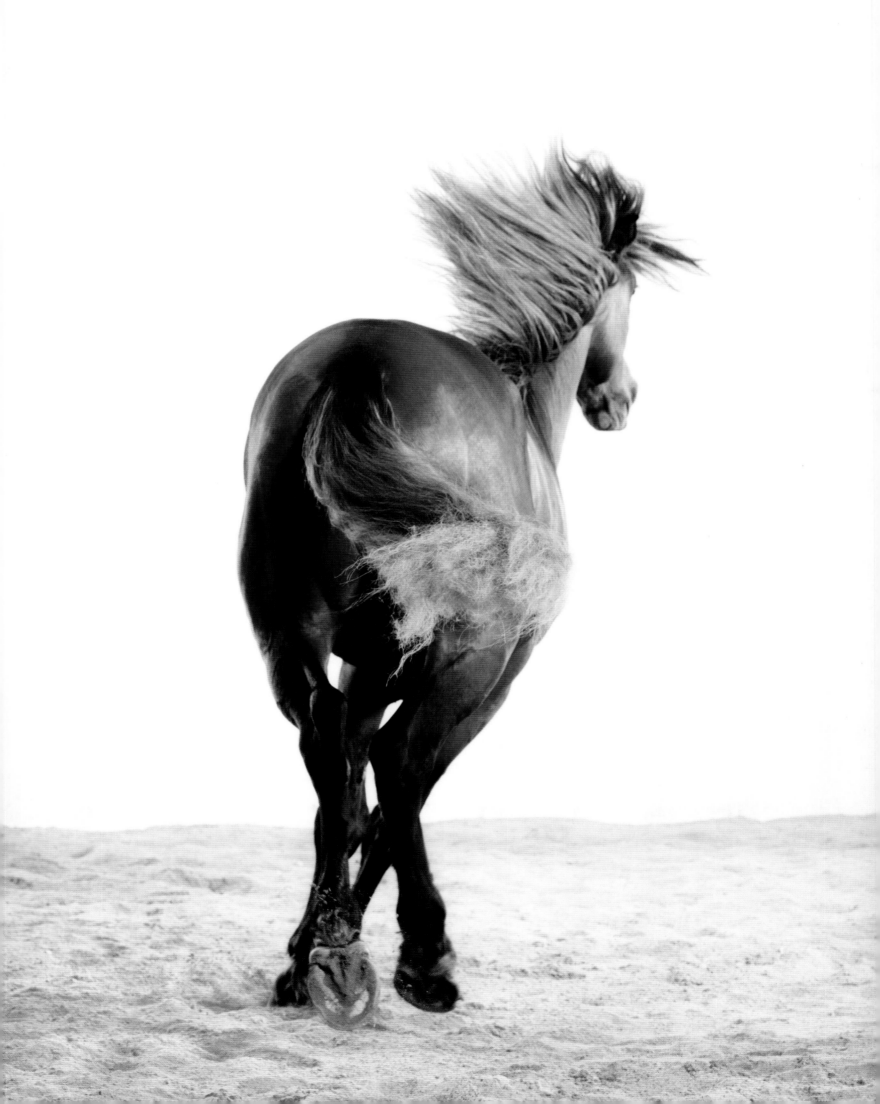

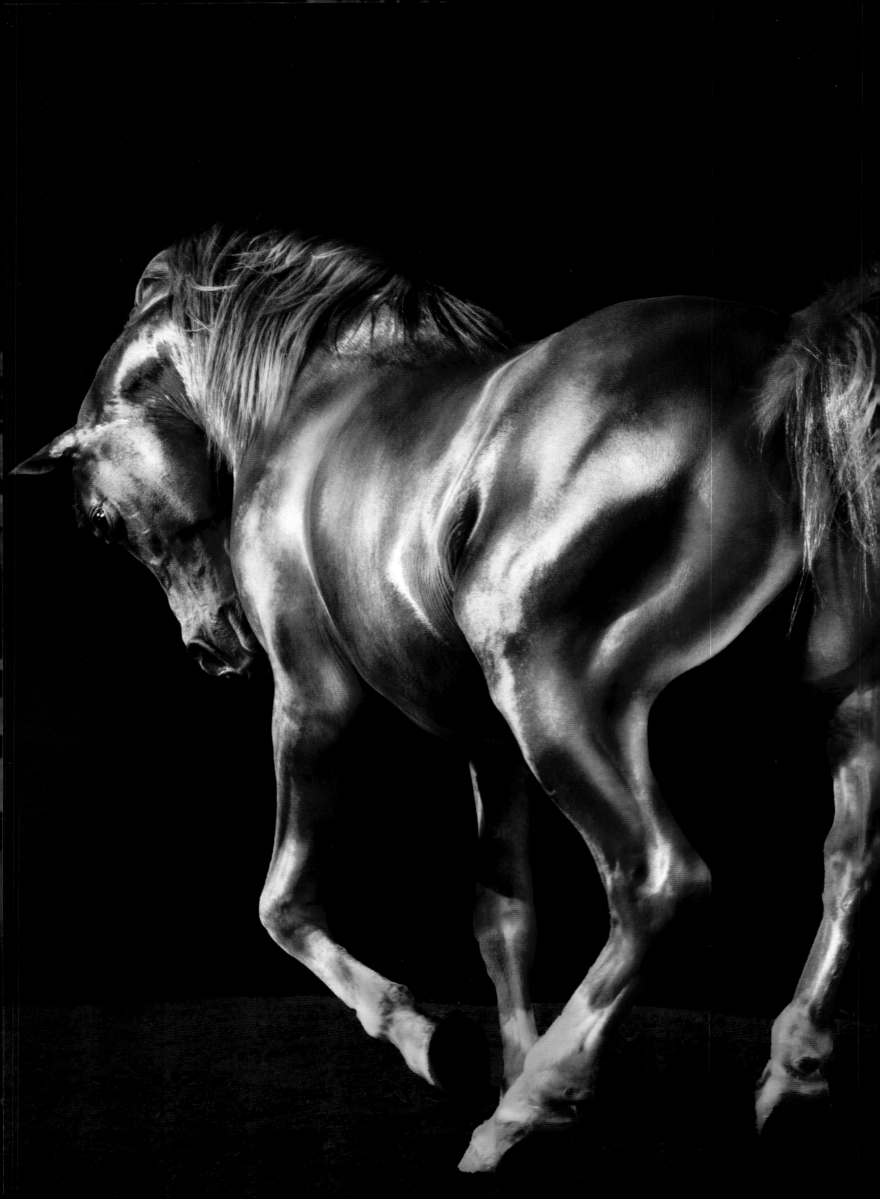

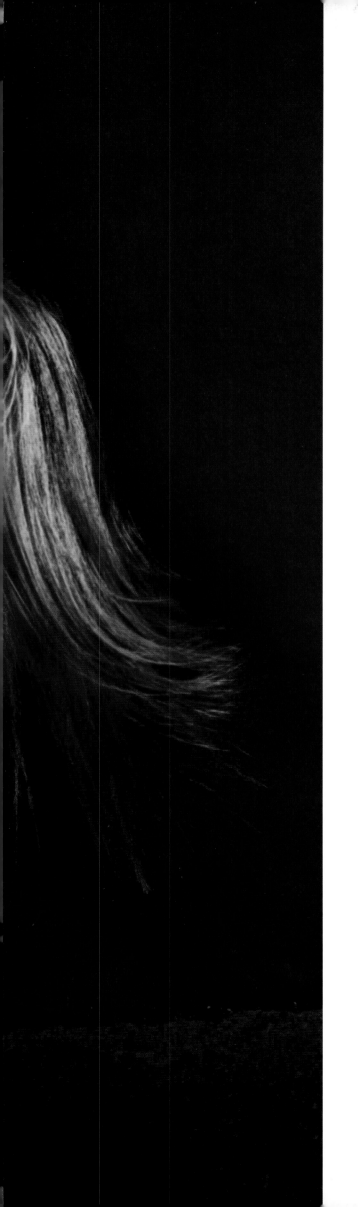

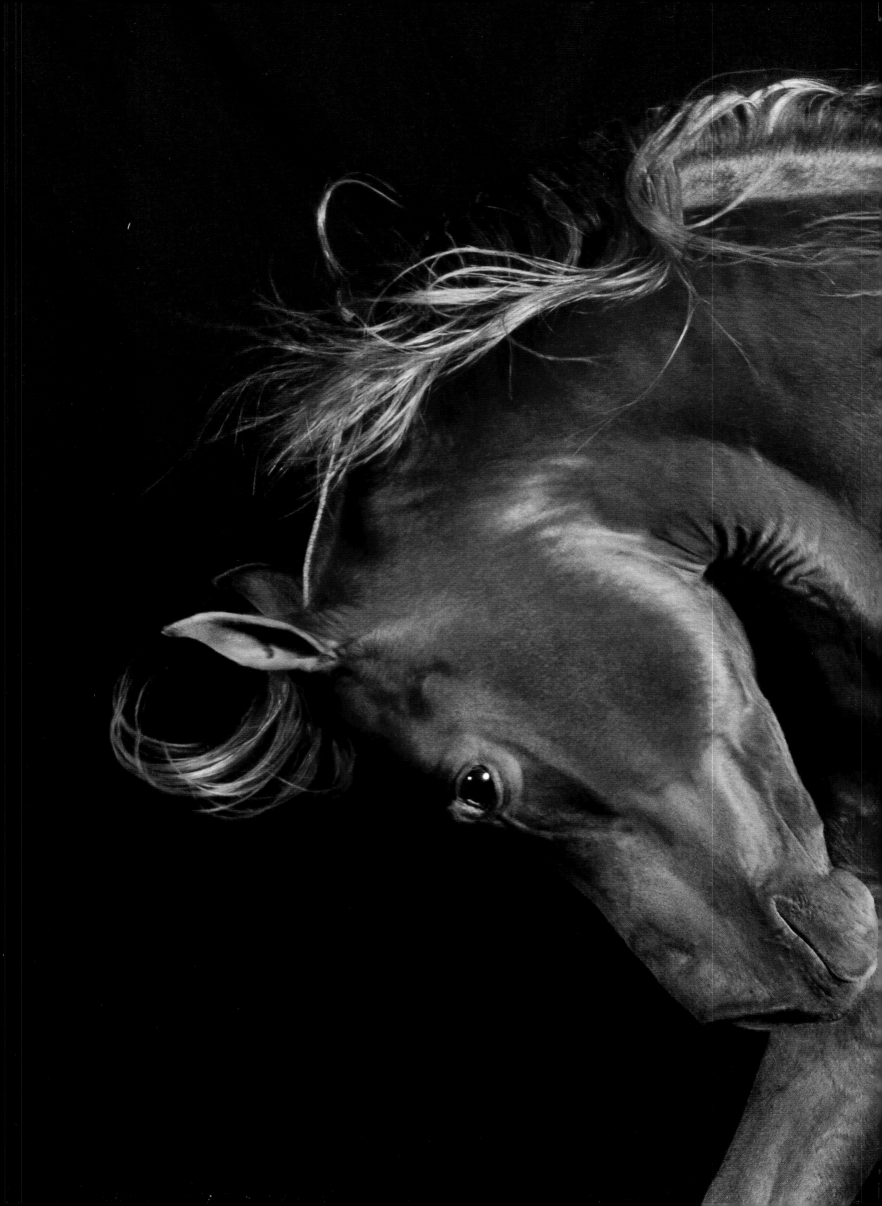

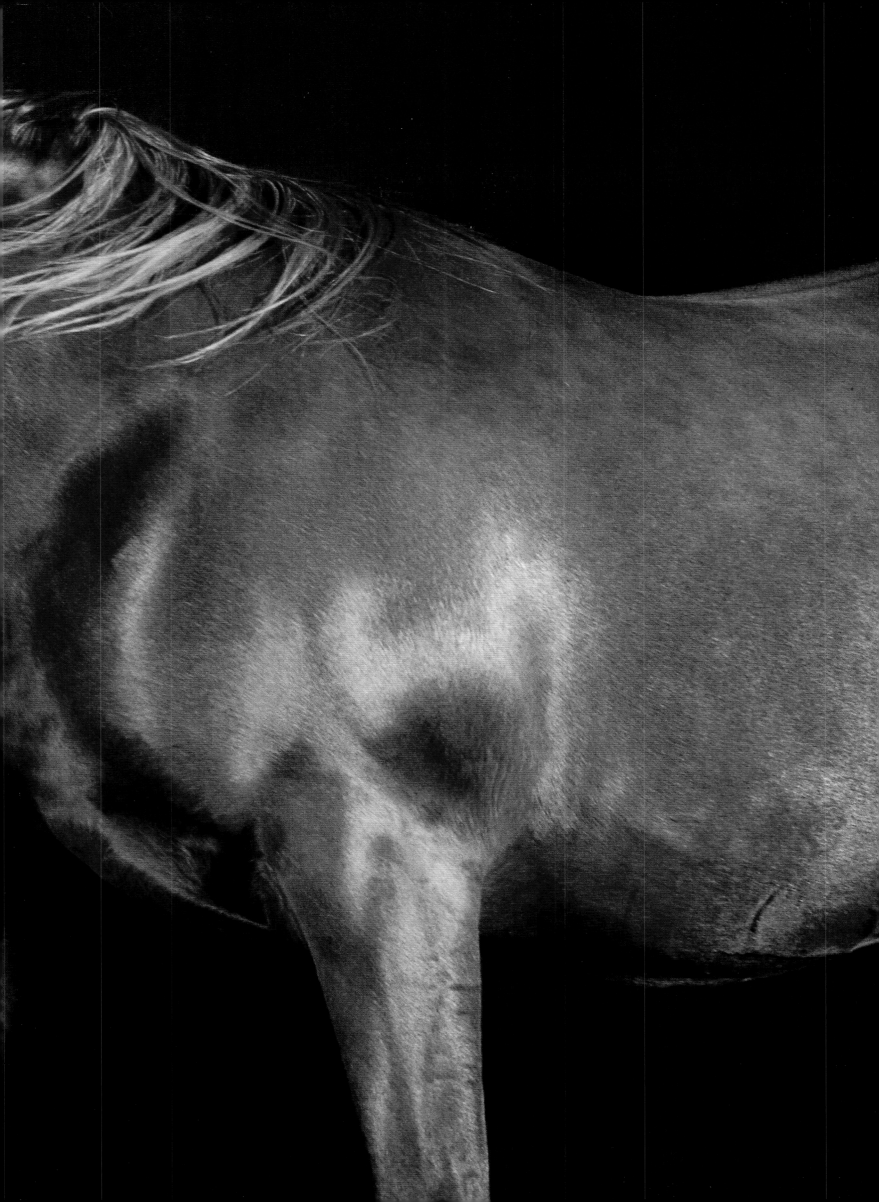

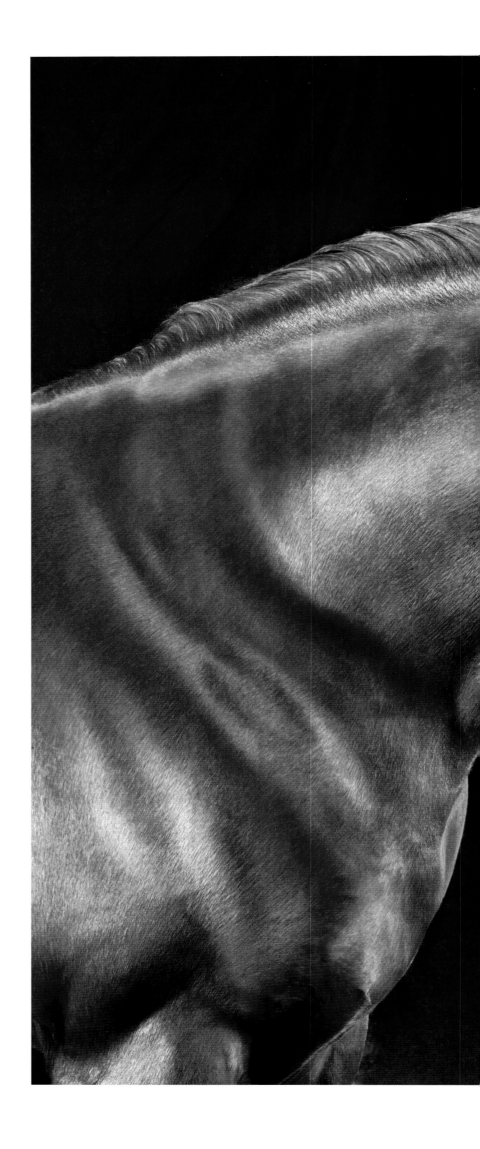

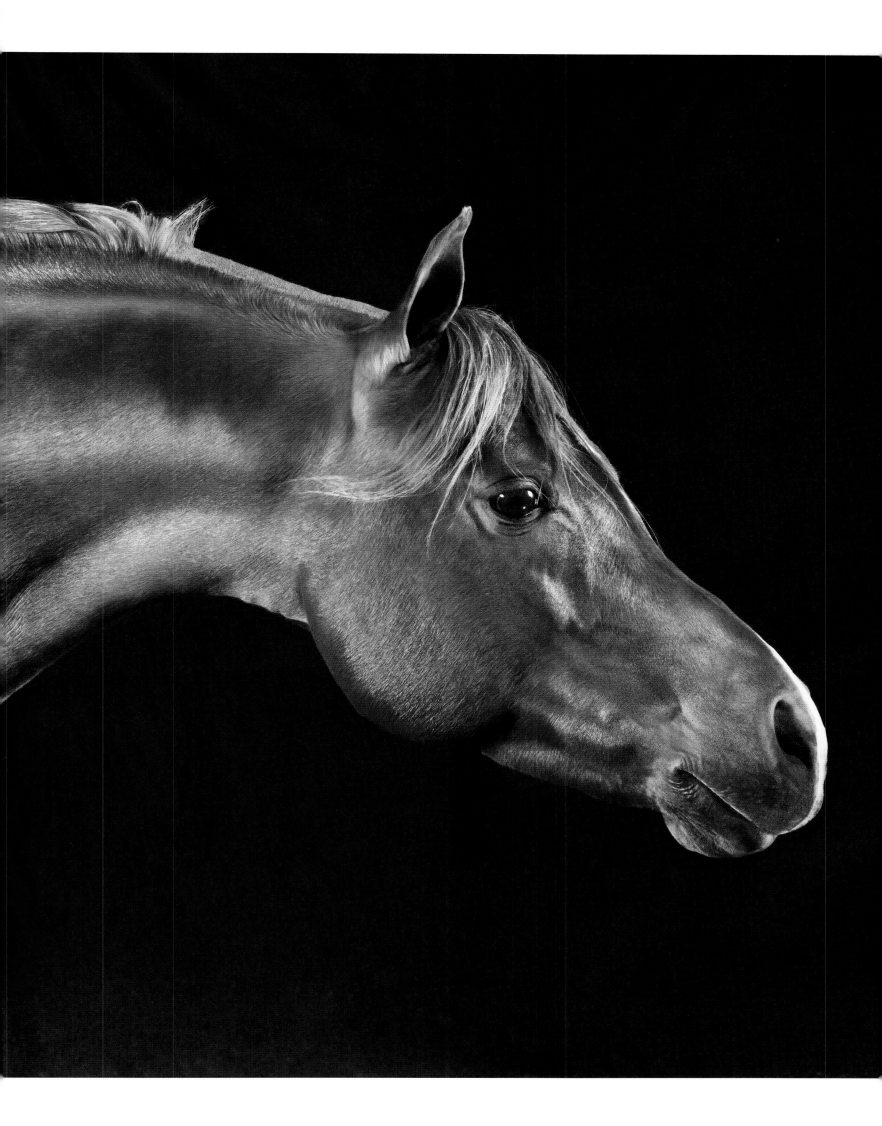

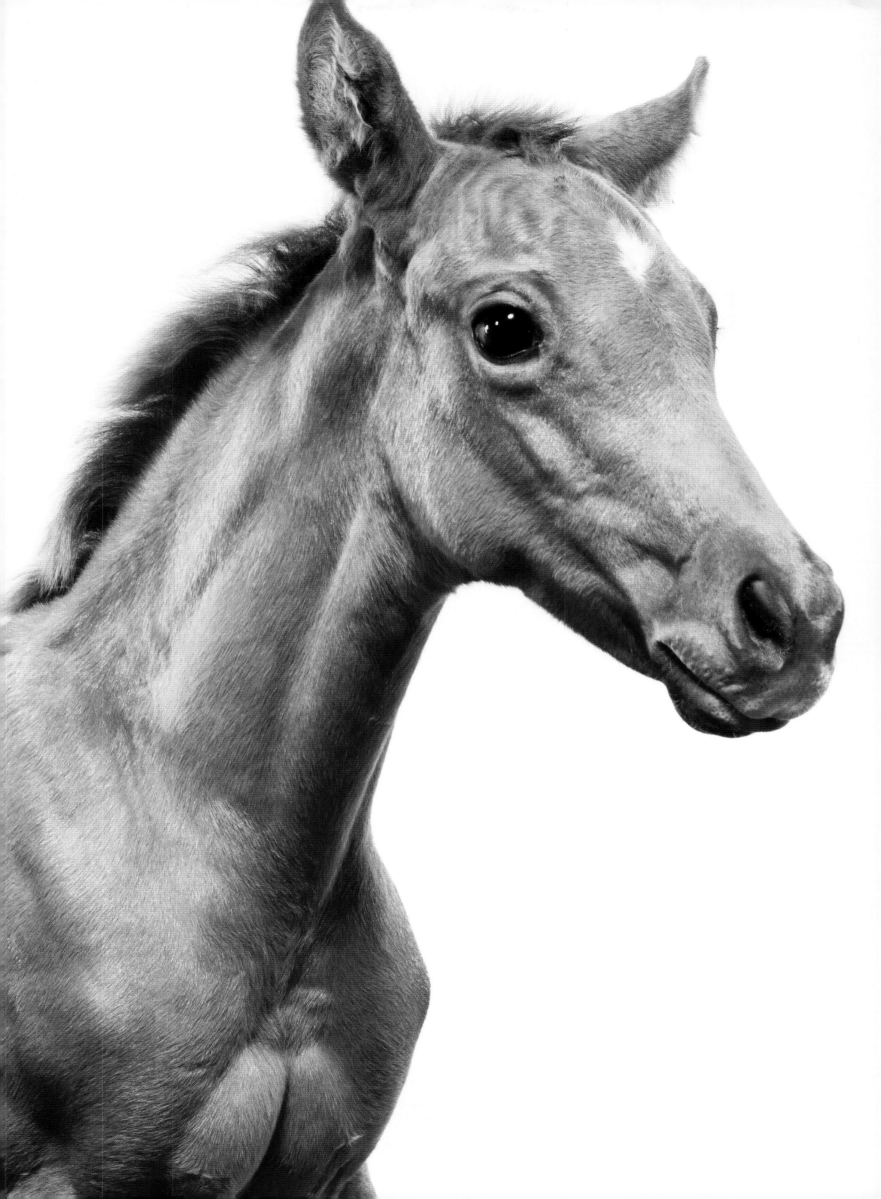

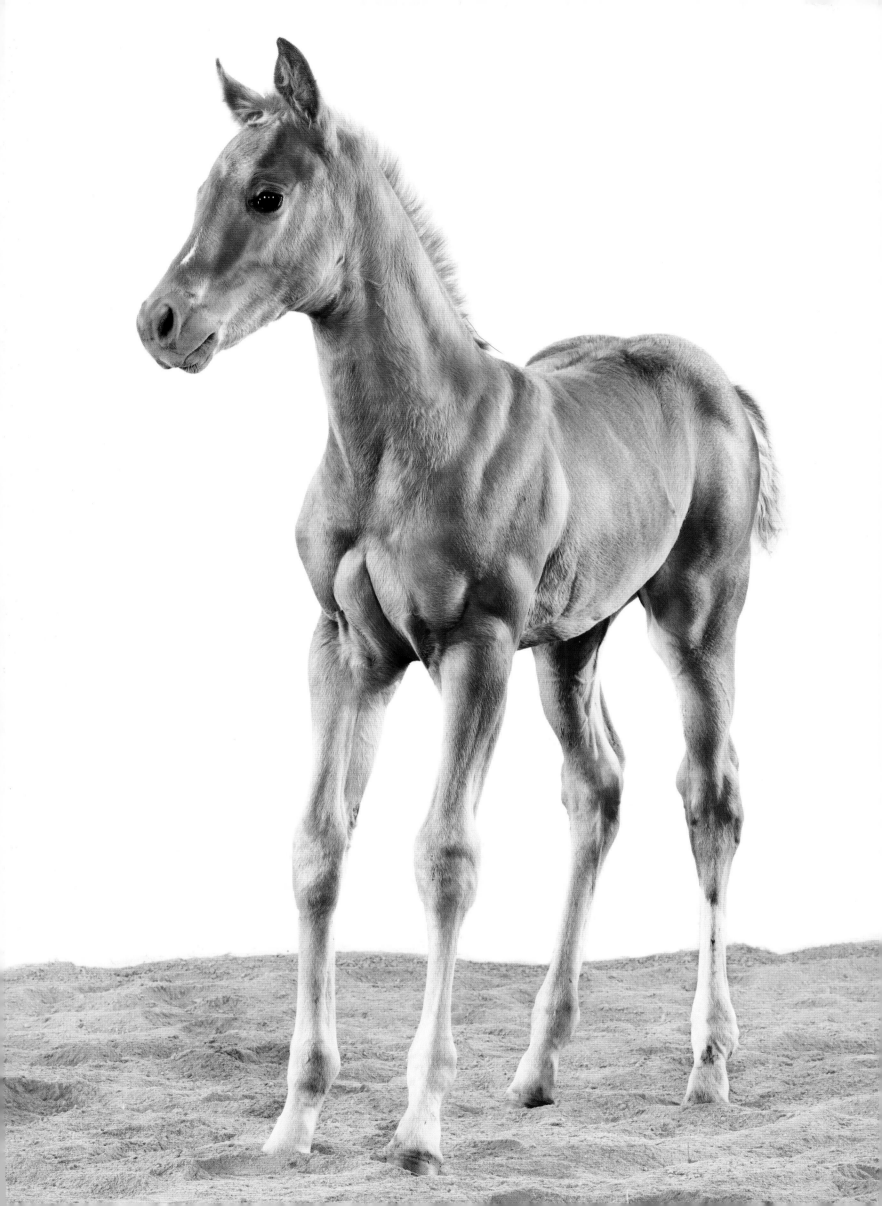

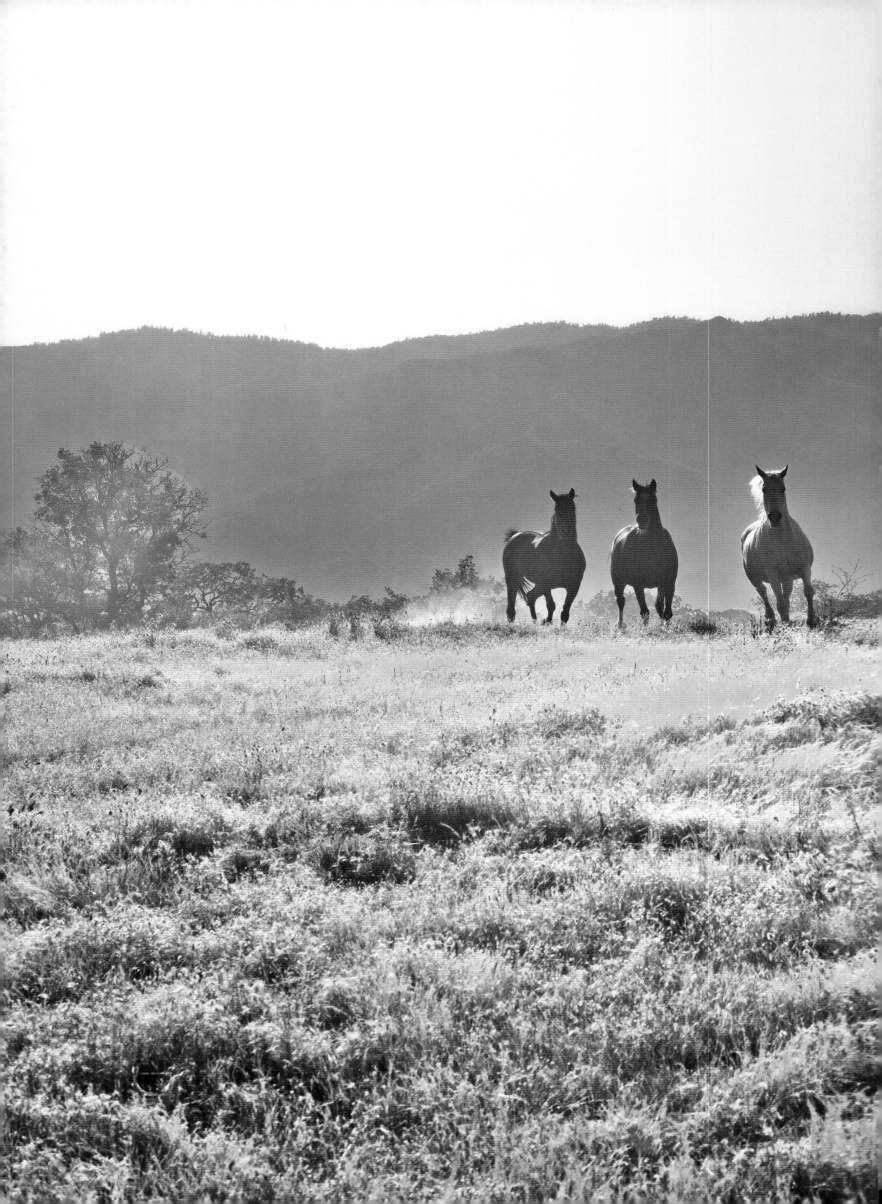

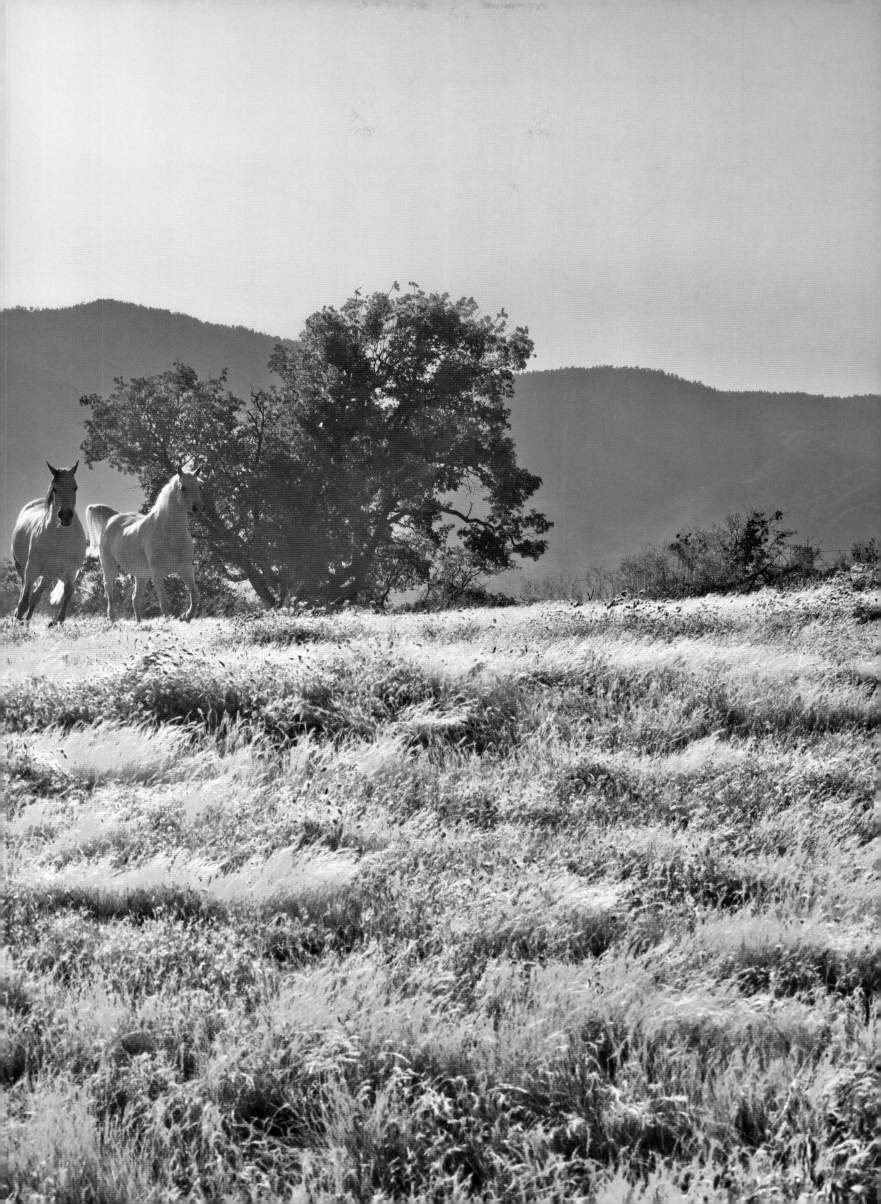

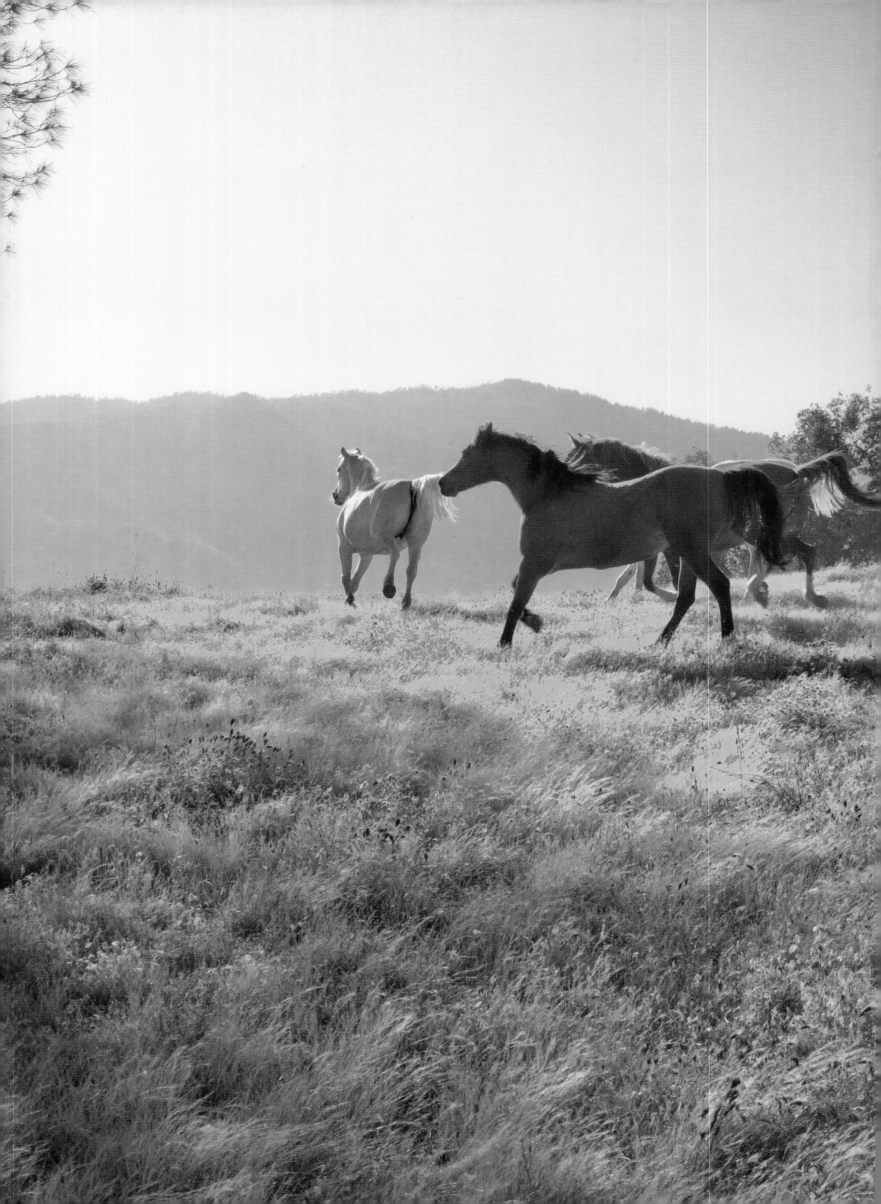

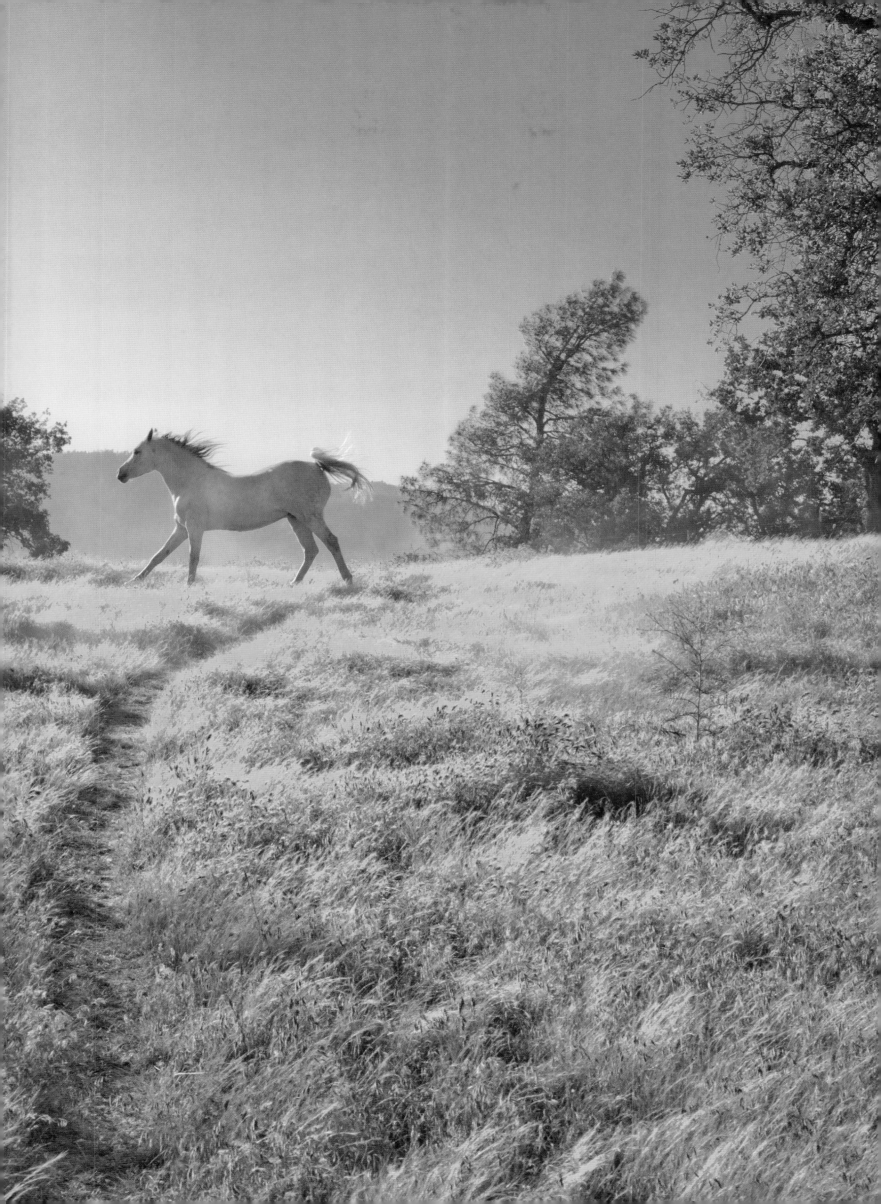

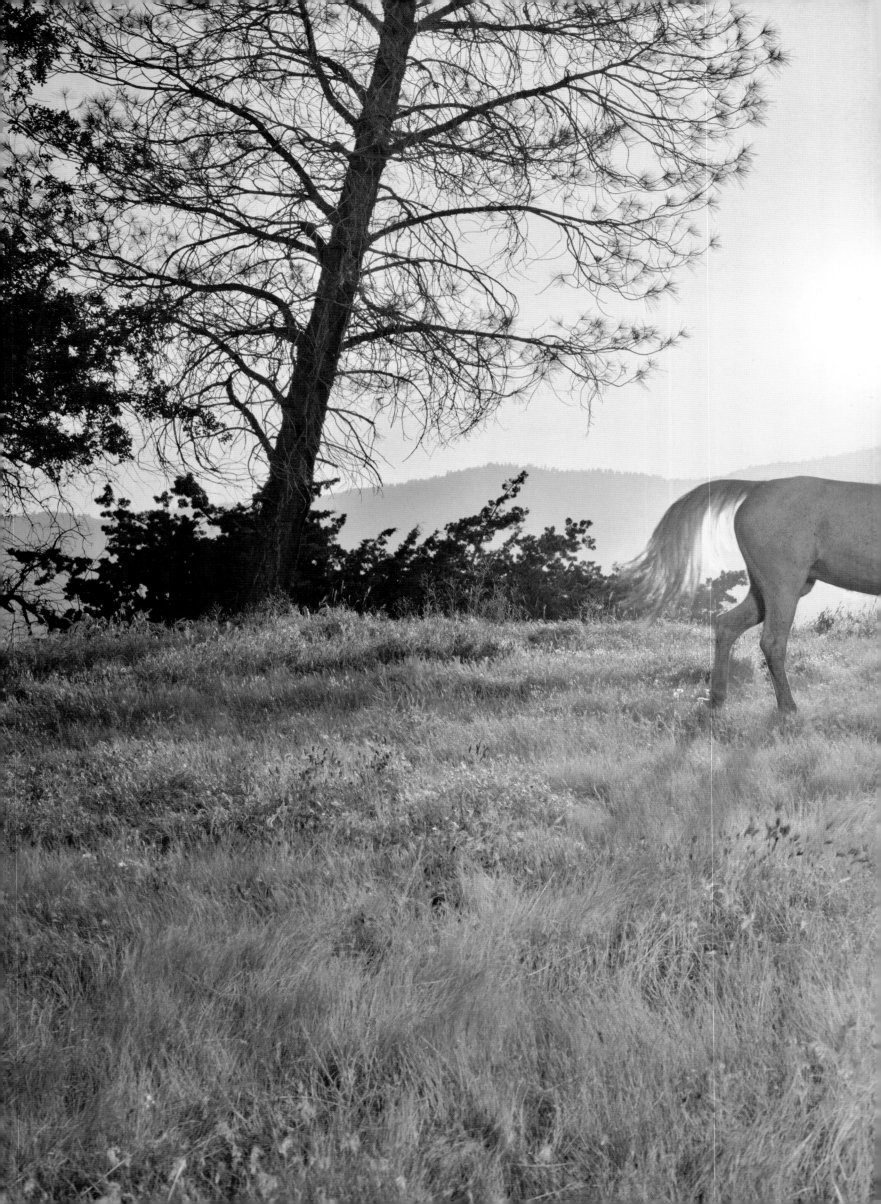

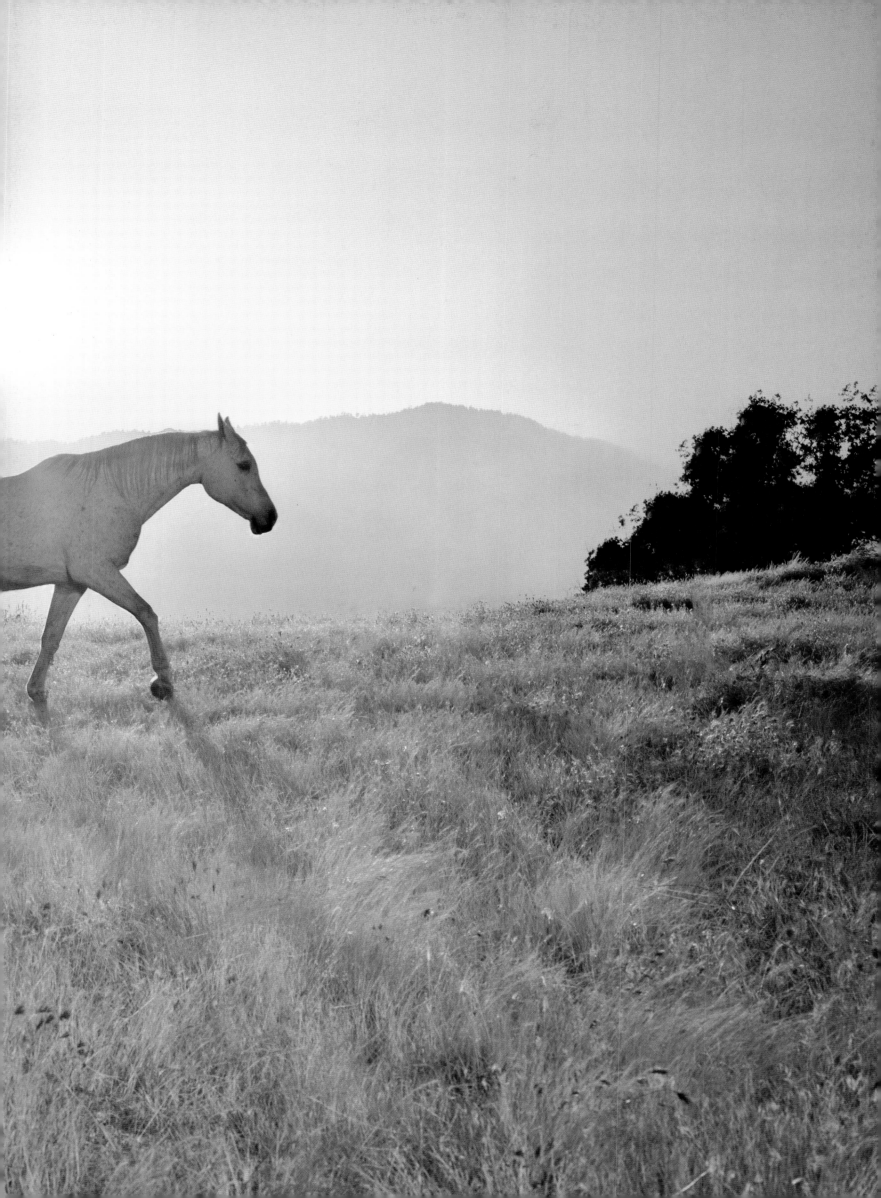

ACKNOWLEDGMENTS

I would like to express special thanks
to the following horse trainers and owners: Danny Virtue, Carah Von Funk,
Bryan and Carol Anderson, Hollywood Animals, Brian Terkleson,
Wess Albrecht, Sarah Olson, Candace Lind Bloomquist,
Petra Beltran, Shari Mahaffey, Tracy Underwood, Lea Bové, Jamie Meyer, Susie Nementi,
Avery Hellman, Olivia Hellman, Tim Beals, Laini Reeves, Leslie Charleson,
Edwina Greenspan, Tim Keeling, Samantha McNeely, Kay March, and Sheryl Abrams.

To the Los Angeles Equestrian Center; the Santa Rosa Equestrian Center;
the Virtue Studio Ranch British Columbia, Canada; and the Rankin Ranch, California.

To the patient subjects of this book: Apache, Arco, Babalu, Beatle, Ben,
Casey, Cinco, Cypress, Ecstacy, Elegido, Encanta, Fine Figure Head, Gabriella Brahim,
Generale Ariosa, Generalissimus Serpa, Heilke Fan De Garelanden, Huracan, Illiad PM, Jaqueton,
Kaboom, Lingot, Lujoso, Marcus, Mercedes, Navarrone, No Denying, Ogroloso, Palone,
Presumido, Private Eyes, Romero, Sergeant Pepper, Sidon Juan, Sidsational, Solana, Tendra's Way,
Tiger Lily, Tjitze, Verso Do Retiro, Warwick, Winter, and Woodstock.

To Julie Di Filippo, Nathalie Kirsheh, Caitlin Leffel Ostroy, Alex Ostroy,
Christine Ciszczon, Danny Mikimoto, Geoffrey Fehr, Digital Fusion,
Eric Macklin, Jon Rosenstock, Sven Boecker, Jamie Beechum, Joe Budd,
and Brian Sunderlin and Gentle Giant Studios.

To my daughter, Violet, whose riding lessons inspired me to revisit my first muse.
To my son, Zed, and husband, Rob, who were patient with me
while I worked nights and weekends on this project, and to my parents.

First published in the United States of America in 2012 by
Rizzoli International Publications, Inc.
300 Park Avenue South
New York, NY 10010
www.rizzoliusa.com

Publication © 2012 Rizzoli International Publications, Inc.
All photography © 2012 Jill Greenberg
Equus Ferus Caballus Horses © 2012 A. M. Homes

Designed by Nathalie Kirsheh

Printed in China

2012 2013 2014 2015 2016 / 10 9 8 7 6 5 4 3 2 1
ISBN-13: 978-0-8478-3866-0
Library of Congress Catalog Control Number: 2012936556

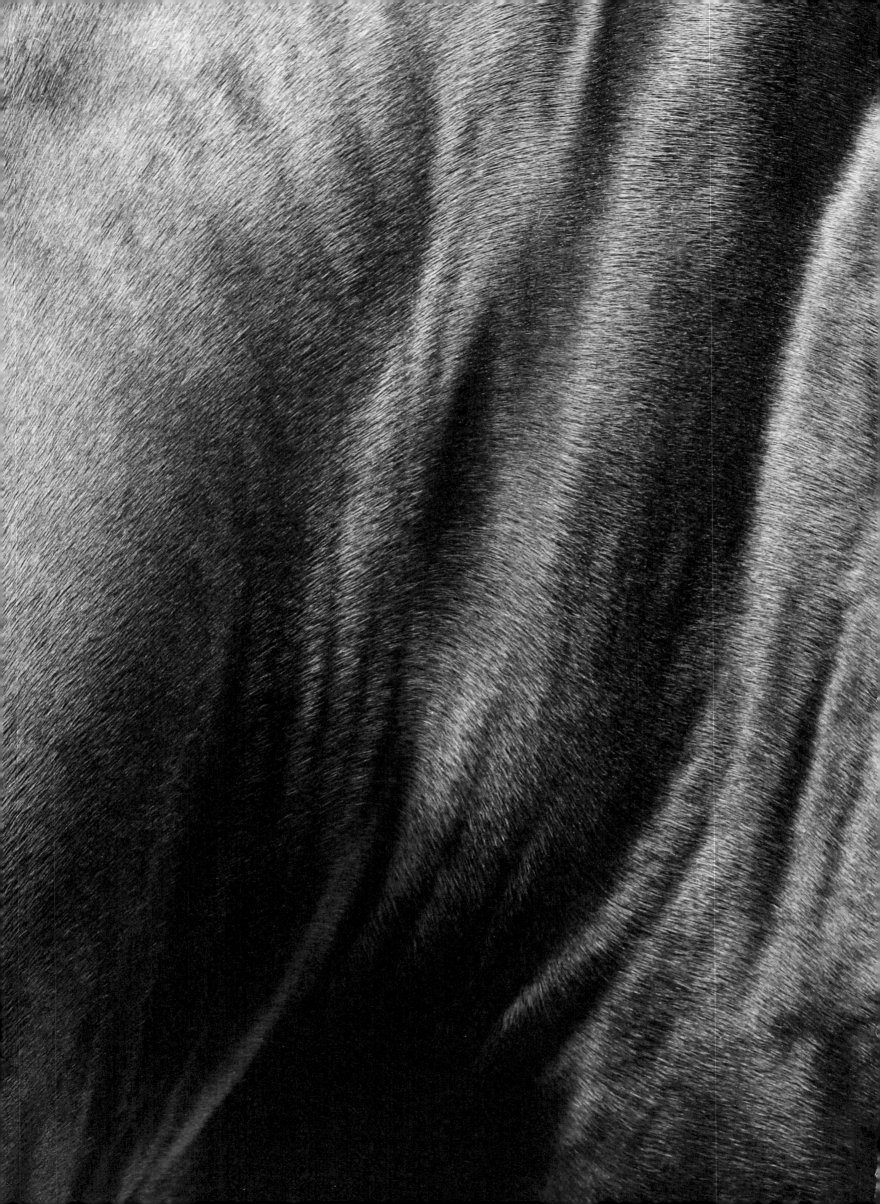